DRAWING RELATIONSHIPS IN
NORTHERN ITALIAN RENAISSANCE ART

Drawing Relationships in Northern Italian Renaissance Art

Patronage and Theories of Invention

Edited by Giancarla Periti
With an introduction by Charles Dempsey

ASHGATE

Published by
Ashgate Publishing Limited
Gower House
Croft Road
Aldershot
Hants GU11 3HR
England

Ashgate Publishing Company
Suite 420
101 Cherry Street
Burlington, VT 05401–4405 USA

The publisher gratefully acknowledges the support
of the Bibliotheca Hertziana (Max-Planck-Institut), Rome

Ashgate website: http://www.ashgate.com

British Library Cataloguing in Publication data
Drawing Relationships in Northern Italian Renaissance Art:
 Patronage and Theories of Invention
 1. Art, Renaissance—Italy, Northern—Congresses. 2. Art,
 Italian—15th century—Congresses. 3. Art, Italian—16th
 century—Congresses. 4. Art patronage—Italy, Northern—
 History—15th century—Congresses. 5. Art, patronage—
 Italy, Northern—History—16th century—Congresses. 6. Art
 and society—Italy, Northern—History—15th century—
 Congresses. 7. Art and society—Italy, Northern—History—
 16th century—Congresses. 8. Renaissance—Italy, Northern—
 Congresses.
 I. Periti, Giancarla
 709.4'5'09024

Library of Congress Cataloguing-in-Publication data
Drawing Relationships in Northern Italian Renaissance: Patronage and Theories of Invention
 / edited by Giancarla Periti; with an introduction by Charles Dempsey.
 p. cm.
 Includes bibliographical references and index.
 1. Art, Italian—Italy, Northern—16th century. 2. Humanism—Italy—History—16th
 century. 3. Art and religion—Italy—History—16th century. 4. Art patronage—Italy—
 History—16th century. I. Periti, Giancarla, 1966–
 N6919.N67D73 2004
 709'.45'109031–dc22

 2003063794

ISBN 0 7546 0658 9

Typeset in Palatino by Manton Typesetters, Louth, Lincolnshire, UK and printed in Great Britain by Biddles Ltd, King's Lynn.

Contents

Contributors

CHARLES DEMPSEY is Professor of History of Art at The Johns Hopkins University and author of several books, including *Annibale Carracci and the Beginning of Baroque Style* (1977; 2000), *The Portrayal of Love: Botticelli's Primavera and Humanist Culture at the Time of Lorenzo the Magnificent* (1992), and *Inventing the Renaissance Putto* (2001). With Elizabeth Cropper he co-authored *Nicolas Poussin, Friendship and the Love of Painting* (1996).

MARZIA FAIETTI is director of the Gabinetto dei Disegni e delle Stampe at the Pinacoteca Nazionale in Bologna. Since 2000 she has been teaching History of Drawing and Print at the Scuola di Specializzazione in History of Art at the University of Bologna, Italy. She has published extensively on Bolognese art, including a co-authored monograph on Amico Aspertini (1995), and has organized several international exhibitions such as *Bologna e l'Umanesimo 1490–1510* (1988), and *Un siècle de dessin à Bologne 1480–1580* (2001).

STANKO KOKOLE completed his PhD in Art History at The Johns Hopkins University in 1998 and was subsequently a post-doctoral fellow at the Villa I Tatti in Florence, Italy and at the Humboldt University in Berlin, Germany. He has published articles on various aspects of Renaissance art in the Adriatic Rim which appeared in *Wiener Jahrbuch für Kunstgeschichte*, *Venezia Arti*, *Mitteilungen des Kunsthistorischen Institutes in Florenz* and *Renaissance Quarterly*.

ALESSANDRA GALIZZI KROEGEL received her PhD at The Johns Hopkins University in Baltimore. From 1988 to 1991 she was Predoctoral Fellow at the Center of Advanced Study in the Visual Arts, National Gallery of Art, Washington. In 1991–92 she worked in the same museum as Assistant Curator in the Department of Italian Renaissance Painting. She has published articles on religious iconography, especially in relation to the Franciscan Order.

Currently she is completing a book on the iconography of the Immaculate Conception, a project for which she received a J. Getty Postdoctoral Fellowship. Since 1992 she has been Adjunct Professor at the Scuola di Specializzazione in Storia dell'Arte, Università Cattolica, Milan. As of 2002 she also teaches at the University of Urbino, Italy.

GIOVANNA PERINI is Professor of History of Art Criticism and Director of the Institute of Art History and Aesthetics at the University of Urbino, Italy. Her numerous publications in Italian, English and German are chiefly concerned with Bolognese and Northern Italian art literature and collecting *c.* 1500–1800, as well as with British art and art literature (especially Sir Joshua Reynolds). Her books include *Gli Scritti dei Carracci* (1990) the editions of Giovanni Ludovico Bianconi's *Scritti tedeschi* (1998) and of Meyer Shapiro's *Per una semiotica del linguaggio visivo* (2002).

GIANCARLA PERITI holds degrees from the University of Genoa and the Catholic University in Milan. She completed her PhD at The Johns Hopkins University, Baltimore, with a doctoral thesis on privately commissioned paintings by Correggio. In 1999–2000 she was the Italian fellow at the Bibliotheca Hertziana in Rome and subsequently taught at the University of Macerata, Italy. She has published articles in various volumes of essays and she is currently editing a volume on the visual culture of the Renaissance in Emilia and the Marches. Her research interests include sixteenth-century Emilian art and Northern Italian painting in general.

ALESSANDRA SARCHI studied at the Scuola Normale Superiore di Pisa and has just completed her PhD at the University of Venice Ca' Foscari on the sculpture of Antonio Lombardo. She has collaborated with the Getty Provenance Index on the Italian Renaissance art collecting project. She has published on Wiligelmo's sculpture at Modena Cathedral, and is currently working on the art collection of Rodolfo Pio da Carpi.

CAROLYN SMYTH is Associate Professor and Chairman of Humanities at John Cabot University, Rome. She received her PhD from the University of Pennsylvania in 1988, and was a fellow at Villa I Tatti in Florence 1991–92. A specialist in the Renaissance painting of Northern Italy, her publications include *Correggio's Frescoes in Parma Cathedral* (1996) and she is currently working on a book on the nave fresco cycle in Cremona Cathedral.

MARY VACCARO is an Associate Professor of Art History at the University of Texas at Arlington. She received her PhD from Columbia University and has been a fellow at the American Academy in Rome and at Villa I Tatti. Her

research, which focuses on Parmigianino and art in sixteenth-century Parma, has been published in various anthologies and journals. She recently co-authored a book on Parmigianino's drawings (2000) and completed a monograph about Parmigianino's paintings (2003).

List of figures

Soprintendenza per il Patrimonio
Storico, Artistico e
Demoetnoantropologico di Bologna,
Bologna)

4.5 Amico Aspertini, *Meeting of Sts
Francis, Dominic and Angelo of Jerusalem*,
1508–1515, pen and brown ink, London,
British Museum, Department of Prints
and Drawings. (Photo: © British
Museum, Department of Prints and
Drawings, London)

5 A misunderstood iconography: Girolamo Genga's altarpiece for S. Agostino in Cesena

5.1 Girolamo Genga, *Dispute about the
Immaculate Conception, c.* 1516–18, oil on
panel, Milan, Pinacoteca di Brera.
(Photo: © Soprintendenza per il
Patrimonio Storico, Artistico e
Demoetnoantropologico di Milano,
Milan)

5.2 Girolamo Genga, *Annunciation,
c.* 1516–18, oil on panel, Cesena, Church
of S. Agostino. (Photo: © su concessione
del Ministero per i Beni e le Attività
Culturali)

5.3 Girolamo Genga, *Conversion of St
Augustine, c.* 1516–18, oil on panel,
private collection. (Photo: © Studi di
Storia dell'Arte/Ediart editrice, Foligno)

5.4 Girolamo Genga, *Baptism of St
Augustine at the Hands of St Ambrose, c.*
1516–18, oil on panel, Bergamo,
Accademia Carrara. (Photo: © Comune
di Bergamo, Accademia Carrara,
Bergamo)

5.5 Girolamo Genga, *St Augustine
Receiving the Habit of the Hermit Monks
from St Ambrose*, 1518, tempera and oil
on panel, Columbia, South Carolina,
Columbia Museum of Art. (Photo: ©
Columbia Museum of Art, Colombia,
South Carolina)

5.6 *Historia Augustini*, 1430–40,
watercolour, MS 78 A 19a, fol. 12 recto,
Berlin, Kupferstichkabinett. (Photo: ©

Kupferstichkabinett – Sammlung der
Zeichnungen und Druckgraphik –
Staatliche Museen zu Berlin,
Preussischer Kulturbesitz, Berlin)

5.7 Francesco Signorelli, *Dispute about
the Immaculate Conception, c.* 1521–23,
tempera on panel, Cortona, Museo
Diocesano. (Photo: © Gaetano Poccetti,
Cortona)

6 Pordenone's 'Passion' frescoes in Cremona Cathedral: an incitement to piety

6.1 Giovanni Antonio de Sacchis,
called Pordenone, *Christ before Pilate*,
1520, fresco, Cremona Cathedral.
(Photo: © Curia Vescovile di Cremona/
Pietro Diotti, Cremona)

6.2 Giovanni Antonio de Sacchis,
called Pordenone, *Christ Led to Calvary*,
1520, fresco, Cremona Cathedral.
(Photo: © Curia Vescovile di Cremona/
Pietro Diotti, Cremona)

6.3 Giovanni Antonio de Sacchis,
called Pordenone, *Christ Nailed to the
Cross*, 1520, fresco, Cremona Cathedral.
(Photo: © Curia Vescovile di Cremona/
Pietro Diotti, Cremona)

6.4 Giovanni Antonio de Sacchis,
called Pordenone, *Crucifixion*, 1521,
fresco, Cremona Cathedral. (Photo: ©
Curia Vescovile di Cremona/Pietro
Diotti, Cremona)

6.5 Girolamo Romanino, *Christ before
Caiaphas*, 1519, fresco, Cremona
Cathedral. (Photo: © Curia Vescovile di
Cremona/Pietro Diotti, Cremona)

6.6 Giovanni Antonio de Sacchis,
called Pordenone, *Prophets and Decorated
Pilaster*, 1520, fresco, Cremona
Cathedral. (Photo: © Curia Vescovile di
Cremona/Pietro Diotti, Cremona)

6.7 Donato Montorfano, *Crucifixion*,
1495, fresco, Milan, S. Maria delle Grazie.
(Photo: © su concessione del Ministero
per i Beni e le Attività Culturali)

8.8 Hieroglyphic, woodcut, detail from
Francesco Colonna's *Hypnerotomachia
Poliphili*, Venice: Aldus Manutius, 1499.
(Photo: © The George Peabody Library
of The Johns Hopkins University,
Baltimore)

**9 Reconsidering Parmigianino's
Camerino for Paola Gonzaga at
Fontanellato**

9.1 Francesco Mazzola, called
Parmigianino, ceiling painting for the
Camerino, *c.* 1523–24, fresco, Rocca of
Fontanellato, Parma. (Photo: ©
Soprintendenza per il Patrimonio
Storico, Artistico e
Demoetnoantropologico di Parma e
Piacenza, Parma)

9.2 Francesco Mazzola, called
Parmigianino, north wall of the
Camerino, *c.* 1523–24, fresco, Rocca of
Fontanellato, Parma. (Photo: ©
Soprintendenza per il Patrimonio
Storico, Artistico e
Demoetnoantropologico di Parma e
Piacenza, Parma)

9.3 Francesco Mazzola, called
Parmigianino, east wall of the
Camerino, *c.* 1523–24, fresco, Rocca of
Fontanellato, Parma. (Photo: ©
Soprintendenza per il Patrimonio
Storico, Artistico e
Demoetnoantropologico di Parma e
Piacenza, Parma)

9.3 Francesco Mazzola, called
Parmigianino, south wall of the
Camerino, *c.* 1523–24, fresco, Rocca of
Fontanellato, Parma. (Photo: ©
Soprintendenza per il Patrimonio
Storico, Artistico e
Demoetnoantropologico di Parma e
Piacenza, Parma)

9.5 Francesco Mazzola, called
Parmigianino, west wall of the
Camerino, *c.* 1523–24, fresco, Rocca of
Fontanellato, Parma. (Photo: ©
Soprintendenza per il Patrimonio
Storico, Artistico e
Demoetnoantropologico di Parma e
Piacenza, Parma)

Preface

The project for this book germinated from a one-day conference I organized at the Bibliotheca Hertziana in Rome in July 2000. The papers and the ensuing discussion shed fresh light on the complexity of fifteenth- to sixteenth-century art produced in the Emilia and Lombardy regions in its humanistic and religious context, and generated much reflection on the part of the audience. The current volume contains the contributions presented at the conference, with several additional papers intended to broaden and enrich the theme. The essays focus on both sacred and secular works of art and their arrangement here is thematically organized to interweave better similar sets of questions and to trace the values of a Northern Italian Renaissance art tradition. Contributions by Stanko Kokole and Giovanna Perini thus open the volume, dealing, from two different viewpoints, with the problematic definition of the specific features of Northern Italian art, followed by two sets of studies, respectively by Marzia Faietti, Alessandra Galizzi Kroegel and Carolyn Smyth on religious images conceived for secular patrons, religious orders and civic communities, and then chapters by Alessandra Sarchi, Giancarla Periti and Mary Vaccaro on private decorated spaces for courtly and sacred milieux. The contributions on the religious images are well-argued studies in which imagery is seen to negotiate social, theological, rhetorical and cultural discourses, while the essays on the profane cycles explore certain aspects concerning the creation of embellished spaces designed to represent cultivated female and male individuals. Taken as a whole, these contributions therefore show how the imagery became constitutive of the various historical, theological and intellectual discourses that engaged their patrons and prime beholders, and how the artists responded to their requirements, while also fashioning their own selves in the works of their hands.

A project of this scale has incurred innumerable debts. As the editor of the volume, I would especially like to thank all of the co-authors, who sustained

this enterprise with much enthusiasm and intellectual rigour. Their support was crucial to the success of the project and invaluable for me during a period of great personal difficulty. I also owe a special debt of gratitude to the legion of scholars who assisted me throughout this project. I am further grateful to the Bibliotheca Hertziana for hosting the symposium and for the financial support for the publication of this volume. Pamela Edwardes and Lucinda Lax at Ashgate also deserve special thanks.

Giancarla Periti
December 2002

Introduction

Charles Dempsey

The point of departure inspiring the studies presented in this volume was provided by a symposium organized by Giancarla Periti, which took place in July of 2000 at the Bibliotheca Hertziana in Rome. The title of the symposium was intentionally broadly inclusive, announcing its theme as 'Cultura Umanistica e Religiosa: Committenza, Teoria e Pratica dell' *Inventio* nell'Arte Rinascimentale dell'Italia settentrionale', that is, 'Humanist and Religious Culture: Patronage and the Theory and Practice of Invention in the Renaissance Art of northern Italy'. The purpose was to provide a particular focus on sixteenth-century Renaissance art in an area given only secondary importance by Vasari, namely the present-day Emilia-Romagna, especially that part of Northern Italy loosely confederated under Julius II as the Papal States. However, it is best not to confine the problems posed by this art too narrowly within the confines of the post-Risorgimento political divisions of Italy. On the one hand, the Papal States were constructed around two great arteries, the ancient via Flaminia, restored by Julius II, leading from Rome through the present-day Umbria to Fano in the Marches (with a spur going to Loreto and Ancona), where it joined the via Emilia, the main road to Bologna. And, on the other hand, the artistic culture with which this volume is concerned can also be extended to include various municipalities, such as Cremona in present-day Lombardy, and even such far-northern cities as Bergamo and Brescia, all of them situated (like Bologna to the south, then considered Lombard by its inhabitants) within the huge watershed of the Po valley.

At the beginning of the fifteenth century, notwithstanding the political significance of Milan, no particular city in this extended region (which had borne the brunt of the 'wars of Italy', namely the French invasion in 1494 and subsequent conflicts for control) had attained a clear pre-eminence in the arts, even though Bologna was beginning to emerge as a major centre thanks

to the achievements of Francesco Francia and the Ferrarese Lorenzo Costa. By contrast, Vasari in his *Vite*, first published in 1550, was able to underscore the dominance of three particular municipal centres in the emergence of the *maniera moderna*: Florence, just to the south of the Apennines, which was then superseded by Rome, the first a centre for the evolution and the second for the rapid triumph of an idealizing classical style that Vasari defined under the rubric of *Disegno*; and Venice, the home of a relatively more naturalistic style, founded upon the values of what Vasari broadly denominated *Colore*. It is well known that after the publication of the second edition of the *Vite* in 1568 northern Italian artists and writers were quick to respond, vigorously defending the contributions of their native region. Indeed, the historiography and criticism of art over the next two centuries – beginning with Lamo's *Discorso intorno alla scultura e pittura* (1584) and Armenini's *De' veri precetti della pittura* (1587) and reaching its high-water mark (but hardly its conclusion) with Bellori's *Le vite de' pittori, scultori ed architetti moderni* (1672) and Malvasia's *Felsina pittrice* (1678) – was framed around a polemic between the rival claims of the northern and central Italian schools. This circumstance was indeed made inevitable by the fact that the Carracci in Bologna had powerfully asserted certain unique values of Emilian art as an important foundation for their famous reform of painting. In particular they emphasized Correggio's affective *colore,* based on pure hue, which they were the first to distinguish from the dramatic energies of Venetian *chiaroscuro*. They thereby divided Vasari's concept of *Colore* into its two constituent parts, identifying the perfection of each with different regions of Italy.

In fact, in the first decade of the sixteenth century the style of Perugino, Francia and the young Raphael had achieved a brief supremacy, quickly to be overshadowed by the unveiling of Michelangelo's Sistine Ceiling and the mature Raphael's frescoes in the *Stanze*, in which the new *maniera moderna* championed by Vasari found its fullest expression. All three artists were from the Papal States, and Vasari indeed acknowledged the accomplishment of Perugino and Francia, whose new manner (he wrote) had been perfected by Raphael before he changed his style in Florence and Rome. Vasari found in their paintings the penultimate advancement in art before the triumph of the *maniera moderna*. In particular, he rightly drew attention to their naturalistic colorism and limpid atmospheric infusions, so natural that everything that had come before seemed wooden and dry by comparison. At the same time Vasari detested (and felt threatened by) the expressive values of the style they had perfected. This manner, as Giovanni Previtali outlined in his *Fortuna dei Primitivi*, was generally known as the *maniera devota*, and it was founded upon models drawn from Emilia-Romagna (especially Ferrara and Bologna) and Umbria, as well as from Flemish painting. Michelangelo, who had heard the thunderings of the proto-Reformist Savonarola against the new humanist

painting in Florence, also despised this 'devout manner', acutely noting its relationship to Flemish art. He found it a style of painting fit only for ignorant women, monks and peasants; he sneered at Francia and Costa as 'due solennissimi goffi nell'arte [two most solemn and clumsy artists]';[1] and he also proclaimed Perugino, the other great originator of the *maniera devota*, a 'goffo nell'arte [an awkward artist]'.[2] Vasari added that he objected to this 'clumsy and inept manner' even being called a *maniera devota*, because of the implication that the modern manner was incapable of expressing religious devotion. His defence of the *maniera moderna* is remarkable:

I would never wish that anyone deceive himself by interpreting the clumsy and inept as devout: and the beautiful and good as lascivious; as some do, who, when seeing figures of women or youths a little more lovely, or more beautiful and ornamented than usual, at once attack them and judge them lascivious: not realizing how wrongly they condemn the judgement of the painter, who holds that the male and female saints, who are celestial, are as much more beautiful than mortal nature as are the heavens over earthly beauty and our works: and, what is worse, they reveal their own souls as infected and corrupt, finding evil and dishonourable desires in those things which, were they truly lovers of honesty, as in their ignorant zeal they would make us believe, should show their desire for heaven, and to make themselves acceptable to the Creator of all things, from whose most perfect and most beautiful nature there arises all perfection and every beauty.[3]

No clearer statement could be wished of the position of an embattled humanist art, with its goal of manifesting a perfected ideal of truth in the forms of an absolutely perfect beauty, around the year 1550, when Michelangelo's *Last Judgement* was under attack from all quarters for impiety and lasciviousness, and when the Council of Trent was beginning deliberations that would call for the reform of art. Set against it was the Reformist position, calling for an art that would touch the affective responses of the spectator, an art that would not flaunt its own skill, but rather invoke in the viewer, whether knowledgeable about art or not, a natural yet typical devotional response that identified manifestations of the divine with human feelings and emotions. Twentieth-century art history and criticism, essentially in agreement with Vasari and Michelangelo, has generally been unsympathetic with the pietistic aims of Francia and Perugino's art, 'più chiesastica che religiosa', as Giulio Carlo Argan put it, more churchly than truly religious, which combines a certain uniform blandness and even sentimentality of expression with the softness of naturally unified colours and atmosphere. Such lack of sympathy is due not least to the quickness with which their *maniera devota* was eclipsed in Rome by the stupendous achievements of Michelangelo and Raphael, not to mention the superbly talented first generation of mannerist artists who followed in their tracks. Nevertheless, the affective qualities and naturalistic colorism of that art never ceased to exert a powerful influence in Emilia-Romagna and the Marches, finding continued expression in the works of

artists like Garofalo, Timoteo Viti and Bagnacavallo, all of whom attempted to unite the classical design of the mature Raphael with that native colorism and pious sentiment, derived from Perugino and Francia, in which they had been trained as youths. For that reason Vasari wrote of such painters that, 'all these masters, from having seen the works of Raphael and associated with him [in Rome] had a certain something overall that seemed as if it should be good, but which in truth did not hold to the well-understood particularities of art as it should.'4

The painter who did achieve the union of the colorism and affective values of the *maniera devota* with, as Vasari acknowledged, the scale and triumphalism of the *maniera moderna* was of course Correggio. And it was substantially on the foundation laid by Correggio, his tenderness and ability to evoke the softness of living flesh, together with substantial support from his later follower the Urbinate Federico Barocci, that the Carracci built their reform of painting. This was made in response to the demands of Church reformers that art cease from exalting its own abilities in celebrating an entirely abstract concept of beauty and return to its purpose, already inherent in the painting of the Papal States, of reinforcing a devotional response from its audience, from the simplest to the most sophisticated. An important result was to ensure that, as distinguished from the ultimate resolution of the *questione della lingua* in favour of Tuscan, the art of the coming centuries in all of Italy, and indeed Europe, would be founded on 'Lombard' values of colour and emotional address (values we would now call Emilian), that is, on a modernization of the earlier *maniera devota*, on the basis of which the ideal abstractions of a classically based humanist art that had been developed in Tuscany and Rome could be endowed with a palpable humanity and with the illusion of natural verisimilitude.

The emotional content and natural colorism of sixteenth-century painting in north Italy had another, more expressionistic, manifestation, however, and one that is less well defined than is the character of the gentler sentimentalism that is only one aspect of the *maniera devota*. The reason for its lack of definition is that the principal practitioners of this alternate naturalistic manner came from such diverse origins. Among them are Dosso Dossi, whose life was for the most part spent in the small but highly cultivated Este court of Ferrara, and who also painted important frescoes in Pesaro; the Venetian Lorenzo Lotto, notorious for his peripatetic existence, which took him from Bergamo at the far north of the Po valley to Ancona and Loreto in the Marches; and the Friulian Pordenone, equally peripatetic and the author of influential frescoes in Cremona, from where the Carracci family originated. All three knew Venetian painting (as well as its distinctly individual adaptation in Bergamasque art), the effects of which are especially notable in Dosso's and Lotto's jewel-like colorism wedded to powerful effects of light

and dark, but they also departed from its conventions in significant ways. A Germanic or even 'Gothic' expressionistic effect has been noticed in their styles, and, even though all three were clearly aware of the classical discoveries of the *maniera moderna*, at the same time they strove to arouse emotional responses in their viewers by means that have been rightly called anti-classical. Such effects include figural distortions and a disregard for the harmonious proportions and serene balance of a Raphael, as well as a naturalistic yet evocative colorism that evokes the mysterious atmosphere of Ariosto's romances rather more than the clarity and grandeur of Virgilian epic. Each has been called an eccentric at one time or another, even though their eccentricities are remarkably consistent. The roots of the manner each developed in different ways can be found in the works of painters like the Bolognese Amico Aspertini, another 'eccentric' who opposed to Francia's sweetness of emotional effect a violence of expressive assault on the responses of the viewer that is really the other side of the same coin, calculated to move the passions of the devout spectator to a viscerally empathetic identification with what he is viewing. And it is a manner that is remarkably consistent and widely spread both inside Emilia and beyond, for examples of which it suffices only to mention the names of artists like the Ferrarese Ludovico Mazzolini and Ortolano, the Brescian Romanino, or Altobello Melone from Emilia. It is worth mentioning that, just as the early reform of art by Ludovico and Annibale Carracci sprang from an assimilation of the tender style of the *maniera devota* as modernized by Correggio, so too did Ludovico's later style (again called 'eccentric' in the literature) have deep roots in this equally native Lombard manner.

 Giovanna Perini's chapter for this volume expertly traces the historiographic traditions of the literature on Emilian painting, which originated in polemic, that is, with the sixteenth-century reactions to Vasari's powerfully negative treatment (indeed virtual erasure, in the sense that he tended to treat all art north of the Apennines under the same rubric) of the art of the region. Even so, thanks to the achievements of the Carracci and their school in Bologna, a high estimation of this art became vindicated in the seventeenth century (though the polemic between the Bolognese and Roman schools was never muted), and it reached a kind of apotheosis by the eighteenth century, culminating with the artist and critic Anton Rafael Mengs. That the esteem in which this art was then held again lapsed in the subsequent centuries (including the years of the establishment of art history as an academic subject, and with it a return to Vasari's model for tracing the history of Renaissance art) is the result of the historical and economic decline of the principalities of northern Italy. No such a waning in critical fortune would have been conceivable had the treasures of the Farnese been returned to Parma from Naples, or those of the Este from Dresden to Modena, or those of the Gonzaga from England and Spain to

Mantua. Nevertheless, great works still grace the museums of Bologna, Modena and Parma. It is toward reconstructing the extraordinarily rich and complex heritage of this region, whether defined as the art of Emilia-Romagna, the Papal States or the Po valley, that the present volume is intended as a contribution. Diffuse as it was, and open to so many broad influences seeping in from all points of the compass, there occurred a kind of *terzo rinascimento,* neither Roman nor Venetian, that was not only outstanding in its own right but also fundamental for the future of art in the next two centuries.

Of especial importance is the existence of a number of small but intensely cultivated courts in the region, among them those at Correggio, at Carpi and at Fontanellato near Parma, a city that in the first half of the century was not itself a major court so much as a centre of Benedictine culture dominated by the family of the Bergonzi. In this volume three studies are devoted to individual frescoed decorations that adorn the art of the region like gems set in a diadem: Giancarla Periti's essay on Correggio's famed Camera di San Paolo in the apartment of the Abbess Giovanna [Bergonzi] da Piacenza in the Benedictine nunnery of San Paolo in Parma; Mary Vaccaro's on Parmigianino's scarcely less well-known Camerino in the Rocca Sanvitale near Parma; and Alessandra Sarchi's on the relatively unknown but no less enchanting studiolo of Alberto Pio at Carpi. This last, which appropriately takes the Muses as its subject, is the earliest of the three, and Sarchi masterfully sets it in the context of such earlier *studioli* as those of Federico Montefeltro in Urbino and of Leonello d'Este at Belfiore in Ferrara, in the process showing the close communications between the humanist cultures of the courts of Emilia-Romagna. The decoration of the Este *studiolo* at Belfiore had also been devoted to the Muses, in the conception of which the new learning of the most distinguished humanists, among them Guarino of Verona, had been joined to the new art of the finest artists, including Cosmè Tura. The electric release of creative energies that resulted – in the products of which for the first time a newly interpreted concept of classical content (*ethos*) was conjoined with an emerging concept of classical expression (*pathos*) – is of central importance for our understanding of the phenomenon of the Renaissance itself. The phenomenon of joining classical form with classical content was famously described by Erwin Panofsky in *Renaissance and Renascences,* in which he dated its origins to the late Quattrocento, in the art of Mantegna and Botticelli. This is certainly too late, and the complex texture of this novel conjunction at its very beginnings is brilliantly set forth in this volume by Stanko Kokole in his essay on the Tomb of the Ancestors in the Tempio Malatestiano in Rimini, in which we find, so to speak, the music of Agostino di Duccio's sculptures complemented by a libretto composed by the brilliant humanist and poet Basinio da Parma.

In a later book, devoted to Correggio's Camera di San Paolo, Panofsky wrote memorably of the particular character of north Italian humanism in

Parma, which he distinguished from that of central Italy, and in particular Florence. Panofsky made a number of fundamental contributions to understanding the origins and meaning of individual images painted by Correggio, but at the same time his overall interpretation of the iconography of the room has found few followers. In her essay, Giancarla Periti clearly explains the reasons why, and she goes on to point out that the question turns upon establishing the genre not only of Correggio's images but also the entirety of the enigmatic inscriptions, devices and other paintings in the Abbess's apartment, and that this entails an understanding of the humanist literary culture peculiar to Giovanna da Piacenza's contemporary Parma as well as to other Emilian centres. She is undoubtedly correct to identify this genre with Renaissance hieroglyphics, which are to be understood as the foundation for a universal symbolic that existed in all times and places, and that encompassed not only pictographs but also verbal utterances such as Pythagoras' *aenigmata* and the parables of Christ. Beyond this she identifies its character with a particular kind of witty and learned *concettismo* that is highly characteristic of the literary and artistic tastes of the courts of north Italy. In so doing she allows us an insight into the unifying concept of the Camera di San Paolo, and by establishing its unifying genre makes a contribution every bit as important as would be the definitive decoding of all the room's individual enigmas.

These essays taken as a whole reveal much about the character of the various methodologies currently being tested by art historians, not so much in the sense of being limited to only one way of proceeding (and hence to narrowing research to single questions) as in the sense of broadening inquiry to encompass cultural reality as a whole, taking in questions of historical particularities, documentation, humanist learning and literary production as well as artistic, and not overlooking the vital questions of style and dating. The approach that emerges is one of inclusion, one aimed at complete comprehension rather than a narrow focus on a single means of attack. Mary Vaccaro's study of Parmigianino's Camerino for the Rocca di Fontanellato argues that the patron of the frescoes was Paola Gonzaga rather than her husband, the Count Galeazzo Sanvitale. She goes on to consider Parmigianino's imagery and its iconography in a new context, determined by gender studies. Her essay also brings into play concepts based in reception theory and in studies of the phenomenon of patronage, according to which she considers the artist's intended viewer, that is, the Countess, who might be considered either as the actual patron or as its intended beneficiary. Nor has the gender of Correggio's patron for the Camera di San Paolo escaped Periti's attention; indeed, as Panofsky pointed out (and Ireneo Affò 150 years before him), one would be hard pressed to find a particular artistic commission anywhere that is more filled with the

personality of its patron. Carolyn Smyth, on the other hand, contributes a close analysis of Pordenone's series of Passion frescoes in the Duomo of Cremona (so critical for the history of the Emilian style, both in the sixteenth century and for the Carracci), finding in the painter's *clamorosità* of manner, and in its Germanicism, a calculated response to the political and social situation of a most dangerous moment in the history of the city and the entire region of the Po valley. It was a moment of crisis that, unsurprisingly, gave rise to a deep intensity of religious passion, and it is this, she argues, that made the powerful, almost visceral emotionalism of Pordenone's art the more welcome.

The religious pietism that is so characteristic of Emilia-Romagna and its art is also the focus of Alessandra Galizzi Kroegel's study of Girolamo Genga's altarpiece for the church of S. Agostino in Cesena. The painting itself returns us to the continuing importance of Raphael in the style of the region, but here not the Urbinate Raphael so much as the Raphael of the *maniera moderna* in Rome as seen through the filter of early mannerist painting in Florence, rendered with a closely focused and reflecting finish that again recalls northern European models. Be that as it may, Galizzi Kroegel subjects the unusual iconography of Genga's altarpiece to elegant and precise scrutiny, demonstrating that it derives from the material of contemporary disputations about the Immaculate Conception and is an ambitious and important statement of this doctrine made well before the familiar iconography of the Virgin Immacolata had become standardized, and very long before the dogma was officially proclaimed by the Church.

Taken as a whole, the individual chapters collected in this volume are a testament to the vitality of present-day studies in the Emilian Renaissance. It is with full acknowledgement of the sophistication and permanent value of the essays here published by each contributing author that I will end by singling out for special notice one essay in particular, by Marzia Faietti, co-author of a recent and indispensable monograph on Amico Aspertini. Her purpose is to draw attention to an unknown document listing the statutes and membership of the Confraternita del Buon Gesù in Bologna, in which Aspertini's name appears. The Confraternity was especially devoted to such communal penitential practices as flagellation and the washing of feet, a circumstance that lends vividness to the expressiveness of Amico's devotional images. Faietti's discussion of its truly remarkable membership, something of a *Who's Who* of Bolognese society, also reanimates the general religious culture that responded so powerfully to such images, as does her discussion of the devotional texts to be found in its library. Any more extended consideration of the northern Italian *maniera devota*, whether in its gentler manifestation in the works of Francia and Correggio or in the farouche expressionism of Aspertini and Pordenone, could do no better than to start

with the material presented in Faietti's essay, consulted together with the case histories that comprise the rest of this volume.

NOTES

1. Vasari (1966–87), 3: 32 (author's translation, here and below).
2. Ibid., 608.
3. Ibid., 274.
4. Ibid., 4: 495.

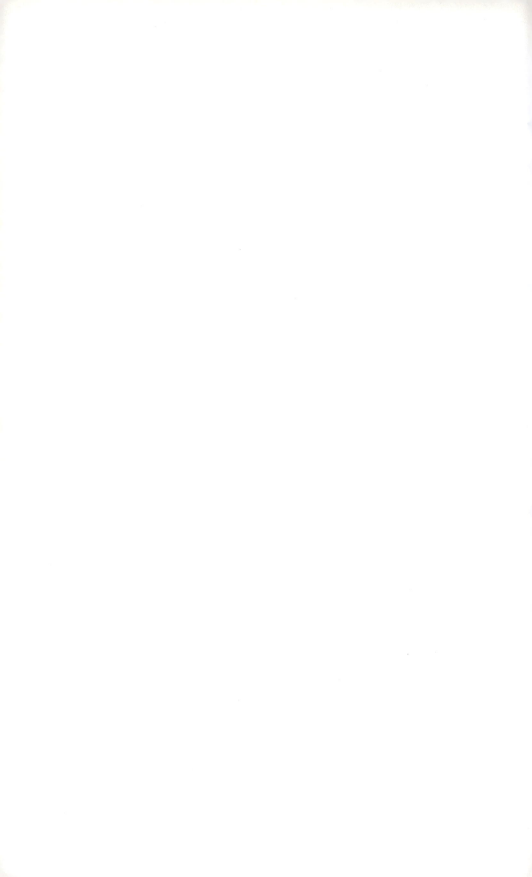

The Tomb of the Ancestors in the Tempio Malatestiano and the Temple of Fame in the poetry of Basinio da Parma

Stanko Kokole

One of the least well-known literary works written in mid-fifteenth-century Rimini under the patronage of Sigismondo Malatesta by his foremost court poet, Basinio da Parma, is a learned mythological epyllion entitled *Diosymposis* (alternately also referred to as *De Iovis compotatione*).[1] The poem as a whole calls for detailed philological analysis, which will systematically address the question of its sources and structure as well as elucidate its twofold meaning, both on the primary plane of a pleasing poetic fable and at the secondary level of a learned cosmic allegory. In this essay I shall, however, only discuss some elements of the elaborate ekphrasis that forms the core section of the poem and – along with several intertextually related passages in one of Basinio's later works – offers a key to solving one of the iconographic puzzles still posed by the sculptural decoration of the Tempio Malatestiano.

The frame story of the *Diosymposis* opens with a description of a joint banquet in the underwater palace of Oceanus, where the gods and goddesses of Olympus are hosted by the marine deities. Having first listened to the songs of Apollo and the Muses, they then depart for the fields of the blessed and the groves of happiness in order to visit the Temple of Fame.[2] Upon reaching the temple's threshold, the divine visitors' eyes first feast on its outer entrance gate, adorned with sculptured images of the Earth encircled by the waters of Ocean, Tartarus, Elysium and the star-studded vault of the heavens. On the brazen interior door Jupiter then admires a golden relief of the Creation of the Universe.[3]

Inside, the temple is filled with resplendent statues of famous men 'consecrated to eternity by Janus', some of which are made of hard imperishable steel (*adamante*) and others of ivory, bronze and marble. Adamantine statues portray eponymous heroes, such as Ulysses and Achilles, as well as numerous Greek and Roman poets, headed by Homer and Virgil.

Ivory effigies were – in Basinio's words – 'made of those renowned for their great deeds' ('... insignes fama factisque superbi ...'), namely the Roman emperor Augustus; the *signore* of Rimini, Sigismondo Pandolfo Malatesta; and his younger brother, Domenico Malatesta Novello, Lord of Cesena. The former two statues are distinguished by additional golden reliefs depicting the sitters' military victories.[4] Malatesta Novello is, however, extolled as a peace-loving patron of the arts by an invocation of the double-peaked Mount Parnassus, whence the resounding voice of personified Fame (*Fama*) assures a throng of true poets of their immortality.[5] Next stood statues carved of Parian marble commemorating ancient orators and philosophers – Cicero, Plato and Aristotle.[6] Yet the very last marble effigy, which attracts the gods' attention just before they leave the sanctuary, portrays Pope Nicholas V, who – Basinio assures the reader in a digressive encomium of the pontiff – deserved such honors 'owing to his holy faith and devout life'.[7]

To my knowledge it has hitherto not been noted that Basinio integrated extensive portions of this same description of the Temple of Fame into his most ambitious poetic work, the epic *Hesperis*.[8] *Hesperis* is perhaps best known to modern scholars for recording and celebrating Sigismondo Malatesta's actual military campaigns of 1448 and 1452 against the Neapolitan king Alfonso and his son Ferrante of Aragon.[9] Yet in its purely fictional central part it also recounts Malatesta's visit to the mythic Island of the Blessed and his subsequent descent into the abodes of the dead, in which the topical perilous journey of the classical epic hero was adroitly adapted by the poet to extol his patron's quest for immortal glory.[10]

In connection with this thematically pivotal part of the poem, the Temple of Fame is first expressly conjured up in the opening section of Book 7. At that juncture Sigismondo has a dream vision of his deceased father Pandolfo, who instructs him to sail to the 'remote island far in the vast ocean, which is called "fortunate" by men but is designated as "blessed by the gods"' (*Hesperis* 7. 16–18). Pandolfo then predicts that there his son will encounter the handsome daughter of Zephyrus – Psycheia, who will teach him how to defeat his adversaries (*Hesperis* 7. 19–23). Having revealed that Sigismondo would pass through the Elysian Fields and Tartarus – Pandolfo furthermore foretells – Psychaea will also lead him to the Temple of Fame (*Hesperis* 7. 49). The final section of Book 7 of the *Hesperis* concludes with the description of a terrifying storm caused by Neptune's wrath: Sigismondo's ship is destroyed; his crew perishes to a man; and as the sole survivor he eventually reaches an unknown shore where he falls asleep (*Hesperis* 7. 606–15). Thus the stage is set for the enactment of Pandolfo's prophecy in Books 8 and 9.

Next morning Sigismondo meets the nymph Psycheia, who tells him that to the immortal gods she is also known by the name of 'Isothaea diva' (*Hesperis* 8. 36) – in addition to being a charming character of poetic fiction,

she also represents a living person of flesh and blood: Sigismondo's mistress and his poetic *dama*, Isotta degli Atti.[11] Later that day, in the course of their tour of the island, Sigismondo and Psycheia-Isotta jointly pay a visit to the Temple of Fame (*Hesperis* 8. 205–6). The description of the images of the Earth and the Ocean and the Creation of the World in the Temple of Fame are retained in the *Hesperis* (in practically identical form), yet in the latter they now directly lead to the evocation of the double-peaked Mount Parnassus, introducing the personified Fame's hortatory address to vatic poets (*Hesperis* 8. 238–56). At this point the visit to the temple abruptly ends with Sigismondo's sudden exit (*Hesperis* 8. 357–8: 'Talibus in templo visis Pandulphius heros / Egreditur …').

In the *Hesperis* the visit to the Temple of Fame merely constitutes one passing episode within a far more complex and multi-faceted narrative. Book 8 centres on the love affair of Sigismondo and Psycheia, as is also indicated by Basinio's line summarizing its gist as 'Octavo Zephyri natam non spernit amantem'.[12] Not surprisingly, therefore, the temple's description has been scaled down to less than a third of its original length in the *Diosymposis*.[13] The omission of any reference whatsoever to the adamantine, bronze and marble statues is, nevertheless, remarkable, as they constitute an essential feature (indeed the focal point) of the earlier poem. In fact, their absence becomes even more puzzling once we recall that in Book 7 of the *Hesperis* itself Sigismondo was expressly told by the shade of his father Pandolfo that Fame's sanctuary housed a select group of mythic heroes and 'those who devoted themselves to [composing] holy songs dedicated to the pious Muses'; those 'who comprehended the causes of things, the wisdom of Jove, and [knew] the perpetually girating movements of the starry heaven'; and 'those who offered the wealth they obtained to [needy] others' (*Hesperis* 7. 50–63):

> Hic Heroes erunt, Alcides maximus atque
> Bellerophontaei decus insuperabile monstri,
> Et quicumque piis coluerunt sancta Camoenis
> Carmina, qui rerum causas novere, Jovisque
> Consilium, atque vias semper volventis Olympi,
> Et qui divitias aliis posuere repertas …

On the evidence of these six lines, it would seem that Basinio initially intended Sigismondo to be shown at least some of the heroes, poets, thinkers and benefactors within the Temple of Fame on the Island of the Blessed, but that (on second thoughts) he abandoned this plan for the obvious reason of generic consistency. According to a well-established convention of Latin heroic epic formulated in exemplary fashion by Virgil, the shades of distinguished and righteous mortals are normally seen by the epic hero undertaking the *katabasis* in a separate paradisiacal precinct of the pagan Underworld.[14]

A sketchy summary of Malatesta's subterrestrial itinerary, which fills up the entire Book 9 of the *Hesperis*, and is in fact largly (albeit far from exclusively) modelled on the sixth book of the *Aeneid*, should here suffice to give an idea of its overall structure.[15] As is underscored in its one-line summary provided by the author himself, its principal theme was Sigismondo's visit to the blessed inhabitants of the 'silvae beatae' ('Invisit nono populos, sylvasque beatas').[16] Having entered through the murky grove and the immense cave and passed the dusk of Limbo (*Hesperis* 9. 8–23, 47–69), he and Psycheia-Isotta thus first encounter Greek and Roman orators who are engaged in a debate on the shores of a mighty river (*Hesperis* 9. 73–106). In a grove of myrtle trees on the opposite side they then see famous women driven to death by desperate love (*Hesperis* 9. 107–42); next they enter Elysium (*Hesperis* 9. 143–76), from which they reach the abodes of ancient warriors. When Sigismondo impulsively rushes down towards their shades, ready for battle and sword in hand, he is stopped by his father Pandolfo, who suddenly appears from the mist and tells him it is of no avail to fight the spectres of the dead (*Hesperis* 9. 196–215). Then the father and son jointly tour the 'fields of Mars' (*Hesperis* 9. 216), where they see the parade of Roman and Carthaginian war leaders, the famous cities and founders of great nations, as well as the kings of ancient Rome (*Hesperis* 9. 226–40), who are set side by side with the 'equally famous other rulers of Italy' – Sigismondo's own forefathers (*Hesperis* 9. 241–4). Taking leave from his ancestors, Sigismondo (still in the company of his father Pandolfo) descends into Tartarus (*Hesperis* 9. 254–379) and is, upon his safe return, rejoined by Psycheia-Isotta, with whom he then returns to the surface, passing once again through the Temple of Fame (9. 393–4), while his parent retires to Elysium (*Hesperis* 9. 379–92).[17]

A closer look at Basinio's description of Elysium itself proves that, while in the *Hesperis* Fame's sanctuary was invoked in a secondary role in the paradisiacal garden of the Island of the Blessed, Sigismondo was in fact confronted by its inhabitants in their appropriate poetic sites in the exalted subterrestrial place of bliss. Elysium in the narrower sense of the word is envisioned as a centrally placed laurel grove bathing in supranatural sunlight (*Hesperis* 9. 144), where Muses sing their songs and sound their instruments in the presence of Apollo (*Hesperis* 9. 151–3); and where poets – led by Orpheus, Homer and Linus – keep company with the chaste priests, the heroes who have willingly fallen for their fatherland, the sages pondering the ultimate causes of things and the magnanimous benefactors of mankind, who all believed in one true God (*Hesperis* 9. 156–62):

> Hic Graii, nostrique viri, castusque Sacerdos
> Quisquis, erat dum vita super; quicumque volentes
> Pro patria cecidere sua; qui noscere rerum
> Tentarunt causas, et qui posuere repertas

> Divitias aliis; unum quicunque Tonantem,
> Non alios, regnare putant; his omnibus alta
> Tempora cinguntur Phoebea laeta corona.

The close resemblance – in both wording and content – of these lines to the anticipatory evocation of the denizens of the Temple of Fame in Pandolfo's address to Sigismondo in Book 7 of the *Hesperis* is self-evident. And no less apparent is their common classical source: Virgil's list of the principal Elysian inhabitants in *Aeneid* 6. 660–65:[18]

> Hic manus ob patriam pugnando volnera passi,
> quique sacerdotes casti, dum vita manebant,
> quique pii vates et Phoebo digna locuti,
> inventas aut qui vitam excoluere per artis,
> quique sui memores aliquos fecere merendo;
> omnibus his nivea cinguntur tempora vitta.

[Here is the band of those who suffered wounds fighting for fatherland; those who in their lifetime were priests and pure, good bards, whose songs were meet for Phoebus; or they who ennobled life by truths discovered; and those who by service have won remembrance among men – the brows of all bound with a snowy fillet.][19]

Pandolfo's speech, incidentally, repeats the exact words with which the Muse Erato exhorts the Olympian gods to pay a visit to the Temple of Fame in the *Diosymposis*.[20] Therefore it should come as no surprise to discover that the choice of mythical and historical characters portrayed in the statues adorning the temple's interior as described in the central part of that poem also neatly tallies with the list of the inhabitants of Elysium in *Aeneid* 6. 660–65, not only with respect to the triad of thinkers, poets and heroes (among whom the obliging court poet ranked Sigismondo Malatesta and Malatesta Novello, side by side with the divine Augustus), but also the chaste priests, who are included among the statues adorning the temple's interior in the effigy of Nicholas V.

In sum, there can be little doubt that in both the *Diosymposis* and the *Hesperis* Basinio's principal poetic model and point of departure for the selection of immortalized greats was the same famous passage in the sixth book of the *Aeneid*, which enumerates the principal categories of mortals who merited a place in the Laurel Grove of Elysium through their valour, wisdom, piety and noble deeds.[21] Individual representatives of each category may vary from one instance to another but the underlying principles of selection remain in all four instances essentially the same.

Given its obvious importance, it seems likely that this motif also found visual expression in artistic production associated with the Malatesta court in mid-fifteenth-century Rimini. As – to my knowledge – no illustrated manuscript of the *Diosymposis* has come down to us, the obvious place to look for its impact is the surviving illustrated copies of the *Hesperis*, which

were illuminated (at the behest of Sigismondo Malatesta) by Giovanni Bettini da Fano and his workshop in the early 1460s.[22] In the miniature that in each of the three manuscripts (now in the Vatican City, Oxford and Paris) heads the text of Book 9 (see Figure 2.1), which was therefore meant to provide the reader with a visually condensed summary of its content, Giovanni da Fano showed the Island of the Blessed placed atop an open spherical cave of the Underworld. On the island Sigismondo is depicted sacrificing a black sheep and a sterile ox to the chthonic deities (*Hesperis* 9. 3–4, 17–19), while the netherworld is subdivided into concentric circles, among which are disposed four distinct groupings of distinguished inhabitants in keeping with Basinio's text.[23] The orators are indicated by the three puppet-like men on the right (*Hesperis* 9. 73–106); an assembly of seated ladies on the left refers to the heroines in the Myrtle Grove 'on the opposite side' (cf. *Hesperis* 9. 107–108: 'inde jugum capit oppositum, quod sylva coronat / myrtea … '), while the packed gathering of fully armoured knights in the centre of the composition evokes the shades of the warriors of the heroic age in the 'laeti campi' that Sigismondo first sees from afar after leaving the Laurel Grove of Elysium proper (*Hesperis* 9. 177–8). The location of this Elysian grove in the foreground below is, however, only marked by Apollo and the Nine Muses, whose inclusion into the subterrestrial place of bliss has no direct classical precedent, and may well be a felicitous invention of a fifteenth-century humanist.[24] Somewhat surprisingly, no unequivocal visual cue refers the reader to the packed gathering of poets, heroes and philosophers which was sanctioned by the authority of Virgil. In the following I shall argue that this specifically Virgilian motif had, however, half a decade earlier, found its way from the realm of literary evocation into the visual plane in the so-called Tomb of the Ancestors (*Arca degli Antenati*) in the Tempio Malatestiano.

This ornate tomb monument, carved by Agostino di Duccio in 1454 and set up on the left-hand lateral wall of the *Cappella della Madonna d'Acqua*, is distinguished by two multi-figure reliefs adorning the front of the sarcophagus (see Figure 2.2). No doubt their subject matter was determined by the fact that the tomb was – as is stated in its dedicatory inscriptions – from the outset intended as the depository of the earthly remains of Sigismondo Malatesta's forefathers and descendants.[25] However, while the scene on the right clearly represents the Roman triumph of Sigismondo's foremost purportive ancestor – Scipio Africanus Major (see Figure 2.4),[26] scholars have occasionally expressed doubts about the traditional identification of the multi-figure scene on the left, which is habitually referred to as the 'Temple of Minerva' (see Figure 2.3). Charles Hope has, for example, pointed out that the female figure on the pedestal in the centre of the composition, who to all appearances represents the 'temple goddess', lacks some of Minerva's attributes: she is not wearing armour and there is no Gorgon's head on her shield.[27]

Accordingly, a more dependable point of departure for determining the subject of the scene would seem to be provided by one subsidiary figure that can be identified by name with greater degree of probability: half-hidden in the middle ground, yet arguably assigned the place of honour under the goddess's raised right arm, there appears Hercules, wearing his characteristic cap shaped as a lion's head (see Figure 2.3).[28] Hercules' presence immediately brings to mind Pandolfo's speech in the seventh book of the *Hesperis* and Erato's song in the introductory section of the *Diosymposis*, which both expressly name the 'mighty Alcides' as the foremost hero in the Temple of Fame (*Hesperis* 7. 50: 'Hic heroes erunt: Alcides maximus … '). It stands to reason, then, that other figures in the relief could represent the remaining 'Elysian notables'. And, in fact, it would seem that some earlier scholars have intuitively sensed their presence in this scene. Corrado Ricci, for example (even though he still subscribed to the theory that the group primarily consists of Malatesta's ancestors) noticed:[29]

Uomini coperti di ricche corazze, adolescenti in vesti succinte, vecchi severamente ammantati … si affollano intorno alla Dea, a rappresentar 'la virtù intellettiva della stirpe' con quanti dei Malatesta, *o guerrieri o poeti o filosofi l'onorarono con l'armi, con l'estro o con la dottrina* … (italics mine)

In addition to men dressed in armour (who could easily be ancient heroes), men of letters and philosophers are clearly referred to on the left-hand side of the relief by at least one prominent representative who is strategically positioned in the foreground on each side of the most prominently placed warrior, the bearded, frontally poised hero who is dressed in pseudo-antique breastplate armour holding a javelin. The beardless man with aquiline profile, clad in a long, richly draped mantle in the foreground on the extreme left of the scene, is clearly designated as a poet by the book he is pressing to his chest and by the laurel wreath adorning his brow.[30] And other members of the cramped group of standing figures behind him, who are visible only in part because our view is cut by the flanking pilaster, might thus also be representatives of the same profession. The isolated standing figure of a bearded old man in the foreground to the right of the frontally poised warrior has in turn long since been plausibly identified as a philosopher. Fritz Saxl had already in 1941 astutely observed that his facial features and characteristic skullcap were derived from the apocryphal 'portrait' of Aristotle, which was based on a classical bust found by Cyriacus of Ancona in 1444 and disseminated in Italy through several derivative drawings and medals.[31]

Incidentally, the portrait of Aristotle (alongside effigies of Cicero and Plato) is also evoked among the marble statues in the Temple of Fame in the *Diosymposis*.[32] But without Saxl's fortunate discovery of the visual clue to his identity, Basinio's poem would by itself not provide sufficiently specific descriptive detail for positive identification. For that reason one could, in the

absence of conclusive iconographic verification, only speculate about the name of the poet.[33]

Still, even though I prefer to refrain cautiously from naming the poet, the fact remains that he is grouped together with the philosopher and a mythic hero in a combination that offers a striking parallel to the key passage in the sixth book of the *Aeneid*.

On its basis (and on the basis of its repeated echoes in Basinio's poems) we might, however, venture to make a subtle distinction between Hercules and the ageing bearded soldier. While Hercules is, of course, the foremost model benefactor of mankind in Greek mythology, and as such may have been chosen to typify those 'who by service have won remembrance among men' (*Aeneid* 6. 664),[34] the latter could belong to 'those who suffered wounds fighting for the fatherland' (*Aeneid* 6. 660). Given this possibility, he may represent the Trojan hero Hector, for he matches the description of his outward appearance, recommended in 1401 to Malatesta di Pandolfo Malatesta by no less an authority than Coluccio Salutati. According to Salutati, Hector was tall, wore an abundant curly beard and had long hair.[35] It is interesting to note that the shadow of Hector is referred to in the *Hesperis* among the Homeric heroes inhabiting the zone allotted to ancient warriors, which Sigismondo and Psycheia-Isotta inspect immediately after having visited Elysium.[36] For this suggests that Book 9 of the *Hesperis* might also provide a justification for the presence of the female character behind the hypothetical Hector further to the left.

Women are not expressly mentioned among the immortal greats listed in *Aeneid* 6. 660–65, nor would their presence in Agostino di Duccio's relief seem to be accounted for by Basinio's derivative descriptions of the same select group. One might, however, in this connection recall that Basinio substantially mitigated Virgil's sombre description of the heroines' lugubrious 'Mourning Fields' (*Aeneid* 6. 440–76), by imagining their myrtle grove as a pleasing meadow with soft grass and odoriferous flowers (*Hesperis* 9. 107–10; [see Figure 2.1]) – where Sigismondo encounters them immediately before reaching the Laurel Grove of Elysium.[37] From the enjoyable Basinian 'Myrtle Grove' to the most exalted category of Elysians in the stricter sense of the word seems but a short step. And such a step would not be unprecedented in classical Latin poetry: the Pseudo-Virgilian epyllion *Culex* expressly places some of the famous women (namely Alcestis, Penelope, Eurydice) into Elysium proper, and thus puts them on equal footing with their male colleagues (*Culex* 295–6: '[f]or you, O Heroines, over against you in the house of the righteous, there waits a band of heroes ... ').[38] On balance, then, if the frontal hero is indeed Hector, his female companion might well be the faithful Andromache, another classic paragon of the loving spouse.

To sum up: each member of the left half of the assembly in Agostino's relief finds his (or her) potential counterpart, be it among the statues listed

in the *Diosymposis*, or be it among the shadows of the famous dead invoked in the *Hesperis*. Bearing this in mind, we can move on to examine the cluster of figures populating the right-hand side of the scene.

In view of the prominence given to Sigismondo Malatesta in both poems (in one he is vicariously present *in effigie*, in the other he features as the protagonist of an epic *katabasis*), his presence is also very strongly indicated within the 'Temple of Minerva' on the Tomb of the Ancestors. Scholars have long sought to identify him with the young beardless warrior grasping his sword with both hands, whose curly head is set against the scaled shield of the 'temple goddess' (see Figure 2.4).[39] Yet his facial features bear no resemblance whatsoever to known portraits of the *signore* of Rimini. Incidentally, Andy Pointner (who took for granted the traditional identification) nevertheless already in 1909 drew attention to a much greater physiognomical resemblance to Sigismondo in the tall knightly figure in the middle ground further to the right, who raises his left hand in salute or wonder; and Charles Hope has later argued that 'this could be Sigismondo arriving at the Temple'.[40] The fact that behind him there also appears a young woman, who happens to be the only other figure in the scene who is likewise excitedly raising her left hand, would be fully consistent with Hope's suggestion, for – on the evidence of the narrative plot of Books 8 and 9 of the *Hesperis* – it is more than likely that she represents Sigismondo's beloved Isotta, hiding under her *senhal* Psycheia. After all, it was Psycheia of whom Pandolfo said to Sigismondo that she would lead the way to the mighty Temple of Fame (*Hesperis* 7. 49: 'Haec te, Nate, docens in Templa superba reducet … ').[41]

For a lack of specific attributes, conclusive identification by name would be, however, hazardous with respect to the pair of foreground figures who both serve as clever compositional devices directing the viewer's attention to the incoming Sigismondo. The man seen from behind could belong to any category of Elysian notables; the woman in a loose gown holding a long sword is evidently another heroine of classical lore.[42]

Given his outstanding position in the centre of the composition, the upright swordsman, who has long been mistakenly thought to represent Sigismondo, can, however, hardly be glossed over as an anonymous supernumerary. It is thus clearly no coincidence that he wears an almost identical partly scaled breastplate armour to that of the *triumphator* in the complementary relief on the opposite side of the sarcophagus (see Figure 2.4), to whom he – moreover – bears a striking resemblance with respect to his oval physiognomy and abundant curly hair. On this compelling visual evidence it seems more than likely that he represents Scipio Africanus Major.[43]

Scipio, rather than Sigismondo, thus turns out to be the key character, not only in the right-hand scene that shows his Roman triumph (see Figure 2.4), but also in the left-hand relief where he is shown confronting the shades of

famous heroes, sages and poets. In other words, within the 'Temple of Minerva' Scipio had been – *mutatis mutandis* – cast in the protagonist role of Virgil's Aeneas visiting Elysium, a role which he had in the classical epic tradition, for example, already assumed in the *Punica* of Silius Italicus (*Punica* 13. 395–895).[44] Silius also recounts Scipio's long conversation with his deceased father and uncle (*Punica* 13. 650–704), which, of course, refers back to the encounter of Anchises and Aeneas in the *Aeneid*;[45] and this episode in turn directs our attention to another figure in Agostino's relief: the beardless soldier, who taps Scipio on his right shoulder (see Figure 2.4). The most plausible explanation for such an affectionate gesture would no doubt be that he is not only Scipio's equal in military rank, but also his kinsman.

Incidentally, the same conventional motif of a deceased parent and his pious offspring jointly contemplating the abode of the blessed souls of the departed was again applied to Scipio Africanus Major in Petrarch's *Africa*, which was in all probability known and read at the Malatesta court of Rimini in the mid-fifteenth century.[46] In Books 1–2, Petrarch imagined Scipio dreaming of his father Publius Scipio, who had not long before been killed on the battlefield in Spain. Father and son then ascend to heaven, where the latter also meets his grandfather, and is shown 'a host of souls of past greats'.[47] The fact that in this episode of the *Africa* (1. 154–557) the encounter with the famous dead takes place not in Elysium but in the heavens in no way diminishes its evidential value. Suffice it to recall Servius' gloss on *Aeneid* 5. 735 that Elysium is, according to the poets, placed in the nether world, while according to the philosophers it lies on the Island of the Blessed; according to the 'theologians', it is, however, placed in the heavenly regions somewhere close to the sphere of the Moon.[48] The starry abode facing the supralunar regions of the universe, the subterrestrial Elysium and the mythical Island of the Blessed (along with – by logical extension – Basinio's Temple of Fame located thereon) all designate one and the same imaginary 'place' whereto the worthy souls of the righteous depart when they leave their bodies.[49]

In terms of its core content, the left-hand scene on the Tomb of the Ancestors therefore depicts the awe-stricken Scipio Africanus Major, incited to the pursuit of honour and valour through a vision of the immortal souls of the wise and virtuous; while, further to the right, his remote would-be descendant, Sigismondo Malatesta, reverently retraces his ancestor's steps on the same path to glory in an act of eager emulation of his great forefather.[50]

However, whereas the pair of primary protagonists in the scene is ultimately of classical derivation – Petrarch's principal model for the dream journey of Scipio father and Scipio son was, of course, Cicero's *Somnium Scipionis* (along with the *Aeneid*),[51] the two secondary protagonists, the gallant knight Sigismondo and his divinized beloved Psycheia-Isotta, would seem to be no

less at home in the enchanted world of chivalric romance. An intriguing parallel to their wanderings through the Island of the Blessed as recounted in Book 8 of the *Hesperis* is, for example, provided by the opening episode in the eighth canto of Matteo Maria Boiardo's *Orlando innamorato*, describing Rinaldo on a mythic island where he, in the company of a *dama*, visits the ornate marble *Palazo zoioso* of Angelica.[52] Still, given the much graver subject of the vision of the virtuous departed, the role that Psycheia-Isotta performs by escorting Sigismondo into the Temple of Fame far more closely recalls that of the omniscient guide who is also a stock character of late-medieval moral-allegorical dream visions.

Boccaccio's *Amorosa Visione*, where the dreaming narrator passes through the imaginary 'noble castle' accompanied by 'a woman bright and beautiful to behold' (1. 26) is a case in point.[53] This is not least because two of the murals that the dreamer admires in the castle's hall also invite comparison with the relief on the Tomb of the Ancestors with regard to particular details.[54] They depict multi-figured triumphs of Wisdom (*Sapienza*) and Glory (*Gloria Mundana*) that are both flanked by personages whom each of these entities in turn made famous: the human train of the former consists of philosophers and poets, led by Aristotle and Virgil;[55] among the numerous classical, biblical and medieval celebrities assembled around the latter there appear Hector and Hercules, as well as Scipio Africanus.[56] Fused together, the assemblages of the two fictive murals of the *Amorosa Visione* would then share all protagonist figures with the interrelated evocations of the Temple of Fame in the *Diosymposis* and the *Hesperis*. And in fact, taking up the same poetic device of a marvellous dream, Petrarch in the *Trionfi* (a century before Basinio) had already united many of the same categories of worthies, who are in Boccaccio's poem still split between the respective worshippers of Glory and Wisdom, within a single *tableau vivant* precisely under the aegis of Fame.[57] It should come, then, as no surprise that the Petrarchan *Triumphus Famae* could in the mid-fifteenth century inspire a visual response that is in its overall structure strikingly similar to the 'Temple of Minerva' (see Figure 2.3). A fine miniature in the manuscript of the *Trionfi* illuminated in the shop of the so-called 'Maestro delle Vitae Imperatorum' between *c.* 1445 and *c.* 1450, now in the Vatican Library, shows the crowned Fame surrounded on both sides by the standing crowds of rulers, soldiers, sages and men of letters (see Figure 2.5).[58]

The fact that its flat background contrasts sharply with the richly articulated and lavishly decorated architectural backdrop of Agostino di Duccio's relief may serve as a reminder that the scene on the Tomb of the Ancestors is not an illustration of the same text as the miniature in the Vatican manuscript. Indeed, one should keep in mind that, by virtue of placing the assembly in an interior (a sort of reception hall with enthroned Fame in the centre), the

latter is an exception confirming the general rule that in the Quattrocento the Petrarchan Triumph of Fame is normally staged in an open landscape.[59]

The association of the 'Temple of Minerva' with the *Amorosa Visione* and the *Trionfi* remains, however, valid on a generic plane, for it is equally true that an ekphrasis of an ornate palace, castle or temple is a recurrent feature of the edifying dream visions of the later Middle Ages and the Renaissance. As is well known, these imaginary buildings are often described in great detail, with particular attention paid to the sculptured or painted images that are thematically appropriate for the plot of the story, or refer to a deity that inhabits it.[60] He or she can be either a pagan god or goddess, or a personification of an abstract concept, as indeed is also the case of the Palace of Venus in Chaucer's *House of Fame*.[61]

This last example finally brings us back to the initial question about the true identity of the 'temple goddess' in the left-hand relief of the Tomb of the Ancestors, for, in retrospect, everything that has been said above would appear to point in one direction: that she must be the personified Fame as well.[62] But, however contextually justified it might seem, this reading is – paradoxically – sharply contradicted by the iconographical evidence. In early Renaissance art the representational paradigm for Fame – familiar particularly from illustrations to Petrarch's *Trionfi* (see Figure 2.5) – invariably corresponds to Boccaccio's description of the Glory in the *Amorosa Visione*. To borrow Sara Charney's words, Fame is 'generally' depicted 'wearing a long dress and crown' and in 'her hands ... holds a trumpet, or an orb, a palm, a book, a sword, a scale, a genius or a cupid'.[63] But – to my knowledge – she never leans on a shield or a lance (or wields a long staff). The iconographic inconsistencies that troubled those scholars who expressed doubts about the traditional title, 'Temple of Minerva' (see Figure 2.3), can in fact be resolved in Minerva's favour. In the Quattrocento she is occasionally represented dressed in a simple fluttering gown and bare-headed – as, for example, in Taddeo di Bartolo's fresco in the antechapel of the Palazzo Pubblico at Siena. The absence of the helmet is therefore not conclusive proof against the traditional reading of the figure.[64] Given the fact that the shield in the relief is covered by the face of Scipio Major, one could even argue that the Gorgon's head, presumably missing from her shield, just happens to be hidden from view. And, last but not least, Minerva is undeniably a singularly appropriate classical deity for presiding over a select group of gallant warriors, brooding philosophers and divinely inspired poets.[65]

But if the 'temple goddess' is indeed Minerva and not Fame, this would also bring into sharper focus the contextual, chronological and thematic links between the two poetic texts by Basinio da Parma and the related sculpted image by Agostino di Duccio, which share the same patron, the same place and an almost identical date of execution. The *Diosymposis* was

already written between 1451 and 1452; the *Hesperis* was probably begun only in 1453, and was reportedly still unfinished at the time of Basinio's death in 1457; the *Tomb of the Ancestors* was almost finished by the end of 1454.

I have indicated above that, reading the description of the Temple of Fame in the *Diosymposis* side by side with its greatly reduced and truncated version in the *Hesperis*, one cannot rid oneself of the impression that in the latter case the poet chose to dissociate two components which he may have originally (or at any rate at some earlier point) envisaged as parts of a single coherent narrative: (1) the ekphrasis of the Temple of Fame, and (2) Sigismondo's and Psycheia-Isotta's meeting the Elysian worthies. In this sense, Agostino di Duccio's relief could perhaps – with due caution – be seen as an abbreviated 'visual record' of an intermediary stage, bridging a gap between Book 7 and Book 9 of the *Hesperis*. And yet, even if this were the case, the introduction of Scipio Africanus as a key player (displacing Sigismondo) finds no justification in either poem.[66]

In short, it would be patently false to regard Agostino's relief as a literal illustration of the Temple of Fame as described either in the *Hesperis* or in the *Diosymposis* (or even in a hypothetical draft for the former). Even though composed of many of the same components and conceived in keeping with some of the same long-established literary conventions, the 'Temple of Minerva' clearly constitutes an autonomous artistic creation. Seen in this light, the deliberate substitution of Fame by Minerva would make perfect sense from the standpoint of the author of the underlying invention (and at this level Basinio's personal involvement as learned advisor is strongly indicated). For, as a final consequence, exchanging the goddess of wisdom for the personification of earthly renown would make the scene on the Tomb of the Ancestors less overtly dependent on the concomitant literary descriptions of the Temple of Fame – therefore offering greater intellectual satisfaction and aesthetic pleasure to a discerning contemporary audience that was aware of the manifold cues in the texts (and subtexts) of the *Hesperis* and the *Diosymposis*.

NOTES

1. There is no modern edition of the poem, which appeared in print only once, in *Trium poetarum ... opuscula* (1539): fols 92r–101r. I have published parts of the text (checked against the autograph manuscript copy of the poem, now in Florence, Biblioteca Riccardiana, MS 904, fols 20r–30r) in my doctoral dissertation, which also provided the basis for the present article; see Kokole (1997), 2:712–23, Appendix 12. The *Diosymposis* has thus far attracted surprisingly little attention; for brief comments see, for example, Affò (1794a), 2: 30; Voigt (1893), 2: 584, n. 1; Ferri (1914): xxxiv–xxxvii, xlix; Massèra (1928): 50–51; and Campana (1965), 7: 91, 95. For updated bibliography on Basinio see now Bessi (1992): 427.

2. *Trium poetarum ... opuscula* (1539): fols 92r–96v.

3. Ibid., fols 97r–87r.

4. Ibid., fols 98r–99r.

5. Ibid., fol. 99r–v.

6. Ibid., fol. 99v.

7. Ibid., fol. 100r–v.

8. Published in [Basinio da Parma] (1794), 1: 288 (cf. Affò (1794a): 31–5). See Campana (1965): 93, 95–6 (with earlier bibliography); and see also Zelzer (1988); Lippincott (1989): 418–20; and Coppini (1996): 452–6.

9. See especially Battaglini (1794), 2. 2: 268–72; Finsler (1913); Belloni [1912]: 92–100; Ettlinger (1988): 161–9 and *passim*, and (1990a): 24.

10. For Basinio's principal literary models and sources of inspiration in Books 8 and 9 – which include, of course, Homer and Virgil as well as Dante – see in particular the still fundamental analysis of Zabughin (1921): 289–93, nn. 85–116. And see also Belloni (1912): 97–8; Ferri (1913); Campana (1965), 7: 93; and Lippincott (1989): 420. Much less trustworthy is the summary of some of the episodes from this part of the *Hesperis* in Ettlinger (1988): 166–8, and (1990b): 139–40.

11. For Isotta see in particular the masterly biographical entry, by Campana (1962), 4: 547–53, esp. p. 555 (with comprehensive bibliography up to 1962). Isotta's immortality is a recurrent topos of the Latin and vernacular poetry written in her honour at the court of Sigismondo Malatesta; see – in addition to Campana (1962): 552–4 – Piromalli (1965): 33–49; Dörrie (1968): 135–9; Turchini (1983); Piromalli (1989); Strobl (1990): 5–10 and *passim*; Ettlinger (1994): 773–8; Coppini (1996): 457–65; Delucca (2000): 87–90.

12. See Affò (1794): 34. The Temple of Fame in Book 8 is merely one of several marvellous sites that Sigismondo and Isotta see as they tour the island. For example, they visit the garden of love inhabited by Voluptas, Venus, Ceres and Bacchus, Genii and Muses (*Hesperis* 8. 153–204, esp. 192–204), and they meet Hesperus, who shows them a shield left to him by Malatesta Ungaro on his visit in search of his murdered lover Viola Novella (*Hesperis* 8. 155–92); see also Zabughin (1921): 290, 315, n. 89.

13. Closer comparative analysis reveals that Basinio's two descriptions of the 'Temple of Fame' are subsequent versions of the same ekphrasis. Frequently, whole verses and even lengthier passages from the *Diosymposis* are repeated word for word in the *Hesperis*; see *Hesperis* 8. 218–21, 224–5, as compared to *Trium poetarum … opuscula* (1539), fol. 97r; *Hesperis* 8. 229–33, as compared to *Trium poetarum … opuscula* (1539), fol. 98r; *Hesperis* 8. 237–56, as compared to *Trium poetarum … opuscula* (1539), fols 99r–99v. One notable element of the ekphrasis in the *Hesperis* (which is lacking in the *Diosymposis*) is the description of the temple's threshold, the steps of which are made of ivory on the left-hand side and of horn on the right (*Hesperis* 8. 207–213). The passage is obviously modelled on Virgil's '*somni portae*' in *Aeneid* 6. 893–8, as was already pointed out by Zabughin, who also noted that thus the Temple of Fame marks the spot of the 'ingresso dell'eroe nell'al di là'; see Zabughin (1921): 316, 323, nn. 91, 114. Nevertheless, Helen Ettlinger misapprehended Basinio's lines as a reference to the 'statues of elephants [that] guard the door … ': see Ettlinger (1990b): 139. For the 'endlessly discussed question of the *somni portae*' in Book 6 of the *Aeneid* see, for example, Horsfall (1995): 146–7 (with further bibliographical references).

14. The *locus classicus* is Virgil, *Aeneid* 6. 637–65; and see, for example, Lucan, *Pharsalia* 6. 782–4; Silius Italicus, *Punica* 13. 5505 and Valerius Flaccus, *Argonautica* 1. 835–46. For the literary device of the *katabasis* in general, and for the otherworldly journey to the abodes of the dead as described by Virgil in particular, see, for example, Ganschinietz (1919): 2359–60, 2395–449; Norden (1935); Clark (1979): 180ff; Setaioli (1985): 955–6; [Virgil] (1991); Colpe and Habermehl (1995): 505–518; Horsfall (1995): 144–54; and Kyriakides [1998] (with further bibliographical references).

15. The most thorough analysis of the *Hesperis* from this perspective is offered by Zabughin (1921): 290–91, 317, nn. 92–5.

16. Affò (1794a): 34.

17. See also Zabughin (1921): 292, 321–3, nn. 109–115.

18. Implicitly, the remarkable thematic correspondence between *Aeneid* 6. 660–65 and *Hesperis* 9. 156–62 seems to have already been recognized by Drudi, whose prose abridgement of the pertinent section of Book 9 reads 'ad Elysium perveniunt [scil. Sigismondo and Isotta-Psycheia], in eoque Musas, Poetas, mortuos pro patria, Philosophos, verae religionis cultores Sigismundus cernit … ' ([Basinio da Parma] (1794)); and see also Belloni [1912]: 98; Zabughin in turn expressly drew a parallel between *Hesperis* 9. 143–76 and *Aeneid* 6. 640 ff. (and Silius Italicus, *Punica* 13. 557–9, 778–97); and furthermore argued that the phrase 'pro patria cecidere' (*Hesperis* 9. 158)

'allude quasi certamente a Lucano', wheras the lines 'qui noscere rerum/tentarunt causas' (*Hesperis* 9. 158–9) might refer to Lucretius. Zabughin, however, only cautiously indicated that 'il posuere repertas divitias andrebbe, può darsi, messo in relazione con *Purg.* xxii, 40 54'; see Zabughin (1921): 291, 319, n. 100. And in fact, on closer examination 'qui divitias aliis posuere repertas' (*Hesperis* 7. 63), viz. 'qui posuere repertas / divitias aliis' (*Hesperis* 9. 159–60), draw upon *Aeneid* 6. 610–11 (' … qui divitiis soli incubuere repertis / nec partem posuere suis … '). However, while clearly imitating the wording of his poetic model, Basinio deliberately inverted the original meaning of the Virgilian phrase: the reference to vicious misers in Tartarus was adroitly adapted to denote the virtuous benefactors in Elysium, who are in the *Aeneid* itself defined as 'quique sui memores alios fecere merendo' (*Aeneid* 6. 664). It has, incidentally, often been stressed that Virgil by means of contrasting complementary categories of inhabitants 'brings out the contrast between the populations' of Tartarus and Elysium; see, for example, Solmsen (1972): 35.

19. Virgil (1935b): 552–3.

20. See *Hesperis* 7. 24, 50–59, as compared to *Diosymposis* (*Trium poetarum … opuscula* (1539), fols 95r–96r). The passages are identical except for the lines that refer to Malatesta's ancestors (*Hesperis* 7. 59–64), which are of course missing in the earlier poem.

21. For discussion of the categories of Elysian inhabitants listed in *Aeneid* 6. 660–65 see especially Norden (1934): 34–8, 295–301; Kroll (1953), 2: 30–31 and *passim*; Treu (1954): esp. pp. 28–37; Brogsitter (1958): 58–62; Setaioli (1985), 2: 961; and Horsfall (1995): 53 (with further bibliographical references).

22. See in particular Pächt (1951–52): 91–101; Campana (1951–52b): 109–111; Pasini (1983): 147–53; Nicolini (1988) and Lollini (2001b): 312; Nicolini (2001): 314, cat. no. 126 (with further bibliographical references).

23. Paris, Bibliothèque de l'Arsenal, ms 630, fol. 82v (for reproduction see Ricci (1927–28): 36); Oxford, Bodleian Library, ms Canon. Class. Lat. 81, fol. 91r (for reproduction see Saxl and Meier, (1953): 323, pl. xiii, fig. 33); Rome, Biblioteca Apostolica Vaticana, Cod. Vat. lat. 6043, fol. 89r (Campana (1951–52a), for reproduction see Figure 2.1 in this article.

24. Schröter (1977), 1: 322, fig. 77 ('Die Verbindung von Helden und Musen enstammt freilich nicht der Elysiumsvorstellung der Antike, sondern wohl erst dem italienischen Humanismus des 15. Jahrhunderts').

25. For the Tomb of the Ancestors see in particular Ricci [1924]: 498–507, figs 594–6; Garattoni (1951): 60–61, Shapiro (1958): 49–66; Arduini *et al.* (1970): 158–64, cat. nos 83–4; Hope (1992): 119–25, pls 20–21; Pasini (2000): 43, 65–6, 174, 175–8; Turchini (2000): 432–7, 562–3.

26. See Kokole (2001): 315–20 (with bibliographical references).

27. Hope (1992): 127.

28. For early Italian representations of Hercules with the same headgear see, for example, Schmitt (1975): 51–86, esp. pp. 68–9, figs 19, 20 (Lombard late-fourteenth-century illustrations of Seneca's *Hercules Furens*, Milan, Biblioteca Ambrosiana Ms. e. 146 sup., fol. 2r).

29. Ricci [1924]: 500. And see also Kühlenthal (1971): 76. Claudia Cieri Via, Maria Grazia Pernis and Laurie Schneider, in turn, identified the goddess's worshippers as warriors and philosophers but glossed over the presence of poets; see Cieri Via (1990a): 27, and Pernis and Schneider Adams (1996): 98, fig. 34. For traditional identification of the group with the Malatesta and their ancestry (which has recently been for good reasons put in doubt by Turchini (2000): 435) see, for example, Nardi (1979) (first published 1813): 55; Yriarte (1882): 223–4; Tonini (1893): 178; Higgins (1892): 187, 192; and Pointner (1909): 103–104, esp. p. 103. And see more recently also Carandente (1963): 118, n. 33; and Poeschke (1990): 133. There were very few voices of dissent. Fritz Burger suggested, for example, that the assembly around Minerva represented Sigismondo and his vassals; see Burger (1904): 186. Maurice Shapiro argued, on the other hand, that the relief showed Aristotle (see, below, note 31) representing 'prudence at the head of the fifteen virtues of his *Nicomachean Ethics*, with Sigismondo Malatesta as Justice and Minerva as Contemplation … '; see Shapiro (1957): 89, and (1958): 53–9. Although rightly critical of Shapiro's inconclusive argumentation, Charles Hope did not altogether exclude a possibility that at least the 'six young women, three on each side' represented personifications of virtues; see Hope (1992): 127.

30. The same position of hands holding a book characterizes the fifteenth-century statue of Ovid, erected in 1474, in his native Sulmona, for which see, for example, Trapp (1995): 266–7, pl. 61a. Moreover, Agostino's poet wears distinctively classicizing toga-like garb; and in this respect even more closely resembles the considerably later drawing (of *c.* 1490) after Mantegna's design

for a statue of Virgil, now in Paris, Louvre, Cabinet des Dessins, for which see Lightbown (1986): 130–31, 189, 463–4, cat. no. 85, pl. 167.

31. Saxl (1940–41): 37, pl. 6 d–f. And see also Lehmann-Hartleben (1943); Shapiro (1958): 51–2; Lehmann (1973): 10–24, esp. pp. 21–2, figs 14–15; Sheard Stedman (1978): cat. no. 2; and Hope (1992): 91, 128.

32. *Trium poetarum ... opuscula* (1539), fol. 99v: '[h]oc nova divini spatio stant signa Platonis / hic bonus Arpinas pleno sonat ore; / sed illos / doctus Aristoteles causas ratione repertas / ipse sequens aperit summa virtute potitos. / Iustitiae memores; tris hos prudentia forti / esse animo terris divina modestia natos / edocuit celso virtus Cyllenia caelo / Pallade cum socia sanctas misere per artes' (cf. Kokole (1997): 458, 720–21). In his recent monograph on the Tempio Malatestiano, Angelo Turchini also draws attention to this section of the *Diosymposis*, and quotes it *in extenso* from the manuscript copy in the Biblioteca Gambalunga of Rimini (MS. 82, fols 77v–78r). Yet, having disregarded the fact that the lines in question form an integral part of the description of the Temple of Fame, he inadvertently mistook them for 'un inno a Minerva circondata da grandi personaggi dell'antichità classica latina e greca'; see Turchini (2000): 436, n. 101.

33. In view of the fact that the series of poets' statues in the *Diosymposis* starts with Homer (*Trium poetarum ... opuscula* (1539), fol. 98r: 'hic sacra effigies magni monstratur Homeri'); but in the following also extols Virgil as 'maximus ... Romanae gloria linguae' (ibid., fol. 98v), they both seem likely candidates. Still, there are also other equally viable alternatives, such as Orpheaus or Linus (ibid., fol. 98r; cf. *Hesperis* 9. 154–5), or Musaeus, who plays a prominent role in the pertinent passage of Book 6 of the *Aeneid* (6. 667 ff).

34. See, for example, Galinsky (1972): 190–1; Schmitt (1975): 79–80 and passim; and Malehrbe (1988): 561 (with further bibliographical references). Incidentally, one Latin literary text cited by Norden with regard to *Aeneid* 6. 664 to demonstrate that Hercules could figure as 'das heroische Prototyp dieser Wohltäter' is Cicero, *De officiis* 3. 25, which mentions 'Herculem illum quem *hominum fama beneficiorum memor* in concilio caelestium collocavit ... ' (see Norden (1934): 36, n. 2, 37, n. 1), and thus in wording and content comes very close to the commentary on the *Aeneid* by 'the most impressive and influential of the fifteenth-century Virgil scholars', Cristoforo Landino, who writes *ad versum*: ' ... et hic activam [scil. vitam] ostendit [scil. Virgilius] in qua et reipublicae et civibus nostris: aut quibuscumque aliis possumus *beneficia praestando optimam de nobis memoriam apud posteros* relinquimus ... ' ('P[ublii] V[irgilii] Maronis aeneidos libri duodecim cum Servii grammatici et Donati atque Christophori Landini interpretationibus', in [Virgil] (1508): fol. 259r (italics are mine)). For Landino's exegesis of Virgil see Allen (1970): 142–54; and Kallendorf (1983) (with further bibliographical references).

35. Salutati (1891–1911): 3: 547: '... videre potes heroem illum fuisse statura magnum ... capillo crispo ... decente coma, vultu venerabili, barbatum ...'. See also Castelli (1978): 521–2; and Donato (1985): 150. Hector would be a logical choice, since he was throughout the Middle Ages one of the best-known and most revered Homeric heroes, and was, incidentally, also their only representative among the Nine Worthies; see Wyss (1957). Moreover, along with Hercules, Hector frequently comes up in the early Italian cycles of *viri illustres*; see, for example, Mommsen (1952).

36. *Hesperis* 9. 183–7: ' ... hic [scil. videt] inclyta Troum / Agmina, et insignes fati melioris Achivos / Laudibus in caelum missos; hic maximus Hector, / Aeacides ferox hasta nituntur iniqua, / Contenduntque manu, et multa bellantur arena.'

37. See also Zabughin (1921): 291 ('i "lugentes campi" sono adorni di fiori, di tenere erbe ed olezzano di dolce profumo, sono insomma una "selva beata"') and 318–19, n. 99.

38. For the English translation see Virgil (1935a): 393. For the poem in general and for its reception along with the rest of the *Appendix Vergiliana* in particular see, for example, Schmidt (1997): 228 (with bibliography); and Reeve (1983). For a concise but fairly comprehensive survey of further Greek and Latin literary evidence referring to other famous women (e.g. Medea, Iphigeneia, Polyxena and Helen) who upon their deaths were taken to the place of bliss, see Waser (1905): 2471–2.

39. See, for example, Yriarte (1882): 224; Higgins (1892): 192; Burger (1904): 186; and Pointner (1909): 103; Ricci (1924): 435; Pernis and Schneider Adams (1996): 98; Turchini (2000): 435.

40. Pointner (1909): 103; and Hope (1992): 128. In fact the facial features of the figure in question tally much better with the aquiline profile of Sigismondo, familiar from the official portraits on the medals: particularly close seems Pisanello's medal of the young *condottiere* cast in 1445; see Hill (1930), I: 10, no. 34; and see now also the catalogue edited by Angela Donati, *Il potere, le arti, la guerra*: Donati (2001): 280–1, cat. no. 105 (with further bibliographical references). Less

individualized but still recognizable in spite of the small dimensions is Sigismondo's physiognomy in some of Giovanni da Fano's illustrations of the *Hesperis*: Paris, Bibliothèque de l'Arsenal, MS 630, fols 61v, 82r, 90v; for reproductions see Ricci [1924]: 33, 35, 37; and see also Pächt (1951–52): figs 1–2.

41. Notably, Giovanni da Fano in his illustrations of Book 8 and 9 of the *Hesperis* likewise imagined Psycheia as a long-haired Diana-like nymph: see Paris, Bibliothèque de l'Arsenal, MS 630, fols 74r, 82r, 90v; for reproductions see Ricci (1924): 34, 35, 37.

42. Given her attribute, the sword, she could be Lucretia, Thisbe or Dido, who are all mentioned by name in Basinio's account of Sigismondo's visit to the Myrtle Grove of the nether world; see in particular *Hesperis* 9. 117–18; but Dido is perhaps the most likely candidate in view of the prominence allotted to her encounter with Aeneas in the *Aeneid* 6. 450–76.

43. The figure is fully consistent with other Quattrocento representations of Scipio. The closest parallel with regard to the posture, and even the details of the armour (such as lion-headed knee-caps), is provided by Taddeo di Bartolo's fresco of 1414 in the antechapel of the Palazzo Pubblico at Siena; see, for example, Rubinstein (1958): 196, pl. 19a; Donato (1985): 137, fig. 93; and Hansen (1989): 137–8, pl. VIII. Similarly attired is also Scipio as depicted in a panel painted in the workshop of Bartolomeo Vivarini, now in Prague, National Gallery; see Joost-Gaugier (1976): 185, fig. 2; and Ciccuto (2000): 43–4, fig. 15. Interestingly, Eberhard Ruhmer suggested that in the 'Temple of Minerva' the statue of the goddess is surrounded by heroes 'unter denen Sigismondo so wenig fehlt wie Scipio Africanus, den dieser zu seinen Vorfahren zählte', yet he did not identify either of them with any particular figure in the relief. See Ruhmer [1970]: n.p., commentary to pl. 9.

44. In Book 13 of the *Punica*, the young Scipio Africanus, dumbfounded by the news of his father's and his uncle's deaths in Spain in 212 BC, decides to call up their spirits and therefore visits the abodes of the dead (*Punica* 13. 391–6); there the ghost of the ancient Cumaean sibyl also reveals to him the ten gates intended for different categories of the deceased (*Punica* 13. 531–61) including the separate entrances for 'men born to endure war's hardships' (*Punica* 13. 532) and for 'those who discovered fine arts and a civilized way of life, and uttered poems which their father, Phoebus, need not despise' (*Punica* 13. 537–9), and then indicates the 'shining portal which leads to the Elysian Fields' (*Punica* 13. 550–55). For English translation see Silius Italicus, *Punica* (1934), 2: 232–71; and see also Billerbeck (1983): 326–38, esp. pp. 330–31 (with further bibliographical references).

45. In the episode describing actual encounters with the shadows of the dead, Scipio is first approached by his parent, Pomponia, who was taken to Elysium along with other mothers of the heroes who were begotten by Jupiter on mortal women (*Punica* 13. 615–49); and then converses with his father and uncle (*Punica* 13. 650–704), whereupon he sees Roman greats, who are followed by the famous Greeks (most prominently placed is Alexander the Great; *Punica* 13. 762–75). In particular Scipio is struck by the noble ghost of Homer 'moving along the Elysian path' (*Punica* 13. 778) and heading the spirits of heroes, which include the 'gigantic Hector' (*Punica* 13. 800: 'stupet Hectore magno'); before leaving he is also shown some of the mythic heroines and other women of renown (*Punica* 13. 806–30). For the reception of Silius' epic – which was discovered by Poggio in 1417 and may well have been known to Basinio in the 1450s (cf. Zabughin (1921): 317–19, nn. 93, and 99–100) – see McGushin (1985): 34 ff.

46. Helen Ettlinger notes that in Petrarch's *Africa* Basinio's *Hesperis* had found a 'deeper context on which to base itself if it was to succeed as epic' not least also because 'Scipio becomes to Sigismondo what Aeneas is to Augustus'; see Ettlinger (1988): 163–4. And in fact several suggestive similarities between the two epic poems call for detailed comparative analysis; see Zabughin (1921): 324, n. 122; and Kokole (1997): 463–4, 505–507, nn. 137–41. It is, furthermore, in this context worth remembering that the 1560 inventory of the library of the Franciscan convent attached to the Tempio Malatestiano listed a manuscript designated as 'Franciscus Petrarcha, Aphricum Carmen'; see Mazzatinti (1901): 351, no. 9; and generally for the reception of Petrarch's epic poem see Fera (1987).

47. [Petrarch] (1926): 9–50; for the English translation see [Petrarch] (1977). For the *Africa* in general see, for example, Bernardo (1962): 22–3, 110–26, 185–98 (with earlier bibliography); Fera (1980) and (1984); Kallendorf (1989): 19–57; and Murphy (1991).

48. Servius on Virgil, *Aeneid* 5. 735: 'Elysium est ubi piorum animae habitant post corporis animaeque discretionem ... quod secundum poetas in medio inferorum est suis felicitatibus plenum ... secundum philosophos Elysium est Insulae Fortunatae ... secundum theologos circa lunarem circulum, ubi aer purior est.' And see also Servius on Virgil, *Aeneid* 6. 887. For the equation of the Elysian plain with the side of the moon towards heaven, see Cumont (1949): 146–7 and *passim*; Kroll (1953): 16, 25–31; Thornton (1976): 66, 186, nn. 124–5; and Setaioli (1985): 961; Colpe, Dassmann, Engemann, Habermehl and Hoheisel (1994–95): 282–4.

49. For the clearly comparable paradisiac sites of the Islands of the Blessed far west on Ocean shores (cf. Hesiod, *Works and Days* 167–73) and the Homeric Elysian Fields situated at the ends of the earth (*Odyssey* 4. 561–9) see Waser (1905): 2471; and see also Gelinne (1988): 225–40; and Sourvinou-Inwood (1996): 17–56 (with updated bibliography); for the postclassical tradition of this literary device see, for example, Giamatti (1966): 16–28 and *passim*). Indeed, it seems that even the motif of an imaginary architecture figuring (like Basinio's Temple of Fame) as the home of the happy dead on the Island of the Blessed can be *in nuce* traced as far back as Pindar, who imagines the righteous souls making 'the Way of Zeus to the Tower of Cronos ... where the Isles of the Blessed are' (*Olympian Odes* 2. 70; for English translation see Jackson Knight (1970): 86), and see also Kroll (1953): 21–3; Gundert (1952); Brogsitter (1958): 40–42 and *passim*.

50. The notion of Elysium as a poetic metaphor for heaven (see above, note 48) is in mid-fifteenth-century Rimini, also explicitly attested by Basinio's mentor and senior friend, Roberto Valturio. In his famous treatise *De re militari* (addressed to Sigismondo Malatesta) which was begun in 1446 and finished in 1455 or 1456 (see Massèra (1958): 14–27), he quoted and commented upon *Aeneid* 6. 660–64 as follows (*De re militari* 2. 3): '[s]unt epici [scil. poetae] qui ... perplurima tamen ac maxima per clarissimos duces bella memoratu digna sub honestis rerum figmentis ac velaminibus ad varium optimumque degendae vitae genus propius videntur accedere. Hi sunt qui ... eos, qui ... iusti probique fuerint, et ob patriam pugnando vulnera passi, Quique sacerdotes casti dum vita manebat, Quique pii vates et Phoebo digna locuti: inventas aut qui vitam excoluere per artes, Quique sui memores alios fecere merendo, puros, impatibiles et beatos *in coelum provehi* virtutum meritis, vel *in campos quosdam fortunatos* rapi hic ubi mira voluptate fruantur: Hoc in genere quum multi nobis occurrant poetae, omnium clarissimi Homerus et Maro primi se ingerunt' (italics are mine); see Valturius (1532): 24–5. Incidentally, Cristoforo Landino also insisted that 'Virgil hides "a knowledge of things in Heaven" under the fiction of the Elysian fields' (Allen (1970): 153), for example in the long gloss on *Aeneid* 6. 641: '... ex media philosophia res inserit figmento poetico ... Sapientum vero et bonorum animae quae semper coelum nulla corporis inquinatione pollutae suspexerunt illud petunt ... et Plato et Cicero in libro de republica rectoribus civitatum et caeteris sapientibus sedes in coelo paratas esse scripserunt: et multos claros viros in deos retulit antiquitas ... Hoc igitur non ingnoravit Virgilius qui licet argumento sui inserviens heroes in inferis relegaverit: non tamen illos separat a coelo: ut geminae doctrinae observatione nec poetices figmentum relinquit: nec philosophiae veritatem omiserit. Recte ergo solem suum in regiones coelestes quae bonis sole debentur: unde ipsorum et non aliorum sunt caelestia habitacula' ([Virgil] [1508], fol. 258r).

51. The only difference between the role in which Scipio Africanus Major appears in the *Africa* and the task that he performs in the *Somnium* is that in the latter case he acts as the guide to his adoptive grandson, Africanus Minor (Aemilianus), while in the former he is himself shown the abode of the blessed; see Bernardo (1962): 111; and Fenzi (1975): 61–115. For Petrarch's drawing upon Book 6 of the *Aeneid* see especially Kallendorf (1989): 31–43. Cicero's *Somnium Scipionis* was, incidentally, also one of the principal sources for the episode of the Book 8 of the *Hesperis*, in which Sigismondo sees in a revelatory dream his deceased half-brother, the Blessed Galeotto Roberto, who tells him about the eternal bliss of heavenly paradise (*Hesperis* 8. 300–56); see Zabughin (1921): 316, n. 91, 323, n. 116. Helen Ettlinger mistakenly assumed that Sigismondo had this vision within the Temple of Fame; in actual fact it takes place after Isotta and Sigismondo return from their tour of the island and fall asleep (*Hesperis* 8. 290, 296–9). See Ettlinger (1990b): 139.

52. Boiardo, *Orlando innamorato*, 1. 8. 1–6 (Boiardo (1995), I: 162–5); for the English translation see Boiardo (1989): 130–33.

53. Boccaccio, *Amorosa Visione* 1. 25–7, 59–63 and *passim*; see Boccaccio (1944): 10, 12–13, and (Branca (1944): 373–662, esp. p. 388. For English translation and the succinct updated Introduction by Branca providing further bibliographical references, see Boccaccio (1986): ix–xxxiii, esp. pp. xii–xiii. Boccaccio's Noble Castle (*Amorosa Visione* 1. 59) is, of course, meant to recall the 'nobile castello' (*Inferno* 4. 106) in Dante's Limbo, which is 'clearly modelled on the Elysian Fields from *Aeneid* 6', and thus also invites comparison with the interrelated reworkings of the same classical model in Basinio's *Hesperis* and *Diosymposis*; see Brownlee (1993): 100–119, esp. p. 103. After all, Dante and Virgil enter the Noble Castle in the company of the Greek and Roman poets Homer, Horace, Ovid and Lucan (*Inferno* 4. 86–96), and there they also see heroes, heroines, and philosophers (*Inferno* 4. 106–151). See Alighieri (1938): 27–35.

54. For discussion of Boccaccio's ekphrases in particular see, for example, Frey-Sallmann (1931): 67–9; and Schlosser (1992): xv, 352–66, 508 doc. no. L (with updated bibliography).

55. Boccaccio, *Amorosa Visione* 4. 7–5. 88, esp. 4. 40–44: ('[n]el verde prato a man destra vid'io / di

questa donna, in più notabil sito, / Aristotile star con atto pio: tacito riguardando in sè unito, pensoso mi pareva ... '), 5. 7–17 ('Vergilio mantovano ... / conobbi quivi più ch'altro esaltato, / sì come degno, per suo lavoro'). See also Branca (1944): 398–434, esp. pp. 403–404, 419–20.

56. *Amorosa Visione* 7. 1–14. 84, esp. 7. 70–75 (Hector), 8. 34–6 (Hercules), 10. 70–75 (Scipio). See also Branca (1944): 440–94, esp. pp. 444–5, 450, 466–7.

57. Again, Aristotle crops up (alongside Plato) as the model philosopher (*Triumphus Famae* 3. 6–7); again, the long list of ancient poets is headed by Homer and Virgil (*Triumphus Famae* 3. 10–18), while Scipio Africanus Major is extolled as 'il primo tra laudati' (*Triumphus Famae* 1. 22, 38–42); see [Petrarch] *Opere* (1992): 220–29. For the *Trionfi* in general see, for example, Eisenbichler and Iannucci (1990), and Berra (1999) (with further bibliographical references). For the influence of Boccaccio's *Amorosa Visione* on Petrarch's *Trionfi* see, for example, Hollander (1977): 207–20; and Bernardo (1990).

58. Biblioteca Apostolica Vaticana, MS Barb. lat. 3943 (cf. Vattasso (1908): 143–7, no. 156)). On fol. 177r the miniature in question (see Carandente (1963): 48, fig. 45) heads the text of Petrarch's *Triumphus Famae* in the earlier redaction that opens as follows: 'Nel cuor pien d'amarissima dolcezza' (cf. [Petrarch], *Opere* [1992]: 236–7). For the manuscript and its miniatures see now Simonetta Nicolini's entry in the catalogue *Il potere, le arti, la guerra* (Donati (2001): 304–305, cat. no. 121 (with updated bibliography)).

59. See Carandente (1963): 24–7, 48–9, figs 40, 45, 63, pls I–V; and Ortner (1998): 67–85 and *passim*, figs 3–12, 41, 47, 60, 66.

60. For the motif of imaginary temple or palace in general see, for example, Frey-Sallmann (1931): 86 and *passim*; Goebel (1971): 27, 32–3 (with further bibliography). A representative specimen from the high Middle Ages is the Palace of Nature in Alan of Lille's *Anticlaudianus*: not only is its entrance hall characterized by lofty columns ('aera metitur altis suspensa columnis') but also its interior is frescoed with twelve effigies that, incidentally, include Aristotle, Virgil and Hercules; see Alan of Lille (1855): 490–491; Brogsitter (1958): 137–8; and Curtius (1965): 129–30. It is worth noting that a manuscript of the *Anticlaudianus* was owned by Valturio; see Massèra (1958): 11, n. 3.

61. Chaucer, *House of Fame* 1. 119–473 and 3. 1176–525 (see, for example, Chaucer (1974): 283–6, 293–6). See also Boitani (1984): 72–174.

62. Personification of Fame along with her worshippers would be, needless to say, a singularly fitting subject for the Tomb of the Ancestors; after all, Petrarch defined Fame as: 'quella / che trae l'uom del sepolcro e 'n vita serba' (*Triumphus Famae* 1. 8–9); and see in general also Braudy (1986).

63. Charney (1990): 223–33, esp. p. 227. For the iconography of personified Fame, and for its relation to the image of the *Gloria mondana* described by Boccaccio in the *Amorosa Visione* 6. 43–75, see also Shorr (1938): 103–104, figs 1–6; Kauffmann (1973): 1438–9 (with earlier bibliography); Gilbert (1977): 56–65; Malke (1977): 242–9, figs 6a, 11–15, 24; and Battaglia Ricci (1999): 280–89, figs 10–13.

64. Taddeo di Bartolo's Minerva is recognizable only by the flying owl at her feet, a laurel wreath on her head, the spear and the shield with the head of Medusa; see Rubinstein (1958): pl. 18c. Around 1465, Minerva with free-flowing hair was shown as 'Philosophy' in the 'Tarocchi of Mantegna' (E-Series, Sheet C 28); see, for example, Levenson (1973): 122, cat. no. 42. However, though 'Philosophy' does not wear a helmet, her upper body is still covered by a breastplate armour. The best-known examples of the nymph-like Minerva from the later Quattrocento are Botticelli's drawings for the lost Pallas, for which see, for example, Wittkower (1938–39): 194–8, pl. 36 d–g; and Settis (1971): pl. 35b. See also Minerva on the medal of 1475 by Bartolommeo Medioli, made for Lodovico III Gonzaga; Himmelmann (1986): 16, pl. 15, fig. 1.

65. Moreover, her choice could be also thematically fully justified with regard to Sigismondo Malatesta; in Basinio's *Hesperis* she is often evoked as Sigismondo's principal divine protectress. See *Hesperis*, 1. 500 and 135–40, and *passim*.

66. In the *Hesperis* and the *Diosymposis* Scipio's name is, notably, mentioned only in passing. He may well be the unnamed kinsman (*gener*) Sigismondo encounters in the abodes of warriors: ' ... venit infelicibus armis / ecce Gener contra; pietas en illa Catonis / trans Noton, et siccas Libyae ferventis arenas' (*Hesperis* 9. 220–1). In the description of the relief of Elysium on the outer door of the Temple of Fame in the *Diosymposis*, Scipio appears alongside Cato the Elder (*Trium poetarum ... opuscula* (1539), fol. 97v): 'Hos supra Elysiae sedes, et certa Catonum / Pectora, tum clades Phoenissae asperrima gentis / Scipiades ... '.

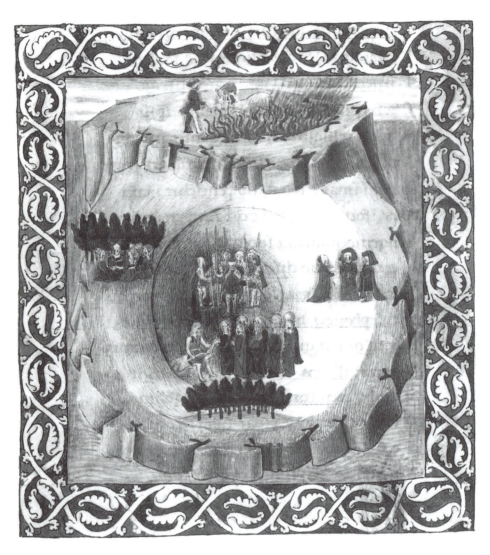

2.1 Giovanni di Bartolo Bettini da Fano, *The Abodes of the Dead*, 1462–64, miniature
from Basinio da Parma's *Hesperi*, Rome, Vatican Library, Cod. Vat. lat. 6043, fol. 98r

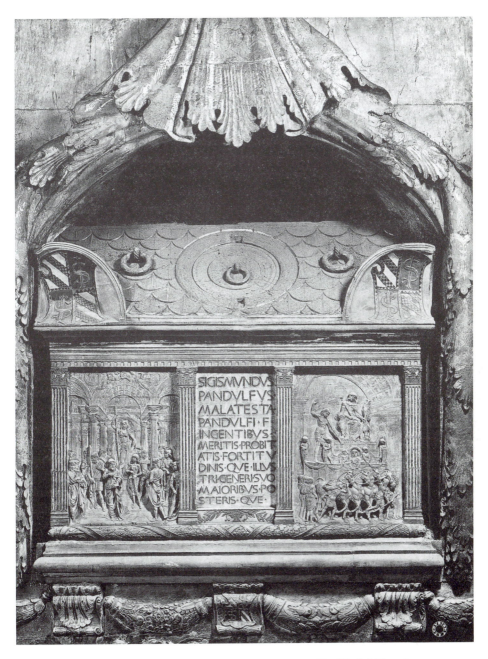

2.2 Agostino di Duccio, Tomb of the Ancestors, *c.* 1454, marble, Rimini, Tempio
Malatestiano

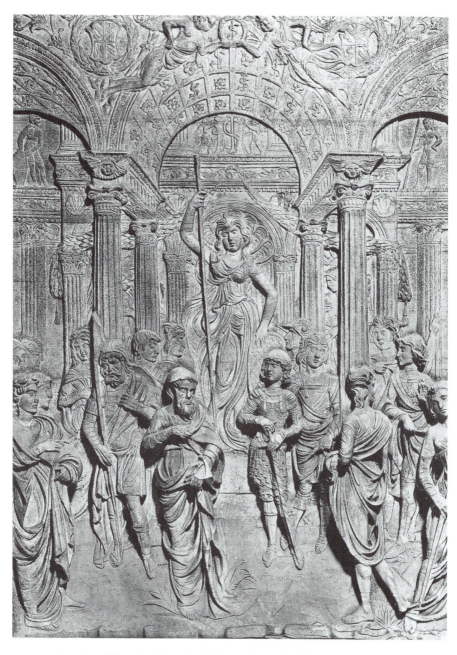

2.3 Agostino di Duccio, 'Temple of Minerva', detail of the Tomb of the Ancestors, *c.* 1454, Rimini, Tempio Malatestiano

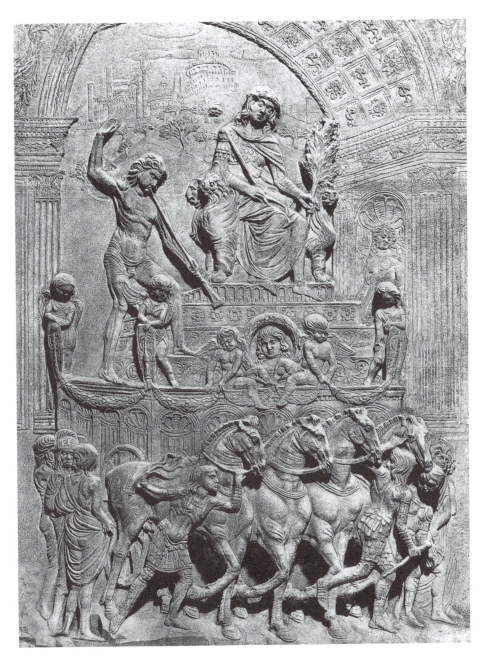

2.4 Agostino di Duccio, 'Triumph of Scipio', detail of the Tomb of the Ancestors, *c.* 1454, Rimini, Tempio Malatestiano

2.5 Attributed to 'Maestro delle Vitae Imperatorum', 'Triumph of Fame', *c.* 1445–50, miniature from Petrarch's *Trionfi*, Rome, Vatican Library, Cod. Barb. lat. 3493, fol. 177r

Emilian Seicento art literature and the transition from fifteenth- to sixteenth-century art

Giovanna Perini

Assessing the transition from fifteenth- to sixteenth-century northern Italian art in the light of seventeenth-century art literature may offer clues to a fuller understanding of Seicento anti-Vasarism, as well as confirm the current widely felt necessity for a more nuanced historical approach to this very transition. It is well known that much seventeenth-century and later criticism levied against Vasari stems from his strong pro-Tuscan bias, especially evident in the depiction of the rebirth of the visual arts after the darkest Middle Ages. While the quality of Florentine and Tuscan painting from the late thirteenth through to the fifteenth century is clearly superior to most regional arts, some non-Tuscan, most often northern Italian historians (Malvasia is not the first, but is foremost among them) correctly vindicate the chronological priority of their local schools, as a matter of factual historical accuracy as much as of local patriotism.[1]

Vasari's account of the transition from the fifteenth to the sixteenth century, or rather from the second to the third part of the art historical progression depicted in his book, has been less studied in this perspective, although some important remarks have been made by Boase and, most recently, Rubin.[2] Suffice to note here that Vasari's selection and chronological distribution of artists' lives implies his assessment of an artist's role in the development of art, so that in his opinion Lorenzo Costa and Ercole Grandi (alias Roberti) belong to the mature second age, somewhere between Benozzo Gozzoli on the one hand and the Bellinis and Cosimo Rosselli on the other, whereas Mantegna, Filippino Lippi, Pinturicchio and Francia, who fall between Ghirlandaio, the Pollaiuolos, Botticelli and Verrocchio on the one hand and Perugino, Carpaccio and Luca Signorelli on the other, happen to belong to its final part, even if they worked on into the following century. The third part opens up with Leonardo, Giorgione and Correggio, in this very sequence, immediately followed by Piero di Cosimo, and the first Raphael forerunners,

companions and satellites (Bramante, Fra' Bartolomeo, Mariotto Albertinelli), heralding the advent of Raphael himself.[3] Not only do the first three artists start the last age, but they line up as the virtual mentors of what would later be identified as the Tuscan, Venetian and Lombard schools. More precisely, Leonardo is portrayed as a highly respected, albeit somewhat erratic, member of the Tuscan school at the turn of the century, still retaining some Quattrocento qualities in art, whereas Giorgione features as a major, albeit indirect, follower of Leonardo in Venice's domain and Correggio as a native genius, Leonardo's equal in the north, namely in the Lombard province, which Vasari could hardly distinguish from the Venetian one.[4]

In fact the theme of Correggio's life is the exception to the rule stated in the opening part of Niccolò d'Arezzo's biography, centred on the Tuscan proverb: 'Tristo a quello uccello che nasce in cattiva valle.'[5] Correggio shows instead how he could become an excellent painter in the 'modern manner', despite being born outside Tuscany and having never been to Rome. Indeed Vasari had already spelled out on several occasions how provincial, uninspiring and unchallenging Lombardy was for artists, when compared to Tuscany or Rome.[6] Nor is it a coincidence if most collective biographies concern artists from the Veneto, Lombardy and Emilia, in the first part of the Cinquecento:[7] this is due partly to comparative lack of information on and even interest in them, but also much to their rating as minor or marginal artists in Vasari's system of values.

Despite Vasari's virtual unification of northern Italy, in the period 1480–1530 this was not a homogeneous political, economical, social or even conceptual entity. It was only, if anything, 'a geographical term' – to borrow Metternich's later hideous but truthful definition of the whole of Italy – identifying an assemblage of different political organizations ranging from city states, to smaller or larger feudal states, to branches of larger regional states. In fact the very first years of the sixteenth century mark a noteworthy expansion of the Papal States well into Emilia-Romagna, featuring the capturing of Bologna (1506) and her consequential drifting away from the history of the rest of the north – of Italy and, most significantly, of Europe. Thus Bologna's intellectual life, centred on her university, was kept isolated from the most fruitful phenomenon of the modern age, the advent of Protestantism, while active cultural exchange with northern Europe was effectively prevented and hampered.[8]

Unlike other northern Italian regions such as Lombardy or the Veneto – or even Piedmont or Liguria – until very recently Emilia-Romagna has attracted less attention in terms of art historical studies of the period concerned. Roberto Longhi's virtual obsession with his mythologies about the quality of Lombard light and Lombard reality at the expense of both Venetian and Emilian art may partly account for this, especially since his approach was

devoutly taken up by his followers. The real problem, however, is the variety of political and cultural situations formerly encompassed by the present regional unit called Emilia-Romagna, and also the uneven quality and haphazard distribution of relevant early historical accounts and critical assessments of facts.

Leaving aside very lively yet marginal and short-lived intellectual and political centres such as Carpi, Mirandola or Correggio, even major cities and courts like Ferrara or Parma are little represented in seventeenth-century local art literature. This may be attributed to a variety of causes. In the case of Ferrara, the dearth of art historical accounts must have had much to do with her forced devolution to the Papal States in 1598 and the end of her role as the capital of the independent duchy of the Este.⁹ Obviously it was not in the interest of the new ruler, that is, the Church, to show how thriving and productive Ferrara had been previously, especially since this contrasted very unfavourably with the city's situation under the Pope's direct management.¹⁰ Therefore it cannot be a coincidence if, by contrast, in the seventeenth century the two major cities of the surviving Este duchy (Modena and Reggio Emilia) not only experienced a comparatively productive artistic spell,¹¹ but accompanied it with the publication of a number of books on local art, most notably Vedriani's biographies of Modenese artists dedicated to the recently established local art academy.¹²

The case of Parma is different. One may well wonder why the Farnese did not make any effort to promote prominent literary celebrations of their artistic treasures, in either descriptive or historical terms, given that they took great pains to have themselves celebrated in frescoes and on canvases, that they patronized some of the finest and most famous late-sixteenth-century artists, from the Zuccari to the Carracci, and that they certainly dedicated much attention to the setting up of a remarkable art collection in both Parma and Rome.¹³ Silence can be as meaningful as a statement, but as far as I know this silence has still to be fully interpreted, and clues may come from other papers in this book. It is clear, however, that the silence of a city regarding local art achievements both before and especially after Vasari's biased account of northern Italian painting signals a degree of unawareness and/or unresponsiveness inviting speculation.

As for Bologna, whose central and therefore key position between Emilia and Romagna hardly needs to be stressed, it is the most vital centre in seventeenth-century Emilian art literature, thanks first to Bartolomeo Dolcini, Giovanni Niccolò Pasquale Alidosi, Ovidio Montalbani and Antonio di Paolo Masini and later, much more deservedly, to Carlo Cesare Malvasia.¹⁴ Although Romagna is apparently less productive, Scannelli's *Microcosmo della pittura*, published in Cesena in 1657 with a dedication to the Duke of Modena, is equally important as a reaction to Vasari, if for nothing else¹⁵ because it is a

more radical answer than even Malvasia's, in structural as well as in aesthetic terms. In fact Malvasia retained the structure of Vasari's book, based on biographies of artists, although he amended it at different levels, whereas Scannelli – well before Boschini, yet some time after Mancini – rejected the very notion of biography and emphasized theoretical and pragmatic rather than historical issues.[16] Suffice to note that in Scannelli there is hardly any *Periodiesierung*, to the extent that artists of different periods can be mentioned and discussed on the same page,[17] whereas Malvasia divided his chronologically arranged sequence of biographies into four periods, instead of the three adopted by Vasari.[18] Malvasia simply added one period (the first part of the Seicento, i.e. his near-contemporaries) to the ones described by Vasari, although he did often rearrange artists already discussed by the latter, shifting them from one period to the next and breaking up periods at different points.[19] By the same token, Malvasia altered the very notion of biography, by constantly opening up its structure to accommodate two or more artists at a time, if they were related by blood, style or artistic collaboration. This unclassical attitude was not unknown to Vasari himself, especially in the second edition of his *Lives*, at least when dealing with his contemporaries or foreign artists on whom he had little information.[20]

Still, it is fair to describe Malvasia's *Felsina Pittrice* as a history of local (Bolognese) painting, and Scannelli's book as a theoretical survey of Italian and European painting from the mid-Quattrocento to his own time. It is worth observing that while the former book is limited in its spatial domain but very broad and articulated in its chronological extension, the latter, despite – or because of – its lack of interest in historical divisions, is very articulated in its spatially based definitions of styles, identified with local schools. The notion of a 'school of painting' had been slowly developed over a considerable time-span, as Ferdinando Bologna has shown:[21] Scannelli's division of Italian painting into three regionally defined schools (the Tuscan–Roman, headed by Raphael; the Venetian headed by Titian; and the Lombard, headed by Correggio) happened to meet with great favour at the end of the eighteenth century (as is well known, it was adopted at that time by Mengs),[22] but is clearly based on Agucchi's earlier division of Italian painting into four schools, for Agucchi had kept the Tuscan school, dominated by Michelangelo, and the Roman school, headed by Raphael, separate. The difference between the systems developed by the Forlì physician (Scannelli) and the Bolognese prelate (Agucchi) can be easily explained in terms of mere timing. Agucchi's treatise on painting, although published in 1646, only a decade before Scannelli's book, had been originally developed at the end of the first or the beginning of the second decade of the Seicento.[23] When Agucchi wrote, the Carracci reform of painting had already taken place, but could still be seen as part of a larger phenomenon, paralleled by Santi di Tito and Cigoli in

Tuscany, or by the Borromean painters in Lombardy, whereas the distinction between the Michelangelesque and Raphaelesque strains of Mannerism was still somewhat important, at least in Roman terms. When Scannelli wrote, a few decades later, it was already abundantly clear that Michelangelo's fortunes were on the decline, and the time was ripe for his solemn condemnation by Roland Fréart de Chambray, to the advantage of Raphael.[24] Scannelli, who was part of this reassessment of Michelangelo's import and value, was clearly reluctant to acknowledge the birth of a new and independent school within Lombardy, namely the Bolognese one. Even so, although he enlisted the Carracci and their major followers in the Lombard school, on the penultimate page of his book, speaking of some of their late followers (who were by then in their early maturity) Scannelli referred to 'this last school of Bologna', only to fall back on 'this third Lombard school' in the immediately ensuing paragraph, where he discussed the case of the painter and writer Luigi Scaramuccia, trained in Bologna.[25]

Maybe Scannelli's reluctance can be explained as a form of restraint, a wish to avoid the proliferation of local schools by aggregating them as much as possible. Maybe as a man from the Romagna linked to the ducal court of Modena he felt some rivalry with the neighbouring city of Bologna, and did not want to give her a higher rank than Forlì, or Ravenna, or Modena, cities which were not entitled to the status of local schools because their art production lacked continuity through the various centuries. Maybe he did not see the continuity of Bolognese art production from the Middle Ages to his own day, which was the hallmark of the three schools he accepted. Or maybe it was a combination of these reasons, and even of others of which we are unaware. Whatever the case, it was up to Malvasia, who was acutely aware of his own and Bologna's Lombardness,[26] to give historical foundation to the Bolognese school of painting and celebrate its glory, showing its development from humble origins in anonymous medieval pictures to the thriving productions of his day.

Scannelli was not uninterested or unresponsive to the problem of 'primitive' painting, if for no other reason than because he was deeply involved in the art market, as a consultant to distinguished collectors such as his dedicatee, the Duke of Modena.[27] Indeed the Italian art market already showed some interest in selected artists and artworks, usually due to historical and/or devotional reasons.[28] Thus, Scannelli did occasionally mention Quattrocento artists like the Vivarini, the Bellini, Vittore Carpaccio, Cosmè Tura, Ercole Roberti, Lorenzo Costa, Gentile da Fabriano, Pinturicchio, Perugino, Signorelli, Domenico Ghirlandaio, Andrea Mantegna, Giovanni Santi, Francesco Francia, but this invariably happened only in special contexts.[29] The most predictable and obvious one is a list of artists anterior to Raphael or Titian or Correggio that can be found within the description of the character and quality of each

school.[30] This can be seen as a minor but necessary concession to basic historical information, and could be easily extracted from earlier sources, such as Vasari and Raffaello Borghini for Tuscany, Baglione for Rome, or Ridolfi and Boschini's as yet unpublished *Carta del navegar pitoresco* for Venice.[31] Interestingly enough, there is little reference to and no discussion of specific art literature dealing with Lombard painting, although Scannelli knew and used Alessandro Lamo, Giovan Paolo Lomazzo and Gregorio Comanini.[32] He preferred to launch a renewed attack on Vasari's hostile presentation of Correggio and other Emilian painters of his own time or earlier.[33] In this context he commented on Alessandro Lamo from Cremona, 'the only individual' in Lombardy who openly complained about Vasari for his disregard of the Campi, his fellow citizens,

non essendo forse egli consapevole che non fosse il primo e determinato intento d'esso Vasari, nel descrivere una tal historia, che di fabricare un sodo e pieno racconto de' propri Toscani, come per se stessi copiosi e degni, e solo accennare gli altri per accidente, o per dir meglio per lor disgratia. Contutto ciò mi do a credere che Scuola cotanto degna non venga a nascondersi in alcun tempo, massime alla memoria de' buoni virtuosi e tanto maggiormente che appaiono tuttavia pullulanti i suoi rari effetti mediante i più eccellenti professori che fanno conoscere ritrovarsi riunito in questa degna parte di Lombardia quello che forsi è diffuso per ogn'altro luogo (...).[34]

Scannelli had earlier lamented that Vasari was ever very willing to bestow every merit on his fellow citizens, to the point of attributing a fresco in the church of Santi Apostoli, Rome, to the Florentine painter Benozzo Gozzoli rather than to its true author, Melozzo da Forlì.[35] This had already been noted by the Sienese physician Giulio Mancini, in his manuscript notes entitled *Considerazioni sulla pittura*.[36] It is not clear whether Scannelli ever saw this manuscript, but I would surmise that he probably did, given the matching information and even wording on Melozzo as well as what we know about the manuscript diffusion of Mancini's book.[37] However this may be, Scannelli's point on Melozzo is particularly significant because it relates to his own *Lokalpatriotismus*, since Melozzo had been a fellow citizen. Nor is he the only artist from Forlì or the Romagna dealt with in Scannelli's book. Suffice it to mention here Marco Palmezzano, Francesco Menzocchi and Livio Agresti from Forlì, Niccolò Rondinelli from Ravenna, or Ferraù Fenzoni from Faenza, Innocenzo from Imola and Girolamo from Cotignola.[38] It is hard to understand why he did not devote a single word to Luca and Barbara Longhi from Ravenna, despite the fact that they were noteworthy enough, whereas it is very obvious that his silence on the Faenza Cinquecento painters Giacomo and Giovan Battista Bertucci was politically motivated, for they had been both condemned as heretics.[39] Clearly Scannelli made a vague attempt at identifying different local strains within the ampler context

of the Lombard school, pointing to Milanese, Ferrarese, Parmesan, Bolognese and Romagna groups of painters, but none of these local groupings (except Bologna, out of a near lapsus[40]) is ever promoted to the status of a school.

I suggested earlier on how this may be linked to the apparent lack of continuity in local art production. As a matter of fact, the case of Bologna is particularly compelling. Given Scannelli's total disregard for artists earlier than the Quattrocento (even Giotto is barely mentioned: only once, together with Cimabue, as the restorer of Western painting),[41] it is no wonder if Trecento painting in Bologna is completely ignored. Yet this is one of the highest moments in local art, as Wart Arslan and later Roberto Longhi have shown.[42] As for the Quattrocento, it is virtually non-existent, given that most local pictures up to the time of Francia were made by Ferrarese painters, most notably Ercole Roberti. As for the Cinquecento, although art was thriving locally, it had no special hallmark, since every major painter in Bologna had been dutifully trained in Florence or Rome and would partake in the general Mannerist idiom, without showing any distinctive local accent.[43] Only with the Carracci, at the very end of the Cinquecento, would a substantially original approach to art become evident again in Bologna, spreading from there to the rest of Italy and Europe, which is why Scannelli used the phrase 'the school of Bologna' in the context already indicated.

Thus in a way Malvasia's history of Bolognese painting can be seen as a logical conclusion to Scannelli's theoretical premises, Malvasia's qualms about Scannelli's book notwithstanding.[44] If both writers were critical of Vasari, they also differed in their general perspective, and not only for the structural reasons already discussed. Malvasia's tracing of the history of Bolognese painting includes a careful survey of its origins, through archival documents and an unprecedented census of extant pictures datable to the twelfth and thirteenth centuries, if not earlier.[45] Given the randomness and paucity of the information available to him, he could not elaborate on the lives of the often anonymous artists who had made them, so he had an extraordinary opportunity to experiment with a new format in art historiography, a historical account totally independent of the biographical tradition, and he exploited it to the fullest. Starting with the fourteenth century, however, he switched back to the older biographical format, although reforming it to accommodate the lives of several artists sharing nothing but presumably contemporary activities.[46] What is also new is the quality and technique of his descriptions of works of art, revealing a keen eye and a genuine interest in the best works of the period, such as Vitale's lost *Nativity*.[47]

Despite his sympathy for these early attempts at a naturalist rendering of events and circumstances, he considers Trecento and Quattrocento painting as mere preliminaries to true art, which starts at the very beginning of the Cinquecento, that is with Francesco Francia, as far as Bologna is concerned.

Unlike Vasari's *Periodiesierung*, Malvasia's does not generally coincide with century divisions. His first part or period extends from early Christianity to the late Quattrocento, whereas his second part includes the very last decade of the Quattrocento through the last decades of the Cinquecento, until the advent of the Carracci and their family, minor followers and direct antagonists, who fall into the third part. The fourth part is made up of all the major Carracci students, who become in turn the most important masters of Seicento Bologna, up to Malvasia's own time.[48]

It is well known that Malvasia's life of Francesco Francia is nothing but a polemic commentary to the text of Vasari's life, which is accurately transcribed therein according to the version of 1568.[49] Still, the very shift in this life's position from the end of the second period, that is at the end of the Quattrocento, in Vasari's book, to the beginning of Malvasia's second part, which corresponds to the beginning of artistic maturity largely coinciding with the Cinquecento, is meant to reassess Francia's importance and role as an artist, for he becomes the first representative, if not the harbinger, of modern art, rather than an epigone of the Quattrocento, that is of the preliminaries of modernity. Undeniably Francia had already been celebrated as the climax of modern art by his contemporaries, most notably Niccolò Burzio in a little known poem of 1498, whose existence must have escaped Malvasia's attention.[50] There is no doubt in fact that Malvasia's celebrated opening lines of Francia's life have a very specific source, and it is a contemporary one. Adopting rather elegant and metrically measured prose, Malvasia wrote:

Siccome allo spuntar del sole, che co' dorati raggi il rinascente giorno dipinge, s'ascondono mortificate le stelle, così all'apparire de' nuovi colori che per le industri mani del Francia in Bologna, e di Pietro in Perugia, l'italico cielo cotanto abbellirono, tacquero vergognosi i più rinomati pennelli.[51]

Summarized and perverted by Longhi in a famous paragraph in which, swimming against the tide of history that equated Francia to Giovanni Bellini,[52] he attributed Tuscan sources to the Bolognese painter ('è riprovato (...) dal veder sorgere nel vostro firmamento pittorico (...) l'arte del Francia, dolce astro bolognese (...). L'astro del Francia io vedo sorgere al di là dell'Appennino, dalle parti di Toscana'),[53] Malvasia's passage finds its intertext in the following clumsy lines by Scannelli:

Per oscurare il chiaro delle stelle, ancorchè siano di prima grandezza, basta che il sole, luminare maggiore, s'inalzi sopra il nostro emisfero; e per offuscare in buona parte il chiaro nome de gli antecessori e più famosi coetanei fu sufficiente la comparsa del solo Raffaello, che nella pittura in guisa di sole palesò mediante i chiarissimi raggi dell'opere più universali, d'eccellente bellezza e con attività suprema procurò concorrere come parte primaria e degna per comporre sopra i già ben disposti fondamenti il gran microcosmo della pittura.[54]

By borrowing this solar metaphor, Malvasia added further implications, for, on a subliminal level, he equated Francia to Raphael, attributing to the Bolognese painter the same role and quality – on a local level – as his younger and more gifted contemporary on a national one. This is further proved by the biographies immediately following Francia's: first a group life of Francia's immediate relations, and of some of his contemporaries, including Timoteo Viti; then the life of Marcantonio Raimondi, with its appendix cataloguing all prints by Bolognese engravers known to Malvasia; then the collective lives of Bartolomeo Ramenghi, Biagio Pupini, Amico and Guido Aspertini and Innocenzo Francucci from Imola. As can be easily seen, most if not all these artists are linked to Raphael, albeit in different ways and forms. Thus, Timoteo Viti from Urbino, after his training under Francia (which is documented by Malvasia and further corroborated by Quattrocento evidence recently rediscovered[55]), fell under the influence of his fellow countryman; Marcantonio Raimondi, first trained by Francia, made his fortune in Rome with the help of Raphael, whose inventions he translated into prints; Bartolomeo Ramenghi and Innocenzo represented the expansion of Raphaelism to Emilia-Romagna; Giacomo Francia and Amico Aspertini, on the contrary, while unaffected by Raphael's style and faithful to their own, were aware of Raphael's because they had both travelled to Rome and seen him in action. They represented two different kinds of local resistance to Raphael, one based on the past (Giacomo kept producing pictures in his father's manner) and the other on the future, or rather the foreign (Aspertini falls easily into the ranks of Lombard eccentrics nourished by German prints and drawings, on the eve of the big cultural split determined by the Reformation).[56] Nevertheless, in one way or another all the biographies of artists following Francia's hinged on the key figure of Raphael, thus strengthening the parallel between Francia and Raphael implied by Malvasia at the very opening of the former's life.

Malvasia's appreciation of Raphael has sometimes been doubted, mostly due to misunderstandings of his text and the lingering effect of Vincenzo Vittoria's false but vehement and successful allegations against him.[57] Suffice it to say here that the assessments of Raphael attributed by Malvasia to the Bolognese artists he dealt with, including the Carracci, were not necessarily his own, and that much in his wording and phrasing can be (and has been) substantially misunderstood, starting with the notorious epithet of 'Urbino potter' bestowed on Raphael in a rather peculiar, highly polemical context.[58] Despite all this, Malvasia did fully acknowledge and feel Raphael's merits, and this is precisely why he did everything he could to link his local hero, Francia, to Raphael, corroborating this relationship with documents of different sorts, verbal and visual.[59] The point here was not only to prove Vasari wrong as to the circumstances of Francia's death and to disprove his

assessment of the Bolognese painter as a bumptious and arrogant fool,[60] but also to show how the Bolognese artist could be treated not so much as an equal but as a superior by the younger Raphael. Admittedly, part of the evidence provided (a letter, a poem) is tainted by a predictably high degree of social hypocrisy, also known as officious courtesy, but if it is accepted as true and valid, it does make the case for a respectful mutual acquaintance of the two painters.[61]

And Malvasia was also very right in placing Francia at the beginning of the Cinquecento, rather than at the end of the Quattrocento as Vasari does, if we consider not so much his style but his status as an artist. Documents that might partly have been available to Malvasia tend to confirm this, although there is no evidence that he ever saw or used them. If we sift through the virtually complete series of documents made available in the most recent monograph on Francia, we can notice that the quality and quantity of the documents concerning Francia from 1501 to 1517 (the date of his death) equals or even exceeds the ones from his birth (c. 1447) to 1500.[62] What is not commutable, though, is the kind of appreciation in terms of art and social status that later documents show: be they private letters of statesmen and women like Lucrezia d'Este or Isabella Gonzaga, printed eulogies by well-known *letterati* like Hermico Caiado, Bartolomeo Bianchini, Camillo Lunardi, Egidio Canisio from Viterbo, Giovanni Filoteo Achillini or Girolamo Casio, or personal political appointments, they tend to concentrate in the period after 1501, to the almost total exclusion of earlier years. This is indeed extraordinary, if we consider that Francia was clearly the artist of the Bentivoglio family, and it would seem fair to assume that after their fall he would have had problems with Julius II. Yet in the third trimester of 1506, soon after the conquest of Bologna by the Pope, he was appointed *massaro* (steward) of the Goldsmiths' Guild at the suggestion of the new ruler; in 1508 he was chosen for the position of engraver at the local mint, by then one of the Papal States' mints;[63] even more significantly, in 1511 he became 'tribuno della plebe', a communal office of some political and economic importance;[64] in the same year, right in front of Francia's workshop, a supporter of the Bentivoglio called Marc'Antonio Bargellini stabbed the astrologist Luca Gaurico (the brother of Pomponio) almost to death. While stabbings were fairly common (in 1482 and in 1488 Francia ended up being marginally involved as a witness in similar accidents happening near his workshop or in his presence), the stabbing of 1511 has a special meaning, because of its political implications at a time of great unrest, when the Bentivoglio had temporarily regained power in the city and were disposing of both real and assumed foes.[65] It is easy to harbour the suspicion that Francia, after serving the Pope throughout the first five years of his reign, had returned to his earlier allegiances as soon as the Bentivoglio had only

too briefly returned to power. Still, from the end of 1511 to his death at the very beginning of 1517 Francia seems to have resumed his previous offices under the Pope's rule: in 1512 and 1514 he again received the appointment as *massaro* of the Goldsmiths' Guild; in 1514 he was listed for a possible appointment as a Bolognese official in the countryside; in 1515 he obtained a commission from the local authorities to prepare silver objects to welcome Medici guests.[66] In any event, all this suggests that despite political changes and shifts in the pattern of patronage as well as of taste, Francia was the most prominent figure in early Cinquecento Bologna – more so than in the late Quattrocento. Therefore Malvasia's assessment of his importance in the Bolognese context and his equation of Francia to Raphael are more historically founded and less paradoxical, less rhetorically based or polemically biased than was previously believed.

Nor is his quest for parallels with the Tuscan–Roman situation illustrated by Vasari devoid of reason and substance: a case in point is that of Amico Aspertini. Allegedly Malvasia replied to Vasari's description of Amico as a ridiculous painter by quoting Guercino's opinion on his two different styles (or, metaphorically speaking, 'kinds of brushes'), the cheap one and the valuable one.[67] According to Malvasia, only works made by the former kind of brush could fit Vasari's description of Amico's style as 'crazy and extravagant'.[68] Interestingly enough, however, the idea of Amico's two brushes came from Vasari himself, who wrote, 'Dipigneva Amico con amendue le mani ad un tratto, tenendo in una il pennello del chiaro e nell'altra quello dello scuro.'[69]

Modern studies have proved that Amico, as a draughtsman, could indeed use his left hand,[70] but this is not the point in Vasari's text, where Amico is portrayed as a comic figure, a forerunner of Malvasia's Giovannino from Capugnano.[71] Vasari's seemingly technical remark on the use of two brushes is only part of this characterization, but Guercino, exploiting the assessment implicit in the identification of right and left as good and bad, turns it into a qualitative distinction in the artist's oeuvre. There is no point in doubting whether Guercino ever said anything about Amico. Malvasia was accurate enough in recording oral opinions, just as he was in quoting or using written sources, and in his manuscript notes preparatory to the book Guercino features frequently amidst his acquaintances and informers.[72] Moreover, the indisputable facts that in Malvasia's time plenty of Amico's pictures were still on view in Bologna, both in public spaces and in private collections, and that Ludovico Carracci had painted his *Ecce Homo* in competition with a nearby fresco by Amico, show that he was still an intriguing artist in Seicento Bologna.[73]

Malvasia was right to point out that Vasari's comic characterization of Amico was utterly unfair. It can be further observed that this characterization

was new, datable to the 1568 edition, for in the earlier version of 1550 it was barely suggested, sketched out in less elaborate, albeit cruder, terms. The qualifications for Amico chosen by Vasari ('uomo capriccioso e di bizzarro cervello, come sono anche pazze, per dir così, e capricciose le figure da lui fatte')[74] sound utterly derogatory, to the point that even ambiguous or partly positive notations such as 'whimsical', which occurs frequently enough in the lives of Florentine painters like Filippino Lippi or Piero di Cosimo, in his case become totally negative, devoid of the positive qualities they may otherwise imply.[75] What is stressed here is not the artist's inventiveness, but his unruliness, his disregard for classical canons of beauty, proportions and composition, as well as for correct social behaviour. And yet it is evident that Amico belonged to the very same period and culture as Filippino and Piero. Although it would be tempting to link him to Lombard painters like Romanino, Bramantino or Altobello Meloni, perhaps even to Venetians like Lotto,[76] his style is closer to Filippino than to Piero, probably due to his early studies in Rome, but his historical function in Bologna was probably closer to Piero's, if for nothing else at least because of his penchant for German art.[77] If we think of the very famous double pen portrait by Hieronymus Bosch portraying himself and/or Pieter Bruegel now in the Albertina, Vienna, it accords well with the extravagant portrait of Amico given by Vasari.[78] It is a 'northern' image, in that Amico's eccentricity in behaviour matches his unclassical, northernish style. The translation of stylistic qualifications into behavioural traits is typical of the biographies of artists, but Vasari was ostensibly more heavy-handed with the Bolognese Amico than with his contemporary Florentine fellows. Thus Malvasia tried to translate Amico's peculiarities from biographical anecdotes back into pertinent stylistic analyses of his works, showing how his better pictures could be inspiring even to modern painters like Ludovico Carracci and Guercino. Unlike in the cases of Bagnacavallo or Francia,[79] here Malvasia did not quote Vasari's text, adding a commentary, but wrote his own version of the story arguing his case against Vasari's, which is its tacit subtext.

Even more tacit, but no less present, is Malvasia's intention to fashion his reconstruction of the development of Bolognese art from the age of Francia to the full-blown Cinquecento as a reply to Vasari's account of the development of art in Italy, most notably in Tuscany and Rome. Unlike Lanzi at the end of the following century,[80] in general Malvasia carefully avoided drawing explicit and systematic parallels between contemporary artists of different schools, but his intention is proven by the sequence in which his arguments are arranged, no less than by his constant allusions to or more or less lengthy quotations from Vasari's text in the lives of Francia's followers, Marcantonio Raimondi, Bartolomeo Ramenghi, Guido Aspertini, Innocenzo da Imola, Francesco Primaticcio, Pellegrino Tibaldi, Orazio Samacchini and Prospero Fontana.[81]

Thus, if Francia is the Bolognese Raphael, Amico is the local Filippino, while the others keep playing the same roles already attributed to them by Vasari, except for a few minor or major amendments.

Among these amendments one should definitely include the lengthy catalogues of works, mostly in private collections and houses, placed in the body or at the end of each biography. It is striking how many works by Amico Malvasia can list,[82] as if to prove implicitly how productive and esteemed the artist was, thus belying Vasari's derogatory presentation, based on the mention of just a few pictures in public spaces. The importance given to the quantity and quality of the pictures and drawings in private collections is very much a sign of the century in which Malvasia and Scannelli wrote, as well as a sign of their personal involvement in the thriving art market of Modern and Old Masters. It was not Vasari's fault if, in his own time, this was much less developed and, as an artist, he did not have as easy an access to private collections, apart from those of his own masters and patrons, most notably the Grand Duke of Tuscany. Thus it is not a coincidence that he mentioned mostly works in the Medici collection or belonging to Tuscan families pre-eminent at the Florentine court. Carlo Ridolfi, in the following century, would openly state that he would mention works in private collections only if very noteworthy, not so much because they were less easy to see, but because they were more bound to change location and ownership.[83] Malvasia and Scannelli, while aware of this, would not deprive themselves of sources of visual materials which were of primary importance for modern as well as for old masters – collections, moreover, which they knew very well, for they had often contributed to their formation. Besides, they were as aware as the most important collectors of their time of the valuable promotion implicit in the references to a given work or collection in their own books. Because of this new emphasis on the quantity and quality of visual evidence, gathered from private as much as from public sources, Malvasia and Scannelli opened up a new, truly modern, approach to the writing of art history. In this respect, as well as in much of what he wrote on Francia, Amico and the other artists active in Bologna at the turn of the fifteenth century, Malvasia was often much in step with the results of present-day studies. The point is not to decide whether he was so influential as to affect present-day scholars, or so modern as to anticipate them. What is striking is that the more written and visual documents are unearthed, studied and correctly interpreted, the more his portrayal of Bolognese painting, even in its early phases, looks accurate and perceptive – more so than Vasari's.

NOTES

1. See e.g. Previtali (1964): 42–69; Bologna (1982): 126–37 and Perini (1988).
2. Boase (1979): 119–48 and Rubin (1995): 224–52, 355.

3. See the contents of Vasari (1966–87), 3: 679–80; 4: 705–706, and the text of his introduction to the third part of the *Lives*, ibid., 4: 7–10.

4. Vasari (1966–87), 4: 15–38; 41–7; 49–56. For his confusion between Venice and Lombardy, see e.g. ibid.: 59 ('Mentre che Giorgione et il Correggio con grande loro loda e gloria onoravano le parti di Lombardia'); 5: 77 ('E perchè erano in sommo pregio in Lombardia le cose sue [by Giulio Romano], volle Gian Matteo Giberti, vescovo di quella città, che la tribuna del Duomo di Verona (...) fusse tutta dipinta (...) con i disegni di Giulio'); 353 ('Dovendo poi il Duca [d'Urbino] come generale della Signoria di Venezia, andare in Lombardia a rivedere le fortezze di quel dominio ... '); 604 ('Poi [Federico Zuccaro] avendo veduto molte cose in Verona et in molte altre città di Lombardia'). See also ibid., 3: 617–18 ('Vita di Vittore Scarpaccia et altri pittori veniziani e lombardi – Egli si conosce espressamente che quando alcuni de' nostri artefici cominciano in una qualche provincia, che dopo ne seguono molti l'un dopo l'altro [...] Furono adunque nella Marca Trivisana et in Lombardia nello spazio di molti anni ... ').

5. Vasari (1966–87), 3: 31 (only in the 1550 edition): 'Bad luck to the bird who is born in an unhappy valley.'

6. See e.g. Vasari (1966–87), 3: 415 (Lorenzo Costa, only in the 1568 edn); 419 (Ercole da Ferrara, only in the 1550 edn); and 4: 50 (Correggio) and 310–11 (Boccaccino) and *passim*.

7. Vasari (1966–87), 4: 407–23 (Alfonso Lombardi and other sculptors, plus Dosso and Battista Dossi); 4: 425–37 (Pordenone and other painters from Friuli); 4: 493–502 (Bartolomeo da Bagnacavallo and other painters from the Romagna), 4: 549–56 (Iacopo Palma and Lorenzo Lotto, Venetian painters); 4: 559–99 (Fra Iocondo, Liberale and other painters from Verona); 4: 619–30 (Valerio Vicentino, Giovanni da Castel Bolognese, Matteo dal Nasaro Veronese and other gem-cutters).

8. Brizzi (1988): esp. pp. 59–60.

9. See Southorn (1988): esp. pp. 1–27. The only account of Ferrarese artists before Baruffaldi's and Cittadella's endeavours in the eighteenth century is in Superbi (1620).

10. Southorn (1988): 99–128.

11. Ibid.: 28–71.

12. Vedriani (1662). On Modena's art academy, see Ceccarelli (1989): 95–104. As for Reggio Emilia, see at least Azzeri (1623) – with a list of local artists – and Squadroni (1620) – including a guidebook to the city.

13. In the volume edited by Lucia Fornari Schianchi and Nicola Spinosa, *I Farnese* (1995), esp. the essays by Roberto Zapperi (pp. 48–57), Claire Robertson (pp. 70–79) and Anna Coliva (pp. 80–91), with earlier literature. For the decorations of the Farnese Palace in Piacenza, see also *Fasti Farnesiani* (1988).

14. See Perini (1981).

15. Scannelli (1966).

16. On Malvasia, see Bologna (1982): 132; on Scannelli, see Giubbini (1966): VIII–XIV.

17. See e.g. Scannelli (1966): 267, 269 and *passim*.

18. For Malvasia's own description of the chronological arrangement of his biographies, see Malvasia (1841), 1: p.n.n. (preface).

19. For the case of Francia, see below, note 49.

20. On Vasari, see Barocchi (1984): 157–70. On Malvasia, see Barocchi (1979), 2: 54.

21. Bologna (1982), with reference to previous literature. On a European level, see Perini (2000b).

22. See Mengs (1996): 43 and *passim*.

23. On Agucchi see Bologna (1982): 77, 124–6, 138–9, and lately Ginzburg (1996): 121–37, who can be consulted for more precise information as to the dating of the treatise (after 1609, no later than 1615, see Ginzburg (1996): 123).

24. Barocchi (1964): 125–47, esp. pp. 135–47. See also Scannelli (1966): 39, 47, 69 and passim.

25. Scannelli (1966): 370.

26. See his letter to Aprosio of 29 January 1678, published in Perini (1984a).

27. See Barocchi (1979): 45, and Giubbini (1966): VII.

28. Previtali (1964): 40–69.

29. Scannelli (1966): 26, 29, 31–4, 138, 139, 145, 146–8, 170, 179, 211–12, 267, 268, 271–5, 319, 320.

30. Ibid.: 138–9, 211–12, 269–71.

31. Ibid.: 2–5, 34–6, 43, 47–8, 90–91, 105, 122, 154, 172–3, 205, 209, 218–19, 252, 267, 325. On Boschini and Scannelli's use of his then unpublished *Carta*, see ibid., modern index, 18–19.

32. Ibid.: 4–6, 16, 27, 29–31, 38, 43, 45, 80–82, 86, 108, 132, 216, 270, 280–81, 321, 336.

33. Ibid.: 20 and 268–73. Other qualms on Vasari are expressed on pp. 39, 47, 90, 270, 307, 315, 325, 334 and *passim*.

34. Ibid.: 270: 'because he was possibly unaware that in composing this history, Vasari's first, resolute intention was solely to build up a substantial, full account of his fellow Tuscans, in that they were numerous and worthy enough on their own, while simply mentioning others by accident, or rather to their misfortune. Nevertheless I am brought to believe that such a worthy school [as the Lombard one] cannot be kept hidden at any time, especially in the memory of good professionals. All the more so now that its rare effects seem still budding thanks to the most excellent professors, who make it known that in this worthy part of Lombardy is united everything that can perhaps be found scattered everywhere else.' (Translations here and below are by the author, unless otherwise indicated.)

35. Ibid.: 121 (see also 122–3).

36. Mancini (1956), 1: 186–7.

37. On the diffusion of Mancini's manuscript, see ibid., XV–LXIV, esp. and XXXVII, XXXVIII, where the copy of Mancini's text in the Estense Library in Modena is discussed. This is a copy that might have been available to Scannelli.

38. Scannelli (1966): 84, 104–105, 123, 179–81, 182–3, 188, 190, 202–203, 223, 259, 281.

39. On the Bertucci, see Colombi Ferretti (1982): 1–2.

40. At one point, towards the end of his book, Scannelli seems to refer to the school of Bologna (p. 367), but if so it is an apax, a concept which does not appear again and is not elaborated further. It is almost a slip of the pen. Besides, the sentence is slightly ambiguous, and the word 'school' might refer to the Carracci (the school of the Carracci) rather than Bologna, but this is not very likely.

41. Scannelli (1966): 138.

42. Arslan's studies on Bolognese Trecento painting appeared in a series of articles in the journal *Il Comune di Bologna* between 1930 and 1931, when the chair of art history at the University of Bologna was held by Igino Benvenuto Supino. Other essays by Arslan were published in the *Rivista del Regio Istituto di Archeologia e Storia dell'Arte* (1932): 3–17, and in *Rivista d'Arte* (1937): 85–114. Longhi (1974): 191–217 (this is Longhi's inaugural lecture at the University of Bologna, when he succeeded Supino in 1934).

43. Zeri (1986), 1: VII–VIII, and Fortunati Pietrantonio (1986), especially p. XXVII.

44. On Malvasia's assessment of Scannelli's book, see Perini (1984b): 215 and 228 (letter of 11 May 1675).

45. Malvasia (1841), 1: 17–24.

46. Ibid., 1: 25–32.

47. Perini (1992): 511–28.

48. See above, note 18.

49. Malvasia (1841), 1: 43–50 (Vasari's life runs from page 44 through to page 47).

50. Burtius (1498): fol. 37 r/v, reprinted and commented in Perini (1999): 23–9.

51. Malvasia (1841), 1: 43: 'Just like stars hide themselves as if humbled when the sun rises and paints a newborn day with its golden rays, so the most renowned brushes went silent as if ashamed, when new colours appeared, which adorned the Italian sky thanks to the Francia's busy hands in Bologna, and Pietro's in Perugia.'

52. For the link between Francia and Bellini, see Burtius (1498): 37v (discussed in Perini (1999): 26 and 29) and Lucco (1987), 1: 240.

53. Longhi (1974): 201: 'this is proven by seeing the art of Francia, sweet Bolognese star, rising in your pictorial sky. I can see Francia's star rising beyond the Apennines, from the parts of Tuscany.'

54. Scannelli (1966): 145: 'It is enough for the sun, the major light, to rise above our hemisphere to dim out the light of the stars, even if they are the largest ones. Thus the apparition of Raphael alone was enough to largely obscure the distinguished names of his antecedents and most famous contemporaries. He, like a sun, showed excellent beauty in painting, thanks to the clearest rays of his most universal works, and with utmost activity he endeavoured to concur as a primary and worthy part to the composition of the great microcosm of painting, on well-placed foundations.'

55. Perini (1999): 27.

56. On Giacomo Francia see Roio (1998): 87–91; on Amico, see instead Faietti and Scaglietti Kelescian (1995): *passim*. More specifically on Aspertini's prints see Urbini (1997b).

57. On Malvasia and Raphael, see most recently Emiliani (2000), 1: 90, and Perini (2000a). On Vittoria's false allegations against Malvasia, see Perini (1996): 73–4 and 109, n. 244.

58. Perini (2000a), 1: 157.

59. On the relationship between Francia and Raphael, see first Dempsey (1986) and also Perini (1997–98). See also below, note 61.

60. See also the anecdote concerning Francia narrated by Vasari in the Life of Michelangelo and discussed in Perini (1999): 67–8.

61. See above, note 58, as well as Roio (1998): 82–3. A different, more traditional approach is taken in Shearman (2003).

62. Negro and Roio (1998): 111–24.

63. Ibid.: 116.

64. Perini (1999): 46, n. 127.

65. On these stabbings, see ibid., and Negro and Roio (1998): 112–13 and 118.

66. Negro and Roio (1998): 118–19.

67. Malvasia (1841), 1: 115.

68. Vasari (1966–1987), 4: 497–8.

69. Ibid., 4: 498 (only in the 1568 edn).

70. Faietti, in Faietti and Scaglietti Kelescian (1995): 21.

71. On Giovannino, see Malvasia (1841), 2: 86–8, and Perini (1998).

72. On Guercino as an oral source, see e.g. Marzocchi [1983]: 325, 341, 387–8. On Malvasia's reliability when using oral sources, see my review of the book, Perini (1984b): 211–20.

73. Malvasia (1841), 1: 116.

74. Vasari (1966–1987), 4: 496 ('a whimsical man with an eccentric mind, just as crazy – so to speak – and whimsical as the figures made by him'). The definition in 1550 was even more blunt: 'capriccioso e pazzo cervello, come pazze e capricciose le figure di lui per tutta Italia si veggono' (ibid.: 'whimsical and crazy brains, just like the crazy and whimsical figures by him that can be seen all over Italy').

75. See the opposite case of Morto da Feltre (Vasari (1966–87), 4: 517–21).

76. See Romano (1998).

77. On Aspertini and Filippino, see Faietti in Faietti and Scaglietti Kelescian (1995): 10; on the function and significance of Piero in Vasari's *Lives*, see Geronimus (2000) and Waldman (2000).

78. Reproduced in Cinotti (1974): 83.

79. Malvasia (1841), 4: 44–7 and 1: 109–12.

80. See Perini (1982).

81. Malvasia (1841), 1: 57–60, 109–12, 118, 124–6, 134–5, 168, 175.

82. See ibid., 1: 115–17, where over twenty works (both paintings and drawings) are mentioned.

83. Ridolfi (1965), 1: 7.

Amico's friends: Aspertini and the Confraternita del Buon Gesù in Bologna

Marzia Faietti

A certain 'M.Amico dipintor' appears on a page (c.21 recto) of the 'Statuti et Matricula d.la Comp.ª del Bon Jesu in S.ᵗᵒ Mamolo' in Bologna.[1] There can be no doubt that this refers to the enrolment in the Confraternita del Buon Gesù of Amico Aspertini (1473/75–1552), a record which has escaped notice in the documentary appendices of the recent monograph on the Bolognese artist.[2] The oversight warrants immediate correction, especially since this discovery allows new reflections on both the painter's activities and his personal associations; moreover, it confirms some interpretative hypotheses presented in the monograph and offers an opportunity for their further re-examination.[3]

For the origins of the confraternity, we may turn to several nineteenth-century Bolognese historical writings. The reading of these sources must be qualified due to some inconsistencies of chronology and lack of reference to documentary evidence, or at least to verifiable and surviving documents.[4] Here we learn that the *confratelli* of S. Maria della Mezzaratta belonged to a confraternity which had its origins in the late thirteenth century and which took its name from the homonymous suburban church. In the middle of the fourteenth century, they relocated inside the city and built their hospital in the Strada S. Mamolo.[5] The visit of St Bernardine of Siena, who preached in Bologna at the end of 1423, inspired the members to dedicate themselves to the devotion of the Name and Symbol of Jesus, adopting the title of the Confraternita del Buon Gesù. Recently, the particular nature of the *confratelli*'s devotions and aspects of their communal life have been examined by Nicholas Terpstra, who, among the many scholars investigating Bolognese confraternities,[6] has focused on the Renaissance period.[7] By comparing the statues of the confraternity with contemporary statutes of other confraternities, Terpstra has been able to give a picture of the character and activities of the Buon Gesù in roughly the period of Amico Aspertini's membership.

Of special interest for our purposes is Terpstra's discussion relating to the confraternity's collective practices of flagellation and washing of the feet, where he observes the existence of a 'gap between clerical and lay piety'. He states:

The laity could conceivably use the 'mea culpa' of mental confession as an exercise for greater personal devotion, but without ordination they could hardly practice the intense eucharistic piety which so animates a work like *The Imitation of Christ* and energises the *devotio moderna*. The *devotio moderna* tended towards an individual identification with Christ, while confraternal piety emphasized collective identification with Christ's disciples, lay friends of the Signore. Hence the former employed frequent individual communion while the latter preferred such group exercises as flagellation. There was a limit to how far the layman could follow a cleric up the *scala perfectionis*. This must certainly be one reason why so many lay confratelli seem to have tried avoiding frequent communion while they adopted flagellation with enthusiasm. Collective identification with the brotherhood of Christ's disciples emerged most clearly through the two rituals of foot washing and flagellation.[8]

In his consideration of the typologies of the prayers recited by various Bolognese confraternities, Terpstra concludes that the 'Buon Gesù was once again the most thorough in this respect, adapting the canonical hours not only to "*homeni mundani e simplici*", but also to the different abilities of members'.[9] He also emphasizes the importance given to the practice of silence during and after the Office.[10]

These and other observations which arise from Terpstra's thorough research need to be developed in a more analytical study on the particular spiritual nature of the confraternity. An investigation into the social composition of the members of the Buon Gesù should not be overlooked, and could reveal valuable evidence not accessible through normal art historical channels of study. One difficulty is that the members are listed in the 'Matricola' in alphabetical order, and, with only a few exceptions, without the year of their enrolment. Even a quick perusal of the list reveals, by the style of handwriting, that it was mostly written in the first half of the sixteenth century, with other subsequent notices added in scripts that date into the seventeenth century.[11] The *ante quem* for the compilation of the Matricola can be established by the death of the members: for example, in the case of Aspertini, 1552. Yet the date of Matricola compilation might of course be earlier by many years, for instance, in the case of another painter member, Ercole Banci, active already in the first years of the sixteenth century in the orbit of Francesco Francia and, for all that is today known of him, documented up to the beginning of the 1530s.[12] The earliest *ante quem* that can so far be established is that of the date of death of Bartolomeo Barbazza in 1527 (c.22 recto).[13]

This type of extensive investigation should be conducted on each individual named in the list, in order to clarify some apparent chronological contradictions that emerge from an initial examination, and to provide solid evidence toward defining precisely the period of *ante quem* and *post quem*.

Several artists, including some individuals not otherwise known, were enrolled in the confraternity. For example: 'Bastiano di pipini depintore' (c.22 recto), alias Sebastiano Pupini, son of the more famous Biagio (documented from 1504 to *c.* 1551);[14] 'erchole di Banzi' (c.23 verso), that is, Ercole Banci (already mentioned above); 'felixe pinarizi' (c.24 recto), must be the still little-known Felice Pinariccio, called 'il Lasagna', whose few documented notices occur between the second half of the 1560s and the following decade;[15] 'Giō: di Rosi depintore' (c.24 verso), to date unidentified; 'm. Lodovico di pepini' (c.25 verso), brother of Biagio Pupini;[16] 'Sebastiano di Serli' (c.28 verso), that is, the painter and architect Sebastiano Serlio (1485–1552);[17] 'Vangelista pagani depintore' (c.29 verso), unidentified; 'Antoni.° di Tribilia' (c.2 recto) and 'zan di Morandi alias di Trbilia' (c.30 recto), that is, Antonio Morandi also known as Terribilia (d. 1568) and his son Francesco Morandi, also called Terribilia (1528–1603), two Bolognese architects connected with the *cantiere* of the Basilica of San Petronio.[18]

In a separate part of the 'Matricola' reserved for women appear the following wives of painters: 'Flora d'un Giō: Batista Depintore' (c.35 recto), with no further identification; 'M.a felise lasagnia' (c.35 recto), the wife of course of Pinariccio; 'Ganevara di m.o Giō: Depintore' (c.35 verso), unidentifiable unless perhaps as the wife of 'Giō. di Rosi depintore', in turn an unknown personality.

The relatives of some of these artists also appear. For instance, the family of the Terribilia is well represented in the confraternity list, including (to mention a few) 'paulo di Tribilia' (c.27 verso); 'Vincencio di Tribilia' (c.29 verso); and 'Zan Batista di Tribilia' (c.30 recto). Along with 'fellixe pinarizi,' enrolled as we have seen with his wife, is listed a certain 'emilio' (c.23 verso), who must be a close relative, perhaps even Felice's son.

Amico, too, is not the only Aspertini noted in the 'Matricola', where we also find Giovanni Battista and Francesca Aspertini ('Zan Batista Spirtini', c.30 recto; 'francescha di spirtini', c. 35 recto), though their exact relationship in the Aspertini family has yet to be determined. One wonders also if 'piere chiodarolo di zanobbi' (c.27 verso) and 'sismondo chiodarolo' (c.28 verso) are from the same family as Giovanni Maria (or Giovanni Antonio) Chiodarolo, a student of Lorenzo Costa who is now little known, but who once enjoyed a certain reputation in Bologna under Giovanni II Bentivoglio.[19] And 'Jacomo felipe di Banci'(c.25 recto) could be of the Banci family, from which we have already noted 'erchole di Banzi,' also better recognized in his own day than in modern art history.

Obviously the members were not only artists and their relatives. The 'Matricola' records also the names of individuals who belong to some of the most important families of Bologna, such as the Albergati, and even the Bentivoglio. (The latter belong to a minor branch of the family and remained faithful to the Pope even at the height of the Bentivoglio ruling power.)[20]

Others include the Bocchi, the Bonasoni (who produced the engraver Giulio Bonasone, active in the mid-Cinquecento),[21] the Campeggi, the Duglioli, the Ercolani, the Lambertini, Magnani, Malvasia, Malvezzi, Marsili, Torfanini and Paleotti (among whom appears, on c.2 recto, none other than Cardinal Alfonso Paleotti, and next to his name the date of his entry, 1590–91). What is remarkable is that a number of the families in the list also promoted prestigious artistic commissions, including urban palaces,[22] often abundantly decorated with frescoes[23] and personal art collections,[24] as well as chapels, likewise of noteworthy decoration.[25]

To understand the role that some of these confraternity members played in the development of Bolognese art, we need only pair them with their sponsored artists, some chosen among the most sought 'forestieri' of the Renaissance (that is, artists not born and educated in Bologna). One thinks immediately of the combination Duglioli–Raphael,[26] the connection of the minor Bentivoglio branch and Baldassarre Peruzzi,[27] the relationship between the Albergati and Giuliano Bugiardini,[28] and finally of the artistic association between Malvezzi and Girolamo Siciolante da Sermoneta.[29]

The Ercolani family, instead, boast only one member in the 'Matricola', Vincenzo (1500–57), who appears on page c.29 verso – but his membership is worthy of note. This entry documents the presence of an especially refined and perspicacious commissioner of art, if indeed we can attribute to him the commission of Raphael's *Vision of Ezekiel*, now in the Pitti Palace, Florence, and of Correggio's *Noli me Tangere* in the Prado.

Prominent representatives of the sixteenth- and seventeenth-century intelligentsia of Bologna are also listed in the 'Matricola'. Achille Bocchi (1488–1562), the humanist known especially for his *Symbolicarum quaestionum de universo genere quas serio ludebat libri quinque* (1555) belonged to the confraternity.[30] Carlo Cesare Malvasia (1616–93), the erudite and prolific canon, also appears. He is especially well-known to Bolognese Scholars for his two-volume *Felsina Pittrice*, published in 1678, and for the *Pitture di Bologna* of 1686.[31]

Bocchi, a complex intellectual personality, had a marked influence on Bolognese culture. His wide network of personal contacts outside the city involved, among others, Cardinal Raffaele Riario, Erasmus, Giovan Pietro Valeriano and Jacopo Sadoleto.[32] Either as a *confratello* of the Buon Gesù, or as *lettore* in the Studio of Bologna, he would have had opportunity to know Aspertini (older than Bocchi by thirteen to fifteen years). In this regard, Amico's decorative illumination of *St Petronius* in the 'Rotulus almi studij Bononiae Medicorum et Artistarum', dated 2 October 1525, is significant (see Figure 4.1).[33] The connection between Amico and the doctor and Aristotelian philosopher Alessandro Achillini (1463–1512), a relationship already noted in my earlier work on the artist's personal contacts,[34] was doubtless through

his brother, the erudite poet Giovanni, called Filoteo (1466–1538), with whom Aspertini had documented connections, as in the case of Bocchi. I have also suggested the artist's probable contributions in the scientific genre of anatomical illustration, which resulted, in the course of 1521, in Amico's collaboration with the editor Girolamo Benedetti for the preparatory drawings for some *spellati* ('flayed figures') in Berengario da Carpi's *Commentaria* on the anatomical treatise of Mondino de' Liuzzi.[35] Also of interest is his participation as a miniaturist – a marginal activity for Amico and secure evidence for which is only offered by his illustration of the *Adoration of the Shepherds* for the *Horae* of Bonaparte Ghislieri in the first years of the sixteenth century[36] – for a document such as the 'Rotuli'. In this period, to judge from the surviving examples, this type of work was not usual for an artist of Aspertini's calibre.[37] Hence, it is possible that Aspertini's rather unusual incursion into the art of illumination might be due to his particular associations of the moment, all the more since the 'Rotulus' lists among the lectors of the Studio the fellow confraternity member and humanist Achille Bocchi, as well as Bartolomeo della Calcina. The latter was a member of the Calcina family, commissioners of Francia, and family also of the famous antiquarian Alessandro, who was celebrated by the poet Girolamo Casio and by Leandro Alberti.[38] Also in the 'Rotulus' appears 'Jo.Andreas albius Parmeñ.', that is, Giovanni Andrea Bianchi called Albio, the Parmesan doctor mentioned by Vasari in relation to a *Conversion of St Paul* painted by Parmigianino during his stay in Bologna after the Sack of Rome of 1527.[39]

Thus the *St Petronius* constitutes an unusual venture into the genre of miniature painting for this curious and many-sided artist, and attests to his capacity to innovate in an established stylistic tradition; moreover, it is a suggestive indication of his situation within a milieu of intellectuals, doctors and philosophers, collectors and antiquarians, some of whom – Bocchi, for one – were also members of the Confraternita del Buon Gesù.

Another look at the 'Matricola' attests to other families to which belonged individuals in contact with Aspertini, primarily the Achillini family, who, by means of Giovanni Filoteo and Alessandro exercised a notable if indirect influence on Amico's artistic orientation: 'Claudio d'm.giō: Achilini' (c.22 verso); 'Clearcho Achilini' (c.22 verso); 'Mauritio di m.Giō: Achilini' (c.26 recto); 'Clearcha Achilini' (c.34 recto); 'Flora di m.Giō: Achilini' (c.35 recto); 'Gintile di Achilini' (c.35 verso); 'Urania Achilini' (c.40 recto). Among Giovanni Filoteo's six children, Maurizio is especially of note for having been probably baptized by Bembo, while Clearco is best known for having followed his father's predilection for letters and as father of the seventeenth-century poet Claudio.[40] Besides Maurizio and Clearco a third son participated in the life of the confraternity, named Claudio after his paternal grandfather. In addition, the wife of Filoteo (Flora) and that of Clearco, as well as 'Gintile'

and Urania, consorts of unidentified family members, appear here. We find finally 'Vinc.° dal Gambaro' (c.29 verso) and 'Matteo Buratti Garzaria Procuratore' (c.26 recto), members respectively of the Gambaro and Garzaria families,[41] with whom Amico maintained relations, including occasional artistic commissions. For Giovanni Camillo Garzaria, the artist who in all likelihood created in the mid-1510s the *Madonna and Child with Sts Lucy, Nicholas of Bari and Augustine*, still today in the Bolognese church of San Martino, while for a member of the Gambaro family he projected around the mid-1520s a funeral monument, never executed.[42] We must also recall his established relationship with the Marsili, for whom he painted the altarpiece in their chapel in San Petronio, to which we shall return shortly. Aspertini also produced frescoes in monochrome for the façade of their stables.[43] With regard to external frescoes, he also painted under the portico of the Ercolani palace in via Galliera a 'Madonna', which was well esteemed in its time.[44] And, finally, it should be recalled that Aspertini had an association with 'Geronimo Dugliolo' (who surely belongs to the Duglioli family), when on 10 June 1532 they, together with others, sold a house for the Compagnia delle Quattro Arti to a certain Nicola Masi.[45] Matteo Malvezzi, on 10 December 1537, acted as godfather to Amico's son Giovanni Antonio.[46]

It is likely that a certain 'Antonio dalla Volta', who on 18 April 1511 participated in the baptism of Amico's son Alessandro, along with others including Cardinal Domenico Grimani,[47] was from the same rich and powerful Volta family as the *confratello* Alessandro Volta.[48]

Naturally, the 'Matricola' lists not only nobles, rich members of the bourgeoisie, intellectuals, artists, but also *'fornari'*, *'calzolari'*, *'sarti'*, *'lanaroli'* … – often registered with only their baptismal name followed by an indication of occupation. Curious in this regard is a certain 'Adamo di enna musico' (c. 21 verso). These are of course the *'homeni mundani e simplici'* mentioned by Terpstra. All categories of individuals were therefore represented and their interests would have been reflected in the artistic choices relating to the decoration of the oratory and of the church of the Buon Gesù. As noted, the confraternity was suppressed on 16 August 1798; the church, designed by Giovanni Francesco Negri and dedicated in 1640, was closed on 16 August 1808 and destroyed shortly after.[49] The appearance of the seventeenth-century building is described in detail by the *confratello* Malvasia in 1686,[50] but what interests us here is the previous 'chiesa del Buon Gesù in S. Mamolo che dicesi piantata nel 1530'.[51] Though Pietro Lamo, writing around 1560,[52] omitted reference to this church in his *Graticola di Bologna*, it was considered in 1603 by the learned Bolognese painter Francesco Cavazzoni.[53] He indicated an 'ancona de Lorenzo Costa' on the main altar, though without giving the subject, and on the side altars were 'S. Appolonia e S. Bernardino di scoltura' which he states as 'di mano de Alfonso ferrarese', that is, Alfonso Lombardi. He attributes to the same artist,

and praises as 'cosa molto bella', 'una figurina di un S. Bernardino di scoltura sopra l'uscio'.[54] The two side statues are mentioned again in the Seicento similarly by Antonio di Paolo Masini, who adds the names of the families who sponsored the two altars: the Belvisi for the altar of St Bernardine and the Vaccari for that of Sant'Apollonia.[55] These are also recorded in 1686 by Malvasia,[56] though later, in the *Vite de' pittori e scultori ferraresi* begun by Gerolamo Baruffaldi between the end of the seventeenth century and the beginning of the eighteenth, only a *St Bernardine* is mentioned as on the main altar.[57] This contradicts in part the more reliable notices of Cavazzoni, Masini, Malvasia, and even of Giovanni Zanti, author in 1583 of a repertory of the names of streets in Bologna.[58] Today the sculptures by Lombardi have been dispersed.[59] If they were indeed executed only after the construction of the sixteenth-century church, then they were most likely begun at the very beginning of the 1530s, before Alfonso's unlucky Roman sojourn and his last Bolognese period, up to his death in 1537.

None of the authors cited above – Lamo, Zanti, Cavazzoni, Masini – considers the oratory of the hospital of Santa Maria del Buon Gesù, the construction of which was planned at the beginning of the 1490s.[60] But the report of the *visita apostolica* of June 1597 (c.31 verso) does describe the altar of the oratory in the following terms: 'Visitavit Altare oratorij, in quo omnia bene se habent, adsunt imagines Annuntiationis Beata Mariae Virginis, S. Bernardini, et S.ta Apoloniae in pariete pictae.'[61] Thus, the altar of the oratory featured a fresco with the *Annunciation* flanked by figures of St Bernardine and St Apollonia. The same document (c.32 recto) testifies that the subject of a painting by Costa in the church was a Nativity: 'Visitavit item ecc[lesi]a populi […] Altare maius habens imagines Nativitatis D[omi]ni, cui nihil deest; Altare S.ta Apolonia a latere dextro; et Altare S.ti Bernardini a latere sinistro …'.[62]

Neither Lorenzo Costa nor Alfonso Lombardi appears in the register of the 'Matricola' of the confraternity and their works can no longer be assessed. The only artist active in the church and also enrolled in the Buon Gesù is thus Amico Aspertini, but in this case as well little survives. In 1603, Francesco Cavazzoni records a *St Bernardine* 'sotto il portico [della chiesa] con molte istorine di chiaro e scuro di mastro Amico ed altre sue opre in detto loco'.[63] About fifty years later Masini added, to 'la divota effigie di S. Bernardino', 'una testa del Salvatore, che nella muraglia sotto il portico si vede'.[64] Yet a few years later, Malvasia, who must have passed frequently under the same portico, suggests that very little remained of Aspertini's frescoes worthy of mention as good examples of his talent;[65] in the manuscript preparatory to the published edition of the *Felsina Pittrice*, the Bolognese canon alludes to only a *St Bernardine*, describing it as a 'bellissima figura intiera'.[66] Returning to the Buon Gesù in his *Pitture di Bologna*, Malvasia supplies a valuable piece

of information regarding the placement under the portico of the new seventeenth-century church of 'quel pezzo di muro, ove si vede ritratto al naturale da Mastro Amico il medesimo Santo'.[67] Already in the late eighteenth century, various writers of Bolognese guidebooks lamented the heavy overpainting inflicted on the remnants of frescoes ('l'immagine poi del Santo, col Sudario sopra trasportati dall'antica chiesa erano di Mastro Amico, ma ora pel ritocco non si reconoscono più tali').[68] Surely their precarious condition was aggravated by the transferral of the frescoes to the church of S. Girolamo della Certosa, since Carlo Bianconi, in 1820, acknowledging the provenance of the destroyed church of the Buon Gesù for a *St Bernardine* 'in muro', judged them unrecognizable due to repeated overpainting.[69] The identification of the *St Bernardine* once in the Buon Gesù with that now in the chapel of the Annunciation of the Certosa has not received recent consensus.[70] Because of the damage to the frescoes that were once in the confraternity church and the very poor condition of the remaining work still in S. Girolamo della Certosa, no conclusions can be drawn either in favour or against the attribution to Aspertini.

Thus we have no real evidence by which to ascertain even those traces of pictorial decoration created by Amico for the exterior walls of the church of his confraternity, a genre furthermore in which the artist was active especially in his later years,[71] and for which today survive only some few pieces of graphic testimony.[72] Only a study of the documents relating to the Buon Gesù can offer an understanding of the surviving works since none of these, as far as we know, can be seen as the expression of the confraternity's patronage.

Advancing along this path of inquiry, I have concentrated especially on an analysis of the Statutes of the confraternity dated 16 March 1520, which is repeated verbatim subsequently in the entry for 14 March 1528.[73] This constitutes a fairly detailed and informative statute which comprises several chapters, and here it is possible to obtain a clearer idea of the devotional life of the confraternity, and in a period relevant to the time of Aspertini's member-ship.[74] On page c.22 recto and verso, in Capitolo 31, we read of the prescribed themes of sacred images; here is established the need for the presence of the insignia of Christ over the door of the house of each and every member. The *confratelli* are advised, in addition, of the certain themes most appropriate for images to be placed in their rooms: recommended are the Crucifixion, the Madonna in Pietà, St Bernardine, St Francis and other saints who may be chosen according to the particular devotion of each member.

The exercises of morning prayer also underscore the focus of the confraternity on the central theme of Christ and the Passion; the confraternity in fact is characterized by its devotion to meditation on the Passion and on the Sorrows of the Virgin.[75] The scant list of religious books which chapter 33 of the statute requires to be kept in the oratory of the company – five in all – also confirms

the members' desire for closeness with Christ (in the sense of practising a mode of life consistent with Christ's dictates on love and charity, mirrored in his life and exemplified in his Passion) and adherence to the central themes of Franciscan spirituality. The list even includes three works by the Domenican author Domenico Cavalca (d. 1342): the 'Spechio de croce' (*Specchio di Croce*), 'La vita dei Santi padri' (the *Vite dei Santi Padri*), translated from Latin, and the 'Pange lingua' (or *Pungilingua*, the translation of the *Somma dei vizi* of Fra Guglielmo di Francia).[76] Also listed are 'li fioretti de Sancto francisco [*sic*]', the known vernacular version of the *Actus beati Francisci et sociorum eius* written sometime in 1370–90 by a Franciscan Minorite of Tuscan origin;[77] and finally a 'Sancto Joanne climacho', by which is probably meant *La Scala del Paradiso*, a treatise on the ascetic life widely diffused both in Latin and Italian, by John Climacus, the important seventh-century theologian of Sinai.[78] Calvaca's *Specchio di Croce* is also a work on asceticism, and is in fact considered his masterpiece on the theme. Here are set forth the teachings of the Our Lord of the Cross and the fruit that we may gather from the Cross. Christ on the Cross is the source of all virtue and especially of charity, the inspiration of the seven gifts of the Holy Spirit, the example of the seven works of spiritual and corporal mercy, and the model of the eight beatitudes that are the goal of the perfect life.[79]

In light of this new information on the reading and devotional practices exercised by Aspertini as a *confratello*, the considerable frequency of Christological themes in his oeuvre and throughout the chronological span of his career acquires particular significance.[80] Besides several fresco cycles depicting episodes of the Passion,[81] he also created several intense representations of the Pietà, (the *Dead Christ with the Virgin and Sts John, Benedict and Scholastica*, once on the Paris art market;[82] the *Pietà with Sts Mark, Ambrose, John the Evangelist and Anthony Abbot*, Bologna, San Petronio;[83] (see Figure 4.2), and of the *Crucifixion*[84] (once in London, Sir J. C. Robinson Collection) and of the *Flagellation*[85] (private collection). Christological themes appear likewise in his graphic oeuvre, for example the *Way of the Cross*[86] (see Figure 4.3; unknown location, once in the Underdown Collection), the *Crucifixion*[87] (New York, the Pierpont Morgan Library, the Janos Scholz Collection); the *Deposition*[88] (Paris, Louvre, Département des Arts Graphiques; Liverpool, National Museums and Galleries on Merseyside Walker Art Gallery; and in the codex 'London II', fol. 2v, London, British Museum),[89] and the *Lamentation and Entombment*[90] (Vienna, Albertina). To this list can be added as well a drawing, now lost but eloquently reflected in a woodcut with a *Lamentation Over the Dead Christ*, of which the only known example is in Berlin.[91] Yet the most incisive example of the artist's exploration of Christological themes is his group *Christ and Nicodemus*, or perhaps *Christ and Joseph of Arimathaea*,[92] sculpted between 1526 and 1530 for the lunette over the right door of the

basilica of San Petronio.[93] Aspertini's lost paintings, frescoes[94] and drawings,[95] too, reiterate his obvious leanings toward Christological subject matter.

Although the artist never had an opportunity to expand his ideas in frescoes of any sizeable dimension (as did, for example, his contemporary Pordenone in Cremona), he did create two images of extraordinary expressive force: the *Pietà* in San Petronio, dated 1519 and commissioned by Agostino Marsili, and the *Blessing Christ with the Madonna and St Joseph* now in the Roberto Longhi Collection in Florence, described by Malvasia as in the guesthouse of the Madonna del Monte dei Padri Benedettini neri.[96] Here is not the place to investigate the German and Flemish elements nor the echoes of Burgundian sculpture which resonate in these two paintings, nor the religious iconography, which is well studied and discussed elsewhere.[97] Here we may simply recall that the *Blessing Christ* testifies to the cult of Joseph and possibly even refers to a passage in the *Summa in quator partes divisa de donis Sancti Ioseph sponsi beatissimae virginis Mariae, ac patris putativi Christi*, published in Pavia in 1522 by the Milanese Domenican Isidoro Isolani, a graduate in theology of the University of Bologna.[98] The *Pietà*, rather, seems to belong to the current of spirituality that animates some terracotta *Lamentations* and *Pietàs* of the fifteenth and sixteenth centuries that are a particular phenomenon Bologna – the most celebrated example being of course that of Nicolò dell'Arca in the church of the Ospedale of S. Maria della Vita dei Battuti.[99] Amico's striving for emotional expressivity and viewer involvement seems to me to be tied to specific devotional needs, including especially the shared participation in the suffering of Christ which is perhaps best exemplified in the *Imitatio Christi* of Thomas à Kempis (d. 1471), a key text of the *devotio moderna*.[100] By means of the document here under discussion, we have a better understanding of what type of reading was considered fundamental in the spiritual life of the brothers of the Buon Gesù precisely during the years of the execution of the Marsili *Pietà*, and can better evaluate the importance, in this devotional context, of a medieval ascetic text like Domenico Cavalco's *Specchio di Croce*.

Franciscan themes are no less recurrent in Aspertini's work.[101] The double portrait *Albertus Magnus and John Duns Scotus*, once in the collection of portraits of famous men of Paolo Giovio and now in the Museo Civico Archeologico 'Giovio' in Como, belongs intimately to Franciscan culture.[102] The painting is very probably the expression of the dispute on the Immaculate Conception of the Virgin, a central issue of debate between the teacher of Aquinas and the famous English theologian. This painting is at the same time consistent with the iconographical scheme of the portraits of 'uomini famosi', a genre most congenial to Giovanni Achillini,[103] who was probably the commissioner. Besides, the cult of the Immaculate Conception was especially defended at the University of Bologna, as evidenced in 1507 by Antonio Benito in his *Elucidarius*,[104] and at the Universities of Paris, Toulouse, Cambridge and Oxford.

Additions to Aspertini's corpus which have been published since my 1995 monograph (with Daniela Scaglietti Kelescian)[105] contribute few substantial discoveries with regard to the painter's Christological[106] or Franciscan interests. One painting and also a drawing, both autograph in my opinion, offer new points of reflection, however, since they represent subjects consistent with the artist's participation in the Buon Gesù. The painting is a *Crucifixion* in the collection of Duke Roberto Ferretti, only recently attributed to Aspertini[107] (see Figure 4.4). The drawing, now in the British Museum, represents St Francis kneeling before another friar-saint, in the presence of a third, also a mendicant saint, who witnesses the scene. This work was published by Berenson with an attribution to Piero di Cosimo,[108] and is now attributed to Amico by Hugo Chapman[109] (see Figure 4.5). The tumultuous and crowded composition of the *Crucifixion* conveys the boldness of Aspertini's imagination in one of the most intensely expressive moments of the artist's career. Unfortunately, the colours – warm and brilliant, tuned in bright and contrasting harmonies – have been irremediably impoverished by past restorations, as thorough as they were clumsy. Had the painting remained in better condition, we would have been able to appreciate – for example, in the rays of light which illuminate the trees against the stormy sky – his connection with Dosso Dossi. Amico had established early on a relationship of reciprocal exchange with the Ferrarese painter, which was destined to persist for some time.[110] Dosso is not the only Ferrarese artist recalled in Amico's *Crucifixion*. The composition of the scene recalls analogous organizational methods in some works by Ludovico Mazzolino, for example in his *Massacre of the Innocents* in the Doria-Pamphilj in Rome (*c.* 1520). In the subsequent version of the subject now in the Rijksmuseum in Amsterdam (*c.* 1528), Mazzolino clusters an agitated crowd in the foreground, and creates in the background a tripartite architetonic structure.[111] In Amico's *Crucifixion* something similar occurs: the tumult of the foreground grouping tends to progressively thin out, while the three crosses span the space and form the intervals for the triad of different landscape passages in the distance. In the three-part organization of Aspertini's composition can also be recognized an echo of Baldassare Peruzzi's cartoon of the *Adoration of the Magi*, executed in Bologna between 1522 and 1523. Considering these stylistic connections, I would place the *Crucifixion* in the 1520s.

Peruzzi and Mazzolino profoundly renewed the same compositional scheme that Aspertini had elaborated in earlier versions of the same subject, such as his (above-mentioned) *Crucifixion* in the Pierpont Morgan Library and the monochrome one in the Robinson Collection. Both of these are rather frozen compositions perhaps still dependent in *inventio* on the late-Quattrocento models of Ercole dei Roberti and of Amico's older brother Guido Aspertini. If we proceed to consider the individual motifs, it is easy to

recognize in the Ferretti *Crucifixion* Aspertini's characteristic figures and postures, re-proposed in a kind of referential montage which is part both of his constant exploration of the antique and of the incessant graphic experimentation of the artist. For example, the man in a helmet next to the Marys, facing right, can be found in the centre of the energetic pen drawing in the Uffizi, *Male Nudes with Another Enthroned*,[112] while the figure seen from the back at the extreme right, in the episode of the dispute over Christ's robe, is repeated in the drawing of the *Way of the Cross*, once in the Underdown Collection. As to the original provenance of the little panel, I wonder if it cannot be identified as the pendant to a painting of the *Way of the Cross*, both cited in 1678 by Malvasia as in the possession of the Signori Cristiani, Bologna, and up to now not traced.[113] I wonder, also, if the ex-Underdown *Way of the Cross* could constitute the drawing for the panel of the same subject, even if in this case we would have to post-date by some time the already indicated chronology that had placed it at the end of the 1510s.

As for the drawing in the British Museum, an initial consideration would seem to place the work at the beginning of Amico's mature period; his sojourn in Lucca (1508–1509) would offer a hypothetical *post quem*.[114] The subject is somewhat obscure. It seems to have been inspired, at least for the compositional solution, by an episode of the life of Francis which is related in both Tommaso da Celano's *Vita seconda* and in the *Specchio di perfezione*.[115] The latter would be a preferable source, since the scene is set outdoors rather than in the house of Cardinal Ugolino, Bishop of Ostia (the future Pope Gregory IX). The episode concerns the meeting between Francis and Domenic before Ugolino, in Rome. Both saints profess their humility before him, and refuse his proposal to elect bishops and prelates from the members of their orders, since both are staunchly committed to the ideals of poverty and charity of the leaders of the early church. Francis, speaking after St Dominic, kneels before the Cardinal, and states: 'My Lord, my brothers call themselves "minor" since they can never become "major". It is their vocation that teaches them to stay all on the common plane, and to follow in the footsteps of Christ's humility.'

It is likely that Amico, *confratello* and reader of the *Little Flowers*, also knew this Franciscan source, which emphasizes through this particular event the virtues of humility and obedience.[116] Besides, as a member of the confraternity, he had promised to be a faithful Christian, obedient to the Holy Church; to live in poverty, humility and purity according to Christ's example; and to maintain the company in '*parvitia*' rather than in '*abundantia*'.[117] But there is an iconographical incongruity that prevents us from immediately accepting this interpretation: the presence of the halo on the head of the supposed Cardinal Ugolino, who was never actually canonized. This could be an error of the artist, or carelessness with respect to the written source, but it would

constitute a negligence of no little importance. I would here suggest another hypothesis (to which I should like to return on another occasion). Perhaps Amico wanted to depict, according to an iconographical scheme contained in the Franciscan sources, the Roman encounter between Francis and Dominic and St Angelo of Jerusalem. This much less widely known meeting of the two founders of the mendicant orders is certainly tied to the cult of the Carmelite saint, to whom was entrusted the mission to Rome to obtain confirmation of the Rule of the Carmelite Order from Pope Honorius III.[118] This interpretation is consistent with what we know of the connection between the Aspertini family and the Carmelites of the church of S. Martino – it was precisely in this church (where the Achillini had their chapel as well) that Amico was buried in the family tomb.[119] Furthermore, we may also recall that for the church of S. Martino, some years later, Ludovico Carracci executed a striking interpretation of the meeting of the three saints, which is now in the Pinacoteca in Bologna.[120]

Thus Amico was, or tried to be, a good Christian. The interconnective study of his artistic experience and of the religious, cultural and political experience of some of his friends and co-members of the Buon Gesù will lead, I believe, to new insights into the coexistence in Bologna, in the first half of the sixteenth century, of diverse movements – confraternities tied to the tradition of medieval societies, elements of the *devotio moderna*, currents of Christian Evangelism – and to an understanding of the impact of this complex and sometimes confused mixture on art of the period.[121]

ACKNOWLEDGEMENTS

The English translation of this text is by Carolyn Smyth. Many thanks to Hugo Chapman, Roberto Ferretti, Giancarla Periti and Piera Tordella.

NOTES

1. Bologna, Biblioteca Comunale dell'Archiginnasio, Fondo Gozzadini, MS. Gozz. 203, n.8; the manuscript is cited in Sorbelli (1937): 7. Another manuscript in the Biblioteca Universitaria of Bologna, with the call number MS. 2022, contains the statutes of the confraternity from 1490, from 16 March 1520 and from 1569 and the 'Matricola della Compagnia del Buon Giesù,' in which is registered the name of Amico Aspertini, as well as other later documents. On the manuscript of the Biblioteca Universitaria see Sorbelli (1915): 5.

2. Manuela Iodice was responsible for the attentive research for the register of documents, which is published in Faietti and Scaglietti Kelescian (1995): 343–8.

3. Before addressing the ramifications of this issue I would like to thank Elena De Luca, who most kindly indicated this document to me, which she consulted during her research on Achille Bocchi: see De Luca (1999). De Luca, noting the presence of the Christological emblem on the paper used by Bocchi for his manuscript, had hypothesized his enrolment in the Confraternita del Buon Gesù, and found confirmation in the 'Matricola' cited above; in addition, she also noticed, among other names, those of Aspertini, the painter and architect Sebastiano Serlio and the Aristotelian philosopher Ludovico Boccadiferro (see especially pp. 87–9). Concerning

Boccadiferro, we may note the marble tomb in San Francesco designed by Giulio Romano; see Tuttle (1989): 572–3.

4. Guidicini (1868–73), esp. vol. 3, pp. 90–93 and 348–9, and (1872): 31–2, 326–7. Also useful are the indices of Breventani (1908).

5. Guidicini (1872): 326.

6. Most recently published, and with up-to-date bibliography, is Fanti (2001).

7. Terpstra (1995): 19 and n. 4, and (1996): 8, n. 14 (the earlier denomination was not entirely abandoned at least until the end of the Quattrocento).

8. Terpstra (1995): 60–61.

9. Ibid., 67.

10. Ibid., 56–7.

11. I thank Franco Bacchelli and Mario Fanti for their help in examining this document.

12. For bibliography on this artist, see Sassu (1999): 22, n. 39, and Pigozzi (1999): 73–4, 76, nn. 61–3, 67; see also Negro (1998): 58, nn. 116 and 117, and Sassu (2001): 265–6, n. 29.

13. Barbazza had invited Tribolo to Bologna, to execute, among other projects, the funeral monument for his father, based on a drawing by Michelangelo; the project was abandoned at Barbazza's death. See Brugnoli (1981): 130–32.

14. The family relationship between Sebastiano and Ludovico Pupini (mentioned below) I have deduced from Cortese (1979): 96, n. 64. Biagio, whose first documented activity has been given as 1511, is instead already mentioned in the *Viridario* of Giovanni Achillini, completed in 1504 even if published only in 1513 in Bologna, edited by 'Hieronymo di Plato': cf. Faietti and Cordellier (2001): 65.

15. For bibliography on Pinariccio see Zacchi (2000); Sassu (2001a): 41–3; Faietti and Cordellier (2001): 183–5, nn. 55 and 55a.

16. Cortese (1979): 96, n. 64.

17. See Frommel (1998). On the personality of the architect see also, with earlier bibliography, Thoenes (1989) and Onians (1992).

18. For the latest publication on the *cantiere* of San Petronio, with preceding bibliography, see Faietti and Medica (2001), especially entry no. 13, 110–114, and entry no. 17, 122–3. On Antonio Morandi see also Manzini (1983): 243–55.

19. Here I cite only the two most recent publications, with preceding bibliography: Faietti and Scaglietti Kelescian (1995): 33; and Sassu, 'Nota 1: "Cappella della Madonna con li tre Maggi fatta in fresco de man del Chiodarolo"', in Cavazzoni (1999): 72–88, with further bibliography. See also Agosti (2001): 327–30, n. 70, for the hypothetical attribution to Chiodarolo of a drawing in the Uffizi, inv. no. 1440F, depicting *St Martin and the Poor Man with Sts Roche and Sebastian*. The author of the catalogue entry attempts to enlarge the growing corpus of the artist's drawings with an *Assumption of the Virgin* in the Royal Library, Windsor Castle, inv. 0102, which still, however, in my opinion, expresses a style peculiar to Aspertini (Faietti in Faietti and Scaglietti Kelescian (1995): 252–3, n. 37); the sheet, besides, presents several elements comparable with the fresco of the same subject done later by the artist behind the door of the Oratory of S. Cecilia (the fresco, unknown to Agosti, was recognized as possibly attributable to Amico already in Scaglietti (1967): 145, n. 30, and Negro and Roio (1998): 56, n. 82; after the recent restoration, Aspertini's authorship is definitive). The ambivalence regarding the artist's name (Giovanni Maria or Giovanni Antonio) derives from some documentary discrepancies: Feigenbaum (1999): 367.

20. For example, Andalò Bentivoglio, whose name appears on c.2 recto. The sixteenth-century painter Pietro Lamo, in his manuscript guide to Bologna, mentions him as already dead in the years around 1560; see Lamo (1996): 96, c.26 verso.

21. For bibliography on Bonasone's activity as draughtsman and engraver – his artistic personality is still mysterious – see Faietti and Cordellier (2001): 105–107, n. 31.

22. On the most significant Bolognese palaces see Cuppini and Roversi (1974) and Roversi 1986.

23. For example, the palazzo of the Torfanini in Via Galliera was decorated with (now lost) monochrome frescoes by Girolamo da Treviso and Prospero Fontana. The interior boasted rooms decorated with scenes from Ariosto's *Orlando Furioso*, partly preserved in the Pinacoteca Nazionale in Bologna, and with episodes of the story of Tarquinius and Lucretia, now lost,

both from the brilliant brush of Nicolò dell'Abate; see Lamo (1996): 87–8 (c.22 r); Cavazzoni (1999): 72 (c.28 v) and nn. 282 and 283.

24. On art collecting in Bologna in the time of Lamo and Cavazzoni see Chiodini (1996): 125–46 and (1999): 111–63.

25. Some families on the list (for example the Bonason, Magnani, Malvasia and Paleotti) possessed their family chapels in the Augustine church of S. Giacomo Maggiore, which was to become, from the middle of the sixteenth century on, a breeding ground for the formal and iconographical elaboration of the altarpiece; see Fortunati (1994a). It should also be recalled that the Bentivoglio of the dominant branch had in the same church their own prestigious chapel, decorated principally by Lorenzo Costa and Francesco Francia (for an inclusive discussion of the church see *Il Tempio di San Giacomo Maggiore in Bologna* (1967)).

26. One thinks immediately of the Blessed Elena Duglioli, wife of Dall'Olio, and commissioner of the *St Cecilia* once in the Church of S. Giovanni in Monte. On the patron of this painting, now in the Pinacoteca Nazionale of Bologna, see Zarri (1983): 21–37.

27. Peruzzi, called to Bologna in December 1521 and documented in the city between 1522 and 1523, did the monochrome cartoon of the *Adoration of the Magi* (now in the British Museum) for Giovanni Battista Bentivoglio, according to Vasari's account; see Vasari (1966–87), 4: 321. For an up-to-date entry on the cartoon see Faietti and Cordellier (2001): 86–9, n. 24, with preceding bibliography.

28. In the early 1520s, Bugiardini painted the *Mystic Marriage of St Catherine with Sts John the Baptist and Anthony of Padua* for the Albergati's chapel in S. Francesco; see Pagnotta (1987): 60 and 210–11, n. 44.

29. For Matteo Malvezzi, the artist painted the *Virgin Enthroned with Sts John the Baptist, Catherine, Jerome, Martin, Luke and Alberto Siculo and Donor*, the main altarpiece in the church of S. Martino, signed and dated 1548. The circumstances of the commission are reviewed most recently in the catalogue entry on the preparatory drawing for the painting (Louvre, inv. 10055), in Faietti and Cordellier (2001): 120–122, n. 35, with preceding bibliography.

30. On c.2 recto, as first noted by De Luca (see note 3 above).

31. The inscription is on c.22 verso; see Malvasia (1678) and (1686).

32. There exists a notable bibliography on Bocchi; for the most recent notices and discussion of the bibliography, see De Luca (1999). For an accurate introductory profile of the humanist which makes evident the variety and depth of his relationships with cultural figures of his time, see Rotundò (1969), 11: 67–70.

33. Bologna, Archivio di Stato, Riformatori dello Studio, 'Rotuli dell'Università degli Artisti', Cartella II, fol. 79: published in Bentivoglio-Ravasio (2000).

34. Faietti and Scaglietti Kelescian (1995): 89–94.

35. Ibid., 339–41, n. 3.

36. London, British Library, Yates Thompson, MS. 29; see Faietti and Scaglietti Kelescian (1995): 115–18, n. 10.

37. On the 'Rotuli della Università degli Artisti', see *Direzione del R. Archivio di Stato in Bologna* (1898): 80–85. See also *I rotuli dei Lettori Legisti e Artisti* (1888–89); for the 'Rotuli' of the second half of the fifteenth century, several indications can be found in Medica (1993): 124.

38. Faietti and Oberhuber (1988): 226; Franzoni (1990): 297.

39. The identification of this painting with the *Conversion of St Paul* now in the Kunsthistorisches Museum in Vienna has not received unanimous agreement, even if generally accepted; see Chapman (2000): 147, n. 97.

40. Traversa (1992): 11–12. For biographical information on the writer, see Basini (1960); for his brother Alessandro, see Nardi (1960).

41. Matteo Buratti, *alias* Garzaria Matteo di Giovanni (1571–1601) appears within these chronological dates in Ridolfi (1990): 100, n. 209.

42. For Aspertini's relationship with the Garzaria family see Faietti in Faietti and Scaglietti Kelescian (1995): 48; for the altarpiece in S. Martino see Scaglietti Kelescian in Faietti and Scaglietti Kelescian (1995): 163–6, n. 33; for his connection with the Gambaro family, see Faietti in Faietti and Scaglietti Kelescian (1995): 62 and 294–5, n. 78.

43. For a drawing possibly related to this project, see: Faietti and Scaglietti Kelescian (1995): 284–5, n. 70.

44. Malvasia (1678): 142. Scaglietti Kelescian includes it among lost works in Faietti and Scaglietti Kelescian (1995): 207, n. 9P, with other bibliography. On the various family branches of the Ercolani and their palaces see Guidicini (1868–1873): 3: 44–45.

45. Manuela Iodice in Faietti and Scaglietti Kelescian (1995): 347.

46. Ibid., 347.

47. Ibid., 345.

48. De Luca (1999): 89, notes the presence of Alessandro and Astor Volta in the 'Matricola' of the Buon Gesù.

49. See Guidicini (1868–1873), 3: 93 (stating that the church was demolished in July of 1809 or 1812) and (1872): 327 (determining the date of demolition in July 1809).

50. Malvasia (1686): 213–15.

51. Guidicini (1868–73), 3: 92.

52. See Lamo (1996).

53. Cavazzoni (1999): 9–111.

54. Ibid. (cc.12–13).

55. Masini (1666): 83.

56. Malvasia (1686): 214.

57. Baruffaldi (1844), 1: 217.

58. Zanti (1583): c.46 verso.

59. They are included among his lost works in Gramaccini (1980): 128, nn. 93 and 94. Emiliani cites a *St Apollonia* in terracotta by Alfonso Lombardi, now in the Pinacoteca Nazionale in Bologna (inv. 3866); see Malvasia (1969): 141 (214/6). On p. 142 (214/26) he identifies the work hypothetically as the sculpture of the saint for the confraternity.

60. Guidicini (1868–73), 3: 91. Masini ((1650): 62) mentions here only Pietro Faccini's *Annunciation* now in the Pinacoteca Nazionale, Bologna.

61. Bologna, Archivio di Stato, Fondo Demaniale, 9/7631. I thank Chiara Albonico and Ilaria Rossi for the reading and transcription of the document, to date unpublished, which is part of a more general project of archival research dedicated to Bolognese artists of the sixteenth century.

62. Masini also makes this reference ((1650): 62). Sassu (1999): 36, note 100, has proposed two possible candidates for Costa's painting in the oratory, a *Nativity* once in the Maccaferri Collection in Bologna, and a *Pietà* in the Staatliche Museen, Berlin, signed and dated 1504 (cf. reproductions in Varese (1967): pls XII, XIII and fig. 48). The latter can be dismissed, while the identification with the first (the Maccaferri *Nativity*) remains a possibility. Unfortunately, we have no evidence for whether this work belongs to the late Mantuan period of the artist, in which case it could have been commissioned at the time of the building of the church, or if, instead, it was already in the confraternity's possession, and even perhaps came from, as seems more likely, the oratory or perhaps even another building of the Buon Gesù, such as the church of S. Maria dell'Orto (later S. Maria della Neve), conceded to the confraternity in March 1510 and transferred to the Padri Girolami/Gerolamite Fathers of S. Barbaziano already in August of 1519 (Masini (1650): 94; Guidicini (1868–73), 3: 92, 349).

63. Cavazzoni (1999): 36 (c.13).

64. Masini (1650): 83.

65. Malvasia (1678), 1: 142.

66. Bologna, Biblioteca Comunale dell'Archiginnasio, MS. B.16, cc.14–18, transcribed in Faietti and Scaglietti Kelescian (1995): 351 (c.17 verso).

67. Malvasia (1686): 213; on p. 215 he returns to the figure of St Bernardine, describing as over it 'la testa di Christo N.S.'.

68. *Pitture scolture ed architetture* (1782): 178.

69. Bianconi (1820): 182.

70. Scaglietti Kelescian includes it among rejected works in Faietti and Scaglietti Kelescian (1995): 210, n. 14R, with preceding bibliography. She instead considers as lost the fresco by Amico described in the early sources (ibid., 207, 18P), with earlier bibliography, to which should be added Cammarota [n.d.]: 411 and Sassu (1999): 36, n. 103.

71. Vasari (1966–87), 4: 497; Malvasia (1678), 1: 143.

72. Faietti and Scaglietti Kelescian (1995): 284–5, n. 70; see also entry n. 76, 291–3; n. 84, 300; n. 87, 302–303; n. 88, pp.303–304, n. 98; 312 (for the latter drawing, cf. also Faietti and Cordellier (2001): 82–3, n. 23).

73. Bologna, Archivio di Stato, Dem, 9/7631, n.1 = Statuto della Compagnia of 16 March 1520; n.3 = Statuto della Compagnia of 14 March 1528. The only change is the name of the confessor; in 1520 he is frate Ludovico d'Arme da Bologna, vicar of the monastery of the Annunciata of the Observant Brothers Minor of St Francis (c.14 recto, Capitolo 15), while in 1528 is named frate Innocenzo da Corte maggiore (*sic*), also vicar of the Annunciata (c.23 recto, Capitolo 15). The *confratelli* in fact were on friendly terms with the Observant Brothers of the Annunciata; see Terpstra (1995): 45.

74. Another Statute of 1490 dates from the period in which Amico could have been already enrolled in the confraternity, but, even if considered in light of the modifications introduced in 1494, it is much less detailed and consequently less suggestive for the present research. The Statute of 1569 is after Aspertini's death. (These Statutes are in the Biblioteca Universitaria and the Biblioteca Comunale dell'Archiginnasio, in the documents cited in note 1, above.)

75. Terpstra (1995): 56–7.

76. Petrocchi (1970), 2: 648–52.

77. Ibid., 641–7.

78. Couilleau (1974).

79. Colosio (1953).

80. For discussion of the chronology of the individual works mentioned below, see the catalogue entries in Faietti and Scaglietti Kelescian (1995).

81. *Scenes of the Passion*, in the Sala della Passione of the Rocca of Gradara; frescoes in the Cappella di Sant'Agostino in S. Frediano, Lucca (especially the *Entombment* in the left lunette and in the area under the arch the *Flagellation*, *Washing of the Feet*, *Last Supper* and *Agony in the Garden*); cf. Scaglietti Kelescian in Faietti and Scaglietti Kelescian (1995): 97–101, n. 1; 141–53, n. 24.

82. Ibid.: 122, n. 13.

83. Ibid.: 169–72, n. 36.

84. Ibid.: 162–3, n. 32.

85. Scaglietti Kelescian (1999).

86. Faietti and Scaglietti Kelescian (1995): 282–3, n. 68.

87. Ibid., 244–6, n. 29: New York, The Pierpont Morgan Library, The Janos Scholz Collection, inv. 1981–18.

88. Ibid., 297–9, n. 82; Faietti and Cordellier (2001): 80–81, n. 22: Paris, Louvre, Département des Arts graphiques, inv. 6859.

89. On the sheet in Liverpool see Faietti and Scaglietti Kelescian (1995): 301–302, n. 86: Liverpool, National Museums and Galleries on Merseyside Walker Art Gallery, inv. LL3000. For a reproduction of fol. 2v in 'London II' see ibid., fig. 45, p. 65: London, British Museum, inv. 1862-7-12-394/435.

90. Ibid., 246–7, n. 31: Vienna, Albertina, inv. 34530.

91. Staatliche Museen, Kupferstichkabinett, inv. 137.1927, 210 × 301 mm (provenance: Boerner, Leipzig, 1927); see Faietti (2001).

92. The identification of this figure with Joseph of Arimathaea is proposed in Urbini (2001). Vasari had identified him as Nicodemus. Both appear in the Gospel of John (19:38–42) as those who wrap Christ's body in the shroud and place him in the tomb. The *Meditationes passionis Christi* of Pseudo-Bonaventura–Johannes de Caulibus and the texts derived from it established the tradition that Joseph of Arimathaea was at the head and Nicodemus at the feet of Christ; see Agostini and Ciammitti (1985): 305–306, with discussion of bibliography on the theme. On the two personages depicted in Niccolò dell'Arca's *Lamentation*, see also Gentile (1989): 194–5;

Fanti (1989): 72–3. Nevertheless, in the absence of other more decisive comparative evidence (in the sculpture, neither Joseph of Arimathea nor Nicodemus has the attributes, respectively, of the pliers, hammer and nails, nor the ointment jar), I here observe only the possible interchangeability of the identities of the characters, without dismissing the testimony of Vasari, who could have seen the sculpture in Bologna. In fact, artists are not always consistent in this matter, and often defy our attempts to schematize: for example, while Lorenzo Costa, in his *Deposition* of 1504, today in Berlin, seems to place Joseph and Nicodemus in literal accordance with the *Meditationes* of Pseudo-Bonaventure, Ortolano, in his *Lamentation with Carmelite Saint* of 1521 (Capodimonte, Naples) instead ignored this text. Niccolò Pisano, in his *Lamentation* of 1518 now in the Pinacoteca, Bologna, not only was unconcerned with the identities of the figures, but even created further occasion for confusion; if we follow the book of John, we would identify Nicodemus as the figure standing behind the supine Christ (as in Aspertini's sculpture), in the act of wrapping the body in the shroud, and Joseph of Arimathaea as the figure to the side holding the nails just extracted from Christ's body (for reproductions of Costa's and Niccolò's paintings, see figs 127 and 536 in Ballarin (1994); for Ortolano's see pl. CXL in Ballarin (1995).

93. See Scaglietti Kelescian in Faietti and Scaglietti Kelescian (1995): 185–6, n. 44.

94. *Mocking of Christ*, copper (painting on copper), in possession of Padre Pittorino, San Francesco (ibid.: 207, 12P; see also 20P); *Christ Taken from the Cross and Embraced by the Maries*, fresco, Bologna, church of the Cappucines (ibid.: 207, 19P); *Crucifixion with Saints*, Bologna, Padri Gesuati fuori Porta San Mamolo (ibid.: 207, 22P); *Resurrection of Christ*, Bologna, San Petronio, Cappella della Madonna della Pace (ibid.: 208, 32P).

95. A '*Crocefisso di legno*', indicated by Scaglietti Kelescian as in Bologna in the house of Giovanni Francesco Negri (ibid.: 207, n. 11P), is in fact a drawing. It is identifiable with a sheet that Malvasia in 1678 described as belonging to 'Bianco Neri' (ibid.: 319, n. 5P). Bianco Neri, *alias* Biagio Negri, was the son of Giovanni Francesco (1593–1659), who was responsible for the project of the seventeenth-century church of the Buon Gesù; in the inventory of his possessions, made in 1689, there appears a 'Crocifissione in legno di Mastro Amico', or a drawing probably attached to a wooden support to be hung on the wall; see Morselli (1998): 357.

96. Scaglietti Kelescian in Faietti and Scaglietti Kelescian (1995): 172–4, n. 37. For a comparison of the *Blessing Christ* with the image designed by Hans Holbein for Erasmus' *Praise of Folly*, see Urbini (2001): 63.

97. In an analysis of the *Pietà*, Fortunati ((1994b), see 307–309), proposes Aspertini's participation in the aristocratic and cultured circles adherent to the Italian evangelical movement. On these questions, besides the entries cited in notes 84 and 97 above, see also Faietti in Faietti and Scaglietti Kelescian (1995): 48–52.

98. Kropfinger-von Kügelgen (1973): 327–8; on the Dominican writer see Schaff (1924).

99. On the religious ambiance of Niccolò's masterwork, see Verdon (1989).

100. On the *Imitatio Christi* and the *devotio moderna* see Delaruelle, Labande and Ourliac (1971).

101. In my opinion, the miniature *San Francesco receiving the Stigmata* (Riforma degli Statuti dell'oratorio di San Francesco, Bologna, Biblioteca Comunale dell'Archiginnasio, MS. B. 983, fol. 32v) is not original; it is published in Benati (1999): 196, n. 43, and accepted by Bentivoglio-Ravasio ((2000): 15). In agreement is Lollini ((2001a): 194–5), pl. XXXIV.

102. Scaglietti Kelescian in Faietti and Scaglietti Kelescian (1995): 174–5, n. 38, and followed by Caroli ((1998): 118, 529–30). See also Klinger (1995), 2: 6, cat. 13.

103. Alberti (1588): 339 recto and verso.

104. Le Bachelet and Jugie (1927), 7: 1126.

105. Reference here is to works which in my opinion present no attribution problems; for reasons of brevity, I would like to reserve more detailed discussion of works attributed since 1995 for a separate study.

106. The *Flagellation* in a private collection has been already published in Scaglietti Kelescian (1999): 321–33. Recall also the lost drawing for a woodcut of the *Deposition* (see note 91).

107. Oil on panel, 91 × 122.5 cm. Independently, Emilio Negro and Nicosetta Roio have referred to the panel as an autograph work by Aspertini in their monograph on Lorenzo Costa; see Negro and Roio (2001): 18 and 24, n. 71. I would like to thank these two scholars for having exchanged with me photographic documentation of the work.

108. London, British Museum, inv.1950.5.20.I (pen and brown ink, 190 × 200 mm); see Berenson (1938), 2: 259, n. 1859E, and 3: plate 430.

109. In an oral communication of June 1999 Hugo Chapman agreed with my opinion, as well as Anna Forlani Tempesti.

110. Faietti (2000).

111. For reproductions, see Ballarin (1994), Ballarin (1995): fig. 530 (a), and fig. 129.

112. Florence, Uffizi, Gabinetto Disegni e Stampe inv. no. 6158F: Faietti in Faietti and Scaglietti Kelescian (1995): 287–9, n. 73.

113. Faietti and Scaglietti Kelescian (1995), 207, n. 7P. On the inventory of the possessions of Camillo Cristiani dated 1 August 1620 see Morselli (1997): 440–41, n. 653.

114. See, for stylistic analogies, the sheets catalogued as nos. 38–42, 253–8, in Faietti and Scaglietti Kelescian (1995).

115. *Fonti francescane* (1977), 1: 1346–7 (*Specchio di perfezione*); 1: 671 (*Vita seconda* di Tommaso da Celano).

116. For the significance Francis attributed to the term 'minori', see Miccoli (1991).

117. Statute of 1520, for which see note 73, Capitolo I, c.3 recto; Capitolo 33, c.25 recto.

118. Morabito (1961).

119. Iodice (1995): 348.

120. Feigenbaum (1993): 148–9, n. 68, with earlier bibliography.

121. Following Fortunati (1994b), Silvia Urbini considers Aspertini's possible connections with Italian evangelical circles; see Urbini (1996).

4.1 Amico Aspertini, *St Petronius*, 1525, miniature, Bologna, Archivio di Stato: Riformatorio dello Studio 'Rotuli dell'Università degli Artisti', Cart. II, fol. 79

4.2 Amico Aspertini, *Pietà with Sts Mark, Ambrose, John the Evangelist and Anthony Abbot*, 1519, tempera on canvas, Bologna, S. Petronio, Garganelli Chapel

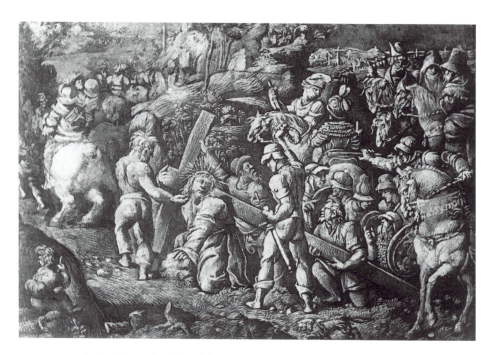

4.3 Amico Aspertini, *Way of the Cross*, 1510s, watercolour, location unknown (once in the Underdown Collection)

4.4 Amico Aspertini, *Crucifixion*, 1520s, oil on panel, Castelfidardo, Collection of
Duke Roberto Ferretti

4.5 Amico Aspertini, *Meeting of Sts Francis, Dominic and Angelo of Jerusalem*, 1508–1515, pen and brown ink, London, British Museum, Department of Prints and Drawings

A misunderstood iconography: Girolamo Genga's altarpiece for S. Agostino in Cesena

Alessandra Galizzi Kroegel

This essay proposes for the first time a detailed discussion of the iconography of the altarpiece painted by Girolamo Genga for the church of S. Agostino in Cesena, a work datable to between *c.* 1516 and 1518 (see Figure 5.1). While the critical rediscovery of Genga's oeuvre dates back to the 1940s, starting from Roberto Longhi's intuition that the artist deserved to be included among such innovative masters as Beccafumi, Rosso and Pontormo,[1] the altarpiece for Cesena became the object of a series of studies particularly in the 1980s, when the celebrations in honour of the anniversary of Raphael's birth generated a renewed interest in the art of Central Italy.[2] On that occasion, Genga's altarpiece was analysed and discussed under different aspects. First, concrete suggestions were made concerning the work's original structure, its wooden *ancona* having been dismantled at the end of the eighteenth century. Secondly, the painting was unanimously indicated as a turning point in Genga's career, a revolutionary mixture of *maniera moderna* and manneristic anticipations.[3] On the other hand, much less attention was paid to the altarpiece's iconography: not only were a number of figures repeatedly given debatable identifications, but also no real attempt was ever made to explain the painting's main subject, which is generally indicated as a 'Dispute about the Immaculate Conception'.[4] In fact, the piece of information according to which this title was used by the patrons, the Augustinian friars of Cesena, in describing the finished altarpiece seems to originate from a misunderstanding rather than from an accurate reading of the documents.[5]

The first document concerning the Cesena altarpiece is an autograph by Genga and dates back to 12 September 1513.[6] It is a contract between the convent of S. Agostino and the artist in which the latter agrees to execute the huge *ancona* both in its wooden and stucco parts, as well as the paintings which were to be inserted into this structure. Genga specifies that everything will correspond to the drawing he is producing in advance.[7] He also encloses

a detailed list of the figures which he is supposed to paint: a scene of the Annunciation in the upper part of the *ancona*; another one with the Madonna, the Christ Child and St John the Baptist, the four Doctors of the Church, four male and two female saints belonging to the Augustinian Order, God the Father and seven angels in the central panel; two *beati* of the same order 'nei pilastri delle colonne', that is along the columns which most likely decorated the sides of the altarpiece; and finally, five scenes with episodes from the life of St Augustine in the predella.

Unfortunately the altarpiece, which had already undergone a number of transformations at the end of the sixteenth century, lost its precious *ancona* during the church's reconstruction between 1758 and 1777. Most likely it was on that occasion that the two *beati* painted on the sides of the wooden structure disappeared. Also it was at this time that the central painting with the *Disputa* (see Figure 5.1) was separated from the small panel of the *Annunciation* (Figure 5.2), and that the shape of the latter was transformed from rectangular to oval.[8] At the beginning of the nineteenth century, when the building was shut down as a consequence of the Napoleonic suppression, only the *Annunciation* remained *in loco*, where it still is, while both the altarpiece and three scenes belonging to the predella were taken to the Pinacoteca di Brera in Milan in 1809. As for the remaining two components of the predella mentioned in the contract of 1513, it is likely that they were never painted. Not only do the sources generally describe just three episodes in the predella,[9] but also the panels which survive are so large that they would have left hardly any space for other episodes to be included in this part of the *ancona*.[10]

Upon their arrival at Brera, the three predella panels were recorded in the inventories as 'Conversione di S. Agostino' (see Figure 5.3), 'S. Agostino che dà il battesimo ai pagani' (see Figure 5.4) and 'Vestizione dell'ordine di S. Agostino'[11] (see Figure 5.5). In the following decades they were exchanged with other works of art and left the Milanese picture gallery.[12] Nowadays they are respectively in an Italian private collection, in the Accademia Carrara in Bergamo and in the Columbia Museum of Art in South Carolina. In the course of the twentieth century, the second and third scenes started being mentioned in the scholarship on Genga as 'St Augustine baptizing the Catechumens' and 'St Augustine giving the Habit of his Order to Three Catechumens'. No explanation, however, seems to have accompanied the choice of these new titles, nor was the iconography of the scenes ever discussed in detail.[13]

The predella

My own investigation of the Cesena altarpiece will start precisely from the subject of the predella, examining it in the context of the iconographic tradition of the hagiography of St Augustine, with particular reference to Italian art. This tradition can be reconstructed through a vast series of cycles from the fourteenth to the early sixteenth centuries, whose main sources of inspiration were the *Confessions* by St Augustine as well as the historic and legendary tradition which developed after them.[14]

Like their literary sources, these cycles put particular emphasis on those episodes from the saint's life which better demonstrate his metamorphosis from a rational intellectual fascinated by pagan philosophies such as Manicheism, to a strenuous believer in and active supporter of the Catholic faith – hence the frequent depiction of the episode of Augustine's conversion, which the saint himself explains began in Milan after listening to the preaching of the local bishop, St Ambrose, while the final revelation took place when he was meditating under a fig tree in a garden of the same town. There is no doubt that this is the scene which Genga depicted in the first panel of the predella, where the saint is the large figure portrayed in the centre, with his left arm raised toward the sky and his right hand open on the pages of a book (see Figure 5.3). According to the *Confessions*, after hearing a voice which had told him 'Tolle, et lege' ('Pick up, and read'), Augustine opened the Letters of the Apostles and found a passage from St Paul's Epistle to the Romans (Romans 13:14) which eliminated his final hesitations in embracing the Catholic faith.[15]

The identification of the other three characters attending the scene is a little less obvious, but can still be explained on the basis of the *Confessions*. According to this text, at the time Augustine heard the celestial voice, he was not completely alone since Alypius, his most faithful companion, had been waiting for him in a place nearby. In fact, after the saint had returned to his friend to look for a book in order to do as the voice had ordered him, and after he had read the revealing passage, using a finger to mark the point where he had stopped – a detail faithfully reproduced in the painting by Genga – Alypius read the next passage and was himself converted.[16] Therefore, the small figure who sits in the right corner of the scene staring at Augustine and holding a book must be Alypius. As for the other two characters standing to the left, their dress and attire, together with their rather heavy features, seem to suggest that here the painter was trying to render a kind of exotic look, probably an African one. In light of this, the two men are likely to be other friends of Augustine who, like Alypius, had followed him from Africa, where they all were born: most likely, one of them is Ponticianus, whom the saint writes that he met again in Milan just before

the episode of his conversion, and who sometimes appears in the iconography related to this episode.[17]

In the Augustinian cycles mentioned above, the episode of the conversion is immediately followed by that of the saint's own baptism at the hands of Ambrose. In some of these works, Augustine is portrayed alone, kneeling half-naked in front of the Milanese bishop; in other examples, however, he is accompanied by one person, more often by two, and the latter are also naked or in the process of getting undressed in order to enter the font containing the sacramental water.[18] In fact, the presence of two companions is the most accurate depiction of the saint's baptism as it is reported in the sources. Augustine himself describes how he was 'reborn in Christ' together with Alypius and the fifteen-year-old Adeodatus, the son ('fruit of his sin') whom Augustine had conceived during his stay in Carthage, when he was still 'very young … a pagan and a philosopher'.[19] In light of this tradition, the subject of the second panel in the predella by Genga must be understood as the baptism of Augustine and his companions and not, as has been unanimously indicated so far, as the saint baptizing a few catechumens (see Figure 5.4). Not only is such an episode not mentioned in the *Confessions* or in the other sources,[20] but also two of the figures painted by Genga – the muscular man pulling his robe off his head and shoulders to the right, and the boyish-looking one (Adeodatus?) who sits on the ground while busying himself with a pair of stockings – recall so closely the postures of Alypius and Adeodatus in the fresco of the *Baptism of St Augustine* by Amico Aspertini in S. Frediano in Lucca (*c.* 1508) that it seems likely that Genga was working with specific examples of this iconography in mind.[21]

However, if we assume that here the bishop is Ambrose and not Augustine, we are left with the question of who should be identified as Augustine among the nudes surrounding the large pool and, even more puzzling, of why there are four nudes rather than three. In spite of its relevance to a full understanding of the picture, Genga's interest in the challenges and beauty offered by human anatomy could hardly justify what at first seems to contradict the hagiographic tradition. As for the first question, a closer look at the painting may provide the answer. Obviously enough, the typical iconography of his baptism requires that Augustine occupies a prominent position and is close to St Ambrose; furthermore, the saint is often portrayed with an expression of awareness and satisfaction which is rendered through a smile. In the painting by Genga, all this applies to the bearded man who is entering the pool to the right.[22] As for the presence of a third companion participating in the sacramental rite, a detail of which I have found no other instance so far, it is again the *Confessions* which provide a possible explanation. Shortly after the episode of his baptism (together with Alypius and Adeodatus), Augustine mentions that during his stay in Milan he and his

companions were all living under the same roof with Evodius, another young African who, after abandoning a military career, had also converted to Catholicism and received baptism.[23] In fact, on the basis of Augustine's account this last episode preceded the saint's own baptism: yet the inclusion of Evodius in the panel by Genga may be understood as an original invention in order to provide the scene with a more dramatic quality. First of all, the four figures enhance the narrative character of the scene by dividing the rite of baptism into four different phases: taking off the clothes, entering the font, getting out of it and getting dressed again. Secondly, the abundance of nudes – so classical-looking with their muscular beauty – is a very effective means of evoking the condition of paganism and sin characterizing Augustine and his friends before their immersion in the sacramental water.

The numerous other figures surrounding the scene alternatively show concentration, a certain amount of suspense, even surprise. However, only the small group in the left corner appears to understand the sacredness of the event fully: the two men have their hands clasped in prayer, and the woman in the background lowers her eyes in devotion. Their peculiar headdress, a turban which recalls quite closely those of the two characters attending the scene of Augustine's conversion (see Figure 5.3), suggests that also in this case we are dealing with some African companions of the saint. In particular, the female figure must be Augustine's mother, Monica, who had joined him in Milan from Tagaste in Numidia and had taken an active part in his conversion.[24]

Indeed, the presence of Monica, as well as that of a few friends, is quite common in the iconography of the first episodes of the saint's life. For instance, Monica is portrayed both in the *Baptism of St Augustine* and in *St Augustine Receiving the Habit of the Hermit Monks* on the very same page of the *Historia Augustini*, an illuminated manuscript from southern Germany datable to around 1430–40[25] (see Figure 5.6). As a matter of fact, this illumination provides a useful term of comparison for the understanding of our predella not only because here all the figures are identified by inscriptions – in the *Baptism*, the bishop 'Ambrosius' is baptizing 'Augustinus' and will soon do the same to 'Alypius' and 'Adeodatus', each in his own font – but also because the two episodes presented one after the other are exceptionally similar to the second and third panels by Genga.

Not surprisingly, the same sequence can be found in many other cycles dedicated to the life of St Augustine, where the episode immediately following the saint's baptism is precisely the one in which he receives the black garment characterizing the Order of Hermits of St Augustine, also known as Augustinians, from the hands of a bishop who, as we read in the German illumination, is once again 'Ambrosius'.[26] Interestingly enough, this scene contradicts Augustine's own account, according to which the saint received

ordination – as a presbyter, and not as a monk – from Valerius, Bishop of Hippo, the city in North Africa where he had returned after his long stay in Italy.[27] The fact that Augustine had entered a monastic community – one that he himself had founded – is mentioned for the first time in the saint's biography by his pupil Possidius, yet this episode is also said to have taken place in Africa.[28] On the other hand, the story of St Ambrose giving Augustine the black habit of the Order of Hermits immediately after baptizing him is reported in the apocryphal sermons *Ad fratres in heremo* as well as in a number of texts related to the Augustinian Order from the late thirteenth century on.[29]

The Order, which had been founded by papal bull shortly before 1244, resulted from the fusion of various hermitical and monastic communities in Italy under a rule inspired by the spirituality of Augustine. By making up the legend according to which the latter had received the hermits' habit from St Ambrose, implying that the event had taken place in Italy, the Augustinians were trying to establish a more direct relationship between themselves and their 'founder', whose role had actually been more ideal than real.[30] The wide diffusion that this legend enjoyed in the iconography promoted by the Order in the following centuries confirms its political character: it was an invention which played an important role within the discourse of self-representation of a monastic community that was seeking to ennoble its origins.

There is no reason to doubt that the very same legend is the subject of Genga's third panel as well (see Figure 5.5), and that its traditional identification as *St Augustine giving the Habit of his Order to Three Catechumens* must be rejected, not least because it does not rely on any solid iconographic tradition.[31] Just as in the German illumination discussed above (see Figure 5.6), here the bishop standing in the centre is identical to the one in the scene depicting the baptism of Augustine (see Figure 5.4); therefore, he must be identified as St Ambrose, while the novice wearing a white tunic who kneels in front of him is Augustine. Furthermore, both in the illumination and in the painting by Genga, the saint is accompanied by two *confrères*: in the illumination, these are already wearing the black habit of the Augustinian hermits and stand behind 'Monica'; in the painting, they are still undressed and their posture reveals an ardent desire to receive the monastic habit. Their robes are carried by two assistants flanking the bishop, while in the foreground, scornfully abandoned, lie the three novices' secular clothes. Monica has been included in the painting as well; she is with the same two African men who accompanied her in the *Baptism*, and here, too, the small exotic-looking group follows the event from the left.

The central panel

The Augustinian Order's self-celebration is certainly a fundamental component also in the iconography of the large panel which Genga painted for the centre of the Cesena altarpiece (see Figure 5.1). As mentioned before, six saints of the Order (four men and two women) had been expressly required in the contract of 1513.[32] In light of this, the identification of the figures surrounding the Virgin so far proposed is not completely satisfactory.[33] Starting from the four Doctors of the Church in the foreground, who are mentioned in the contract as well, our reading of the panels for the predella suggests that the traditional identification of the two bishops must be reversed: the one to the right is Ambrose and not Augustine, his mitre being identical to the headgear of the Milanese bishop in the *Baptism of St Augustine* and *St Augustine Receiving the Habit of the Hermit Monks from St Ambrose*. Furthermore Augustine, who sits to the left and is discussing with Pope Gregory the Great, wears a black cloak with a hood above his bishop's robe: such clothing belongs to the tradition of the Augustinian monks, and is a frequent attribute in the Renaissance representations of the Order's founder.[34] The identification of the two bishops that I propose is confirmed by the fact that Ambrose looks definitely older than Augustine, which makes Genga's portrayals correspond to the actual age difference between the two saints.[35]

As for the characters in the second row, the identification as St Anthony of Padua, so far unanimously given to the friar holding a lily to the left, is problematic. Although it is true that he initially belonged to the Order of the Augustinians and only later became one of the most fervent followers of St Francis of Assisi, his inclusion in the Cesena altarpiece would have hardly been flattering for the order that in the end he decided to abandon.[36] It is more likely that this young man with a tonsure is St Nicholas of Tolentino, one of the most venerated saints of the Augustinian Order. Just like St Anthony of Padua, he is generally portrayed wearing the Order's dark habit with a hood – very similar indeed to the cowl of the Franciscans – and holding a lily, the traditional symbol of chastity.[37] Most often a star appears on his chest, yet in the painting by Genga the latter would not have been visible anyway, the saint being partially covered by the figure of St Gregory with his large papal tiara.

Moving clockwise, the figures next to St Nicholas are a man with no attribute other than the Augustinian habit – an anonymous saint – and an elderly woman who stares at the Virgin while holding the little St John the Baptist by the hips. She is generally said to be St Monica, who can be considered a forerunner of the order entitled after her son.[38] Yet such an identification too is problematic, since the woman's close relationship to the little St John suggests that she is, rather, his mother Elizabeth. Furthermore,

the saint's attire is much more fitting to the Renaissance iconography of Elizabeth – mostly portrayed as an elderly woman with white cloth wrapped around her head – than to that of Monica, who is generally presented wearing dark matronal clothes, sometimes even the very same black habit of the Augustinian nuns.[39] As I shall discuss further on, the identification of the saint as Elizabeth makes sense also in light of the immaculist component of the painting.

Much more certain is the identity of the young nun to the right of the Virgin; the large heart she is carrying – its deep red colour stands out from her black habit, creating a very dramatic effect – demonstrates that she is St Clare of Montefalco, a popular mystic of the Augustinian Order who was believed to have had the symbols of the Passion impressed onto her heart.[40]

As for the last two figures to the right, the first is again an anonymous member of the Augustinian Order, presumably another saint, and the last one is St Sebastian. His inclusion in a work celebrating this order is less extravagant than it looks at first. The saint, who is the patron against the plague par excellence, might have been portrayed precisely in connection with the Black Death of the fourteenth century. This series of events, which had deprived the Augustinians of more than five thousand friars, marked the beginning of an extremely long period of decline and was still remembered with great pain in the Order's chronicles at the end of the fifteenth century.[41] In light of this, the presence of St Sebastian in the altarpiece can be interpreted as a sign of apprehension and desire for protection from a tragic event, for which the Order had not yet finished suffering the consequences and which was still perceived as a potential danger.

An examination of the altarpiece's other groups of figures – the four Doctors of the Church animatedly discussing among themselves, the Virgin Mary accompanied by the little Jesus and St John the Baptist, God the Father in a glory of angels pouring flowers over the crowd underneath – raises the question of the work's main subject. As I mentioned before, the title 'Dispute about the Immaculate Conception' does not seem to be reported in the documents concerning the commission, nor does it appear in contemporary sources.[42] This title is repeatedly mentioned in the studies on Genga during the second half of the twentieth century, but it has never been explained in detail.[43] It is true, however, that the painting for Cesena presents a number of analogies with the Renaissance iconography of the Immaculate Conception, and that the latter had enjoyed an exceptional diffusion precisely in the area of Emilia-Romagna and the Marches.[44]

In particular, the figure of God among angels suspended above the Virgin, often forming a sort of protective baldachin, and the inclusion of St Augustine – accompanied by St Ambrose, or by a few other saints – are recurrent elements in the altarpieces by Marco Palmezzano in S. Mercuriale in Forlì (1509–1510),

by Francesco Zaganelli for the church of S. Biagio in the same town (*c.* 1513, now in the local Pinacoteca), by Girolamo Marchesi da Cotignola for S. Francesco in San Marino (1513, now in the Museo di S. Franceso), and by the same artist for S. Maria delle Grazie in Pesaro (1513, now belonging to the Pinacoteca di Brera in Milan).[45] The altarpiece by Genga, which was commissioned precisely at the same time, is the first work to present the figure of St Augustine together with the other three Doctors of the Church. Interestingly enough, this group of four saints was soon destined to become a topos of the *Immaculate Conceptions* which were painted in Emilia in the next decades: we find it in the altarpiece by Pordenone for the church of S. Maria Annunziata at Cortemaggiore (*c.* 1530), in three works by Dosso and Battista Dossi datable around the same time, and in the one by Bagnacavallo Junior in the Bolognese convent of Corpus Domini (1575).[46]

In light of these similarities, the hypothesis according to which Genga's altarpiece would allude to the doctrine of the Immaculate Conception is quite plausible. This issue, however, is crucial enough to deserve further investigation. Having already explained most of the characters in the second row of saints in light of the Augustinians' penchant for self-celebration, I shall now examine the other groups of figures according to their possible theological implications.

As is well known, the doctrine of the Immaculate Conception states that the Virgin Mary is the only human being who did not inherit Original Sin from Adam; because she was destined to become the mother of Christ, she was exempted from sin from the very first moment of her conception. Although the cult related to Mary's immaculacy had enjoyed increasing popularity since the eleventh century, the doctrine reached its dogmatic definition only in 1854. This is because from the thirteenth century on the belief of Mary's exemption from Original Sin was the object of a heated debate between the Franciscans, who supported this doctrine, and the Dominicans, who strenuously opposed it. Trained to take a rational approach to theology under the influence of Thomistic thought, the Dominicans correctly pointed out that Mary's immaculate conception is never mentioned in the Scriptures.[47]

Indeed, like all the Fathers of the Church, the four Doctors – Augustine, Ambrose, Jerome and Gregory the Great, whom Genga portrayed in the front row of his composition – never spoke in favour of nor against such a doctrine: in fact, Mary's exemption from Original Sin did not become an explicit theological issue before the eighth century.[48] Soon enough, however, the supporters of the Immaculate Conception, also known as 'Immaculists', began to include the four Doctors among the numerous *auctoritates* ('authorities') whom they used to mention in order to give credibility to the belief they wanted to propagate. In fact, most of the *dicta* ('quotations') attributed to those famous authors were apocryphal or resulted from a cunning manipulation of the historical sources.[49]

The case of St Augustine, who is present in all the Emilian *Immaculate Conceptions* listed above and who certainly plays an important role in the altarpiece by Genga, his presence occurring again in the predella, is a perfect example of this kind of rather unscrupulous propaganda. In his *De natura et gratia* (c. 415), a fundamental text written in order to rebuke Pelagius' heretical opinion claiming that some men and women of the Old and New Testament had actually been living without sin, including the Original one, Augustine explained that everybody, from Abel to John the Baptist, had been a sinner. Yet, as far as the Virgin Mary was concerned (it was with her that Pelagius' list had ended), the saint refused to include her in the discussion because, he explained, 'We know that she was given more grace [than every other figure in the Bible] in order to conquer sin under every aspect, since she deserved to conceive and generate the One who is known as never having had any sin.'[50]

This sentence, which actually shows only how Augustine wished to maintain a neutral position regarding such a complex issue as Mary's relationship to Original Sin, was used by the Immaculists as an important testimony in favour of her exemption. This was done by extrapolating the passage from its original context, and by inserting it, together with quotations from other Fathers of the Church, within the lengthy and erudite discussions in strictly immaculist terms which recur in most of the literature in favour of the Immaculate Conception from the fourteenth century on. The same erudite discussions with abundant quotations from the Scriptures are included in the two Offices for the feast of the Immaculate Conception which were approved by Pope Sixtus IV, a Franciscan, in 1477 and 1480.[51]

A few recent studies have already pointed out how deeply the two Offices, which were composed respectively by the Franciscans Leonardo Nogarolo and Bernardino de' Bustis, influenced the development of the iconography of the Immaculate Conception in the Renaissance.[52] Indeed, the very first commissions of altarpieces explicitly celebrating this subject date precisely to the years following the introduction of these liturgies, and most of those representations are inspired by them quite literally.[53] Between the two Offices, the one by de' Bustis was certainly well known in the areas of Emilia and Romagna, where the Milanese Franciscan had conducted intense preaching between the end of the fifteenth century and 1513, when the last piece of information concerning him reports on a sermon he gave at the cathedral of Ravenna.[54]

As a matter of fact, in Emilia the immaculist propaganda by de' Bustis did land on soil that was already quite receptive. This was mainly due to the influence of the theological *Studium* in Bologna, where the thought of Duns Scotus, the Franciscan who had provided the belief in the Immaculate Conception with its first theological foundation, played a fundamental role.[55]

On the other hand, also the 'maculist' propaganda – that is the propaganda against the Immaculate Conception – had its fulcrum in this city, and precisely in the convent of S. Domenico. The co-existence in the very same area of a strong party in favour of Mary's exemption from Original Sin with another which was strenuously opposing it is undoubtedly one of the reasons why two of the most famous public disputes about the Immaculate Conception took place in this region during the last decades of the fifteenth century, namely in Imola (1474–75?) and Ferrara (1478).[56]

The representation of a group of Church Fathers heatedly debating at the feet of the Virgin, which characterizes the contemporary iconography of the Immaculate Conception in Emilian painting (including the altarpiece by Genga), is likely to be an echo of those historical events.[57] Renaissance sources confirm that their memory did have a great impact on the local devotion to the Marian privilege.[58] A further component of the *fortuna* of the motif of the dispute in immaculist iconography can be found in the Office by de' Bustis. Here the open confrontation between opposite ideas is celebrated as a way to strengthen the immaculist belief itself, making it more 'shining' and convincing; therefore, arguing is warmly recommended.[59]

That the Office by Bernardino de' Bustis played an important role in the invention of Genga's altarpiece is confirmed by another element of the composition, namely the red and white flowers which the angels surrounding God spread like a colourful, odorous rain on the Virgin and her court of saints. This very same motif appears in the *Immaculate Conception* by Francesco Signorelli, an altarpiece which was commissioned in 1521 for the church of the Confraternity of Gesù in Cortona and is now in the Museo Diocesano of the same town[60] (see Figure 5.7). As its numerous figures and inscriptions indicate, this work too was deeply influenced by the liturgy written by de' Bustis.[61] In particular, the poetic vision of the Virgin Immaculate emitting a wonderful scent, surrounded as she is by roses and lilies of the valley as on a day in springtime, seems to be the most likely literary source for the cascade of flowers in the paintings by both Signorelli and Genga.[62] In the altarpiece by Genga, the figure of God the Father suspended above the Virgin, his large mantle covering her like a baldachin, can also be explained in light of the liturgical texts for the feast of the Immaculate Conception. Both the Offices by de' Bustis and by Nogarolo stress how the Virgin was 'protected' from the darkness of sin because of God's will: in fact, the painting by Genga is not the only Renaissance example in which this image is rendered through the motif of God holding his mantle over Mary in a protective way.[63]

There is one element, however, which makes Girolamo Genga's altarpiece for Cesena rather peculiar within the contemporary iconography of the Immaculate Conception. At the centre of the painting the Virgin does not

stand alone above the group of saints nor float in the air underneath the figure of God the Father. On the contrary, she sits on a large pedestal while the Christ Child emerges from her lap. With the most delicate *contrapposto*, he and the infant John the Baptist turn to each other, Jesus in order to bless his cousin, the latter awaiting the benediction with his hands clasped in prayer. The figure of Mary stands above the two children and encloses them in a pyramidal composition of which she is the vertex; her attitude – she is touching each boy on his left shoulder – is both protective and encouraging, as if she were urging the children to come together.

Surprisingly enough, the general similarity between Genga's composition and Leonardo's *Virgin of the Rocks* has not been investigated so far. Such a similarity, however, is quite interesting, especially in light of the fact that the painting by Leonardo was the central panel of a large *ancona* which is documented as having been indeed dedicated to the Immaculate Conception.[64] It may be useful to recall that the *ancona* had been commissioned in 1483 for the church of S. Francesco Grande in Milan; this means that the altarpiece was conceived within the very same Franciscan milieu in which de' Bustis had been actively preaching and writing on the Immaculate Conception, and that this happened just a few years after Sixtus IV had approved the Office by the Milanese friar. This is not the place to discuss the likely immaculist component of Leonardo's cryptical invention in detail.[65] What remains true, however, is that in both *The Virgin of the Rocks* and the Cesena altarpiece Mary plays a more predominant and active role than any other Madonna in the typical iconography of the Sacra Conversazione. Her importance is stressed further by the presence of some elements which can be interpreted as allusions to the Immaculate Conception. In the painting by Genga, such allusions are the rain of flowers as well as the dispute among the Doctors of the Church; in the work by Leonardo, immaculist overtones can be detected particularly in the imposing rocky landscape in the background, which echoes a number of geological images from the Bible that the Immaculists used as symbols of the Virgin Immaculate.[66]

Both altarpieces, on the other hand, include some clear references to the mystery of the Incarnation: in the work by Leonardo, the drapery around the woman's lap is hit by a special light, while in the one by Genga Mary is presented with her legs wide open, the Christ Child emerging from them as if he were just coming out of the woman's womb. The human dimension of Jesus' experience is further stressed by the presence of John the Baptist, who accompanied his cousin in some of the most crucial moments of his life and prophesied his Passion, another fundamental step within God's plan for the redemption of mankind. The presence of these motifs in a composition which otherwise shows a strong Mariological character is only apparently contradictory. In fact, this presence is perfectly fitting with

the core of the doctrine of the Immaculate Conception. According to Duns Scotus, the theological justification of Mary's exemption from Original Sin is precisely the role which she was destined to play in Christ's incarnation, the ultimate goal of which is our redemption. This role of Mary required an absolute purity on her side. In light of this, the mystery of the Immaculate Conception and that of the Incarnation are complementary to each other: the first is the fundamental premise to the second, and the second is the final justification of the first.[67]

The inclusion of John the Baptist in both paintings may be understood as an allusion to the Immaculists' doctrine as well. According to this doctrine, in addition to the Virgin only two other human beings had enjoyed the privilege of having been purified from Original Sin while still in their mother's womb, namely the prophets Jeremiah and John the Baptist. In fact, the Baptist happened to be 'sanctified' in the womb of Elizabeth precisely during Mary's visitation to her elderly cousin, and the words pronounced by the latter on that occasion – 'Blessed are you among women' (Luke 1: 42) – were considered by the Immaculists an important proof of Mary's privileged conception.[68] In light of this, the identification as Elizabeth of the woman holding the little St John by the hips in the altarpiece by Genga becomes particularly convincing. Her close relationship to the Virgin, a relationship which St Monica would have had no reason to have, is confirmed by the fact that she is the only one in the crowd of saints who does not lower her eyes with devotion. On the contrary, she stares at Mary, her younger and holier relative, with the most direct, familiar expression.

The *cimasa*

According to the reading so far proposed, the altarpiece painted by Girolamo Genga for the church of S. Agostino in Cesena merges two main themes: the Augustinian Order's self-celebration, which is particularly clear in the predella but is present in the central panel as well, and the friars' belief in and support of the doctrine of the Immaculate Conception. In this sense, the work's traditional title, *Dispute about the Immaculate Conception*, can be considered correct.

As a matter of fact, the Augustinians are not known to have ever taken an especially active part in the theological debate on Mary's privilege. Yet the Order was always extremely flexible in adapting its own strong Marian devotion to local and regional cults.[69] As mentioned above, the cult of the Immaculate Conception was extremely 'fashionable', albeit controversial, in the region of Emilia in the first decades of the sixteenth century. Furthermore, the 'incarnational' component of the Immaculists' doctrine,

that is its interdependence with the mystery of the Incarnation, a concept which is rendered quite effectively in the iconography by Genga, was perfectly fitting to the Order's spirituality. Like the Franciscans, the Augustinians have always had a special devotion for the Incarnation, so that even their passionate veneration of the Virgin concentrates on her major role within this mystery.[70] Finally, by embracing the immaculist doctrine the Augustinian friars were certainly convinced to follow the teaching of the Doctor of the Church whom they proudly celebrated as their founder: as we have seen, the immaculist propaganda had attributed to Augustine the reputation of having been an early promoter of the Immaculate Conception.

Moving to the last compartment of Genga's altarpiece – the small panel with the *Annunciation* in the *cimasa* (see Figure 5.2) – its iconography first of all recalls the most diffused form of Marian veneration among the Augustinians, who celebrated the Virgin as 'Our Lady of Grace'. This title derives from the angelic salutation during the Annunciation (Luke 1: 26), a salutation for which the Augustinians had developed a special cult since the fourteenth century.[71] Undoubtedly, the Order's enthusiasm for Gabriel's words must have played a certain role in this beautiful invention by Genga: the angel, an astonishingly powerful and lively figure, is portrayed with his lips wide open and swollen cheeks, as if he were addressing the Virgin more by screaming than speaking. Furthermore, it is his arm raised in the well-known greeting gesture which marks the centre of the composition.

Yet the angelic salutation plays a fundamental role in the doctrine of the Immaculate Conception too. Eager as they were to find passages from the Holy Scriptures which could be interpreted in favour of Mary's exemption from Original Sin, the Immaculists used to argue that Gabriel's words to the Virgin were actually to be understood as the very first proof of her privilege. Such an argument was based on a series of plays on words which had already appeared in the writings of some Church Fathers, and in the Renaissance enjoyed great popularity in the preaching and writing on the Immaculate Conception.[72]

The main wordplay concerned Gabriel's greeting, '*Ave*', which was interpreted as '*sine vae*' (without sin), an etymology derived from a fusion of the Greek privative alpha 'a' with the Latin 'vae' – a threat, or an exclamation of sorrow, rather arbitrarily interpreted as synonymous with '*peccatum*' or '*culpa*'.[73] As for the expression '*gratia plena*', this too was analysed in strictly immaculist terms by pointing out that its two words indicate a state of being rather than a condition *in fieri*.[74] Therefore – the Immaculists argued – Mary must have been 'full of grace', that is without sin, prior to her meeting with Gabriel. According to them, this had happened at the very moment of her conception.

Not surprisingly, both the wordplay on *'Ave'* and the Immaculists' exegesis of *'gratia plena'* are reported in the Office by de' Bustis: 'Also the angelic salutation demonstrates the innocence of Mary by saying: "Ave", which is like "sine ve", that is without sin; then moving on it says "Gratia plena". Yet she would not have been full of grace if she had lacked the grace of preservation [from Original Sin].'[75] As discussed above, the text by de' Bustis was a fundamental source of inspiration for the central panel of the Cesena altarpiece. Therefore, it is likely that the same liturgy had some influence on the execution of the *cimasa* as well, both in the choice of the subject and in its peculiar rendering. In light of this, Genga's beautiful invention of the angel agitatedly floating in the air, almost breathless in pronouncing his famous words, merges the novelty of the artist's 'modern manner' in painting with the accurate rendering of a theme which was both dear to the Augustinians' tradition and crucial to immaculist propaganda. As I have suggested in this essay, the same applies to the entire altarpiece.

NOTES

1. Longhi (1956b): 151, and for a brief mention of the Cesena altarpiece see p. 62.

2. See Fontana (1981); Petrioli Tofani (1983): 357; Fontana (1983); De Vecchi (1984); Colombi Ferretti (1985); and Monticelli (1988).

3. The most thorough discussion of both issues is given in Colombi Ferretti (1985) (esp. pp. 7–18) and Morandotti (1992): 126–31. To Morandotti goes the merit of having identified the predella's third panel (Morandotti (1993): 275–90).

4. To the best of my knowledge, the altarpiece is referred to as a 'Dispute about the Immaculate Conception' for the fist time in the *regesto* of the documents on Genga published by Pinelli (Pinelli and Rossi (1971): 298–9). Since here this title is published in italics, it is likely that later on it was misunderstood as an actual quotation from the documents, which does not seem to be the case (see note 5, below). In the studies prior to the one by Pinelli, the painting used to be given more generic titles such as 'Dispute among the four Church Fathers' (see Patzac (1920)) or 'Madonna enthroned with Saints' (see Venturi, (1932), 9: 5, 601).

5. All the documents related to the altarpiece were first published in Grigioni (1909) and (1927): 175–6. According to De Vecchi (1984): 43, the altarpiece is called a *'Disputa sull'Immacolata Concezione'* in a document dated 18 March 1518 concerning the completion of the payment to Genga. Yet according to my own reading of the same document (Cesena, Archivio di Stato, Not. Roberto Pasini, f. 332, c.18 r.), here the work is simply called 'ancone sive taule [*sic*] altaris maioris' ('ancona or panel for the main altar'). I wish to thank Dr Pier Giovanni Fabbri, an expert of the Cesena archive, for helping me in finding the document. My thanks go also to Prof. Mirella Ferrari and Dr Simona Gavinelli of the Catholic University in Milan for assisting me in attempting to conduct a paleographic analysis of the document, which is written in a very difficult handwriting.

6. Grigioni (1909): 57–9.

7. For a brief discussion of the altarpiece's preparatory drawings, of which there are at least five, see Colombi Ferretti (1985): 88, n. 6, and Morandotti (1992): 127 (with bibliography).

8. Colombi Ferretti (1985): 10–12.

9. The predella is described as consisting of three panels both by Marcello Oretti in his notes on Cesena of 1777 and in the memoirs by the Cesenate author Sassi of 1845 (Colombi Ferretti (1985): 48, n. 53). On the other hand, the description by another nineteenth-century author from Cesena speaks of 'cinque quadretti dipinti sul legno … rappresentanti la vita di S. Agostino in parte, cioè il di lui battesimo, la di lui conversione, l'elezione a vescovo e la di lui morte' (Cesena, Biblioteca Communale, Carlantonio Andreini, *Memorie di Cesena*, MS. 164/31, 12, pp. 65–6,

quoted in Colombi Ferretti (1985): 14, n. 12). As Colombi Ferretti observed, such a description is not exactly reliable because, by mentioning five panels and then describing only four episodes, it contradicts itself. However, the testimony by Andreini is quite interesting because it suggests that originally the local understanding of the subjects depicted in the predella was different from the titles which were given to the panels after their arrival in Milan (see note 11, below).

10. Each panel is approximately 90 cm wide (Figure 5.3: 47.2 × 87.5 cm; Figure 5.4: 47 × 80 cm; Figure 5.5: 47.3 × 86.7 cm), so that their sum corresponds to little less than the width of the Brera altarpiece (290 cm), under which the three scenes would have fit perfectly (allowing also the presence of a little space between each of them). See Morandotti (1993): 275, 278 (n. 8) and 281 (with a photomontage of the relationship between the central panel and its predella), and Colombi Ferretti (1985): 14, 92 (with the *ancona*'s graphic reconstruction).

11. Milan, Pinacoteca di Brera, *Inventario Napoleonico*, 1811, nos. 255–7.

12. According to a later inventory, the *Conversione di S. Agostino* (no. 255) left the picture gallery in 1821, while the *Vestizione* (no. 256) had been the object of an exchange two years before. Although the inventory is not quite clear about this, it looks as if also the panel *S. Agostino che dà il battesimo* (no. 257) was given away in 1819. See Milan, Pinacoteca di Brera, *Registro dei dipinti delle soppresse chiese e corporazioni religiose*, s.d. [after 1811], f. 4v.

13. These new identifications seem to have been suggested for the first time in Salmi (1927–8): 234–6. Besides the bibliography given above (in notes 2 and 3), see also the catalogue entries on the predella panels in the Accademia Carrara and in the Columbia Museum, respectively, in Rossi (1979): 122, 126, and Shapley (1968), 2: 107–108.

14. See in particular the cycles of the second half of the fourteenth century in Pavia, Padua and Gubbio, the latter probably well known to Genga, who was from Urbino, and those by Benozzo Gozzoli in San Giminiano (1465) and by Giovan Pietro da Cemmo in Cremona (1498–1504). These and many other examples are discussed in the fundamental study by Courcelle (1965–1969). As for the literary sources, besides the *Confessions*, which were written between about 397 and 400, the best biography of Augustine is the *Life of St Augustine* by his pupil Possidius, datable to 431–39. Less reliable, but quite popular and influential from the thirteenth century on, were the apocryphal sermons *Ad fratres in heremo* by the Pseudo-Augustine as well as Jacobus da Voragine's *Golden Legend* ((1965): 15–16.

15. St Augustine (1991): 8. 12. 28–9.

16. 'Then I inserted my finger or some other mark in the book and closed it. With a face now at peace I told everything to Alypius ... He asked to see the text I had been reading. I showed him, and he noticed a passage following that which I had read ... ' (ibid., 8. 12. 30).

17. Ibid., 8.6.14. Ponticianus appears together with Augustine and Alypius in the polyptych in the convent of Neustift (c. 1460–70): Courcelle (1965–1969), 2: 113, pl. LXIX. Morandotti (1993): 278, n. 11, who identified both Augustine and Alypius correctly, suggested that the other two figures could be a visualization of Augustine's description of the voice which had spoken to him as if it belonged to a boy or a girl (St Augustine 8. 12. 29). This interpretation, which may be convincing in the case of the two boys appearing to the left of the same scene in Benozzo Gozzoli's fresco cycle at San Giminiano (Courcelle (1965–69), 2: 97), does not seem appropriate when applied to the figures by Genga, which do not look particularly young. On the other hand, two exotic-looking men similar to them can be found also in the fresco cycle by Ottaviano Nelli in the church of S. Agostino at Gubbio, a work datable to the end of the fourteenth century (Courcelle (1965–69), 1: pl. LXXXIX). The presence of a number of spectators is rather common in the iconography of this scene (ibid., *passim*).

18. See the numerous examples illustrated in Courcelle (1965–69), *passim*.

19. St Augustine 9. 6. 14; Voragine (1995): 688.

20. The episode is not even included among the 49 episodes which are listed in a fifteenth-century treatise intended to instruct artists precisely on how to portray the life of St Augustine; see Stiennon (1952).

21. Faietti and Scaglietti Kelescian (1995): 141–53.

22. Among the most famous examples of this iconography, the Vatican panel by a pupil of Salimbeni shows Augustine not only smiling but also as a young man with a beard (Courcelle (1965–69), 1: pl. CIV). The beard appears to be an attribute of the saint also in the fresco by Ottaviano Nelli in the Church of S. Agostino in Gubbio (ibid., pl. XC). Both these works are datable to the end of the fourteenth century. In the following century, Augustine was portrayed openly smiling in the polyptych of Neustift (Courcelle, (1965–69), 2: pl. LXXI; see above, note 17) and in that of Carlisle (c. 1484–1507) (ibid., pl. LXXXIII).

23. 'You make people to live in a house in unanimity (Ps. 67: 7). So you made Evodius a member of our circle, a young man from my home town. When he was a civil servant as an agent in the special branch, he was converted to you before we were. He was baptised and resigned his post on taking up your service. We were together and by a holy decision resolved to live together ... ' (St Augustine 9.8.17).

24. Ibid., 8. 12.30.

25. Berlin, Kupferstichkabinett, Staatliche Museen zu Berlin, Preussischer Kulturbesitz, MS. 78 A 19a, fol. 12 recto. On the *Historia Augustini* see Courcelle (1965–69), 2: 27–64.

26. For instance, the episodes of Augustine's baptism and of his taking the habit, in both cases at the hands of Ambrose, are portrayed in the very same scene in the cycles of Pavia and Gubbio (Courcelle (1965–69), 1: pls. LVIII, XV).

27. The episode is not reported in the *Confessions* but in the *Sermons* (St Augustine, 'Sermones ad populum', Sermo CCCLV (1865): 1569).

28. *Sancti Augustini vita scripta a Possidio Episcopo* (Possidius (1919), 5: 1–3).

29. Pseudo-Augustine, *Sermones ad fratres in heremo commorantes*, Sermo XXVII (Pseudo-Augustine (1887)): 1282. See also Courcelle (1965–1969), 1: 15.

30. For a thorough discussion of the Augustinians' manipulation of the historical sources in order to stress their relationship to St Augustine, see Rano (1973b): 1: 292–302.

31. To the best of my knowledge, such a subject does not belong to the iconography of the life of St Augustine. The title given to the third panel of Genga's predella may originate from a confusion with the episode in which Augustine donates his Rule to the members of his first monastic community (*Sancti Augustini vita scripta a Possidio Episcopo*, 5. 1–3; Possidius (1919): 48–9). In this scene, the saint is generally portrayed as a bishop, but what he passes on to the friars is a book or a scroll, never a monastic habit.

32. See notes 5 and 6, above.

33. See in particular Fontana (1981): 166–7.

34. See the several examples shown in Dania and Funari (1988).

35. St Ambrose (Treviri *c.* 339 – Milan 397) was fifteen years older than St Augustine (Tagaste 354 – Hippo 430). In fact, the two bishops were correctly identified in De Vecchi (1984): 43, and Morandotti (1992): 127.

36. St Anthony of Padua (Lisbon, 1190/95 – Padua, 1231) entered the Augustinian Order when he was fifteen and switched to the Franciscans in 1220.

37. Gentili (1967).

38. The woman is identified as Monica in Fontana (1981): 167, De Vecchi (1984) 43, and Morandotti (1992): 127. On the other hand, Grigioni (1909): 178, n. 1, had suggested that she could be St Anne or St Elizabeth.

39. Belli Barsai (1964); Raggi (1967). Among the numerous Renaissance paintings showing St Elizabeth according to the same iconography adopted by Genga are Raphael's *Sacra Famiglia Canigiani* (Munich, Alte Pinakothek) and the *Madonna dell'impannata* (Florence, Pitti), as well as Mantegna's *Madonna della Vittoria* (Paris, Louvre) and *The Family of Christ with the Family of St John the Baptist* (Mantua, Sant'Andrea, Chapel of San Giovanni Battista). As for St Monica, she is portrayed as an Augustinian nun in the fresco cycle by Benozzo Gozzoli in San Giminiano (see above, note 14). For the habit of this order see Rano (1973a), 1:166.

40. Del Re and Belli Barsai (1963).

41. Rano (1973b): 324.

42. In the contract of 1513 the work is simply described figure by figure, with no reference to a general subject; the other documents speak only of the 'ancona for the main altar': see Grigioni (1909): 57–9 (1927) 175–6, n. 3, and see above, notes 5 and 6). As for Vasari, in the 1568 edition he describes the work with the following words: ' ... all'altare maggiore una tavola a olio, in cima della quale è una Annunziata, e poi di sotto Dio Padre, e più in basso una Madonna con un putto in braccio in mezzo ai quattro dottori della Chiesa: opera veramente bellissima e da essere stimata' (Vasari (1966–87), 6: 318).

43. See above, note 4.

44. The most comprehensive studies on the iconography of the Immaculate Conception are still the ones by Levi d'Ancona (1957); Schiller (1966–80), 4: 2, 154–78. For a discussion of the immaculist

iconography in Emilia see my dissertation, Galizzi Kroegel (1992). For the Marches see Simi Varanelli (1986).

45. Grigioni (1956): 85–8, 330–31, 460–83; Viroli (1980): 98; Fioravanti Baraldi (1986): 103–104.

46. For the altarpiece by Pordenone see Barbieri (1993) and Galizzi Kroegel (1999). For the other works see Ballarin (1994), 1: 347, 357, 363, and Winkelmann (1986): 432.

47. For an introduction to the doctrine of the Immaculate Conception and its troubled history see in particular Le Bachelet and Jugie (1927), 7: 845–1218; O'Connor (1958); and Söll (1981).

48. Söll (1981): 217–63. See also Jouassard (1958).

49. On the Immaculists' use of scriptural and medieval *auctoritates*, including manipulation of their *dicta*, see Jouassard (1958) *passim*; Bouman (1958): 152–3; and Barbieri (1993): 67–76.

50. St Augustine, 'De natura et gratia', (1865): 267 (translations from Latin, unless otherwise indicated, are mine). On this issue see Jouassard (1958): 69–73, and Söll (1981): 146–8.

51. On the two Offices see Bouman (1958): 150–03; Laurentin (1958): 296–300. Both Offices are reported in the *Armamentarium*, a seventeenth-century collection of immaculist texts (De Alva y Astorga (1965), 2: 55–105).

52. Besides my own dissertation (see note 44, above), see Dal Prà (1988); Appuhn-Radtke (1992); Barbieri (1993): 69–71; Galizzi Kroegel (1999); and Barbieri (2000): esp. pp. 72–81.

53. One of the first commissions explicitly dedicated to the Immaculate Conception is the *ancona* including Leonardo's *Virgin of the Rocks* (1483), a work which has already been suggested as having been influenced by the Office by de' Bustis (see later on in this essay, note 65). An altarpiece which is undoubtedly related to this liturgical text is the one by Vincenzo Frediani for the church of S. Frediano in Lucca, a work dated 1503, see Tazartes (1987): 34.

54. De' Bustis is recorded to have been preaching in Modena in 1498. From there he was asked to go to Reggio Emilia; in 1513 he preached in the cathedral of Ravenna. He must have died between 1513 and 1515 (Alecci (1972): 15: 594). Since the Office by de' Bustis is longer and is characterized by a much stronger narrative quality, it could offer a broader repertoire of invention to the artists. On its diffusion see also Dal Prà (1988): 277–81, and Appuhn-Radtke (1992): 221 ff. The Office by de' Bustis has been indicated as the probable source for a few specific immaculist works also in Goffen (1986): 73, and Stefaniak (1995): 108–109.

55. See Piana (1947). Duns Scotus' immaculist theology is summarized in Balic (1958): 204–211 and Söll (1981): 289–93.

56. Piana (1957) (with bibliography); Sebastian (1958): 234–7.

57. On the iconography of the 'dispute' see Schiller (1966–80), 4: 2, 171–4. The debates' influence on the contemporary iconography has already been suggested by Tea (1954): 154; Alce (1957), 15: 117–18; Vloberg (1958): 486–90; and Toscano (1960), 2: 56–9.

58. Piana (1957): 9–18.

59. 'Quanto pluries aurum per ignem transit, tanto maiorem acquirit claritatem. Idcirco Immaculatam iterum B. Virginis Conceptionem in ardenti disputationis flamma reclinemus, quo eius puritas amplius elucescat. Sic itaque arguamus' (De' Bustis in De Alva y Astorga (1965) 2: 90).

60. Casciu (1992); Kanter (1994): 200–203.

61. Three inscriptions out of five in the painting by Signorelli can be found in the Office by de' Bustis; the liturgical text also includes most of the figures of this iconography. I discuss Signorelli's altarpiece in more detail in the book on the iconography of the Immaculate Conception which I am completing.

62. 'Vidi speciosam, sicut columbam ascendentem desuper rivos aquarum, cuius inaestimabilis odor erat nimis in vestimentis eius: et sicut dies verni circundabant eam flores rosarum, et liliarum convallium.' (De' Bustis in De Alva y Astorga (1965), 2: 77). The passage, resulting from a fusion of Eccl. 50: 8 with Canticle 2. 1, was borrowed by de' Bustis from the responsary of the Office for the feast of the Assumption, itself of ancient origin (Gregory the Great (1849)). For a discussion of this passage on the visual arts see Pozzi (1993): 202–206, 216. I believe that the influence of this passage on the two altarpieces may hold true even if in both compositions the white flowers look more like jasmines than lilies of the valley, and the red ones – especially in the altarpiece for Cesena – recall carnations rather than roses. All these flowers, however, are symbols of the Virgin Mary, and in the Renaissance both carnations and jasmines were occasionally substituted for roses and lilies, or were represented with them beside the figure of the Virgin Mary. See Levi

d'Ancona (1977): 79–80, 193–5 (where the white flowers in Genga's painting are actually identified as jasmines), and 221.

63. De' Bustis, in De Alva y Astorga (1965), 2: 71; Nogarolo, ibid., 63. See also the two *Immaculate Conceptions* by Giovanni Antonio Sogliani (Florence, Galleria dell'Accademia and Empoli, S. Maria di Ripa) and the one by Pier Francesco Foschi (Florence, S. Spirito). See Appuhn-Radtke (1992): 221 figs 1, 27.

64. For an updated account of the state of the question on *The Virgin of the Rocks* see Marani (1999): 124–55.

65. That *The Virgin of the Rocks* may indeed allude to the Immaculists' doctrine has been suggested by a number of scholars, although on the basis of different arguments. See for instance De Vecchi (1982): 254–6; Snow-Smith (1987); and Ferri Piccaluga (1994). A more direct relationship between the painting and the writing by de' Bustis has been suggested in Tea (1954): 281, and more recently in Stefaniak (1997).

66. Stefaniak (1997). See also De Vecchi (1982): 256. This geological symbolism will be discussed in more detail in my forthcoming book (see above, note 61).

67. See above, note 55.

68. On the theory of the 'sanctification in womb' of the Baptist and Jeremiah, which was still quite inferior to Mary's Immaculate Conception, see Söll (1981): 274; De Vecchi (1982): 255; Snow-Smith (1987): 55. The immaculist reading of Elizabeth's words is discussed in my study of the prayer 'Ave Maria', Galizzi Kroegel (1994): 71.

69. Rano (1973b): 348.

70. Rano (1973b), 347.

71. Ibid.

72. Galizzi Kroegel (1994). See also Gössmann (1957).

73. Galizzi Kroegel (1994). Evidently this widely accepted interpretation did not suffer from the objection that Gabriel most likely spoke to the Virgin in Aramaic, and that the Gospel of Luke was written in Greek, while '*Ave*' appeared only in the Latin translation. In fact, even some modern supporters of the Immaculate Conception have defended the immaculist reading of '*Ave*' by arguing that at the time of Christ such a greeting form was used both in Latin and Hebrew; see Sardi (1904), 1: 300–303.

74. As the modern exegesis confirms, the Greek word corresponding to the Latin '*gratia plena*' [κεχαριτομενη] is in the perfect tense, 'which signifies a state, whereas the aorist would signify the occurence of an event' (Journet (1958): 26, n. 42).

75. 'Maria etiam innocentiam Angelica salutatio demonstrat, dicens: Ave quasi sine ve, idest sine peccato: deinde prosequens ait, Gratia plena. Non foret autem plena gratia, si praeservationis illi gratia defuisset' (de' Bustis, in De Alva y Astorga (1965), 1: 91).

5.1 Girolamo Genga, *Dispute about the Immaculate Conception*, *c.* 1516–18, oil on panel, Milan, Pinacoteca di Brera

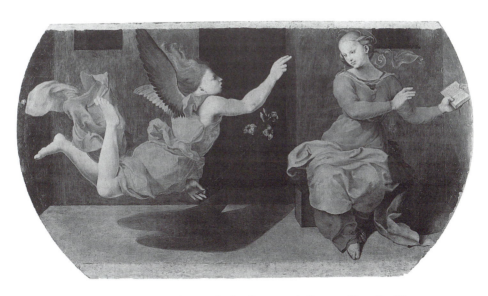

5.2 Girolamo Genga, *Annunciation*, 1516–18, oil on panel, Cesena, Church of S. Agostino

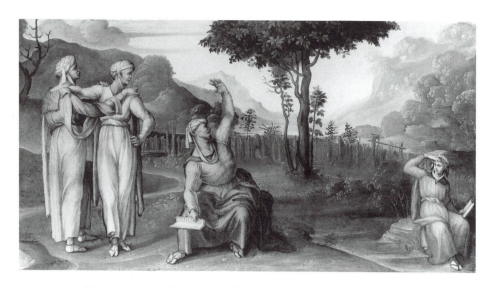

5.3 Girolamo Genga, *Conversion of St Augustine*, c. 1516–18, oil on panel, private collection

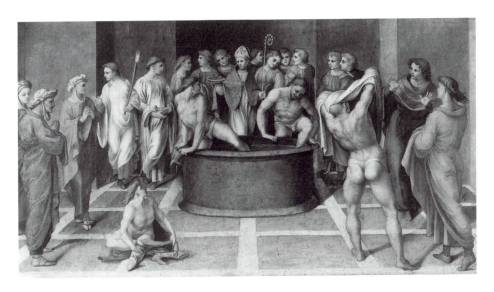

5.4 Girolamo Genga, *Baptism of St Augustine at the Hands of St Ambrose*, 1516–1518, oil on panel, Bergamo, Accademia Carrara

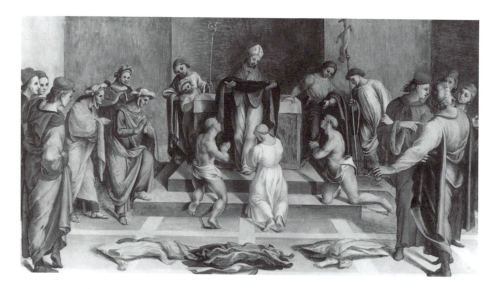

5.5 Girolamo Genga, *St Augustine Receiving the Habit of the Hermit Monks from St Ambrose*, *c*. 1516–1518, tempera and oil on panel, Columbia, South Carolina, Columbia Museum of Art

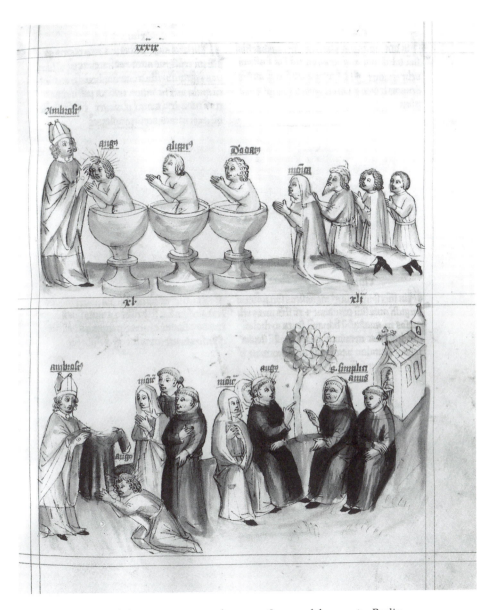

5.6 *Historia Augustini*, 1430–40, watercolour, MS 78 A 19a, fol. 12 recto, Berlin, Kupferstichkabinett

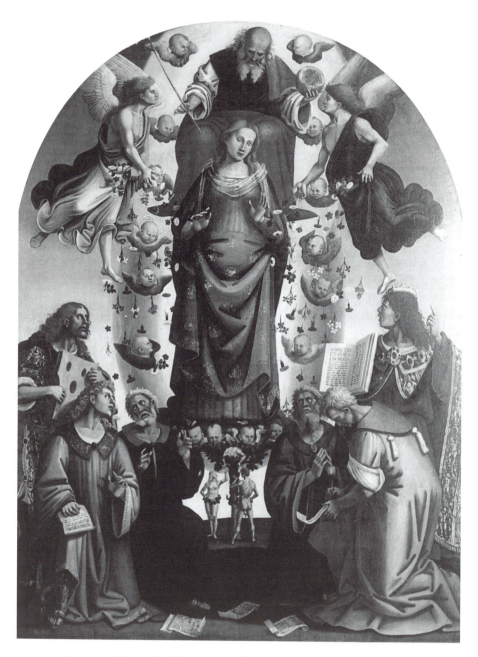

5.7 Francesco Signorelli, *Dispute about the Immaculate Conception*, c. 1521–23, tempera on panel, Cortona, Museo Diocesano

Pordenone's 'Passion' frescoes in Cremona Cathedral: an incitement to piety

Carolyn Smyth

On 20 August 1520 the members of the *fabbriceria* of Cremona Cathedral with high expectations brought in Pordenone – Giovanni Antonio de Sacchis – to complete the fresco project in the nave. The appraisal on 9 October of the same year of his first scene, the *Christ before Pilate*, was received with unanimous acclaim, and his commission to finish the cycle was confirmed.[1] (See Figures 6.1, 6.2 and 6.3). The paintings over the nave arcades and in the presbytery, begun in 1514 by Boccaccio Boccaccino and continued by Gianfrancesco Bembo, Altobello Melone and Girolamo Romanino depicted the life of the Virgin and Christ's Passion, and culminated with Pordenone's terrific *Crucifixion* of 1521 on the counter-façade.[2] (See Figure 6.4.)

A word used more than once by the foremost scholar of Pordenone, Caterina Furlan, to describe the artist's work is *'clamoroso'*.[3] Writers on Pordenone must seek the source of this *'clamorosità'*, and they find it variously in his primitive Friulian roots; in his provincial patrons and their *'popolare'* taste; in contemporary Roman art, especially Michelangelo; in art north of the Alps; or, always vaguely, in the troubled climate of his time. The most interesting and attentive reading of Pordenone's frescoes in Cremona remains Charles Cohen's article of 1975, largely restated but updated in his monograph of 1996.[4] Cohen finds the unusual elements in Pordenone's work to derive from German influence, and traces these through specific visual examples in northern European prints and paintings. Though not the first to note a 'Germanic' quality in Pordenone's Cremonese frescoes, his study is funda-mental.[5] I would like to qualify his findings by considering Pordenone's work in a larger context: that is, the place of the frescoes in the cycle in the Duomo as a whole; in the larger culture of Lombard art; and in the historical, social and religious moment in Cremona. I would argue that Pordenone's decisions in the 'Passion' paintings – whether derived from German art or not – are not merely formal, but were devised to promote particular devotional

issues that answered to the patrons' needs in these years. These interests can be illuminated by a study of the individuals involved and the turbulent state of Cremona in the period in which Pordenone was painting. A priority was the solicitation of the personal involvement of the viewer – through drama, emotion, illusion, as has been observed – but also by the selection of sequences, episodes and interpretations of the Passion events which most challenge the individual worshipper. In this sense, the frescoes satisfied what must have been a crucial demand of the commissioners, that the concluding scenes in the nave should not simply be a gripping representation of the Passion, but should function as an incitement to piety.

Pordenone received the commission in circumstances of conflict. Romanino, who had painted four Passion scenes on the previous two nave walls in 1519, had been rewarded by the *fabbricieri* of that year with the completion of the work. But on 20 August 1520, the contract was taken away from him and given to Pordenone, with the slim excuse that Romanino's commission was executed with the *massari* of the previous year, on the last day of their office (31 December), and so was no longer valid.[6] Romanino's frescoes may have lacked an ingredient essential to the *massari* that Pordenone was sure to accomplish – a quality of *righteousness*. Though Romanino's frescoes are full of shimmering light and colour, exotic costumes, some marvellous portraits and a heavy dose of 'Germanism', they lack the soul-shaking menace that Pordenone was to deliver. For all the dash of style and fantasy, his message is even ambiguous. For example, in Romanino's *Christ before Caiaphas*, the young man to the left of Christ touches him tenderly, while the guards also are melancholy, as though capable of repentance.[7] (See Figure 6.5.)

Pordenone's frescoes are a corrective lesson. One difference, of course, is that the artist won the chance to fill each bay with one scene. But also there is no spiritual ambiguity. Pordenone's evil vulgarians never look sad, or suggest compassion. The heightened cruelty is also amplified with the large military cast who threaten every episode with wanton violence. The inclusion of the prophets expands the spatial and temporal dimension of the scenes, as the narrative crescendos to the great *Crucifixion* with its commanding Centurion. None of these elements are present in the descriptions included in the contract.[8]

A look at the political, economic and social situation in Cremona in these years might help us understand why Pordenone's imagery found favour. Cremona had been the dowry of Bianca Maria Visconti in her marriage to Francesco Sforza, and many of the local nobility of the early sixteenth century looked back nostalgically to this era of secure identity. Ludovico Sforza's invitation of Charles VIII on to the peninsula began the disastrous chapter in the history of Italy in which Cremona suffered mightily. The Venetian rule of Cremona, from 1499, closed with the Republic's defeat at Agnadello in 1509.

In the shifting alliances between Venice, the French, the Emperor and the Pope the ineffectual Massimiliano Sforza was tossed about as a pawn and, after a brief nominal rule, permanently exiled. In 1515–21, exactly the period of the nave programme in the cathedral, Cremona, under Milan, was occupied and dictated to by the French. The city had to endure the constant presence of hundreds, sometimes thousands, of foreign soldiers in the *contado* and even in the houses of the citizens.[9]

Who was responsible for the cathedral cycle? The Bishop, the noble Venetian Girolamo Trevisani, was mostly in exile from Cremona from the defeat of Venice at Agnadello in 1509 until his death in 1523.[10] A similar turn of events had befallen the previous bishop, Ascanio Sforza, Ludovico il Moro's brother, elected to the diocese of Cremona in 1483 but excluded from physical presence in his office with the loss of Sforza power in 1499. The absence of a controlling bishop facilitated the *fabbricieri*'s increasing appropriation of decisions regarding cathedral property. The Venetian government, profiting (in 1507) from Bishop Sforza's expulsion, seized the revenues of the '*mensa vescovile*',[11] thus assisting lay control of the funds of the Duomo that would determine events in the following years – just the period of the decoration of the nave.

Hence the artistic responsibility in the cathedral was in the hands of the *fabbricieri*, headed by the *massari*, three patrician citizens elected annually.[12] These men came from the most influential, noble and wealthiest families in Cremona, many of which had a longstanding relationship with the cathedral, and they were the secular but hereditary dictators of the cathedral works. The influence of these individuals, and their sense of legitimate authority in directing the *fabbriceria* during the Bishop's absence, cannot be overestimated.

The history of the cathedral in Cremona from the late Middle Ages to the Counter-Reformation demonstrates an unusual possessiveness on the part of the lay *massari*, marked at its beginning and end by two conflicts in which episcopal power overcame the traditional claim of the secular citizens. The circumstances of three occasions of lay–ecclesiastical controversy together offer a synthetic overview of the situation in the Duomo.

An early confrontation between *fabbricieri* and Bishop dates to 1346, when Cinello Sommi, *massaro* and canon, submitted the account books of the *fabbrica* and keys to the door of the cathedral to the Bishop only under threat of excommunication. Cinello put up a vigorous fight, stating that the 'fabbrica' and its funds 'aspetta ali Signori di Milano e al la Comunità di CremonǍ', not to the Bishop, and his assertion was to be realized in the following years.[13] In 1567, the Bishop of Cremona, Niccolò Sfondrati (later Pope Gregory XIV), requested a clarification of his rights to the properties of the *fabbrica*, when the *massari* had refused his access to their accounts. The case was taken before the Congregation of Cardinals, and the *massari* won by presenting evidence that in Cremona the governance of the cathedral was from time

immemorial in the hands of the *comune*, represented by the *fabbricieri*. As the civic council wrote in their successful legal defence, 'esser detta Fabbrica luogo privato della città et non luogo religioso, per non esser fondata con autorità di Sua santità nè di alcun Vescovo', the *massari* were the traditional heirs to the property of the cathedral, answering only to civic authority, while the Bishop had only temporary use of these goods during his office.[14] And Giulio Bora has already noted, as evidence for the prominent role of the secular commissioners in the fresco project, how in 1575 the *massari* defied even Carlo Borromeo's access to the library and the *fabbrica* ledgers, their claim overturned by threat of excommunication.[15] Hence, while such a secular assertion might seem astonishing in the period of the Counter-Reformation, we see that this was only the turning point of a long tradition in Cremona which had favoured secular over ecclesiastical authority. The *massari* in Pordenone's period were, by tradition and unusual political circumstances, at the peak of their power.

Even during the foreign dominance of Cremona, the decorations of the cathedral not only enjoyed a remarkable florescence, but boldly vaunted the responsibility of the individual *massari*. Most have noted the preponderance of portraits in the nave cycle; it should also be noted that the names of the individuals in office from 1516 are prominent already from the Piazza, in the Latin inscriptions over the arches of the 'Bertazzolo' or loggia that connects the façade of the Duomo with the 'Torazzo' or campanile. Pordenone's commissioners, Zuccho, D'Argento and Mainardi, are featured on the fifth bay from the left. The decorative phase of 1509–1513 strikes an especially political and personal note – in the wall areas within the Gothic vaulting, and over the later narrative programme, large plaques with dedications to the present rulers, governors, prefects and important members of the *fabbriceria* were surrounded by putti, garlands and portraits. It was repainted entirely in the eighteenth century, but the inscriptions were preserved.[16] The wall over Pordenone's *Christ before Pilate* presents a particularly poignant message of 1512: 'Afflicted by the French, punished by the Swiss, weakened by plague, and degraded by famine, yet not dissuaded from worship.'[17] The *massari* were not only businessmen and politicians, but men of faith, and the cycle is by no means 'secular'.

In fact, several local histories of noble Cremonese families, to date not consulted with reference to the cathedral programme, begin to reveal a picture of the political sympathies, social pretensions and civic responsibilities of the *massari*. Two families, the Sommi and Zuccho, are perhaps representative. Both claimed long residence in Cremona, involvement in public office and a passionate attachment to the Sforza, and suffered persecution, economic devastation and exile at the hands of the French. Giovanni Maria Sommi, *massaro* in 1508 and 1518, and his brother Andrea, *massaro* in 1519, were both

descendants of Cinelli Sommi, the intransigent Trecento canon discussed above. Under both the Venetians and the French, several members of the family were saved from hanging only by exile, and Giovanni Maria was among the list of 'gentlemen' called by Lautrech in 1518 to make 'loans' under duress to pay the King for the expenses of the Swiss troops.[18] A similar profile emerges for one of Pordenone's commissioners of 1520, Giovanni Francesco Zuccho, as fiercely pro-Sforza and anti-French as the Sommi. A certain Giovanni Zuccho even shared imprisonment with Ludovico il Moro, and Giovanni Francesco was exiled in 1522 in the last months of the failing French domination. Unlike the Sommi, the Zuccho had complied with Venetian rule, and Giovanni Francesco's connection with the Veneto – his residence in exile and site of death was near Verona – might have been a factor in the selection of the Venetian-based Pordenone.[19]

From 1515 to 1521, the *massari* and their relatives had frequent ambassadorial duties for the *comune*, carrying petitions to Lautrech, especially pleas for clemency in the exaction of taxes, and protesting against the raids of soldiers and unbilleted adventurers in the city and *contado*. The puzzling coincidence of a major and expensive project of decoration in the cathedral with a period of grave economic and political difficulty may after all be explained. The wealthy Cremonese citizens would have had an incentive to divest themselves of any dispensable revenues that would only be seized by the French. To the *massari*, it was far wiser to invest in the cathedral, in a programme that could offer spiritual interest, a protection surely more effective than the often violent 'protection' of the foreign garrison troops.

A reading of the chronicles and histories, filled with unending accounts of abominations, robberies, devastations, rape and mayhem and punctuated with sad laments, gives a picture of a world that is nothing short of being at the brink of hysteria. During the foreign occupation, no wine-keg or daughter was safe. The paintings in the cathedral do not of course refer directly to these events in any literal way – they are faithful, if vigorous, representations of the Bible, and follow its words (as we shall see) unusually carefully – but the sense of outrage in the face of unjust torment, in which good must submit to evil, seems to press the story of the Passion to new limits that might well have been stimulated by daily suffering. Pordenone may have contemplated Dürer's figures of *landsknechts* in the creative quiet of his studio, but he could also have stepped outside.[20]

In the *Christ before Pilate* (see Figure 6.1), the fresco of the third nave bay on the south side of the Duomo, Pordenone begins his contribution to the 'Passion' sequence initiated by Altobello and Romanino, and establishes his distinctive narrative methods. The episode depicted is after Pilate's sentence, when the condemned Christ is led away and harassed as he is taken from the hall of justice. The contract specified that the artist depict 'How Pilate

condemns Christ to be crucified, and washes his hands, with various Scribes around him and various Jews, who begin to whip him with various ropes, and with palaces, landscapes, views, and other things necessary for the representation of such an event and mystery.' ('Como Pilato condemna Christo chel sia crucifixo et chel se lava le mane cum diversi Scribi intorno et diversi giudei quali lo comenzeno ad strassinare a diverse foze, cum Palazo, paiesi, prospective ed altre cose circa ciò necessarie, Como se recercha alla representazione de uno simile acto et misterio.')

I would like to use this first fresco to investigate further the assertion, made by Cohen and others after him, that the painting can be explained as a conflation of German imagery and Romanizing influence. Cohen finds that Pordenone's 'High Renaissance, inspired way of making form is expressively distorted and combined with Germanic elements to explore a character of feeling and a quality of communication which until this point had been virtually foreign to Italian art'. 'German' are the crass types, the costumes, the depiction of Christ as the 'pathetic Schmerzensmann' and the general iconography.[21] Some of these elements had already been explored by Altobello and Romanino, but as we see by comparing Altobello's *Christ before Annas* with Altdorfer's woodcut of the subject which the Cremonese painter took as his model,[22] Pordenone's usage is certainly more indirect. Cohen also notes a large difficulty:

Pordenone's deep penetration into a Germanic mode of expression and iconographical patterns goes beyond what is by this time the usual borrowing of compositional schema and individual motives from German prints, usually Dürer's. It is, I think, not a paradox to say that the very fact that there are few instances in the Cremona frescoes in which one can point with certainty to a single German source helps demonstrate Pordenone's deep immersion in them.[23]

In Altdorfer's panel for the St Florian altarpiece, the costumes, the unpleasant types and especially the view of Christ as he is led away are suggestive for Pordenone's interpretation. Dürer selected the same moment for his *Small Passion* woodcut of 1511. But Pordenone's space, his strict focus on Christ and the uncontrolled action are very unlike both German versions. In Dürer's version, the soldiers are quite well-mannered as they escort the condemned man off-stage; in Altdorfer's, the guards are uncouth, but physical violence is still suspended. In other words, an essential element of Pordenone's fresco is completely lacking – the sense that the entire situation has been consigned into the hands of depraved men of violence.

Pordenone's remarkable interpretation of the scene also depends for its effect on the unique tripartite arrangement of the composition, in which the broken and besieged Christ is flanked by the calm ritual gesture of Pilate and his pleading entourage, and the phenomenally inventive rearing horse. Pordenone's interpretation of the scene shows an attention to scripture that

goes beyond his patrons' stipulations. Most especially, his characterization of Pilate adheres much more closely to the sense of the New Testament. While the abbreviated orders of the contract seem to make Pilate condemn Christ, Pordenone captures the resignation and even nobility of Caesar's governor, contrasting his behaviour to that of the condemning Jews and the raucous soldiers. Pordenone paints Pilate as a dignified, mature man, the same attractive bearded type that appears, for instance, as Jerome in the choir vault of Rorai Grande (1516–17). Pilate's pose, too, expresses psychologically his reluctance, as he turns his back upon the crowd to cleanse himself from the deed, glancing back impassively at the madness below. Indeed, Dürer, in his poignantly understated woodcut version, also emphasized the ambiguous situation of the governor, relegating the soldiers with the shadowed, almost anonymous Christ to nearly off-stage. The German artist has also contemplated the biblical story, but his staging of the scene is radically different in feeling. Instead, the closest visual precedent for Pilate in the fresco in Cremona can be found in much earlier art. A northern Italian ivory relief of the fifth century depicts Pilate in the same elevated turning position, slightly higher than the other figures.[24] Pordenone has clearly completely rethought the subject since his youthful Friulian fresco of the same theme in the parish church of Villanova (1514). Pordenone's figure of Pilate, generally overlooked in favour of the more colourfully violent characters, is crucial to the meaning of the scene, and marks the artist's awareness of early Lombard tradition, and attention to the essential biblical meaning of the subject.

Many authors have seen in the *Pilate* especially an acute case of Romanism. Cohen, exploring the 'unlikely combination of Roman High Renaissance and German elements', saw here an 'intensely plastic form [which] clearly derives from Pordenone's experience of High Renaissance art in Central Italy'.[25] This plasticity has been attributed by most modern writers to at least one Roman sojourn on the part of the artist. Among the several Roman motifs identified by writers from Schwartzweller on, I would like to look at two: Michelangelo's *Battle of Cascina* and Raphael's rearing horse in the *Expulsion of Heliodorus*.[26] For each of these 'models' we encounter alternative possibilities.

The *Battle of Cascina*, that favourite figure-trope of the Renaissance (or the prints after it) had already been cited by Pordenone in his previous cathedral cycle in Treviso, in the rude scrambler who presents his hind-end on the left side of *The Adoration of the Magi*. But one could pose two qualifications. First, Michelangelo respects the dignity of the human form, exalting it in the *Cascina* to express the Florentine soldiers' hurried readiness. Pordenone instead vulgarizes the figure, to convey in both Treviso and Cremona the ignoble nature of those who reject Christ. Second, Michelangelo goes to great pains to allow each body to be shown in its wholeness and integrity, no matter how crowded his composition, while Pordenone confuses body parts.

For instance, what we first read as the helmeted head of the man in red trousers is in fact that of another figure behind him. Pordenone's Passion scenes are full of these deliberate fragmentations of the body. A fundamental (and non-classical) hallmark of Pordenone's style of composition in Cremona is not only the crushing and spilling of human volumes in space, but also a wilful segmentation of anatomy created through overlap and stacking.

A black chalk drawing in the Museo Civico in Pordenone shows his earlier, and more shocking, notion for the rear-ended figure in the *Pilate*.[27] The ruffian was to have his buttocks completely exposed, with an obscenely placed dagger between his legs. But Pordenone did not dispense with the idea altogether. The figural concept would be used, with the artist's decorous sense of the usefulness of the indecorous, at the moment of highest trauma in the *Nailing*, as the last figure before the Crucifixion on the counter-façade. (See Figure 6.3.)

Nor is the electrifying device of the rearing horse and rider really similar to Raphael's group in the *Stanze*. The main point of Pordenone's horse is the exciting projection of its forelegs into the nave and over the head of the viewer. Raphael's horse and his shouting victim exist within a reasoned three-dimensional grid of space. In the cathedral, the Friulian artist subjects the animal to a truncation similar to the disruptive treatment of some of his human figures. A metaphor of the 'animal spirits' of the bestial executioners, the horse breaks through the midst of the scene and threatens to bound into our space. He is also the only character to meet our gaze, besides Christ. The fear the horse inspires might be that felt by the Cremonese peasants ravaged continually by hundreds of cavalrymen[28] – more to the point, however, is the sense of danger and of the 'real' that the plunging animal gives to the religious content of the picture. A *Cavalier with Horse* in a façade painting in Spilimbergo by Andrea Bellunello shows the currency of the motif in Quattrocento Friuli.[29]

Many writers point to Pordenone's designation in the cathedral documentation as '*pictor modernus*' as evidence that the artist was chosen for his 'modern' experience of High Renaissance Venetian and especially Roman art.[30] In his well-documented 1989 study of the fresco cycle as a whole, Guazzoni commented, in passing and without explanation, that this meant nothing but that Pordenone was 'the painter of the moment'.[31] He was absolutely correct. In Altobello's contract of March 1516, the commissioners refer to themselves as '*moderni massari*' – meaning the *massari* of that year.[32] The long-cherished hypothesis that Pordenone went to Rome, first proposed (by Schwartzweller) as one trip in 1518–19, then as two trips of 1516 and 1519 (by Fiocco), has finally begun to be challenged by several scholars. Most notably, Rearick, in an article of 1984, has insisted upon the fact that there is no documentation that Pordenone ever went to Rome.[33] Without

entering into the debate on this occasion, I would simply state that I am beginning to agree.

An essential element in Pordenone's programme, the Old Testament Prophets, have not received their due in any analysis. This may be partly because they were long subject to attributional confusion, since the others in the nave, done in the 1570s, were in fact subsequent additions in imitation of Pordenone's. Though hardly innovative in the general context of Renaissance art, they were a novelty in the nave programme in Cremona. Only Cohen has noted them, and uses them as testimony of Pordenone's inspiration from religious drama. This is possible, though the standard recurrence in fresco cycles as early as the Romanesque period of Prophets with extruding scrolls ends them already a solid pictorial pedigree. The motive for the addition of the prophets, and their exact significance in Cremona, remains to be addressed. Intimately linked with the compositions above – spatially, as design elements and for the relevance of their messages – they provide not only the proof of the preordained verity of the scenes above, but also the key to some of the peculiarities of Pordenone's interpretation of the Passion.[34]

Pordenone's integration of the Old Testament figures with the New is exceptional (see Figure 6.6). King David on the left sweeps us inescapably into the narrative above. The thrust of his message generates the diagonal sway of all of the forms of the right two-thirds of the composition. Even the horse seems to spring with the energy begun in the unfurling scroll. David's words are from Psalm 109: 'For the mouth of the wicked and of the deceitful are opened against me.' This Psalm is a curse, full of language violent even in the context of psalmic invective. Obeying the prophecy, the wicked soldiers shout, and one brazenly bellows in Christ's ear. He is coarse, his features distorted by his noisy hatred, but reference to Leonardo's open-mouthed caricatures is unnecessary, now that we have read the text.[35] The other Prophet speaks from Lamentations 3: 59, in which Jeremiah pleads to God to see the hatefulness of his enemies, and cries for their punishment: 'Thou hast seen all their vengeance and imaginations against me.' In the same passage, the prophet calls out to 'persecute and destroy them'.

The particular passages chosen are commonly linked with the scenes they accompany. But Pordenone has heeded the instructions of the prophecies to the letter. He calls upon the seers in order to stretch time, and to remind us that all is foreseen, part of a larger scheme which will bring justice and redemption. The specificity of Christ's suffering, and even the gratuitous scenes of violence, bring Him into the reality of the Renaissance viewer, in his own world of daily subjugation. By adding the Prophets to the cycle, Pordenone lends a cosmic, Christian sense of order to scenes that would be otherwise of an unbearable pain.

Whether it was Pordenone, the *massari*, or both, who decided that the bays should receive one big scene instead of two, the decision brilliantly gave Pordenone elbow-room for his expansive ideas. The three bays together read as a triptych. Pordenone must have designed the three paintings and their Prophets from the first as an ensemble. The *massari* would have required approval of the first fresco as always, to see how it would look in the church, but nothing in the three bays seems 'added'. The drama and devotional content function best as the three scenes are read together. There are no completed compositional drawings to prove this, but a view of the frescoes in the cathedral offers compelling evidence.[36] Here one can appreciate the unity of the three compositions, the pairs of Prophets and the fantasy of the pier decorations. The latter, another conspicuous 'addition' to the programme described in the contract, spawned a whole decorative genre in sixteenth-century Cremonese art.[37] (See Figure 6.6.) From the first scene, we are pushed into the second by the vector of David's outstretched gesture, and by the soldiers who tug and worry the saviour.

In the *Christ Led to Calvary*, Christ tormented falls under the cross, while left and right respectively Veronica displays the sudarium and the Virgin collapses in John's arms (see Figure 6.2). Cohen sees the clarity of the *Pilate* here shift to a 'static, turgidly crammed' composition; he notes the shocking ugliness of Christ's 'rubbery unstructured face ... distorted into a mask of anguish', and traces the conception to the 'Schmerzensmann' of German art.[38] Boase's observations that Pordenone's scenes 'flag' at the centre and that the representation of Christ conjures up despair rather than triumph are, if negative, insightful.[39]

In situ study of the composition as the middle of an orchestrated sequence makes sense of the seeming oddness of the *Christ Led to Calvary*. The very midpoint not only of this scene but of all three frescoes in the nave is the face of Christ. The long horizontal of the flail and rope unite with the vertical beats of the lances, whip and crossbar to pin movement to a halt at Christ's head. It is the only scene in which Pordenone shows Christ head-on, and the homeliness of his features are here most horribly exposed. He is coming nearer, as his hand escapes over the moulding of the frame. The persecutors become strident, and uglier. The Redeemer's face echoes the icon that Veronica carries, and the artist borrows, perhaps, Schongauer's concept of the mayhem of transient life, spinning around the fulcrum of the Man of Sorrow. But is this image 'basically a Germanic conception', as Cohen states? In both Teutonic and northern Italian art, the more prevalent tendency is to contrast Christ's heroic calm and suffering with the hideousness of his tormentors. As Cohen admits, Dürer's Christ in all three versions of the subject is 'more heroic', and it is also a beaten but handsome Saviour who crouches under the cross in Schongauer's and the Housebook Master's prints.[40] The physiognomic

juxtaposition of spiritual beauty and baseness culminates in Bosch's several close-up images of *Christ Bearing the Cross*, Dürer's *Christ among the Doctors* (1506) and the many northern Italian depictions of Christ tormented in works like those of Luini and Correggio.[41]

The prophets in Cremona tell us (Jeremiah 11: 19), 'But I was like a lamb that is brought to the slaughter', and on the right (Isaiah 53: 7), 'he is brought as a lamb to the slaughter, and he openeth not his mouth'. Christ bears his cross silently, and walks on all fours like an animal. The same chapter in Isaiah, perhaps the most famous of Messianic prophecies, gives a retort to the writers who have criticized Christ's homely features: 'he hath no form nor comeliness; and when we shall see him, there is no beauty that we should desire him'. Christ's very homeliness challenges our faith and love. He enters ever more persistently into our space as we move to the next bay.

Christ Nailed to the Cross explodes, but takes and reverses the axial thrust of the first bay in order to fulfil the rise and fall of the cadence of the three-bay triptych (see Figure 6.3). The subject is found in German art, but also in northern Italian Passion cycles. At the centre stands the personage of supreme evil, the fat Centurion. Many elements hint of the counter-façade drama to come, while the violence and projection of the third and last scene still respond to the precepts established in the *Pilate*. Here too is a case of gratuitous violence, in which the soldiers do not simply cast die for Christ's robe but kill one another. The assassination mirrors the location of the other non-biblical episode, the rearing horse, and together they frame the *Christ Led to Calvary* and its pitiful central icon. In *Christ Nailed*, the Prophets both speak from the Psalm that, like the dispute over the robe, is usually connected with the Crucifixion. Psalm 22, which begins 'My God, My God, why hast thou forsaken me', Christ's words on the Cross, is cited on the left: 'They part my garments among them, and cast lots upon my vesture', and below *Christ Nailed* itself: 'the wicked have pierced my hands and my feet'. Not only do the seers pronounce, they also physically participate in the consequences of their predictions – one is cloaked by the robe of Christ that falls from the skirmish above; the other, as active as King David on the opposite side, looks to us, leans out and points to the cross that enters our space. Strange that the wood is already bloodied: either Christ's blood is ever-shed, or the shedding of blood is ever-repeated.

The climax of the entire cathedral cycle, Pordenone's *Crucifixion*, was, and still is, the most conspicuous work of art in Cremona (see Figure 6.4). The sheer size of the painting, about 9 × 12 metres, was at this point remarkable in Italy.[42] Nor does the inescapable urgency of the scene, thronged with figures in a landscape beset by earthquake and eclipse, have any equal in art of the period. It was painted swiftly; the artist probably began work on the

west façade wall in May of 1521 and received approval for the allocation of the final payment on October of the same year. The fact that it was ordered during one of the city's worst moments of economic want and instability speaks for the *massari*'s ambition and faith in the artist, but also for their conviction that a compelling image of Christ's suffering would benefit the souls of the Cremonese people.

In the *Crucifixion*, Pordenone shifted his style to create a scene that is a 'picture'. Not only are there finally the 'paiesi, castelli, terre et prospective belle' stipulated for each scene, but there is atmosphere, even weather. As in the Gospel text, 'there is darkness all over the land', and 'the earth did quake and the rocks rent' (Matthew 27: 45, 51). The actions and responses of the figures are pitched to a state of intense and immediate awareness.

The extraordinary Centurion, posed over the main door of the church, figures urgency; he seizes our gaze and commands our eyes and soul to behold Christ on the Cross. Planting his right foot perilously on the brink of both the abyss of the earthquake and the space of the cathedral, he swings the pommel of his sword out to defy the picture plane.[43] The Renaissance viewer would recognize him both as the Good Centurion who speaks in the Gospel, 'Truly this was the Son of God' (Matthew 27: 54), and as an alarmingly immediate image of his own experience, the war-worn mercenary soldier. The Centurion's vulgarity gives him the authority of reality, stressing the 'now' of his message, and tells us that even the most renegade can be converted under grace to become a witness to salvation.

Cohen has found once again models for Pordenone's painting in Germanic art. The Good Centurion especially occurs in countless northern European *Crucifixions*, where his testimony is often written on a banderole. For Cohen, the centurion 'fits into [a] tradition which has no significant Italian parallel'.[44] But Pordenone had stronger and more meaningful motivations which impelled him to emphasize the Centurion in his *Crucifixion*. First, the Good Centurion survives in northern Italian art long after the extinction of his Central Italian counterparts.[45] And second, the Centurion is essential to Pordenone's conception of the Passion as both a universal and living event.

The Good Centurion is a commonplace of Lombard Crucifixion scenes, as is also the inclusion of Longinus. One example among many is Donato Montorfano's *Crucifixion* of 1495 in the refectory of S. Maria delle Grazie in Milan, across from Leonardo's *Last Supper* (see Figure 6.7). Though now less celebrated, Donato's was also an important Sforza commission. The premise here is different from Pordenone's – the ducal couple and family kneel in courtly piety, introduced by Domenican saints, and the composition is decorously calm and symmetrical. The converted Longinus and pointing Centurion are not only both present, but also they serve similar roles to those in Pordenone's fresco. Christ's head tilts toward the praying Longinus

as if to bestow his grace. Exactly across from him, on another white charger, the good captain looks out to us and points. There are many other such compositions in Lombardy, Piedmont and Friuli from the fourteenth to the sixteenth century. The custom of painting a *Crucifixion* surrounded by compartmentalized scenes of the life of Christ on the wall between the nave and presbytery is widely diffused in northern Italy, and often offers just this iconographic type, with Longinus and the Centurion. One of the most famous is probably Gaudenzio Ferrari's fresco of 1513 on the *tramezzo* of S. Maria delle Grazie in Varallo Sesia.[46]

Yet the conspiciousness of the Centurion in Pordenone's painting surpasses any of these depictions, even the most flagrant German scroll-bearing captains. Pordenone's unprecedented emphasis on this character, his decision to pull him from his usual side-line position and to place him squarely in the centre foreground, must be seen in the context of his 'Passion' paintings as a whole. Now that the importance of the Prophets in the 'Passion' cycle has been understood, the *raison d'être* of the Centurion becomes clear – he takes over the function of the seers.[47] Just as the Old Testament figures of the nave bay frescoes bend into our space to foretell Christ's Passion, the Good Centurion stretches space and time. Like them, he expresses the eternal nature of salvation, but expands this history forward, rather than back, by linking the scene with the Renaissance viewer's own reality.

Another surprising and effective aspect of the *Crucifixion* in Cremona is the assymetrical disposition of the crosses. Cohen is here absolutely correct that such an arrangement is foreign to surviving Italian paintings of the subject, but frequent north of the Alps. Notable examples are Altdorfer's, Cranach's and Wolf Huber's.[48] The scholar also notes in a footnote the only Italian precedent for such an arrangement known to him – Jacopo Bellini's drawing in the British Museum Sketchbook. Yet this 'exception' suggests that a painted version, or versions, could have existed in a Venetian-influenced ambience. One of the most lauded lost works of Bellini's oeuvre was the frescoed *Crucifixion* of 1436 in the S. Nicolo Chapel in the Cathedral of Verona. It was very anecdotally narrative: it featured an eclipse, a converted centurion with a banderole, and also prophets with scrolls.[49] This again should alert us to the possible alternatives to looking exclusively north of the Alps for Pordenone's inspiration.

More importantly, for Pordenone, the tilting of the crosses off-centre fulfils wonderfully his expressive religious task. Christ's positioning favours the Good Thief, who seems to resist his bonds not in pain but in lively eagerness and devotion. By turning the Bad Thief on axis, the painter uses his favourite device for representing evil. The suffering villain's features are lost, and he becomes a mass of kicking legs and protruding rear-end.[50] Pordenone gains other advantages through this compositional choice – the scene becomes, of

course, less normative and more 'real', but it also makes the viewer, like the Good Thief, strain to win access to Christ. We must travel visually over the rough and tumble of believers and unbelievers to reach Him, the only point of rest in the composition. Christ is not presented in the iconic fashion that guarantees devotion – we must struggle for Him on our own. This method of viewer-involvement is consistent with the spiritual nature of the last Passion scenes in general.

Pordenone turns the earthquake at Golgotha in the biblical text into a divinely ordained force that separates believers from non-believers.[51] Such a division was not new. Nicola Pisano used it for example in his *Crucifixion* relief (1260s) for the pulpit in Siena Cathedral, and it recurs in Trecento art. It is absent in Lombard *Crucifixions* (like Montorfano's), and significantly absent in German art. Pordenone's dynamic division has occurred as a cosmic act of God and it separates the two factions, good and evil, as Christ predicted in Matthew, the passage that tells of the Last Judgement. The separation is inexorable, but not predictable. Pordenone's fresco might even seem, if not for the eerie atmosphere, optimistic, for the number and region of the faithful are larger than the opposing side. Many of the contrasts occur in pairs; besides the exaggerated contrast between the thieves, the white horse on the left bows reverently to the Virgin and Christ while the dappled horse shies from the opening gap at his feet. Their riders similarly embody reverence and doubt. The Magdalene, dashing to Mary, is opposed by the cowardly boy who escapes in self-expulsion to the lower right.

In the figure of Mary Magdalene, Pordenone performs his most radical fragmentation of the body. A dash of orange and a foot tell us that she is running. Her head, in illuminated profile, is an emblem of hysteria, and seems to erupt from the Centurion's shoulder. This head is a focal point. Mary Magdalene, the figure of penitence *par excellence*, and who expresses the most outward grief, is absorbed in the Virgin mother, Maria-Ecclesia. Combined as it is with the faithful soldier with the Roman banner, this may be the closest Pordenone gets to an ecclesiological statement.

Right at the centre of the composition is a formal *tour de force* which demonstrates Pordenone's unconventional methods of persuasion (see Figure 6.8). From the pinnacle of the arch over the cathedral door, the Centurion's sword begins a diagonal trajectory that races through Longinus and his lance to the yearning gaze of the Good Thief. Here the laws of High Renaissance organization have been violated in an almost modernist collapse of spatial planes. Why are these elements so deliberately drawn together? The menacing sword of the Centurion becomes the lance of Longinus, which pierced the side of the Saviour, and which also, in the broadly diffused medieval legend, erupted the salvific blood that allowed the blinded soldier to see.[52] Both Longinus and the Thief are all eyes, and their bodies strain

forward to Christ, subject to the desiring force of their new vision. They are both powerful examples of sinners saved by faith, and of the metaphor of revelation by ocular experience. The artist makes sure that we link them in our eyes and minds, even at the sacrifice of illusionistic space that he has manipulated so concertedly in other passages.

The sin-side rotates upon the gesturing Jew, arguing his false doctrine, 'cum diversi altri Iudei a cavallo'.[53] He is astride the tiny ass, which, as a traditional symbol of Synagogue, turns to us in emblematic dumbness. Naturally, he has northern counterparts, as well as possible theatrical parallels.[54] Andrea Solario's *Crucifixion* of 1503 in the Louvre offers a northern Italian example.[55] Yet it is worth noting that the status of Jews in Cremona was particularly sensitive in this period.

There had always been a substantial Jewish population in Cremona, protected from persecution first by the Sforza, then by the Venetians and the French government in Milan. From the mid-fifteenth century on, periodic tension flared up between official tolerance on the part of Cremona's rulers and the acrid resentment of the Cremonese people.[56] A fresh stirring of anti-Semitic feeling erupted just at the moment in which Pordenone was painting his Passion scenes. Already in 1519, the Cremonese identified the city's economic misfortunes with the presence of its non-Christian population, writing to Lautrech to sanction the expulsion of 'questa putridine qual'è molestissima a tuta la città'.[57] In March 1521, when Pordenone was ready to begin the *Crucifixion*, the Cremonese asked to limit interest rates from the Jewish bankers and to arrest offenders.[58] Lautrech continued to refuse to condone any persecution. But the government in Milan could not control the treatment of the Jews on the walls of Cremona Cathedral. The *massari*'s descriptions of each scene stipulate inclusion of the 'iudei', and the brutal imagery of the frescoes may well reflect the frustrated hatred of the citizens, who dictated a visual condemnation. The foolish arguer in the *Crucifixion* and his company, who occupy most of the precinct of unbelief, fulfil the anti-Jewish feeling of the Cremonese commissioners – many of whom belonged to the same class, sometimes families and level of influence as the orators protesting to the Milanese government.[59]

The sense of dramatic suspension in the rider and teetering horse in the foreground has been noted, but not carefully read. Their position is precipitous, but not irremediable. The horse balks at the gaping crack – and one feels the split is ever-widening – but the soldier shuns with his right arm the unrepentant, and turns his gaze to us. In fact, two drawings (in the Louvre and the Albertina in Vienna) show that Pordenone worked on the orientation of his glance, shifting it toward the viewer.[60] In the fresco, both rider and horse look to us, as if with a decisive nod of the head we could urge them to make the jump quickly across the brink to join Christ's followers.

The presence of a *Crucifixion* on the interior of the west façade of a cathedral is unusual. *Crucifixion*s usually occur in the area of the presbytery, at the back of a chapel, or over a rood screen where, associated with the altar and the mass, the image of Christ's sacrifice is most apt. The more expected 'last scene' for a western entrance wall in the Italian medieval tradition is of course the Last Judgement. In Cremona Cathedral, this last message to the faithful before they step into the worldly piazza – Christ on the cross, suspended over the fearsome rift between believers and sceptics – takes on the overtones of a Last Judgement. Across from Boccaccino's radiant *Sommo Dio* with civic patron saints in the apse (1507), it culminates the previous scenes of suffering, and bids us now to think on our own spiritual place.

Why the selection and pacing of this sequence of Passion scenes in the right nave and counter-façade?[61] In Romanino's and Pordenone's contributions, the telling of the Gospel slows to concentrate on Christ's torments, combining the Gospel accounts in a way that maximizes the process of Christ's torture and omitting the scenes of redemptive satisfaction such a detailed cycle would seem to entail. The unusual *Christ Nailed*, especially, postpones the progress toward redemption, and even appropriates one element, the battle for Christ's robe, which by rights should be in the *Crucifixion* itself. In the northern European Passion altars, in the Franciscan *tramezzi*, in the other Lombard, Friulian and Piedmontese cycles of Christ's life, and in Dürer's sets of *Passion* prints, the Christian story cannot end on the Crucifixion, but must include the message of hope promised in the Resurrection.

We should recall that the lower walls were as yet unaccounted for. The idea that other paintings were planned for the lower area of the counter-façade is a mistaken reading of the documents.[62] Pordenone's *Lamentation* belongs to another project, added in 1522. The *Resurrection* – the representation of Christ's promise of eternal life and the greatest celebration of the Christian church, in the pascnal holiday – had to wait until Gatti's commission for the undistracting painting of 1529. Thus not only were important scenes canonical to a cycle of the life of Christ excluded, but the entire cycle ends, over the entrance door, on a dark note. It leaves us suspended, like the rider at the chasm, dramatically and spiritually.

The formal choices made, and sources used, all unite in a consistent devotional programme. Pordenone's means are attention to the word of the Bible, an aggressivity that poses danger and also spiritual difficulty for the viewer, an immediacy that reflects the reality of the times, and a sense of righteousness, urgency and outrage – in short, '*clamorosità*'. It would be simplistic to say merely that the viewers, in their own suffering, identified with the scenes depicted. The violence is a purge, a means of seeing in Christian torment the possibility of hard-won salvation. Perhaps this is why Pordenone did not follow in the end the instructions of the contract to show

Longinus plunging the lance into Christ's side. The horror had been accomplished in his earlier paintings, and the *Crucifixion* was to propose issues instead of penitence and true faith.[63]

The cycle thus ends with a question that truly involves the viewer – so that along with the more obvious spatial, dramatic and emotional call for spectator involvement noted by all writers on Pordenone's paintings, the worshipper is sought to contemplate Christ's suffering and death, and to draw conclusions from his or her personal faith. This may seem remarkable in the context of a cathedral, where under the control of a bishop, instructor to his flock, the viewer would be told to think and to submit to institutional rule and mediating guidance. But these paintings were ordered, instead, by the worshippers themselves, the good *massari*.

I would like finally to put Pordenone's work in context by comparing it to another enormous, illusionistic cathedral fresco, Correggio's *Assumption of the Virgin* painted in the years immediately following (1522–30) in Parma, a city just won for the Papal States. The two works have often been seen together as representational of northern Italian illusionism. And yet, how could their messages be more different – the celebratory image of the triumph of Maria-Ecclesia who rises to heaven, victorious over sin and death, and the tragic, open-ended 'Passion' paintings in Cremona, which leave us with the discomfort of spiritual self-examination?

NOTES

1. Not only did the *fabbricieri* approve of the *Pilate*, but the fresco apparently found favour as well from the more casual Cremonese observers, 'tota fere civitas'. It seems that the painter followed his timetable punctually, completing the other two bays and beginning the *Crucifixion* at least by May 1521; he received promise of final payment for the entire project on 8 October 1521. The *Lamentation* further down to the right of the central door belongs to a second campaign of 1522.
 The nearly complete, but confusingly presented transcriptions of Sacchi (1985): 187–9 and 273–5, are still used by many modern authors. The archival material for Pordenone is summarized most completely in Cohen (1996), 2: 580–81, 586. (Translations in this essay are by the author, unless otherwise indicated.)

2. The best treatment of the complete fresco cycle is Guazzoni (1989): 94–103. See also Boase (1956) and Puerari (1971).

3. See Furlan (1988): 102 and 124.

4. Cohen (1975) and (1996), 1: 69–221; 2: 578–88.

5. For example, Fiocco sees the commission in Cremona as an opportunity for 'un risveglio di quelle esperienze tedesche, che erano al fondo della sua educazione' ('the awakening of those German experiences that formed the core of [Pordenone's] education': Fiocco (1969), 1: 62, 64). For other writers who signal Germanic elements in the frescoes, see references in Cohen (1975): 75, n. 8; Cohen (1996), 1: 215, n. 39.

6. See Ferrari (1961): 27–31, 81–8, and Nova (1994b): 233–4. The '*massari*' in Cremona were the heads of the *fabbriceria* (see below).

7. Many authors have attributed the *massari*'s disposal of Romanino to the more 'advanced' Romanism of Pordenone. In an insightful analysis, Panazza also sees a tired aspect to Romanino's drama; see Panazza (1965): 20–21.

8. Much has been made of these descriptions, which, though unusually loquacious for a

Renaissance contract, are limited as iconographical texts. They are very like the titles found commonly painted in the margin of Lombard and Piedmontese narrative frescoes – for instance, under the Passion scenes by an unknown fifteenth-century Lombard artist in nearby Castelleone, in S. Maria in Bressanone. For reproductions, see Dell'Acqua and Mazzini (1965): pls 90–92.

9. For the history of the period, see especially Bonetti (1939): 75–149, an anthology of various journal and newspaper articles that the archivist published separately in the 1910s, often without specific references to the documentation he used from the Communal archive; he supplemented with other sources, especially the correspondence of the Gonzaga.

10. Elected to the diocese in 1507, he made a few brief visits in 1512–15; see Aporti (1837), 2: 91.

11. Guazzoni (1989): 89.

12. The role of the *massari* is discussed in Bora (1985): 153. See also Guazzoni (1989): 89–90.

13. He is commemorated in an inscription of 1342 on the north transept pier in the cathedral, with a tribute to his Visconti lord, rather than to the Bishop for whom he served as canon; see Bonetti (1936).

14. See Guazzoni (1989): 89; Bonetti (1936): 5–9.

15. Bora (1985): 153.

16. Guazzoni (1989): 90–94, is especially valuable for his emphasis on the civic pride evident in the early campaign and his consideration of the Renaissance decoration in the cathedral as a whole.

17. Puerari (1971): 29.

18. Sommi-Picenardi (1893): esp. pl. XII, Biblioteca Statale, Cremona, collected and published by the author from the family archives and other sources. On the list of men called to donate to the King, see Bonetti (1939): 113–14.

19. Bresciani, G., *Origine et antichità della nobile famiglia Zuccha di Cremona con gli huomini insigni d'essa sì nelle armi come lettere*, 1647, Cremona, Biblioteca Civica, MS. AA.4.46, fols 10v–12r. As *massaro* of 1520, Zuccho was also involved in the commissioning of the Veronese marble font in the Baptistery. Among what I believe to be other private references in the decorative 'grottesques' of Pordenone's nave pilasters is a 'zucca' or squash, clasped by a putto, similar to the punning coat-of-arms on the seventeenth-century manuscript.

20. For the sake of brevity, I mention here only in passing an area of research which seems promising for an understanding of the nave fresco as a whole – that is, the relevance of certain trends in contemporary Cremonese writing for the content and visual 'language' of the frescoes. The work of two authors closely connected with the *massari*, both vocally anti-French, may serve here as examples. Matteo Fossa was responsible for an irreverent poem on the invasion of Charles VIII, which offers special fun in allusion to the King's large nose (see Bonetti (1939): 243, for excerpt). A 'Pater Noster of the Lombards' of 1516, one instance of what seems to be a spontaneous genre of these years, recorded by Bordigallo (see below) is attributed by Bonetti to Fossa as well (Bonetti, ibid., with transcription, 240–42). In the *Pater Noster*, the poet sets a political and social lament within the lines of the conventional prayer to Our Father, in a spirited, rather than spiritual, protest against French oppression (see Novati (1879): 21). This unorthodox mix of the liturgical and ribald, and the vernacular ferocity of language, are suggestive for the style and message of the paintings in the Duomo. A certain Giacomo Fossa was the notary for Altobello Melone's contract for the *Flight* and the *Massacre of the Innocents*, commissioned in the same year as the *Pater Noster* – which makes intriguing the identity of the large-nosed man witnessing the slaying of infants in the fresco.

The manuscript chronicle of Domenico Bordigallo, notary and pro-Sforza patrician, is likewise revealing, not only for his records of daily events and attitudes but also for his poetry: Cremona, Biblioteca Civica, *Domenici Burdigali inclyte urbis Cremone patricij cronicorum veterum ab inicio mundi Mediolani precipue Cremone et Italie omnium provinciarum Europe regine aggregato suisque temporibus principum rerum gestarum et civitatum addicio supplementum et chronicha seu istoria*, 1527, MSS Bib. Gov. 264. This enormous volume, written from 1514 to his death in 1527, is a 'universal history' which begins with the Creation, but presents especially invasions, diplomatic missions, public decrees, famine, plagues, miracles and apparitions, epitaphs, and the crimes and injustices visited upon the Cremonese populace. It is a pot-pourri, and a mine of relevant and irrelevant information. Intersected are his poems, Latin laments and pleas with sometimes surprisingly experimental touches. For example: a *carmen* of September 1516 (f. 248, and also transcribed in Novati (1880): 9, n. 1) uses onomatopoeia for the sounds of bells, drums and fifes in order to convey the joy of the citizens at the hoped-for opening of the city canals and sewers. A plea for French justice of September 1520 employs both nonsense words and an eccentric but

learned use of Latin metre (f. 295). In another, the month before (f. 293), Bordigallo inserts words which he claims are German and Turkish, and includes an 'expositio ... in lingua teutonica et arabica'. In consideration of the 'Germanisms' of the frescoes, and also in relation to contemporary issues of language and art as discussed in Nova (1994a): 664–79, it may be noted that the investigation of Lombard literary forms offers a rich field of study which I hope further to explore. I thank Rolando Ferri and Claudio Vela for assistance with Bordigallo's poetry and for information on the manuscript, respectively.

21. Cohen (1975): 76, and (1996), 1: 178.

22. The comparison is illustrated in Frangi (1990): 260.

23. Cohen (1975): 77; see also Cohen (1996), 1: 194.

24. Schiller (1968), 2: fig. 206. Cohen ((1975): 76) notes the early Christian tradition, but dismisses it in favour of German influence.

25. Cohen (1975): 75, and (1996), 1: 177.

26. Schwarzweller ((1935): 58) was insistent on Pordenone's debt, in Cremona, to Raphael; Cohen ((1975): 75–6; (1996), 1:177) sees the connection with the *Cascina*.

27. Reproduction in Furlan (1988): D3 recto, p. 244.

28. As demonstrated by only one of the many similar episodes related by Bonetti ((1939): 121): in September 1520, the Comunità, in a denunciation of the injustices visited upon Cremona, described among other brutalities the destruction created by the nearly 1000 soldiers with horses in the city and countryside.

29. Reproduction in Fossaluzza (1996): 145. If we recall that the *massari* specifically indicated that his frescoes were to be of the same or better quality as his façade painting for Paride Ceresara in Mantua (Sacchi (1985): 274), it seems to me irresistible not to at least suggest that the lost frescoes may have included such a 'clamorous' equine motif – soon to become the standard test of mastery in this genre.

30. Furlan ((1988): 23) entitles her section 'Il Pordenone a Cremona: "pictor modernus"'; most recently, see Bertling-Biaggini (1999).

31. Guazzoni (1989): 103.

32. Sacchi (1985): 182.

33. Rearick (1985).

34. See Cohen (1975): 78–80, 87, and (1996), 1: 179, 182, 184, 202–203, for his formal analysis and speculation on the relation to sacred theatre; for the attribution and transcription of the prophecies, first provided also by Cohen, see (1996), 2: 580, 586–7. The author suggests that the Prophets may have been projected only at the point of the execution of *Christ Nailed*, hence the absence of mention in the contract. I would argue instead that these elements are formally and iconographically intrinsic to the programme, and had to be conceived from the first.

35. For instance, Cohen's citation of a figure from *The Battle of Anghiari*; see Cohen (1975): 76, n. 13, and (1996): I, 177.

36. In Pordenone's time, the floor of the nave was much deeper than it is now, and one descended as many as nine steps in order to enter the church. The floor was raised in 1605–1606; see Voltini and Guazzoni (1989): 42. The expanded forms of Pordenone's frescoes would have had an even more positive effect on the then more distant viewer.

37. Only Cohen mentions these ornamental elements; see Cohen (1996), 2: 587. They merit further study; see note 19 above.

38. Cohen (1975): 77.

39. Boase (1956): 215.

40. Cohen's examples of 'ugly' visions of the Saviour include Ratgeb's panel (Cohen (1975): fig. 2), which is instead a *Flagellation and Mocking*; Reichlich's *Way of the Cross* (fig. 6) and that of the Housebook Master conform to the 'contrast' type.

41. See Bialostocki (1959) and Marrow (1977).

42. I can think of no unified single-subject wall fresco of such dimensions existing in any church, even in Rome, in 1521.

43. The gold frame that now surrounds the fresco dates from the late-seventeenth or eighteenth century and somewhat spoils the spatial effect.

44. Cohen (1975): 80, fig. 15, and (1996), 1: 198. See also Schiller (1966–80), 2: figs 513, 516, 520, 522 and 525.

45. Cohen, while acknowledging the presence of the type in Trecento painting (Cohen (1975): 80, and (1996), 1: 198), understates the importance that the Centurion is given in much Italian art.

46. For a reproduction, see Briganti (1987): 27. For northern Italian *tramezzi*, see Nova (1983); see also Dell'Acqua and Mazzini (1965): pls 86 ff. and 401.

47. Cohen notes the similar roles of the Prophets and the Centurion as didactic intermediaries with the viewer, but as evidence of their derivation from sacred theatre; see Cohen (1975): 87, and (1996), 1: 184.

48. Cohen (1975): 79–80 and fig. 14, and (1996), 1: 198, fig. 33, and 217, n. 58.

49. See Eisler (1988): 344, pl. 206, 346 and 525.

50. As in Treviso, where Pordenone exaggerated the protruding bottom of the figure who moves away from the Christ child.

51. Cohen (1975): 79.

52. See Schiller (1966–80), 2: 168–70, for the blind Longinus, a legend first disseminated in the *Golden Legend*.

53. Sacchi (1985): 275.

54. Cohen ((1975): 79), proposes theatrical sources for Pordenone's caricatured Jews; this is developed in Cohen (1996), 1: 203ff.

55. See Brown (1987): 87.

56. See Bonetti (1982): 89.

57. Bonetti (1982), 20–22 and Bonetti (1939): 114–15.

58. Bonetti (1939), 21–2 and ibid., 121–2 and 124.

59. Roberto Venturelli's study on Pordenone's *Crucifixion* addresses just these issues; see Venturelli (2001): 163–73. While I would agree that an uprising of anti-Semitism in Cremona at this moment accounts for elements in the fresco, it is not the whole picture. The *Crucifixion* and the Passion scenes which precede it may allude to the evilness of those who are blind to the coming of the true Messiah, but they especially challenge aggressively the personal spiritual commitment of the viewer. Righteousness is not to be taken for granted, nor are the most brutal, like Longinus and the Centurion, unredeemable. Thus, Pordenone's fresco is not a complacent reminder of Christian faith and Jewish betrayal; it is rather an image that demands an involved response on the part of the worshipper. Nor can the addition of the Old Testament prophets be seen as anti-Jewish, but as representative of the continuity of Hebrew and Christian history, violated by barbaric and violent men in Christ's time and in Renaissance Cremona. I have not had the opportunity to consider here Venturelli's more extensive treatment of Poderone's 'Cremonese frescos' in *Venezia Cinquecento* (2002), which appeared as this essay was in press.

60. See Furlan (1988): D6, 247; D8, 249.

61. Schwarzweller ((1935): 58; 123, note 45) wonders if the original idea were for the programme to end with a *Last Judgement* instead of a *Crucifixion*.

62. Nova (1994a): 234, corrects Bora (1985): 154.

63. An investigation of Pordenone's frescoes in the context of contemporary religious debate must await discussion on a future occasion. I would like here simply to note that in the same years that Pordenone was painting in the cathedral, nearby in S. Domenico, Isidoro Isolani was writing his *Revocatio*, a treatise in the form of a personal letter to Luther to recant (*Revocatio Martini Lutherii Augustiniani ad Sanctam Sedem*, November 1519, Cremona). The fact has been mentioned in passing by art historians, but no scholar has yet studied Isolani's text to ascertain its relevance. Isolani argues against Luther's theses, which challenge the papal right to bestow indulgences and the problem of the 'treasure of grace' reserved in the saints and the church as institution; see Defendi (1953). While his discussion of papal authority, based on Aquinas, the Decretals and scholastic methods, and largely dependent of the contemporary arguments of Prierias and Cajetan, is not so pertinent to the fresco, another theme emerges that might bear examination with respect to Pordenone's message. Isolani also examines Luther's questions concerning the meaning of Christ's word, 'repent', as a distinct act of confession, or as a continual internal state of the faithful. The nature of repentance, and the healing force of Christ's mercy toward the penitent were indeed matters which interested the *massari* and were vividly expressed in Pordenone's *Crucifixion*.

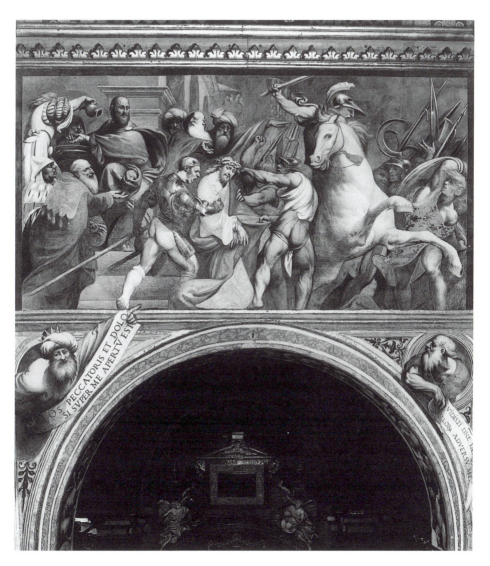

6.1 Giovanni Antonio de Sacchis, called Pordenone, *Christ before Pilate*, 1520, fresco, Cremona Cathedral

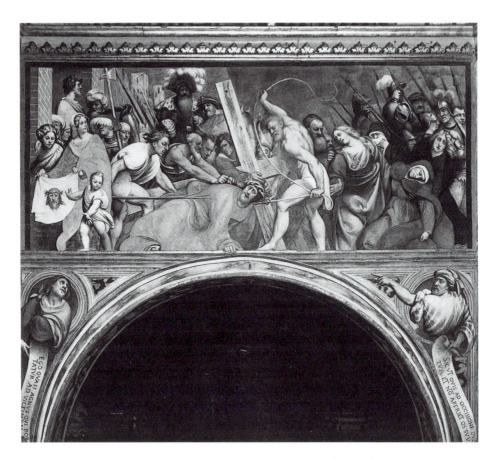

6.2 Giovanni Antonio de Sacchis, called Pordenone, *Christ Led to Calvary*, 1520, fresco, Cremona Cathedral

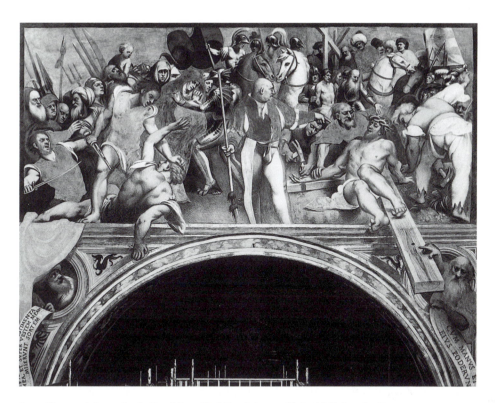

6.3 Giovanni Antonio de Sacchis, called Pordenone, *Christ Nailed to the Cross*, 1520, fresco, Cremona Cathedral

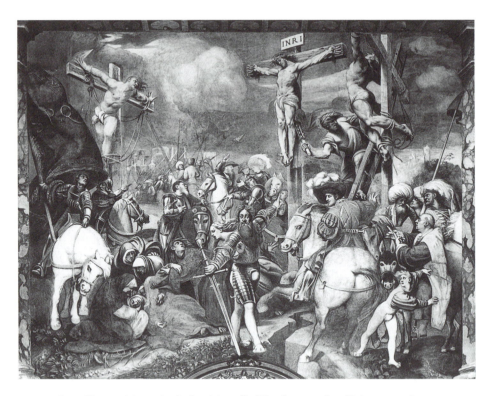

6.4 Giovanni Antonio de Sacchis, called Pordenone, *Crucifixion*, 1521, fresco, Cremona Cathedral

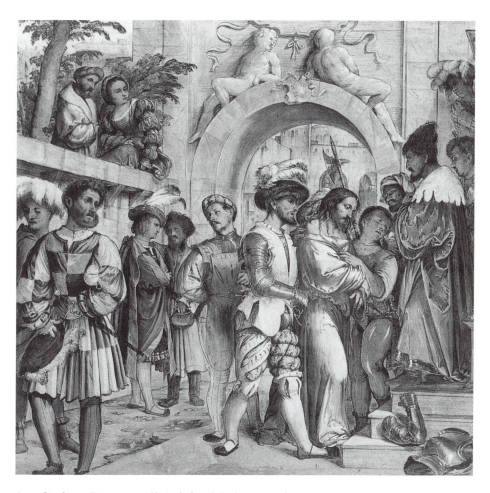

6.5 Girolamo Romanino, *Christ before Caiaphas*, 1519, fresco, Cremona Cathedral

6.6 Giovanni Antonio de Sacchis, called Pordenone, *Prophets and Decorated Pilaster*, 1520, fresco, Cremona Cathedral

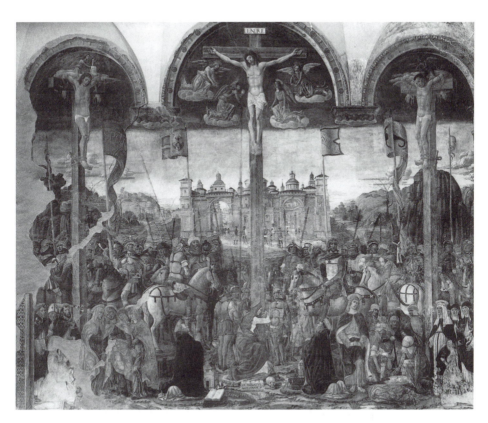

6.7 Donato Montorfano, *Crucifixion*, 1495, fresco, Milan, S. Maria delle Grazie

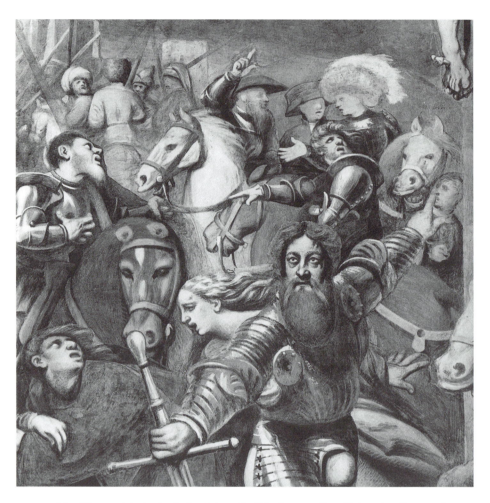

6.8 Giovanni Antonio de Sacchis, called Pordenone, *Crucifixion*, detail, 1521, fresco, Cremona Cathedral

The *studiolo* of Alberto Pio da Carpi

Alessandra Sarchi

'Lord Alberto would gladly be left in peace so that he may study.'[1] In these words, in a letter dated 25 July 1496 addressed to the young marchioness of Mantua, Isabella d'Este, Sigismondo Golfo gives us a revealing glimpse of Alberto III Pio da Carpi. Golfo's remark constitutes an especially meaningful psychological portrayal of the young prince in light of his situation in the years following the death (in 1494) of Marco I Pio, lord of Carpi, when Alberto and his cousin Giberto Pio were engaged in a bitter struggle for possession of the fiefdom.[2] The contest was waged not only with the weapons of diplomacy and dynastic vindication – the two cousins should in fact have reigned together, following the example of their respective fathers Marco and Leonello – but also with episodes of true belligerence culminating in Giberto's assault and sack of Alberto's palace and, finally, the intervention of Ercole I d'Este, duke of Ferrara, who in 1499 conceded Sassuolo to Giberto and established the shared rule of Carpi for himself and Alberto Pio.[3]

Alberto's friendship with the Este duke, as well as his continuous efforts to gain favours at the Gonzaga court in Mantua, were probably responsible for his keeping the fiefdom. However, his victory brought with it the imposition of an uneasy co-rule with the Este, a situation that became especially difficult in 1505 when Alfonso I, who was wholly committed to the much contested recognition of the Este's lordship in the territory of Reggio Emilia and Modena, which included the small Carpi principality, succeeded Ercole I. During the final years of the Quattrocento, in exile from Carpi, Alberto was repeatedly a guest at the Este court, and in this milieu he cultivated friendships and intellectual company from which not even his political preoccupations could distract him. With him was the Aristotelian philosopher Pietro Pomponazzi, in his entourage since 1496, and it is easy to imagine the young prince in Ferrara enjoying the company and conversation of Celio Calcagnini, Pietro Bembo and Lilio Gregorio Giraldi, as well as of his old schoolmate Ludovico

Ariosto.[4] The ties of education and shared interests between Alberto and these poets and literati would prove strong enough to weather changes in political circumstance,[5] as well as the impact of Erasmus' thought.[6]

Thus we have the dialectically constituted image of a man of letters and a political leader, in correspondence with Guarino Veronese's theoretical and highly articulated ideal:[7] the philosopher prince – which Alberto consciously aspired to be – surrounded by a court of intellectuals and humanists. The elegant gentleman in French dress with an open book in his hands who appears in the *Portrait of Alberto III Pio* (London, National Gallery)[8] of about 1512, attributed to Bernardino Loschi, and the no less intense image (whereabouts unknown; formerly in the Fossati Collection) by Bartolomeo Veneto, is a humanist rather than a man of arms, as Ercole I and Alfonso d'Este I instead preferred to have themselves portrayed in the same period. Juan Ginès de Sepulveda, another Aristotelian scholar who had been with Alberto in Carpi and Rome, described the prince in 1532 in the following terms: 'In his house he always had Italians who were extremely learned in all literary genres, who served him in part as preceptors and in part as companions in the exercise of letters.'[9]

But if we try to gain a sense of the concrete historical reality behind the abstract, idealized image conveyed by the splendid dedications in Aldine editions, no less than by Ariosto's famous verses ('I see, conjoined in friendship and in blood, / Pico and Pio, geniuses sublime')[10] immortalizing Alberto and his cousin Giovanfrancesco Pico della Mirandola, it becomes apparent that not only is our knowledge quite limited with respect to the actual physical space of Alberto Pio's court, but also that the data we can rely on fail to match either the idealized image, or analogous, better-known models. When Sepulveda refers to the house in which Alberto received his 'preceptores et socios', is he speaking of the palace in Rome or in Carpi?

Even in Hans Semper's fundamental study,[11] where concrete achievements are weighed against the ideal model of a Renaissance court, the relations between the man and the biographical data, the development of the city of Carpi and the Renaissance renovation of the Pio family's palace are not fully resolved.[12] In Semper's book and in the sporadic later studies, the structure and composition of Alberto's court in Carpi do not emerge, nor do we find answers as to how this prince lived, who oversaw the organization of life in the palace during his many absences, or what the shared rule with the Este family entailed, in terms not only of the administration of politics but also of the actual division of space in the palace.[13] In raising these questions, several factors – the co-rule, Alberto's frequent absences from Carpi, the prolonged political instability, and the lack of a university or court school – stand out as anomalies with respect to the elements that typically define the model of courtly culture.[14] It may also be for this reason that research on the artistic

Renaissance in Carpi has never coincided with an analysis of the culture and art patronage of Alberto. Keeping in mind these anomalies and the role they played in making the Carpi court unusual, in this essay I would like to reassemble elements of Alberto's art patronage and analyse a room in the Carpi 'Rocca Nuova', the Pio family palace, restructured and embellished by Alberto for himself, which recent restoration (1996–97) has unveiled as rich in mural decoration. As we shall see, this decoration strongly identifies the function of the chamber as a princely *studiolo* (see Figure 7.1).

It is a well-established fact that Alberto dedicated constant and careful attention to the renovation of the Pio palace as well as to its urban environs in Carpi, and it should be properly emphasized that in his will this man, who had resided at both the papal and imperial courts, showed tenacious and affectionate concern not for his palace and '*vigna*' in Rome, which he left to his nephew Rodolfo Pio, but for what he still called '*domus mea*', that is the palace in Carpi.[15]

The rare studies of Alberto's patronage, however, have underlined his spiritual and dogmatic zeal even in this area.[16] The same fervour, marked with a scholastic flavour, also underlies his chief literary undertaking, the *Locubrationes* on Erasmus' writings.[17] Certainly, if we consider only the works of art commissioned by Alberto with sacred iconography for religious contexts such as the *Lamentation over the Dead Christ* by Cima da Conegliano, *Madonna and Child with Sts Niccolò da Tolentino and Augustine*[18] by Bernardino Loschi, and *Sts Anthony of Padua, Ursula and Catherine of Alexandria*[19] by Lorenzo Costa, we are struck by the constancy of the reflection on themes of Catholic faith and by the evident intention that the images should be faithful and inspiring interpretations of these themes. But if we define Alberto's artistic taste only on the basis of his patronage of religious art with specific thematic and devotional aims, we risk relegating his other commissions, including the artistic renovation of his palace in Carpi, to a marginality that is out of proportion and inadequate for a comprehensive understanding of Alberto and of the Renaissance in Carpi. The mediocre stature of his court artists, including Bernardino Loschi and Giovanni del Sega, has perhaps further discouraged study in this direction. However, this should not be considered reductively as indicative of Alberto's lack of interest in the intrinsic quality of the works.[20] When the '*alter moecenaus*' (as Aldo Manuzio calls Alberto in a celebrated dedication to the 1497 edition of Aristotle's *De Historia*) had the financial means and political stability, he employed high-ranking artists like Baldassare Peruzzi, and commissioned decorative projects inspired by highly prestigious models, but they were carried out by eclectic and *retardataire* artists – the only ones he could afford to keep as court artists.

In a letter of 1498 Pietro Bembo, who had met Alberto as a young, aspiring prince, acknowledged his sure and superior taste. Writing from his villa, the

Noniano on the River Brenta, Bembo described his ideas for renovations he wished to carry out, but entrusting himself to Alberto's judgment, he wrote: 'I don't dare decide anything without having first consulted you, who has built not only villas but castles, too.'[21] This passage has been justly emphasized by Semper, and should be considered together with other correspondence dating from a few years earlier.[22] In 1494, Alberto had written to Francesco Gonzaga to obtain permission for the passage through Gonzaga territory of materials needed for the palace under construction in Carpi: 'It happens that I need a transit permit for a shipload of limestone for construction.'[23] Thus, even before his political sovereignty over the Carpi fiefdom had been determined, and at a relatively early date, Alberto showed an inclination to undertake architectural projects; moreover his opinion in matters of garden design was evidently known to Pietro Bembo, and we know for certain that he was planning decoration for his own apartments.[24] Documents (of 1497) record a 'camerino superiori', situated that is, on the piano nobile in the north-eastern wing of the palace.[25] This small room facing onto the nymphaeum is ideally positioned to qualify as the studio of Alberto. Located at the end of a passageway crossing the public reception halls (such as the Salone dei Mori and the Sala dei Trionfi), it is surrounded by other private rooms such as the Sala Ornata and the Sala della Dama, according to a distributive logic repeated in many princely palaces.[26] Analyses carried out during the latest restoration campaign (1996) on the walls, now lacking any decoration, revealed no trace of paint. The hidden spiral staircase that connects the *studiolo* to a room below, however, is an important element, signifying a connection between the rooms on two floors of the palace. The link between the two floors is still more revealing in light of the recovery of the fresco decoration of the room located directly below the 'camerino superiori'. This lower room has a rectangular plan, and its polylobed vault is decorated with an elaborate interwoven pattern in red, blue and ochre with gilding and stucco inserts. At the centre of the vault is a painted oculus containing a winged horse, while ten lunettes encircle the uppermost segment of the walls. Standing female figures with musical-instrument attributes appear in eight of the lunettes, while the ninth and tenth, both situated above the fireplace mantle, have lost their original fresco ornament.[27] Six monochrome tondi painted in an intense ochre colour with profile male heads crowned with laurel are placed between the vault lobes (see Figure 7.2). The decorative programme, which features the Muses, Pegasus and learned poets, represents a celebration of music and poetry based on classical associations between the creative process and the daughters of memory, an association renewed during the early humanist period by Boccaccio.[28] It can be surmised that the subject of the lost decoration in the tenth lunette was either Apollo, the god who governs the activity of poets and artists, or Orpheus, the mythical shepherd-poet who is often shown in the company of the Muses.

It seems perfectly plausible, because of the depicted theme, to connect a reference in a document of 19 January 1509 to a 'camera della musa' (Chamber of the Muses) on the second floor of the Rocca Nuova with this painted room.[29] The fragments of the spiral staircase that led from the so-called 'camerino superiori' to the Chamber of the Muses constitute an important element in identifying the architectural typology of these spaces, insofar as they furnish evidence of the functional and residential link between the two parts of the Rocca Nuova. These were rooms that Alberto may have intended for his private moments of meditation, letter-writing, the composition of documents, and so forth. The upper room may well have functioned as a *studiolo*, one example among many such rooms developed by humanists on the model of the monastic scriptorium.[30] The larger Chamber of the Muses below presents a cycle of the Muses who display musical instruments in use during the period, including a harp, lute, bowed lyre, tambourine with cymbals, double flute and a portative organ, as well as a musical score (see Figure 7.3); the latter has been identified as a paraphrase of the opening of *Ile Fantazies*, a celebrated polyphonic piece by Josquin des Prés, the much-admired Flemish composer at the Este court.[31] The Chamber of the Muses suggests itself as a place intended for musical entertainment, poetry recitation and similar diversions for a select company, comparable in certain respects to Isabella d'Este's grotto in the Scalcheria in Mantua which also contained images and allusions to music.[32] The communication between the two floors facilitated access and circulation, as well as privacy with respect to the other rooms of the palace, the indispensable and easily recognizable prerequisites of a *studiolo*. The attributes of this double *studiolo*, that is a linked reading room and a room for musical or literary activity, indicate a specific prototype, namely the *studiolo* created by Federico da Montefeltro in the ducal palace in Urbino, and completed (in terms of the pictorial and wood-inlay ornament) by the late 1480s.[33]

Federico da Montefeltro had commissioned the architects Francesco Laurana and Francesco di Giorgio Martini for a small room with a rectangular plan on the second floor of the palace, completely panelled in perspective *intarsia* images more than two metres high, above which were twenty-eight portraits of famous ancient and modern authors placed in perfect correspondence to the panels beneath. On the lower floor below, and linked to the *studiolo* by an internal staircase, were two additional rooms: a small reliquary chapel and a *tempietto delle muse*. The logic of the architectonic structure and the arrangement of these rooms within the overall design of the Urbino ducal palace is repeated in Carpi. Placed between public reception halls and smaller rooms with a more strictly private function, the two *studioli* link different levels of the palace, and offer a privileged view of the exterior in proximity with a tower.[34]

Because the Carpi room has been stripped of its original furnishings, it is impossible to verify a correspondence between Alberto's '*camerino superiori*'

and Federico da Montefeltro's *studiolo* with its *intarsie* and portraits. But the fact that no trace of decoration has come to light adds substance to the idea that the walls formerly carried *intarsie*, stamped leather, or tapestries, any of which could have easily been removed from the walls.[35] The Chamber of the Muses in Carpi, on the other hand, reveals a very close relationship with the Urbino Temple of the Muses,[36] which was originally decorated with nine panels showing the Muses and Apollo with a lyre.[37] The Urbino panels, with the exception of *Thalia* and *Apollo*, both considered the work of Timoteo Viti, have been attributed to Giovanni di Santi (d. 1494) and dated to the last years of his activity.[38]

The link between the Carpi and the Urbino Muses emerges first and foremost from the common approach to the subject, an approach that breaks away from the acknowledged prototype, that is, the Muses in the Este *studiolo* in Belfiore. While the Belfiore Muses (of 1447) are the first example of this theme applied to a *studiolo*, they differ greatly from their later Urbino and Carpi counterparts in both conception and characterization. According to the interpretation provided by Guarino Veronese, which carries over elements of medieval encyclopaedism, their attributes are consonant with the human activity over which they preside, especially agriculture, and in connection to the Liberal Arts.[39] In the *studioli* of Federico da Montefeltro and Alberto Pio, on the other hand, the Muses hold musical instruments, following the established Neoplatonic tradition according to which they are charged with maintaining the harmony of the celestial spheres.[40] If we examine each individually, we find that in Carpi as in Urbino, Erato is holding a tambourine with cymbals, Polyhymnia (see Figure 7.4) plays a reed organ, Euterpe has a flute and Terpsichore a bowed lyre or viola. One of the Carpi Muses, whose attribute is no longer legible due to the loss of the painted surface, could be Clio (who may have held a book); she is depicted without attributes in the panel by Giovanni di Santi. The Carpi Urania, her right index finger pointing towards a barely visible astrolabe, has no counterpart in the Urbino cycle; she was probably represented in one of the two lost panels. Likewise, in the Carpi series there is a Muse with a harp that has no parallel among the Muses in the Museo Corsini, although she compares well to one identified as Melpomene in a painting of *c.* 1460 in the Museum of Budapest, by an unknown artist from Ferrara.[41] The Calliope in the Carpi series holds a musical score, while in the Urbino cycle she has a long trumpet and, finally, in Carpi there is no image of Thalia, who was probably shown in one of the lunettes that has lost its original ornament.[42]

The iconography of the Muses in Carpi comes close not only to the series depicted by Giovanni di Santi in the 1480s, but also to those of the 'Tarocchi del Mantegna' series engraved in the second half of the 1460s by an unknown artist scholars have called 'Master E'.[43] The Urbino Muses are also related to

the Tarocchi series. A possible link between the Tarocchi and the Urbino Muses is found in the illuminations to *De gentilium deorum imaginibus* by Ludovico Lazzarelli,[44] where the Muses depend directly on the Tarocchi engravings; the Lazzarelli illuminations may thus be the common model for both the Urbino and the Carpi cycles, as well as for the lovely Muses attributed to Alessandro Pampurino, from the octagonal ceiling of what is believed to have been the residence of the prior of S. Antonio in Cremona.[45]

It has been observed that in this representational typology, which also characterizes the Muses Euterpe and Melpomene (who are important for the identification of Melpomene as the harp-playing Muse in the Carpi lunette) in the Szèpmuvèszeti Museum in Budapest,[46] there is a direct return to the iconography of classical Antiquity. On ancient sarcophagi and in paintings, the Muses are shown wrapped in ample draperies and carrying musical instruments, and perhaps even more importantly, Macrobius describes them with musical instruments in his commentary on Plato's *Republic* (10, 717). The Neoplatonic interpretation of their role as mediators between the terrestrial and celestial spheres, however, is closely tied to music and poetry, which purifies, spiritually elevates and leads to truth, as Giovanni Pico della Mirandola wrote in a commentary that was certainly known to Alberto Pio da Carpi.[47] This interpretation, which replaces the medieval conception of the Muses as *figurae* of the Liberal Arts, constitutes the best discourse for adaptation within the Christian tradition,[48] identifying the Muses as channels of the celestial harmonies to Earth. The Carpi Muses therefore relate to a cultivated literary context that is profoundly different from that which inspired the painted Muses in the *studiolo* of Belfiore and those sculpted in the Tempio Malatestiano in Rimini. They are pagan divinities as well as Christian beings, dispensers of immortality and links between earthly and divine wisdom. Alberto Pio did not adhere to the iconographic typology of the Belfiore *studiolo* Muses, certainly known to him, probably because of their indecorous and conspicuous formal qualities which updated the medieval association between the Muses and the Liberal Arts. For his own chamber of the Muses, Alberto favoured an iconography more closely tied to the classical tradition and which took its inspiration from the *studiolo* of the duke of Urbino. Alberto is known to have stayed for a time at the Urbino court in the early sixteenth century, visiting his fiancée, Margherita Gonzaga, who was in residence at the Montefeltro court together with Alberto's cousin, Emilia Pio. This in no way contradicts Alberto's noted preference for allegorical interpretations of the Muses reconciling his Christian and Neoplatonic education, and it may be also seen in relation to the debate on the Muses then in progress in the court context, and especially in Carpi.[49] Here the humanist Lilio Gregorio Giraldi wrote the *Syntagma de Musis* (1511), a short treatise with a woodcut illustration for each Muse as well as the

Historiae poetarum tam graecorum quam latinorum, dialoghi X (completed by 1507), a compendium of literature from Antiquity to Giraldi's day.[50] In the latter he includes a description of a fresco cycle in the library of the Pico della Mirandola family, in which 'our Cosimo', clearly a reference to Cosmè Tura, had painted the Muses. Giraldi's learned text, rich in Greek and Latin erudition that would evidently have been read and appreciated by Alberto Pio and the Pico circle, represents the Muses with their musical attributes and sphere of influence on literature. Composed in the humanist genre of the dialogue and constituting a handbook of quotations from ancient authors, Giraldi's text presents the theme of the Muses according to the classical view, at a remove from the seductive aspects stressed in the Belfiore *studiolo* cycle.

The Muses in the Palazzo dei Pio in Carpi are not the only example of Alberto's humanistic vision: in the background of his portrait in the National Gallery in London is an animated miniature Parnassus, complete with Apollo and Bacchus and their circular temples dedicated to poetry and music. Furthermore Alberto's longstanding interest in the theme of the Muses may also be gleaned from Baldassare Peruzzi's *Dancing Muses with Apollo* (Florence, Pitti Palace),[51] probably identifiable as the painting described in one of Rodolfo Pio da Carpi's post-mortem inventories.[52] It is likely that Rodolfo inherited Peruzzi's painting from his uncle, Alberto.[53]

A link may be observed between the subject and the pictorial language adopted for the Carpi fresco cycle. The visual appearance of the Muses, adhering to the canons of both Antiquity and Christianity, is characterized by a graceful manner embracing both the Ferrarese and the Mantuan courtly styles, though incorporating a slightly archaic quality. Documentary clues and stylistic analogies have led me to conclude that the Carpi artist was Bernardino Loschi,[54] a painter who was heavily involved in the artistic renovations of the Carpi palace.[55] To start with, there is significant art historical evidence. Loschi, who was Alberto's court artist from 1500, when he signed a triptych for the Compagnia della Incoronata Vergine Maria in the church of S. Felice sul Panaro, was well established in the Carpi milieu. He married Margherita Dolcibelli, sister of the printer Benedetto, who founded a press with Aldus Manutius in the town of Novi, and in 1505 he was nominated 'pictor illustris Domini Alberti Pii', a title that ensured him a permanent and privileged place in the entourage of Alberto Pio da Carpi. In the provisions of Alberto's will, in fact, Loschi was treated almost like a member of the family, and ensured perpetual sustenance.[56] In an account book of 1506 there are numerous payments to Loschi for artists' materials (such as pigments, varnishes and sponges). The entries dated 2 and 6 August 1506, which reveal that Loschi was paid 'in contanti quattro lire e meza de vernise liquida che have M. Bernardino depintore per el Camerino del S. re', deserve special

attention.[57] Before the rediscovery of the Chamber of the Muses, these entries would have been difficult to associate with a specific room in Alberto's palace; at this point it is almost impossible not to connect the written document with the visual evidence of the room.

Furthermore, if we compare Loschi's autograph works with the Muses, the stylistic and typological similarities that emerge make the attribution quite persuasive. For example, the same squarish and elongated forehead, lowered eyes and sober, centrally parted hair characterize both the Virgin in the altarpiece *Virgin and Child with Sts Augustine and Louis of Toulouse* (see Figure 7.5) and the Muses; also very similar is the typology of the hands, with unarticulated joints and rounded knuckles. The full draperies of the Muses are characterized by a swelling of the skirt at the hips and of the undergarment on the shoulders as if shaped by a sudden gust of wind, a cadence similar to that of the mantle and robe of the Virgin in the *Annunciation* panel of 1528 (see Figure 7.6), originally placed on the fourth altar to the right in the church of S. Niccolò in Carpi. Like the Muses' draperies, the Virgin's blue mantle is characterized by an inherent fluidity creating volume and a pattern of highlighted raised areas, and vice versa, by cavities produced by the cross-folds. The Carpi Muses present several clumsy anatomical features such as the imperfect rendering of the joints of the hands, the flawed foreshortening of the shoulders of Polyhymnia and Melpomene and even of Pegasus in the oculus, features that Crowe and Cavalcaselle noted in other works by Loschi.[58] As far as can be judged from the slightly damaged pictorial surface and the occasional lack of attention to correct perspective and anatomy, Bernardino attained an illusion of depth through light and shadow alternating from the open sky in the background to the Muses' draperies in the foreground. This method of creating a sense of space relates in particular to painting in Lombardy, which is typified by the work of Bergognone. Girolamo Tiraboschi, regarded Bernardino as a follower of Lorenzo Costa and Francia.[59] Although Bernardino's pictorial language shows elements characteristic of Lombard painting – including the conspicuous influence of Foppa evident in the angels and the Doctors of the Church in the fresco for the Cappella Pio, now unanimously attributed to Loschi – in the Carpi cycle, he comes closer to the courtly pictorial culture that flourished in Bologna with Francia and in Mantua with Costa.[60] The Muse Calliope in Carpi, seen frontally with the musical score in her hands, has much in common with Costa's youthful female figure in the *Concerto Bentivoglio* (London, National Gallery), who is characterized by the same graceful movement, coloration, style of hair and dress, and has the same delicate chains encircling her forehead and throat. Loschi's Calliope also recalls the female figures in the left background of Costa's *Triumph of Death* in the church of S. Giacomo Maggiore in Bologna,

in the Louvre *Kingdom of Como* and the sitter (possibly Isabella d'Este) in Costa's *Portrait of a Lady with a Dog* at Hampton Court. The flowing draperies, jewellery and sweet, harmonious air of these figures recall the somewhat outmoded but still persistent taste and fashion of court culture. And although the Muses in Carpi are less voluptuous and exude a more austere, pious air that Vasari might have defined as a 'grazia semplice che ha del modesto e del santo', they belong essentially to the same courtly milieu.

To define better the artistic crossroads at which the Carpi Muses stand, it is also important to examine the spaces they inhabit. In contrast to the Urbino and Cremona Muses, who rigorously appear as full standing figures, the Carpi Muses are shown as little more than half-figures, as if the lunette occupied by each was a window, or the arch of an external loggia enclosing the room. The small cornices with egg-and-dart palmettes in the lunettes strengthen the effect that the lunettes are actually arches supporting vegetal and animal pergolas in the ceiling vaults. The half-figure rendering of the Muses inevitably recalls an illustrious precedent – the ceiling of the *Camera Picta* by Mantegna in the ducal palace in Mantua – although Mantegna's audacious and exhibitionist perspective is absent from the Carpi cycle. A chronologically closer parallel, and one with more similarity of effect, is the so-called 'aula costabiliana' in the Palazzo Costabili in Ferrara; the frescoes here were carried out within the first decade of the Cinquecento by Garofalo, Cesariano and other Ferrarese painters.[61] In the Palazzo Costabili cycle, we find a painted balustrade, and therefore a division that renders the figures visible only from the waist upwards, behind which sport a company of variously painted women and youths with musical instruments, books and exotic animals, evoking the light-hearted and festive atmosphere of court life. It is difficult to say, given our present lack of knowledge about Bernardino Loschi, whether he could have seen Mantegna's *Camera Picta* – indeed so geographically close, and also well known during his period – or the Costabili room, or if it was rather Alberto Pio who had seen the latter and suggested the idea of half-figure Muses to the painter. Judging by the rather simplified results in the Chamber of the Muses, the second of these hypotheses seems more probable. Even when Loschi imitated artists like Lorenzo Costa, then in vogue in the court circuit, or tried to master fashionable pictorial inflections, he remained a painter anchored in an artistic culture based on decorative rather than perspective or spatial values. This is perfectly evident in the ceiling, embroidered with flowers, miniature griffins and satyrs reminiscent of medieval *drôleries*, exhibiting the same exuberantly ornamental taste championed by Pinturicchio in the Borgia apartments in the Vatican. A date check may help to clarify both the antiquated and the up-to-date elements of the decoration of the Chamber of the Muses. Payments to Bernardino date to

1506, and we may assume that the room was already painted by 1509, since it is mentioned in documents from that year. Thus 1509 is a firm *terminus ante quem* and a date that permits us to compare the cycle with coeval works, through which we are able to gain a sense of the conservatism of the whole project. A possible parallel is the room by Alessandro Araldi in the convent of S. Paolo in Parma, painted within a year of it and in a relatively similar style.

The inconsistent quality in the rendering of several of the Muses, together with the discrepancies between the figures and the magnificent ceiling that overshadows them with a network of verdure – perhaps meant to evoke the Muses' natural woodland habitat – makes it natural to suspect that the splendidly shadowed fruit and flowers, the gilt lozenges meant to represent forest fruits and the monochrome poets' profiles are actually the work of another painter who was active at the Carpi court during this period, namely Giovanni del Sega. Giovanni evidently acquired skill as a painter of *all'antica* decoration while working in Rome, probably in the workshop of Melozzo da Forlì, as is proven by the ornament on the painted pilasters and on the frieze with profiles of emperors and monochrome battle scenes in the 'Salone dei Mori' in the Palazzo dei Pio, which is documented as the work of this little-known painter from Forlì.[62] Garuti's attribution to Giovanni del Sega of the entire mural decoration of the Chamber of the Muses is problematic; it is instead more plausible to think in terms of collaboration between Bernardino, invariably cited in the documents as Alberto's court painter and privileged faithful artist, and Giovanni, who may have came to Carpi following the assault on Forlì and the defeat of Caterina Sforza by Cesare Borgia. In this way the presence of both artists at the Pio court would be justified, as well as the undeniable and somewhat surprising mixture of stylistic manners and the internal discrepancies observable both in the Chamber of the Muses and in the earlier Sala dei Gigli.[63] A closer examination of the vegetal and architectonic decoration in the Chamber of the Muses reveals elements that sustain its derivation from Melozzo's workshop practice;[64] that is, precisely because they are elements of a decorative syntax, they plausibly constitute the more easily adaptable and transferable repertory of a relatively modest painter like Giovanni del Sega. For example, the minutely polylobed oak leaves terminating in berries and acorns are very similar to those flowering in the painted pilasters framing Melozzo's fresco *Sixtus IV Nominating Platina Prefetto of the Vatican Library* (Rome, Pinacoteca Vaticana). The painted mouldings sustaining the lunettes and decorating the extradoses of the arches echo the perspective effect of the fictive architecture in Melozzo's frescoed cupola of the S. Marco sacristy in the basilica of Loreto. In a comparable manner, the artist of the Carpi lunettes has rendered the gradations of the shadows in the intradoses of the arches, producing a studied, effective spatial

atmosphere, and even in the system and typologies of the Carpi motifs there is a close tie with the hierarchy established by Melozzo in the capital bases of the pilasters in the above-mentioned Vatican fresco.

Throughout the mural decoration in the 'Salone dei Mori' in the Carpi palace perspective effects are achieved through the fictive architecture rather than on the basis of the figures, and we know from payment entries that this decoration was carried out by Giovanni del Sega. While it is not my intention to attach definitive attributions, for which an extremely close analysis of the frescoed surface would surely be required, I would like to suggest here that in the Chamber of the Muses, and probably in the other coeval rooms of the palace as well, we are in the presence of two distinct artistic personalities. This is not an effort to conclude by reconciling all sides of a complex problem so much as an attempt to provide a foothold from which to reconsider the situation of the local pictorial Renaissance in Carpi. The spatial and perspective effects of the Carpi frescoes seem somewhat incongruous with Bernardino Loschi's known oeuvre, while the idea of a collaborating artist, even one of a rather mediocre level who had worked with Melozzo, seems more in keeping with the evidence. The hypothetical collaboration of Loschi and Giovanni del Sega requires further study in the context of the career and oeuvre of each artist, keeping in mind as well the presence in Carpi of works by artists like Marco Meloni and Lorenzo Costa, who contributed to, or were influenced by, figurative culture in Carpi during this period.[65]

Epilogue

In the dialogue *De laudicus philosophiae* (1538) by Jacopo Sadoleto, set in the early Cinquecento like Baldassare Castiglione's *The Book of the Courtier*, we are offered a magnificent view of the ideal court of a humanist prince.[66] One of the characters, after explaining that not even in Rome was it possible to find so many fine minds reunited as those of the elect assembly in Urbino ('Urbini preclarum coetum'), and listing their names and excellent qualities, concludes: 'Without continuing to name names, it is enough to say that, more than a dwelling place for men, the city [of Urbino] seemed the home of the Muses.'[67]

It is likely that this was also the aspiration of the prince of Carpi for his own court; the rediscovered frescoes in the Chamber of the Muses demonstrate Alberto's complete adherence to this type of culture and civilization, and add a significant fragment to the 'local Renaissance' in Carpi. If compared to other more illustrious examples, however, Alberto's *studiolo* appears relatively modest. But instead of attributing this result only to a scarcity of means, or to Alberto's presumed indifference to artistic quality, it seems to me that a better

explanation lies in the Carpi prince's sense of cultural identity: like the painters whom he hired, he was a man deeply rooted in the final years of the fifteenth century. This is corroborated by his subsequent polemical, learned and deaf resistance to the ideas of Erasmus.

The English translation of this text is by Julia Triolo.

NOTES

1. Morselli (1932): 82: 'Il signor Alberto volentieri staria in pace per possere studiare.' (Translations here and below are by the author, unless otherwise indicated.)

2. For biographical information on the prince of Carpi, see Rombaldi (1977): 7–40, and Vasoli (1981). Carpi is 18 kilometres north of Modena, towards Mantua.

3. Giberto was helped by troops sent to the Panaro area by his father-in-law, Giovanni Bentivoglio, the father of Giberto's wife Eleanora. On the struggle between the cousins and Giberto's exchange of properties in favour of Ercole I d'Este, who offered Sassuolo in exchange, see Trombetti Budriesi (1981).

4. On the presence of Pomponazzi in Alberto III Pio's entourage, see Oliva (1926): 181–183, and Nardi (1965).

5. Ludovico Ariosto and Alberto Pio had studied together at the school of Gregorio da Spoleto, and on many occasions Ariosto had dedicated poetic verses to the lord of Carpi, who hosted him often. When Alberto Pio was in Rome in 1513 as ambassador to the emperor Maximilian and his influence in papal circles was widely recognized, the role Ludovico Ariosto played in the service of Cardinal Ippolito d'Este, who represented his brother's interests in Rome, must not have been easy. Having lost the joint rule of Carpi in 1510 the Este were pushing to reopen negotiations for the Carpi territory, and above all, for Modena and Reggio Emilia. In contrast, Alberto Pio had every interest in keeping the Este dukes away from these territories. On this situation, see Morselli (1937).

6. Calcagnini's response to Erasmus' ideas was certainly more pliant and ductile, less doctrinaire and scholastic than that of Alberto, to the extent that a closer reading reveals a veiled concordance with the thought of Erasmus. For Calcagnini's position, see Ginzburg (1970): 163–5.

7. Guarino Veronese was called to Ferrara in 1429 by the marchese Niccolò d'Este as preceptor for his son Niccolò, and he remained with the Este court until his death in 1460. For his theories on the virtues and characteristics of the prince, and the special emphasis on illustrious men of Antiquity, see Pade (1990).

8. Gould (1975): 130–32; Gilmore (1969); Svalduz (2001b): 137.

9. Sepulveda (1780), 4: 552: 'Qui semper habuit domi viros Italiae in omni genere litterarum doctissimos, quibus partim praeceptoribus, partim sociis studiorum ad litterarias exercitationes uteretur.'

10. Ariosto (1987), 2: 46, 17: 'Veggo sublimi e sopraumani ingegni / di sangue e d'amor giunti il Pico e il Pio ... '; on Manuzio's dedications to Alberto Pio, see Dionisotti (1975).

11. Semper, Schulze and Barth (1999). The text, published in Italian translation, is accompanied by a substantial commentary with new directions for research.

12. Semper locates Alberto in a context of shifting cities – from Ferrara to Mantua and Rome – and in an extremely select intellectual and artistic milieu, without relating such activities to his artistic choices in Carpi; see Semper, Schulze and Barth (1999): 143–5. Observations similar to mine are found in Svalduz (2001a): 49–64.

13. Research in this area, with an excellent examination of archival documents, is found in Svalduz (2001a).

14. On this topic see Romano (1981).

15. Alberto's will was published in Svalduz (1999): 471–81.

16. See Humfrey (1978); Schmidt Arcangeli (1996).

17. Published in Venice and Paris, 1531.

18. Both these paintings are now in the Galleria Estense, Modena. The painting by Cima da Conegliano dates to the first six years of the sixteenth century, while the altarpiece by Loschi appears extremely archaic for its date of 1515. Both Humfrey and Schmidt Arcangeli have highlighted the unusual iconography of Cima's *Lamentation* that hinges on the fainting Virgin, and linked this emphasis with the theory of the co-Redemption, according to which the Virgin's suffering and participation in Christ's Passion were equally functional in the redemption of humanity. This theory depended on texts on Christ's Passion, especially those by St Bernard de Clairvaux and the *De Beata Vergine* by St Bernardino of Siena, where great emphasis is given to the salvific role of the suffering endured by Christ's mother. In the case of Cima's painting, the theoretical premises provided by Alberto helped to create a work of forceful originality with respect to the scheme of the Lamentation generally found in painting from the Veneto. The representational style of the Virgin and the relationship created between her and the dead Christ have analogies only in Flemish paintings such as the *Depositions* by Rogier van der Weyden. Schmidt Arcangeli also underlines the role that Cima's *Lamentation* had with respect to coeval sculpture in the Veneto, finding analogies and echoes in the altar by Tullio Lombardo in the Gussoni Chapel in the church of S. Lio, Venice.

19. This painting is now in the Cassa di Risparmio di Carpi.

20. Schmidt Arcangeli ((1996): 95–100) establishes a comparison between Isabella d'Este's modern, secular patronage and the devotional commissions of Alberto. However, Humfrey (1994) has suggested that Alberto's choices of artists for his religious and lay commissions reveal a qualitative difference in favour of the former.

21. Bembo (1987): 29.

22. Semper, Schulze and Barth (1999): 104, n. 116.

23. Alberto's letter was published by Sammarini (1877), 1: 351: 'El mi accade fare conducta de una nave de scaglia de calcina … che è per fornire certa mia fabricha in casa.'

24. On Alberto's early architectural activity in the Carpi castle, see Svalduz (2001b): 62–135.

25. See Garuti (1983): 58. Here Garuti confutes the traditional and unfounded opinion that Alberto's room was identifiable with the so-called decorated room on the piano nobile, frescoed on the walls with architectural motifs composed of painted pilasters surmounted by Corinthian capitals and with a ceiling of splendid gilt-wood intaglios.

26. The topography of the palace is easily detachable from the reliefs inserted in *Il Palazzo dei Pio da Carpi* (1999): 60–61. On the location of *studioli* in Renaissance palaces, see Liebenwein (1992): XII–XIII; 41–62.

27. The first report on the rediscovery of the images was given in Garuti (1999): 398.

28. On the description of the Muses, see Ovid, *Metamorphoses*, 4.785–6; 5.256–64. For the alternating fortune of the Muses from Antiquity through the Middle Ages and Renaissance, see Curtius (1997): 255–73, and Anderson (1991).

29. Garuti (1999): 404.

30. On the link between monastic and humanist typologies of rooms reserved for writing and meditation, see Liebenwein (1992) and Franzoni (1984), 1: 316–38.

31. The reading and identification of the piece of music are owed to Elena Luppi in Semper, Schulze and Barth (1999): 398.

32. Hypotheses on the function of the second grotto and of Isabella's *studiolo* have been made in Fenlon (1990): 225.

33. For Federico da Montefeltro's *studiolo*, essential contributions on the reconstruction of the project and the chronology are Rotondi (1950): 332–82, Cheles (1986): 12, and Liebenwein (1992): 66–84. It should be noted, however, that these studies deal principally with the *studiolo* ornamented with the *intarsia* panels and portraits of famous literati rather than the Chamber of the Muses below. For the latter, see Calzini (1908).

34. In reality, if we compare the design of the Carpi palace (cf. Armentano, Garuti and Rossi, (1999): 60) and the Urbino palace (cf. Liebenwein (1992): 60, pl. xx), several obvious discrepancies emerge, understandable in part because of the larger area covered by the Urbino palace. Alberto's *studiolo* in Carpi is in fact more similar to Federico da Montefeltro's *studiolo* in the ducal palace in Gubbio, which is also published in Liebenwein (1992): 75, pl. xxv.

35. Svalduz (2001b): 344.

36. In the Urbino *studiolo* as well, the musical instruments held by the Muses in the *tempietto* and in the *intarsia* decoration alluded to the 'Pythagorean [and Neoplatonic] tradition in which music was assimilated to the harmony of the celestial spheres.' Neoplatonic culture was in circulation at the Urbino court by the 1470s, through the works of Ficino and Landino. Cf. Cieri Via (1986).

37. The decoration of the Temple of the Muses in Urbino was removed from the palace at the time of Antonio Barberini's cardinalate of Urbino (1632). Barberini obtained them, together with several portraits from the *studiolo* on the floor above, as gifts from his uncle, Pope Urban VIII; the panels with the Muses and Apollo were inherited by Barberini's relative, Anna Corsini, and they are now in the Galleria Corsini in Florence.

38. The attribution to Giovanni di Santi is by Calzini (1908), with earlier bibliography. For an illustration of the seven surviving Muses (two have been lost) and Apollo, see Liebenwein, (1991), 2: 136–8, figs 63–70.

39. For the *studiolo* of Belfiore and the literary sources that inspired the decoration, see Anderson (1991), and with relevant considerations to the topic, Campbell (1997): 29–38.

40. On the relation between the Muses and the movement of the celestial spheres as illustrated in Macrobius' *Somnium Scipionis*, see Seznec (1981): 530, and Wind (1971): 323.

41. For an illustration and an updated entry on the painting see the entries in Benati (1991), nn. 99–100.

42. In the woodcut illustration in the short treatise by Lilio Gregorio Giraldi, *Syntagma de Musis* composed in Carpi and first published in Strasbourg (1511), the scroll held by the Muse Calliope is similar to the one held by the Carpi Muse; see 'Syntagma de Musis' in Giraldi (1580), 1: 555–67.

43. For the dating and cultural context in which the 'Tarocchi del Mantegna' were produced, see Faietti (1991). On the specific iconographical problems, see Cieri Via (1987): 49–77.

44. The two known examples of this codex are in the Biblioteca Apostolica Vaticana: Urb. lat. 716 and 717. For the dating, see Cieri Via (1986): 53–4.

45. This room has been identified as the decorated chamber seen and described by Marcantonio Michiel in the early sixteenth century, see Michiel (1884): 93; Seznec (1981): 85; Cieri Via (1990b). On Pampurino and his frescoed ceiling, see Gregori (1985).

46. The two panel paintings have been traditionally, though not unanimously, considered part of the Belfiore cycle in Ferrara. Recently Daniele Benati ((1991), 1: 429) convincingly argued that the Budapest Muses were not part of the Belfiore cycle. According to Benati, the Budapest Muses are characterized 'by a tradition stemming from medieval encyclopedism in which the Muses were located within a Classical–Christian context (they participate in the divine harmony of the cosmos and transmit it to Earth), a context which Guarino had consciously rejected in Ferrara, returning to the Greek root of *Mousai* as an incentive to human intelligence' ['Le Muse di Belfiore soner improntate ad una tradizione legata all'enciclopedismo medievale, che situa le Muse in un contesto classico-cristiano (esse partecipano dell'armonia divina del cosmo e la trasmettono sulla terra): ovvero un contesto che a Ferrara Guarino aveva coscientemente accantonato per tornare alla radice greca delle *Mousai* come sprone dell'intelligenza umana].

47. Giovanni Pico della Mirandola (1942): 4 (Lib. III, cap. XI, stanza nove) wrote with regard to the Muse of Poetry that she holds 'un pomo doro coperto da un velo sottilissimo nel quale era iscritto Veritas a dimostrare che sotto celeste velamento poetico è nascosto il vero'. For the role of the Muses in Renaissance Neoplatonic thought, Marsilio Ficino's 'De Vita, De Novem Musis Studiosorum ducibus', in his *Opera* (1576): lib. 1, cap. 1, should be considered.

48. It should be remembered that in his late years Federico da Montefeltro developed an intense religiosity which is reflected in Marsilio Ficino's dedication of 'De Christianitate legis Divinitate' to the duke. This is an aspect which would have been of particular interest to the equally pious Alberto Pio da Carpi.

49. Suggestions are offered in Benati (1991), 1: 429.

50. Giraldi came to Carpi in 1503 as the preceptor of Giovanantonio Pico, son of Francesco Pico della Mirandola. On Giraldi, see Barotti (1792–1811), 1: 339–42.

51. In a recent article, Cordellier (2001), has tentatively put forward the hypothesis that the small panel with Apollo and the Muses was intended to decorate a musical instrument. He also attributes to Peruzzi a series of panel paintings (Paris, Louvre) with images of musician deities.

52. Milan, Biblioteca Ambrosiana, Archivio Falcò Pio di Savoia, v. N. 492, n. 3, 24 April 1564: 'Un quadretto longo tre palmi e mezzo et alto uno e tre quarti con le nove muse et apollo colorito a

olio che ballano in un campo d'oro tornito di mano di messer Baldassar da Siena, che è stato raro con ornamento di noce intorno.' I was aware of the content of the Rodolfo Pio inventory, but I am grateful to Elena Svalduz for allowing me to see her essay (in typescript), in which she proposes this convincing identification; see Svalduz (2001a): 5.

53. Cf. Frommel (1967–68). If Frommel's proposed dating of *c*. 1522 for the panel painting (and the Cartone Bentivoglio) is correct, it follows that Alberto had a persistent interest in the theme of the Muses, since the Carpi fresco cycle would predate the Peruzzi painting by at least ten years. However, it is also possible that the destination of the Peruzzi panel for Alberto's residence in Rome gave him the idea of returning to the theme of his Carpi *studiolo*.

54. Instead, Garuti ((1999): 404) has attributed the Muses cycle to Giovanni del Sega. However, the latter's pictorial corpus and biographical data are too scanty and uneven to act as bases for a convincing attribution to him of the Carpi Muses.

55. The frescoes in the *cappella palatina* adjacent to the 'Salone dei Mori' in the Palazzo Pio, Carpi, documented from 1511, have been attributed to Bernardino Loschi. Alberto entrusted him with the supervision of the construction site of S. Niccolò. No catalogue raisonné or adequate treatment of Loschi and his context have been published. Cf. Pellicelli (1929), 23: 401–02; Semper, Schulze and Barth (1999): 167–87, and n. 183; and *Arte in Emilia* (1962): 39 n. 26, 41–3 n. 27. See also Ghidiglia Quintavalle (1962): 39, n. 26, and 41–3, n. 27.

56. Svalduz, in Semper, Schulze and Barth (1999): 471–80, transcribes Alberto Pio's will, notarized in Paris on 21 July 1530. The passage concerning the provisions for Loschi reads as follows: 'Item lego quod magister Bernardinus Luscus de Palma [sic] habeat victum et vestitum ab heredibus meis toto tempore vite sue' ('I also establish that master Bernardinus Luscus de Palma shall be provided by my heirs with food and clothing for the rest of his life').

57. 'In cash four and a half lire of liquid paint that M. Bernardino painter used for the Camerino of the prince.' At this date, the renovation and decoration of Alberto's palace were in full progress: on 30 April 1506, the first payments are recorded for the decoration of the 'Salone dei Mori', a ceremonial room and a sort of 'aula magna', which with its proportions and illusionistic loggia open to the exterior, columns and painted pilasters topped by Corinthian capitals and painted grisaille statues at the centre, was meant to recall Paul II's perspective rooms in the Palazzo Venezia in Rome (see Casanova Uccella (1980); records show that at the same time Giovanni del Sega, who was at work in the Salone, was also paid for the decoration of the palace façade, where fragile warriors and Roman emperors appeared in niches in the upper part. From what can be judged from the remaining evidence, these frescoes reflected a pictorial culture halfway between the famous-men cycles of the fourteenth and fifteenth centuries and the bold stances and studied anatomy of Bramantesque men at arms.

58. Crowe and Cavalcaselle (1871), 1: 77; 296–7.

59. Tiraboschi (1781–86), 4: 458. Tiraboschi's judgement found credit, though not in a strictly positive vein, in Lanzi (1795–96), 2: 257. Lanzi viewed Bernardino as close to Marco Meloni, the 'pennello accuratissimo,' for their common Bolognese stylistic background. The best definition of Bernardino's eclectic manner was supplied by Semper, Schulze and Barth (1999): 302, n. 183: 'The altarpieces in San Niccolò, in turn, are distinguished by a warmth and commanding luminosity that immediately recalls Dürer. Moreover, the heads of Bernardino Loschi in particular, have such a precise characterisation, enchanting sweetness, grace and spontaneity, that he does not deserve to be punished with the scorn that several writers have shown him. ... As far as the components of his style are concerned, he seems to meld influences from Ferrara and the Umbria-Tuscany areas. The often harsh characterisation of his male heads recalls Ferrara, for example the work of Costa and others. The tender sensibility and delicately rounded oval framed by curls of the Virgins, babies and angels call to mind the influence of Umbrian painting and of Francesco Francia; his favourite head angles, and the aesthetic sense they expressed also recall Melozzo da Forlì. Nor was the painter indifferent to Lombard-Leonardesque influences, while in his ornament he follows the Bramante current.'

60. On the definition of courtly culture and Costa's role, see Romano (1981), 6.1: 50–57.

61. On the chronology and the various working periods of the frescoes in the Palazzo Costabili, see Pattanaro (1994).

62. See Calzini (1905); Ricci (1911); and Tumidei (1987). Tumidei rightly noted the uncertainty of the identification of the 'Joannes frescante' recorded in payment documents for Melozzo's decoration in the Vatican with Giovanni del Sega.

63. At present I am conducting research in collaboration with curators from the Museo Civico in Carpi on this room and on the pictorial decoration in general commissioned in the palace of

Alberto Pio. I would like to take this occasion to extend my thanks to Manuela Rossi, the director of the museum, for her learned assistance and support.

64. See Tumidei (1994); Clark (1989) missed the occasion to offer a much-needed monograph on the painter but does offer good-quality photographic reproductions (pls VII, IX) of the frescoes in the Vatican and in the cupola of the S. Marco sacristy in the basilica of Loreto.

65. This seems the principal direction for future research, since the documents relative to these years were destroyed in the 1532 fire in the Torrione degli Spagnoli, part of Alberto Pio da Carpi's palace.

66. Floriani (1981): 50–51.

67. Ibid., 50.

7.1 Bernardino Loschi, Chamber of the Muses, *c.* 1509, fresco, Carpi, Palazzo dei Pio (now the Museo Civico)

7.2 Bernardino Loschi, Chamber of the Muses, ceiling, *c.* 1509, fresco, Carpi, Palazzo dei Pio (now the Museo Civico)

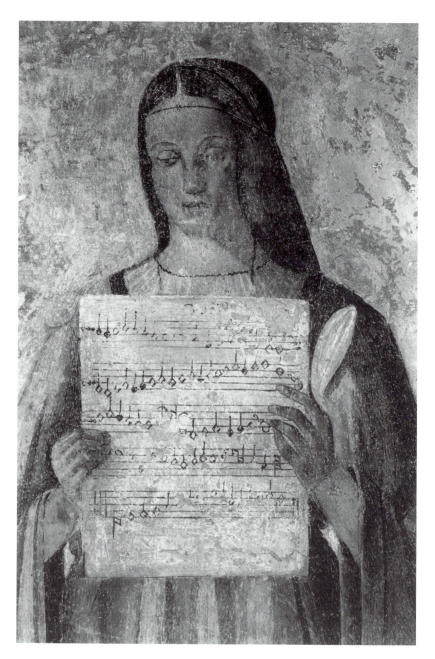

7.3 Bernardino Loschi, Chamber of the Muses, *Calliope*, *c.* 1509, fresco, Carpi, Palazzo dei Pio (now the Museo Civico)

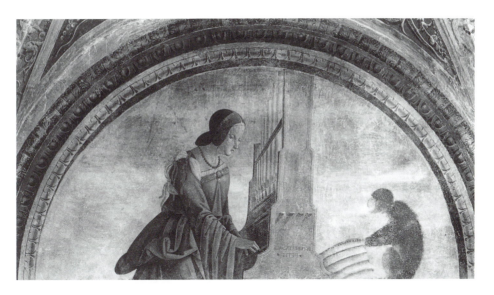

7.4 Bernardino Loschi, Chamber of the Muses, *Polyhymnia, c.* 1509, fresco, Carpi, Palazzo dei Pio (now the Museo Civico)

7.5 Bernardino Loschi, *Virgin and Child with Sts Augustine and Louis of Toulouse,*
1515, tempera on panel, Modena, Galleria Estense

7.6 Bernardino Loschi, *Annunciation*, 1528, oil on panel, Carpi, Palazzo dei Pio
(now the Museo Civico)

Enigmatic beauty: Correggio's Camera di San Paolo

Giancarla Periti

In mid-1518, Antonio Allegri, also known as Correggio, arrived in Parma to paint a room within the abbatial private apartment in the Benedictine nunnery of San Paolo. The patron was the Abbess Giovanna da Piacenza, and the chamber, the so-called Camera di San Paolo, was part of the intimate space that she had furnished and embellished for herself in the early 1510s. The abbatial residence, located between the two cloisters of the nunnery, comprised a sequence of rooms of different sizes and shapes. Two square chambers, the nucleus of the apartment, have vaulted ceilings, and are pierced by two windows framing fireplaces on their respective north walls. Correggio's frescoes cover the upper walls and vault of the second room, while the ceiling of the other room was painted by Alessandro Araldi in 1514.[1] In addition, the private apartment included carved and incised inscriptions and a profusion of escutcheons carrying the abbess's coat of arms distributed on the lintels of the doors, fireplaces and friezes, as well as on the zenith of Allegri's vaulted space (see Figure 8.1).

Although the fashioning of these abbatial private spaces was consistent with a European medieval tradition of monastic domestic residences, Giovanna da Piacenza's suite of rooms represented something new. In northern European communities, intimate rooms were commonly constructed to provide living quarters to accommodate the needs of both secular and monastic social elites engaged in the handling of administrative affairs.[2] In Italy, aristocratic nuns tended to maintain the lifestyle of their class in monastic houses, inhabiting rooms furnished with fireplaces and embellished with coats of arms.[3] If abbatial private rooms were thus spaces traditionally designated for the conduct of administrative activities and which mirrored the abbesses' aristocratic status, Giovanna da Piacenza's suite of furnished and embellished chambers went beyond what was customary. The magnificent private residence she created was, as Roberto Longhi characterized it, 'unlike any other example from the

Italian Renaissance. Neither Isabella's Camerini, nor Cardinal Bibiena's Stufetta are comparable.'⁴ What distinguished her apartment from other contemporary examples was that it constituted an original solution to the problem of decorated private spaces, a solution consistent with the northern Italian tradition of intimate adorned spaces at the princely courts, while representing a transformation of that tradition because of the pervasively enigmatic atmosphere it created. Correggio fashioned an ideal space that presupposed and thematized the status and sophisticated culture of his female patron Giovanna da Piacenza, redefining conceptions of space suitable for both private use and intellectual activities.

Allegri covered the vault with a richly coloured bower of foliage, fruit and bamboo ribs pierced by sixteen ovals enframing a playful, joyous band of naked putti (see Figure 8.2). At the bottom of the vaulted segments are a series of monochromatic lunettes containing mythological scenes and images of ancient gods, with an imitation marble cornice adorned with rams' heads and supporting classical sacrificial implements below (see Figure 8.3). The lunettes present a wide range of personifications and mythological figures, few of which have been satisfactorily identified. The contrast between the monochromatic lunettes and the lively and colorful putti could not be greater. Overshadowing the sober mythological personifications, Correggio created an arcadian world filled with jocose children who emerge exuberantly from the ovals: some lean far out from the fictive openings, while others sound instruments and gesture across space to one another as though there was a continuous world of childish creatures within the sky of the vault. Over the fireplace, at the centre of the north wall (see Figures 8.4, 8.5) Allegri portrays the huntress Diana – with the quiver and the bow slung on her back – conflated into the goddess Luna (wearing the crescent in her hair) to govern this sensuous band of putti. There is a visual dialectic between the frozen lunette representations, the putti in motion above, and the Diana–Luna figure on the fireplace, whose mantel bears the Pythagorean saying IGNEM GLADIO NE FODIAS ('Do not stir the fire with a sword'). This precept, included in Desiderius Erasmus' 1508 edition of his *Adagiorum Chiliades*, stresses a notion of prudence. Although the Camera's decorated space was meant to be understood as a whole, modern attempts to decode its meaning have shown several problems in reconstructing the content and a lack of consensus in the identification of the lunette subjects. It is evident from the enigmatic quality of the lunettes that Allegri and his patron did not intend their meaning to be immediately apparent: this quality, in fact, is an important component of their intended effect and of the genre through which the pictorial invention was conceived.

In addition to the fundamental importance of Allegri's room within the history of Renaissance art, the frescoes have played a primary role in the

twentieth-century historiography of sixteenth-century artistic culture. The vast literature on the Camera demonstrates the full range of art historical approaches. In his *The Iconography of Correggio's Camera di San Paolo* Erwin Panofsky demonstrated that the lunette images were tied to a sixteenth-century northern Italian humanist culture. Panofsky argued with passionate conviction for the intellectual nature of the frescoes whose themes he related to the abbess's struggle with the local authorities who attempted to enforce seclusion on the nunnery. The scholar's main focus for the 'humanistic foundation' of the Camera were the lunette images, which he discussed according to each individual wall, associating each image with the oval above it, thus dividing the imagery into four groups whose themes harmonized under general rubrics.

Panofsky's study of Correggio's Camera was chiefly a testing ground for the iconological method as a whole, revealing both its strengths and its limitations.[5] Since Panofsky's publication, a number of other methodological positions have been articulated with reference to Allegri's frescoes. The very basis of his interpretation has been called into question, as well as the relationship of art to humanist culture. Scholars have pointed out fundamental problems with Panofsky's approach and with his identification of several of Allegri's subjects. Ernst Gombrich advanced the 'lunatic interpretation' of the Camera, based on Giovanna da Piacenza's blazon of three crescent moons, while Maurizio Calvesi and Maureen Pelta championed a 'discourse of Christian salvation' beneath the surface of Allegri's lunette imagery.[6] Subsequent contributions by Alessandro Nova and Regina Stefaniak, informed respectively by theories of reception and of gender, suggested that the Camera's imagery evokes the myth of Diana and Actaeon, and that a 'gendered' female presence is implied to complete the decoration.[7] Despite the different methodological and ideological positions that have been advanced, questions about interpretation itself, and of the relation of art to humanist culture, still remain problematic. It is not appropriate, in my view, to insist on a novel interpretation of Allegri's images before carrying out an investigation of the genre informing their invention. This essay, which develops from the presupposition that any discussion of Correggio's imagery must confront the issue of pictorial invention, aims at supplying the basis for an understanding of their enigmatic features. I will locate the Camera's patronage, iconographical genesis and recondite invention at the core of humanistic conceptions of *aenigmata*. This contribution, intended as a preliminary analysis of Correggio's Camera di San Paolo, develops an argument in three stages. I will first attempt to demonstrate that the pictorial invention of Allegri's images was informed by the conventions of brevity and conceit that characterized the literary genre of sixteenth-century *aenigmata*. The imagery was created according to the same rules that made up the

literary invention of works like the Planudean anthology of Greek epigrams (1494) and Erasmus' *Adagia*. Allegri's lunette figures function therefore as a type of humanistic hieroglyphics. The second step will be an examination of the status and agenda of the artist's patron, the Abbess Giovanna da Piacenza, in the light of a model of individualism that is relational rather than individualistic in the modern sense.[8] This model will allow us to situate Allegri's decorated space within its socio-historical context as a site that spoke of the abbess's identity, inextricably tied to that of her *familia*. Through the commission for her highly embellished residence the abbess emphasized not only her public self-image, but also that of her socially emerging group of cultivated citizens in Parma. Thirdly, by presenting new visual evidence, namely a previously unpublished drawing of the Da Piacenza coat of arms carrying the motto 'Festina Lente', I will consider how Giovanna da Piacenza and her circle were prepared to read hieroglyphic signs as words of a discursive language that fixed in the beholder's mind the essence of concepts in the poetics of *brevitas*. This component was highly appropriate for the re-creation of meaning in the Camera, which served as the abbess's bedroom.[9]

Ireneo Affò was the first to recognize that Correggio's monochromatic lunettes derive from the imagery on the reverses of classical coins, and subsequently Corrado Ricci identified specific Roman coins that served as visual models for twelve out of the sixteen lunettes.[10] The *imagines* on the reverses of classical coins were considered in the Renaissance as a species of hieroglyphics.[11] Hieroglyphics and all symbolic utterances such as adages, proverbs, Pythagorean *symbola*, rebuses and riddles were regarded as *aenigmata* in the sixteenth century.[12] Published in 1551, albeit composed in the first decade of the sixteenth century, Lilio Gregorio Giraldi's *libellus* on *aenigmata* defined them as a condensed form of literature that concealed truths within the rhetoric of *brevitas*; the discovery of their hidden meaning provided the courtly elite with entertainment and instruction, wit and wisdom.[13] *Aenigmata* were thus designated to bear a coded message, compressing experience into small forms intended to communicate concepts; it is their very smallness (*forma brevis*) that makes their truth effectively communicable, explaining also the reason for their success in humanistically oriented circles.[14] Given that the literary invention of the *aenigmata* had its foundation in the rules of brevity and conceit, obscurity in meaning results as an additional quality of the genre.[15] The pictorial invention of the San Paolo lunette images falls within the genre of *aenigmata* not least because classical coins were considered hieroglyphic forms, but also because Allegri invented his subjects according to the same rules of brevity and conceit, with the consequent concealment of meaning. The lunette imagery presents a condensed interpretation of subjects taken from ancient literature, bearing the imprint of humanist learning and artistic culture. Pictorial invention did

not merely involve the illustration of literary subjects, but rather their creative transformation and re-creation according to the conventions of the genre under which the invention falls. Composed of the same elements and in keeping with the same conventions of the small-form literary genre, Allegri's enigmatic images are like frozen gems of a classical past, tokens of hidden learning such as those stored in commonplace books or disseminated in the Planudean anthology.[16] Allegri's lunette images capture the beholder's attention, requiring him or her to discover their concealed truth in order to participate in their contingent meaning, which encapsulates, in its abbreviated form, a concept. Rudolf Wittkower first suggested that Correggio's language in the Camera 'is implicitly, though not explicitly, hieroglyphic', but he supplied no further specification.[17] In this essay I propose that Allegri's lunette figures functioned as a species of hieroglyphics because the artist reinvented their argument according to the specific rules of *brevitas* and conceit that characterized the literary genre of *aenigmata*. Consequently, Allegri intentionally created 'capsules of signification' whose *aenigma* corresponded to their hidden kernel: their concealed meaning remains perpetual. Allegri's lunette figures, as well as Erasmus'*Adagia* and the Planudean anthology epigrams, therefore constitute a product of sixteenth-century humanistic culture.

Although Allegri was learned enough to understand and enjoy vernacular poetry and literature, he surely created the subjects of the lunette figures, the Diana–Luna representation and the playing putti in collaboration with a humanist who probably worked according to Giovanna da Piacenza's instructions. The local *letterato* Giorgio Anselmi, with his documented interest in hieroglyphics and coin-reverse imagery and his epigrammatic literary production, remains the most likely candidate for such a task. The decoration may also be regarded as the product of learned conversations taking place in the abbatial apartment. Correggio appears to have had considerable freedom in the visual shaping of the literary subjects, however, interpreting them according to both his own stylistic devices and his practice of imitation. Allegri's Camera is therefore a product of visual and literary culture that instructed while giving pleasure, translating for the Abbess Giovanna da Piacenza experiences of the present with all the beauty of art.

Up to now, little has been known about the patron of the Camera, Giovanna da Piacenza. New information about her household, and reconsideration of the dynamics of relationships and the network of kinship, reveal how the decorated abbatial apartment was designed to express its female owner's personal self, as well as the modern civic identity of the urban, socially emerging group to which she belonged. The future abbess was probably born in Parma in the mid-1480s into an urban household of *gente nuova*.[18] Her father, Marco de Boronibus, better known as Da Piacenza, was a

descendant of a mercantile family and lived in his ancestral house near the church of Santo Stefano.[19] The building was contiguous with Petrarch's house in Parma, and the family identified with Petrarchan poetics in more ways than one. Giovanna's mother, Agnese Bergonzi, also resided in the Santo Stefano parish before her marriage.[20] In addition to Giovanna, Marco and Agnese da Piacenza had two other children, Cesare and Caterina.[21]

It is likely that Giovanna da Piacenza was able to pursue her studies because she took her vows in the humanistically oriented nunnery of San Paolo, where her relatives Cecilia and Orsina Bergonzi had served as abbesses and had distinguished themselves as patrons of art. The wealthy nunnery of San Paolo was in fact under the control of Giovanna da Piacenza's maternal family, the Bergonzi. Her profession of monastic vows, which signalled her obedience to her family's strategies and her ceding herself to their goals, would have enabled the 'formation of [her] sense of autonomy', in Zemon Davis's words,[22] and gave her the opportunity to pursue the career of *badessa-signora*, and to be transformed into a figure of importance. The abbatial office was a life-time position, whose power was exempted from the supervision of the local authorities, and was subject only to the authority of the Pope.[23]

The basic framework for our understanding of the relationships between the abbess's election, her life-time office, the power of her family and discourses of reform and seclusion in the early sixteenth century has been greatly enriched by the scholarship of Gabriella Zarri and Letizia Arcangeli. Zarri has argued that nuns and their families constructed networks within the monastic houses to maintain their privileges and handle the election of their relatives to the highest office. The control of the abbess's election was one of the chief instruments in the exercise of power within the city.[24] Letizia Arcangeli has suggested that throughout her tenure Giovanna da Piacenza was supported by her *familia,* an emerging social network of relatives, clients and friends. The abbess and her *familia* opposed reform in San Paolo not because it would enforce the nunnery's seclusion, but rather because it would lead to the suppression of the abbess's life-time office.[25] The struggle for the administrative, social and spiritual independence of the nunnery was thus not so much to prevent seclusion per se, but to oppose the fixed-term office of the abbess that local authorities wished to introduce in order to gain control over this monastic institution. This would have shifted power over the monastery from the abbess and her *familia* to the communal government. Arcangeli's persuasive point has major consequences in terms of the fashioning of Giovanna da Piacenza's private space. In contrast to what scholarship has generally assumed, the struggle undertaken by the abbess and her group was to secure the monastic institution, richly endowed with properties and benefices, firmly in their hands, as a realm in which the lady-abbess could perpetually reign. In other words, it

was the Da Piacenza–Bergonzi's struggle for full, unconditional control over the nunnery that, in the meanwhile, enabled Giovanna's *familia* to be successful in the game of power politics in the city of Parma. In the light of this socio-historical reconstruction, the decorated abbatial suite of rooms, while designed to respond to particular aspects of the lady-abbess's personal self, individuality and status, was also aimed at representing this emerging clan in the eyes of other citizens of Parma. While Allegri's images advertise the taste, refinement and character of the female patron-viewer, they also thematize concepts that speak as much of her family's dimension, and of the artist's redefinition of his individuality in the process of creating enigmatic images.

The culture displayed throughout the abbatial residence reveals a keen preference for the language of hieroglyphics, for its components of *brevitas* and obscurity. Hieroglyphic iconic images appear in the abbess's coat of arms as the tail-devouring snake (*ouroboros*) from Horapollo's *Hieroglyphica*[26] that encircles the abbess's insignia, both in the version of the three crescent moons and in the form of her monogram, IO.PL.[27] Another common hieroglyphic from Horapollo, the two feet walking on water meaning 'the Impossible', found its way into Giovanna da Piacenza's residence, in the other room, decorated by Araldi.[28]

The rediscovery of the manuscript of Horapollo's *Hieroglyphica* in 1419, which contained Egyptian picture-script in the canonical form, and the humanists' knowledge of classical sources explaining hieroglyphics as representations of concepts (Ammianus Marcellinus), moral symbols, enigmas and allegorical concepts (Plutarch) generated a vogue for this cryptic language in Italian humanist circles.[29] The vogue culminated with the publication of a series of texts including the *Hypnerotomachia Poliphili* (1499), the Greek edition of Horapollo's *Hieroglyphica* (1505), Erasmus' *Festina Lente* adage-essay (1508), Filippo Fasanini's Latin translation of Horapollo (1517) and Pierio Valeriano's *Hieroglyphica* (1550). While in his *De re aedificatoria* Leon Battista Alberti had championed the use of hieroglyphics as a substitute for language, Fasanini recommended their practice within the restricted circles of educated elites to maintain privacy in correspondence, and as a secret language for lovers. As humanists were fascinated by the idea of hieroglyphic images as a natural language, exempt from the arbitrary and the conventional, that could be understood in a flash as a signifying concept, they translated the method of this ancient–modern language into the invention of utterances such as mottoes that were adopted in various contexts, including the ornaments of families, such as coats of arms. The abbess's family, the Da Piacenza, relied on this code to represent themselves in their heraldry.

An unpublished drawing of the mid-nineteenth century from Enrico Scarabelli-Zunti's *Blasonario Parmense* reproduces the Da Piacenza insignia in its full heraldic form (see Figure 8.6), comprising the arms with the crest

diagonally disposed in an ovoidal shield, and the motto 'Festina Lente' ('Make haste slowly') on the lateral bands; a helmet, a dove and mantling appear above the shield. Although this coat of arms, taken by Enrico Scarabelli-Zunti from a sixteenth-century *Portrait of a Man* (now in storage at the Galleria Nazionale in Parma) was somewhat elaborated in a subsequent period, its nucleus, the shield and the motto, probably represents the original arms devised for the Da Piacenza.[30] What makes this assumption almost certain is the presence of the motto 'Festina Lente', one of the most widely known Renaissance adages, first published with an essay in the 1508 edition of Erasmus' *Adagia*.[31] The most interesting aspect of the Da Piacenza insignia resides in the 'Festina Lente' motto and in its interpretation through the adage-essay supplied by Erasmus, a text that was probably known to the family. Erasmus presents a long commentary on the adage, which he relates to hieroglyphics, expanding on the method of this ancient–modern language which expressed ideas as iconic images rather than as words.

Erasmus' *Adagia* – a collection of proverbs, sayings and precepts explained through philological essays that provide classical sources and an evolving range of meanings for the adages – was the key commonplace-book in sixteenth-century Europe.[32] Erasmus preferred the 'Festina Lente' adage above all others for its form as a paradox; its brevity, which can be further compressed into a hieroglyph; and its meaning, which finds application to every situation and experience of life. He defined it as the 'regius', considering it the king of adages, since even kings require the wisdom it contains. After expressing his admiration for the brevity, brilliance and copiousness of the adage, traversing the history of the maxim, he offered three possible interpretations:[33] (1) a notion of deliberation and prudence in initiating business; (2) a concept of quickness and steadiness that should be equally developed in all affairs; (3) a notion of 'ripeness' achieved by the development of strength, in which quickness and elasticity of conduct are equally balanced.[34] Erasmus cited the adage as an example of prudence, in particular. He mentioned ancient sources and modern texts like the *Hypnerotomachia Poliphili*, the vernacular romance which set the tone of enigmatic yet sensual lyricism, and reflected archaeological and antiquarian interests in terms of hieroglyphics. Erasmus was especially impressed by the hieroglyphic form in the *Hypnerotomachia Poliphili* as a circle–anchor–dolphin image. Since the circle symbolizes eternity, the dolphin quickness and the anchor delay, in discursive language the hieroglyph is read as 'Festina Tarde' ('Hasten slowly'). In the romance, the circle–dolphin–anchor hieroglyph described on the bridge leading to the realm of Queen Eleuterilda is read discursively as a sentence: 'ΑΕΙ ΣΠΕΥΔΕ ΒΡΑΔΕΩΣ. Semper festina tarde.'[35]

Erasmus then elaborated on the nature and method of the language of hieroglyphics that express ideas as iconic signs, and invited the reader to translate the concealed significance in words:

Hieroglyphics is the name given to those enigmatic designs so much used in the early centuries, especially among the priest-prophets and theologians in Egypt, who thought it quite wrong to express the mysteries of wisdom in ordinary writing and thus expose them, as it were, to the uninitiated public. What they thought worth knowing they would record by drawing the shapes of various animals and inanimate things in such a way that it was not easy for the casual reader to unravel them forthwith. It was necessary first to learn the properties of individual things and the special force and nature of each separate creature; and the man who really penetrated these could alone interpret the symbols and put them together, and thus solve the riddle of their meaning.[36]

This passage, as Thomas Greene acutely observed, reveals that Erasmus considered the hieroglyph as superior to the adage on three counts: (1) its *absoluta brevitas*; (2) its perennial meaning; and (3) it represents the sign as the absolute signifier. Hieroglyphics thus represent, according to Greene's convincing and sophisticated analysis, 'semiotic perfection': 'they present the ultimate code, and thus they dramatize the imperfection, the vulnerability of language'.[37] The *Adagia*, as the scholar observes, are therefore 'capsules of signification [whose] resistance to understanding must be pierced for the initiated to participate in their latent semiotic infinitude'.[38] Their understanding becomes, as Jean Chamorat has pointed out, an intellectual game in which the reader subjectively interprets the nucleus of the adage, thereby discovering its dynamic, persistent continuity throughout history. In the interpretive process the reader, taking pleasure in such intellectual activity, reveals his or her wit and spirit.[39]

If an adage or a motto attached to a family's coat of arms was meant to ornament the family and to highlight its emerging social identity, the words 'Festina Lente' added to the Da Piacenza heraldry demonstrate even more. First, the inscribed motto was calculated to show the family's adoption of fragments of authoritative pieces of learning stored in commonplace-books which could be turned into 'cultural capital' and used to promote its upward mobility in society. Second, it demonstrated the fascination for a 'capsule of signification' that refers to the *absoluta brevitas* of a hieroglyph; and, third, it confirmed the family's identification with the notion of prudence conveyed by the adage in terms of a concept of ethical wisdom. Prudence of conduct – the operation of reason in adjusting and redirecting human actions according to practical contingencies – was applicable to the whole range of human affairs with great benefit.[40] This form of prudence, which Erasmus recommended and which Aristotle had described in the *Nicomachean Ethics*[41] as *phronesis* (that is, the practical reason that guides one's choice in the process of ethical decision-making), conforms well to the Da Piacenza's and the abbess's experience of life in sixteenth-century Parma. This is further attested to by the presence of the Pythagorean precept of prudence on the mantelpiece inscription in Allegri's room. The abbess and her family's mode of expression

thus worked through the creative language of the symbolic forms of hieroglyphics. Their interest was focused on the method rather than on the use of true Egyptian symbols to express ideas, that is, they harnessed the perennial signification of hieroglyphic signs and their context to their own purposes of self-representation and to the communication of ideas.

That hieroglyphic inscriptions were adopted as a substitute for language in Parma to express truths about the individual self emerges from other evidence, namely the project for Canon Vincenzo Carissimi's funerary monument. A drawing for the canon's tomb (see Figure 8.7), dating to around 1520, shows a sarcophagus supported by three leonine protoms, and contains three hieroglyphics from the *Hypnerotomachia Poliphili* in the central piece.[42] The hieroglyphic inscription (see Figure 8.8) consists of a helmet ornamented with a dog's head, a bucranium with branches tied to its horns and a bird-headed lamp, whose meaning in the *Hypnerotomachia* reads:

PATIENTIA EST ORNAMENTUM CUSTODIA ET PROTECTIO VITAE. ('Endurance is the ornament, care and protection of life.')

In Carissimi's tomb drawing, hieroglyphic signs replace an epitaph, as Alberti's *De re aedificatoria* recommends. Alberti wrote that inscriptions for funerary monuments 'should either be written – these are called epitaphs – or composed of reliefs and images'.[43] In the design of the Parmese canon's tomb, hieroglyphics were adopted to convey a message about his personal self through iconic images meant to be understood within the learned circle of his friends, among whom the Abbess Giovanna da Piacenza was prominent. The specific hieroglyphic inscription was certainly chosen to denote one of the canon's distinguishing features and to memorialize him. This drawing, which has been discussed as the chief example of the translation of the *Hypnerotomachia* hieroglyphics into visual art, constitutes rather a precious incunabulum for the history of Renaissance hieroglyphics, their adoption and interpretation in discursive language within humanistically oriented circles. The drawing assures us that this language of iconic signs was used to communicate ideas, and that each part of the hieroglyphic inscription was read like words to construct a sentence of discursive meaning.

In the city of Parma, the same learned elite was also acquainted with emblematic combinations of letters and hieroglyphics that were intended for discursive reading, such as those found in Andrea Baiardi's *Trattato Amoroso de Hadriano et de Narcisa titulato Philogyne*.[44] First published in Parma in 1507, the latter contains a *strambotto* as a rebus in which iconic signs and letters 'combina[no] doppi sensi autentici con geroglifici al modo del Colonna e con equivalenze banali fra disegno e vocabolo'.[45] Produced by 'un pittore excellente' to convey a message of love to one of the protagonist's beloved ladies, the rebus images function emblematically and, although they were of

simple decipherment, as Giovanni Pozzi has put it, they constitute 'l'unico caso di rebus inscritto in un poema.'[46] Nevertheless the fact remains that, in the city of Parma, writers and readers were aware of the principles of emblematic and phonetic hieroglyphics, and adopted this inventive language of images and letters for their amusement and edification.

In the Emilia region studies of hieroglyphics were complemented by epigraphical and antiquarian research such as that conducted by the Carmelite Michele Fabrizio Ferrarini.[47] In his sylloge, Ferrarini, a native of Reggio Emilia, disseminated copies of Cyriacus of Ancona's and Felice Feliciano's antiquarian drawings reproducing Egyptian hieroglyphics in the standard script-form.[48] Ferrarini's research on hieroglyphics was shared with the local humanist Anselmi, whose poem *In Cupidinem captivum* (1506) bears a dedication to Ferrarini. In the text, fascination with the hieroglyphic mode is evidenced through the mention of volumes of hieroglyphics in the protagonist's library.[49] Whether this passage is a reference to Anselmi's own library or a homage to Ferrarini's, the fact remains that Anselmi cultivated an interest in this iconic code of hidden meanings. Since scholarship has neglected Anselmi's acquaintance with Ferrarini, whose reputation as antiquarian ranked higher among his contemporaries, their shared views on antiquity and their rediscovery of its smaller remains (epigraphs and coins) have never been related to Allegri's own creation of his *all'antica* style.

That the two fundamental modern texts for the humanist interpretation of hieroglyphics, the *Hypnerotomachia Poliphili* and Erasmus' *Festina Lente* adage-essay, were known to the abbess and read within her learned network demonstrates that she was prepared to interpret hieroglyphic forms in discursive language. Allegri responded to this cultivated world by adopting and adapting coin-reverse low-relief scenes in his lunettes. As the Ferrarese humanist Celio Calcagnini recorded in a letter to Peregrino Morato, images on the coin-reverses were regarded as *symbola*: they denoted symbolic signification.[50] That Anselmi considered coin-reverses as imagery that concealed truths emerges clearly from Pierio Valeriano's *Hieroglyphica*.[51] Allegri's lunette images, invented on the model of coin-reverses according to the same conventions of brevity and conceit, therefore function as a species of hieroglyphics. Allegri's figures constitute tiny gems of meaning whose *absoluta brevitas* conveys the essence of a concept. As in the theory of the literary genre, hieroglyphics referred to concepts without establishing any direct relationship between the signifier (the image) and the significance (the meaning). Iconic images took the place of the meander of words, fixing in the beholder's memory the sheer essence of the concept. Because the signifier is not unequivocally pertinent to the significance, it would be almost impossible for the decoding of hieroglyphic images to reveal a linear programme. Their decoding instead proceeds by the accumulation, incrustation

and juxtaposition of iconic images that were grouped together to convey the essence of concepts. Their interpretation reveals subjects that might be translated into short sentences, but the images themselves might not have any relationship to one another as they normally have in narrative pictorial contexts.

Correggio's discovery of beautiful forms in which to express perennial truths re-enacting the classical past in the experience of the present in a language of hidden significance itself constituted a form of poetic invention. Within the abbess's private residence Allegri shaped mythological and literary subjects that herald, according to Henri Lefebvre's notion of representational spaces, practices and activities of a humanistic nature taking place within the chamber.[52] Allegri's Camera was thus intended to serve as a site for the re-creation of the spirit through the contemplation of works of art whose conjunction of beautiful forms and learned content restored and delighted while supplying intellectual pleasure. That the chamber specifically functioned as the abbess's bedroom is suggested both by Diana's gesture of drawing her sky-blue mantle to denote the coming of night and by the fact that the room served as the key representational space in the apartment. In the Renaissance, bedrooms were locations that were not off-limits to relatives, friends and clients.[53] Legal deeds were written and meetings and conversations were held in bedrooms, which were richly furnished and embellished spaces celebrating the personality of the occupant.[54]

The Diana that Correggio depicted on the fireplace (see Figure 8.5) has often been associated with the abbess since the crescent moon was her insignia, and it has been argued that she wished to be 'regarded as a new Diana'.[55] In classical literature, Diana, the huntress, is presented as a virginal divinity, benevolent with her nymphs and with those who seek her protection, yet prepared to punish her detractors.[56] While Diana may well stand as a *figura* for the abbess, it is my contention that Allegri's voluptuous image of the goddess – with a crescent moon, driving a two-wheeled chariot drawn by a pair of what appear to be stags (one white, the other black) – also alludes to the function of the room. Allegri fused Diana into Luna, returning to the poetic association that conflated the Greek Artemis (Diana) with Selene (Luna).[57] If the textual source for Diana's outward appearance is Claudian's description of the goddess in the *De raptu Proserpinae*,[58] the equation Diana-Luna was often evoked in classical literature and as such was recreated in Renaissance poetry.[59] Allegri knew Catullus' *Carmen Dianae* because Giorgio Anselmi, one of the abbess's learned interlocutors and friends, wrote poems adopting Catullus as his model.[60] Anselmi's *Hymn to Diana*, which adopts both Catullus and Claudianus as subtexts, enumerates the spheres of concerns of the goddess, her manifestations as Hecate, Luna and Lucina, and celebrates her association with childbirth. In a final invocation, Anselmi calls Diana to come and calm

tensions on earth: 'Et tui patrona ades / Huc Sentiam, sospitemque gentem / Hostibus ferox, quate / Et hos minis, et hos manu Diana.'[61] ('And you Diana, Senziano's protector, come here and be fierce with your enemies, and shake the healthy people; save your enemies by threats and the others by your hand.') Both classical and modern textual sources could thus have inspired Allegri's artistic invention. It has also been suggested that the artist had seen classical sarcophagi in Mantua that portrayed Diana seated upon the rim of a chariot with the wind-blown mantle behind her head.[62] Allegri, however, merged the Diana–Luna poetic conflation with details of his own creation such as the drawing of the sky-blue mantle to denote the onset of Diana's ascension into heaven, and the coming of Luna.[63] The poetic conceit of the coming of night into the room is reinforced by the figure's gesture of pointing towards the black deer, another allusion to the night. The coming of the night evokes the coming of silence, which quiets human affairs and all playful, childish activities such as those displayed in the parade of putti set in the ovals above. Silence encompasses prudent habits of life, as recommended in the Pythagorean saying on the fireplace and as in the secret mode of communication through hieroglyphics that is used in Allegri's lunettes. The silence, which brings reflection and meditative activities, is therefore a highly appropriate context for representations such as those by Allegri, which involve the beholder in sophisticated games to recapture the images' meaning.

The reconstruction of the cultural world of Abbess Giovanna da Piacenza, and her predilection for hieroglyphic forms of expression, show that Allegri's invention, structured according to the genre of *aenigmata*, well suited his patron's humanism. The artist conceived his pictorial invention according to the rules of *brevitas*, conceit and obscurity which characterized the genre, thus engaging the beholder in an intellectual game in the same way that literary works could do. Allegri's images are 'gems' of signification that invite the beholder to participate in their hidden truth in order to take visual and intellectual pleasure from them. The result in the case of Allegri's images, the Erasmian adages and the Greek epigrams was thus the creation of modern works of literary and visual culture that conveyed learning with wit in the poetics of *brevitas*. One may further ask if Allegri's creation of this unity of form and content in the *forma brevis* was already responding to the theory of art subsequently discussed in Paolo Pino's *Dialogo di Pittura* (1548). Pino wrote that painting is 'poetry itself, that is to say invention' and he recommended the observation of certain procedures such as that of *brevitas*, which he describes as the concision in the figurative *invenzioni* and in the pictorial process itself. The procedure of *brevitas*, Pino wrote, 'fills the beholder with admiration'.[64] Allegri's poetics of *brevitas* and his concealed language of form could further be seen in fruitful relation to the quintessential trait of the ancient painter Timanthes, in whose paintings, Pliny reports, 'more is

always implied than is depicted'.[65] Allegri's formal language and content in the Camera were combined to veil concepts, that is, to convey hidden truth in such a way as to capture the beholder all the more powerfully.

Giovanna da Piacenza, operating within a restricted, humanistically oriented circle, surely much appreciated and enjoyed the veiled images that a creative, ingenious artist like Correggio conceived within the genre of *aenigmata*, long before the poetics of brevity was declared the quintessential feature of poetic invention itself. Indeed, modern generations of beholders have continued to be stunned by the enigmatic features and appeal of the pictorial invention that Correggio created for an abbess's bedroom in early-sixteenth-century Parma.

ACKNOWLEDGEMENTS

I am grateful to the Charles S. Singleton Center for Italian Studies, to the Bibliotheca Hertziana (Max-Planck Institut) and to the Università degli Studi di Macerata for their financial support for of research. Those to whom I owe my thanks are legion. First, and foremost, to Charles Dempsey, my dissertation adviser, and Elizabeth Cropper. I am also much indebted to Salvatore Camporeale, Charles McKay, Pier Luigi De Vecchi, Pier Massimo Forni, Giovanna Perini and Julia Triolo for their generous help.

NOTES

1. Zanichelli (1979).

2. On the creation of private abbatial spaces in monastic communities, see Gilchrist (1994): 120–23; Bonde and Maines (1997).

3. Zarri (2000): 82–100.

4. Longhi (1956a): 57: ' … non è altro esempio paragonabile nel nostro Rinascimento. Nè i Camerini di Isabella, né la Stufetta del Bibbiena potrebbero stare al confronto.'

5. A critical discussion of Panofsky's method has been outlined in Holly (1984) and Bois (1985).

6. See Gombrich (1975); Pelta (1989); Calvesi (1990) and (1996).

7. See Stefaniak (1993) and Nova (2000).

8. See Greenblatt (1986) and Zemon Davis (1986).

9. Pelta ((1989): 129) has argued for the function of the chamber as Giovanna da Piacenza's bedroom on the basis of the reconstruction of the original function of abbatial spaces. In the current essay I consider the function of Allegri's Camera from a different point of view.

10. Affò (1794b): 44–5; Ricci (1930): 51–4.

11. Giehlow (1915): 35–40.

12. Ibid., 118–28.

13. Giraldi (1551) Vuilleumier Laurens (2000): 135–44.

14. See Balavoline (1984); Vignes (2001).

15. Colie (1973): 32–75; Champigny (1978); Fowler (1982): 222.

16. Erasmus (1991), 3 [33]: 3–28; Hutton (1935): 36.

17. Wittkower (1987): 127.

18. Modern biographies date the abbess's birth to 1479 on the basis of the declaration that she was twenty-eight years old at the time of her election in 1507: see Anon. (1999): 532. Since Giovanna da Piacenza's age was investigated and questioned from the very beginning, this invites speculations that the date of her birth was adjusted to fit the rule of the Benedictine order. Although I have not found any record in the baptismal registers, I believe that she was born in the mid-1480s.

19. Parma, Soprintendenza per il Patrimonio Storico, Artistico e Demoetnoantropologico, MS 101–111, Enrico Scarabelli-Zunti, *Materiale per una guida artistica e storica di Parma*, 111, cf. 227r, 'Chiesa di Santo Stefano'.

20. Parma, Archivio di Stato, Not. Gian Ludovico Sacca, f. 280, 28 November 1482, Sebastiano Bergonzi's will. Thanks are due to Alessandra Talignani for having brought this record to my attention.

21. Caterina da Piacenza married Cavaliere Scipione Montino Dalla Rosa, the canon Bartolomeo Montini's nephew and universal heir, as appears from several documents: Parma, Archivio di Stato, Not. Gaspare Bernuzzi, f. 611, 5 October 1518, Not. Galeazzo Piazza, f. 930, 26 January 1524. Cesare da Piacenza was married to Joanna Taurella who left money to Scipione Montino Dalla Rosa to found a chapel in the church of S. Antonio Abate in Parma: Parma, Archivio di Stato Not. Andrea Cerati, f. 744, 1528, 13 July 1528.

22. Zemon Davis (1986): 62–3.

23. Affò (1794b): 26; Dall'Acqua (1990): 31–5.

24. Zarri (2000): 89.

25. Arcangeli (1996): 167–8.

26. Horapollo (1950): 57: 'When they [Egyptians] wish to depict the Universe, they draw a serpent devouring its own tail, marked with variegated scales.'

27. Dempsey (1990): 490–93.

28. Zanichelli (1979): 26.

29. For hieroglyphic studies during the Renaissance the bibliography is becoming vast: See Giehlow (1915): 1–232; Iversen (1961): 57–87; Castelli (1979); Allen (1979): 107–33; Drysdall (1983); Wittkower (1987): 114–28; Dempsey (1988): 348–55; Curran (1997); and (1998–1999).

30. Parma, Soprintendenza per il Patrimonio Storico, Artistico e Demoetnoantropologico, MS 162, Enrico Scarabelli-Zunti, *Blasonario Parmense*, f. 153: 'Piacenza, Da'. On the *Portrait of a Man*, recently attributed to a follower of Girolamo Mazzola Bedoli and identified as a portrait of Giovan Battista Puelli, whose family had a kinship relationship with the Da Piacenza, see Giusto (1998): 74.

31. Erasmus (1508): 112r–115r, and 'Festina Lente', in Erasmus (1991), 3 [33]: 1–17.

32. See Erasmus (1964); Appelt (1942); Mann Phillips (1978) and (1990); Moss (1996): 106 *passim*; Eden (2001); Wesseling (2002).

33. Erasmus (1991), 3 [33]: 15–16.

34. See Wind (1968).

35. See [Colonna] (1499); [Colonna] (1980), 1: 61; 2: 91–3; and [Colonna] (1998), 2: 41. The dolphin–anchor image hieroglyphic was the trademark of Aldus Manutius.

36. Erasmus (1991), 3 [33]: 9.

37. Greene (1982): 137.

38. Ibid., 136.

39. Chamorat (1981), 2: 761–82.

40. Erasmus (1991), 3 [33]: 16.

41. Aristotle (1994): 6. 4–6, 6. 5–8, 6. 7. 4–7, 6. 8. 9–11. See Saint-Jean (1986) and Kuhn (1985): 89–114.

42. A discussion of Canon Carissimi's tomb, which was produced without the hieroglyphic inscription in the 1520s, is given in Talignani (1997).

43. Alberti (1988): 256, and (1485): 8. 4: 'Sed tituli quidem erunt aut scripti, quos epigrammata noncupant, aut notati signis et imaginibus.' (Translations here and below are by the author, unless otherwise indicated.)

44. On Baiardi and his literary writings see Tissoni Benvenuti (1972); Ceruti Burgio (1988); Medioli Masotti (1986): 231–61.

45. Pozzi (1984): 84 (iconic signs and letters 'combine authentic double meanings with hieroglyphics in the manner of Colonna and with banal equations between text and image').

46. Ibid., 89 also consult Céard and Margolin (1986), 1: 189–99 ('the only case of a rebus within a poem').

47. On the antiquarian and epigraphist Ferrarini, see Mitchell (1960): 476 *passim*; De Maria (1988): 22, 24; Franzoni (1999); and Franzoni and Sarchi (1999).

48. f. 35v. Professor Brian Curran and I are writing an article on this and other related drawings from Ferrarini's epigraphic codices. Reggio Emilia, Biblioteca A. Panizzi, 398, F. Michaelis Ferrarini Regiensis, *Antiquarium sive Divae Antiquitatis Sacrarium* (*Inscriptiones graecae et latinae undique collectae*), 8 nn. + CCXII ff.

49. Anselmus (1506), s.n.: 'Iam Bibliothece pluriiugis librorum voluminibus hieroglyphicis multi: graeculis nonnulli.'

50. Calcagnini (1544): 173.

51. Valeriano (1556), 2: 24. In his *Epiphylliades in Plautum* [Actii Plauti Asinii, *Comoediae viginti nuper emendatae, et in eas Pilade Brixiani Lucubrationes; Thadei Ugoleti, et Grapaldi virorum illustrium Scholia, Anselmi Epiphylliades*, Parma, 1510] Anselmi himself reports an instructive description of a classical coin that he had received as a gift, revealing an interest in numismatics on his part.

52. See Lefebvre (1984).

53. Bedrooms as locations of visions and possessive frights have been proposed in literature; see Propertius (1990): 2. 17, 5–6, and Petrarch (1995): 226. 7–8: 'For me the night is sorrow, bright sky dark; and bed for me a grievous battleground.'

54. Thornton (1991): 285–90.

55. Panofsky (1961): 46.

56. See Giraldi, 'De Diana, Luna, Hecate, Iside' in his *De Deis Gentium* (Giraldi (1976)): 491–526.

57. Boccaccio, 'De Luna Yperionis filia', in *Genealogiae Deorum Gentilium Libri* (Boccaccio (1951)): 4. 16, and 'De Diana prima Iovis secundi filia', 5. 2 (also in Boccaccio (1951)), records the Luna–Diana conflation. Boccaccio reports that Luna's chariot was drawn by horses, while Diana's was pulled by stags. The wheeled chariot depicted by Correggio is probably drawn by stags (though the truncation of the animals' heads makes their identity somewhat ambiguous), yet another means to render the Diana–Luna conflation.

58. Claudianus, *De raptu Proserpinae*, 2.30–35.

59. Catullus, *The Poems and Fragments* (Catullus (1871)): 34. 13–16.

60. Haig Gaisser (1993): 126.

61. Anselmi (1528): 2. 56.

62. Hagen (1924): 155; Ricci (1930): pl. 3.

63. For the Artemis–Selene conflation in classical art, see Daremberg and Saglio (1963) and Simon and Bauchhess (1981), 1: 900–911.

64. Pino (1960), 1: 115. The quotation comes from Pardo (1984): 336–7.

65. Pliny (1995): 35. 36. 77. On the Plinian ideal of compressing meaning, see Pfisterer (1996): 124–5.

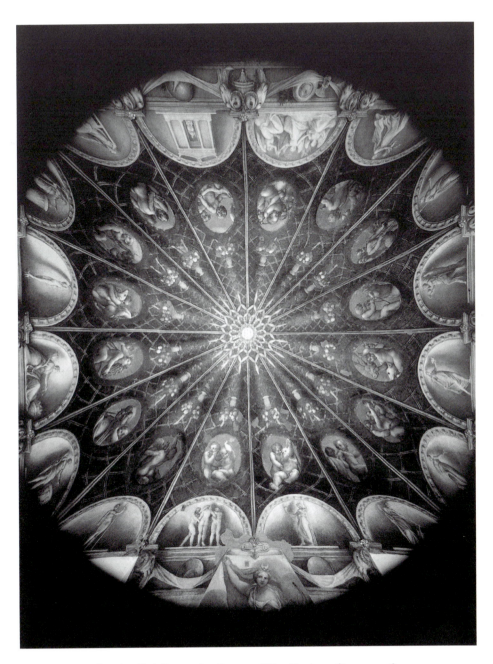

8.1 Antonio Allegri, called Correggio, Camera di San Paolo, ceiling, *c.* 1518–19, fresco, Parma, Nunnery of San Paolo

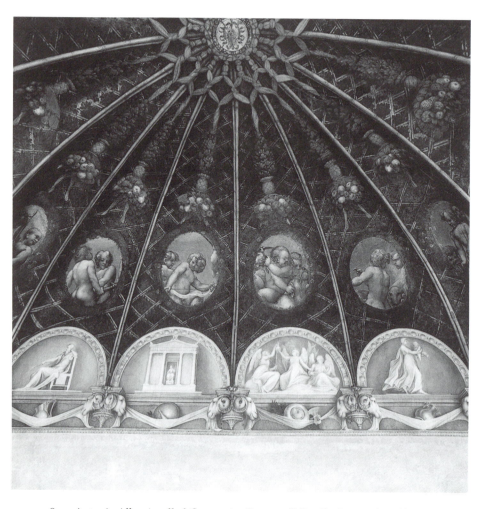

8.2 Antonio Allegri, called Correggio, Camera di San Paolo, south wall lunettes, *c.*
1518–19, fresco, Parma, Nunnery of San Paolo

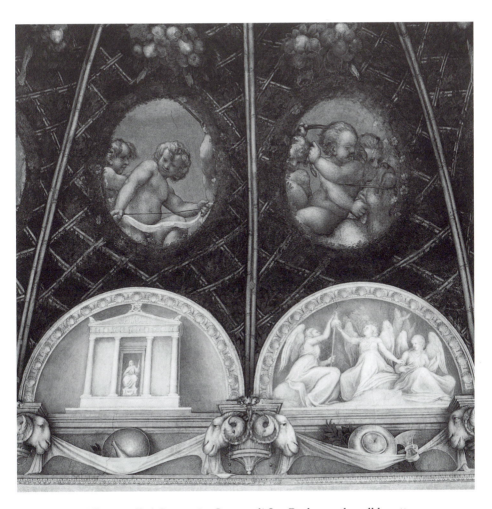

8.3　Antonio Allegri, called Correggio, Camera di San Paolo, south wall lunettes
(detail), *c.* 1518–19, fresco, Parma, Nunnery of San Paolo

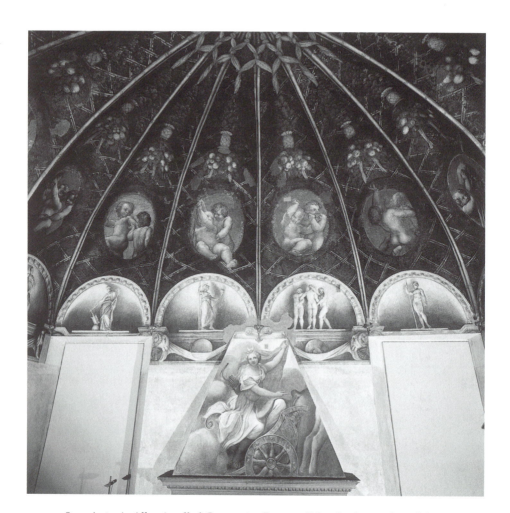

8.4 Antonio Allegri, called Correggio, Camera di San Paolo, north wall lunettes, *c.* 1518–19, fresco, Parma, Nunnery of San Paolo

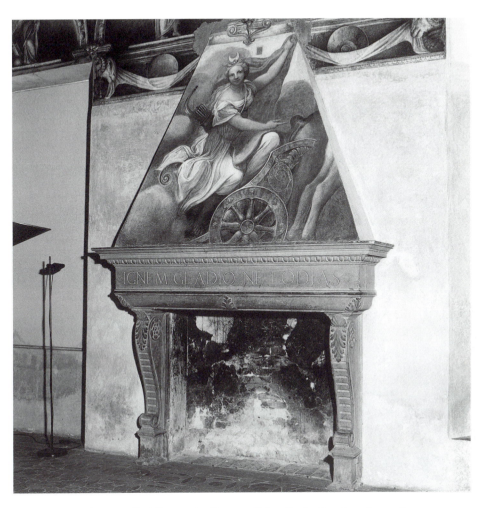

8.5 Antonio Allegri, called Correggio, Camera di San Paolo, fireplace decoration
with *Diana on her Chariot*, *c.* 1518–19, fresco, Parma, Nunnery of San Paolo

8.6 Enrico Scarabelli-Zunti, 'Da Piacenza', *Blasonario Parmense*, MS 162, 1. fol. 153, nineteenth century, ink on paper, Parma, Soprintendenza per il Patrimonio Storico, Artistico e Demoetnoantropologico di Parma e Piacenza

8.7 Anonymous artist, *Project for the Carissimi Tomb*, *c.* 1520, ink on paper, Parma, Archivio Notarile Distrettuale

PATIENTIA EST ORNAMENTVM CVSTODIA
ET PROTECTIO VITAE.[4]

8.8 Hieroglyphic, woodcut, detail from Francesco Colonna's *Hypnerotomachia Poliphili*, Venice: Aldus Manutius, 1499

Reconsidering Parmigianino's Camerino for Paola Gonzaga at Fontanellato

Mary Vaccaro

In the period immediately before his departure for Rome in 1524, Francesco Mazzola, better known as Parmigianino (1503–40), painted a small room, the so-called Camerino, in the Rocca Sanvitale of Fontanellato, near Parma, a commission for which no documents are known to exist.[1] The patron is traditionally identified as Count Galeazzo Sanvitale, whose portrait by the artist bears the date 1524, yet the room is usually associated with Sanvitale's wife, Paola Gonzaga. Scholars have widely speculated about the use of the Camerino, with possibilities ranging from it being Gonzaga's *stufetta*, or boudoir, to a ritual space commemorating her dead infant. The first hypothesis, which takes its cue from a depiction in the room of the goddess Diana bathing, disregards more serious aspects of the overall decoration, while the second, admittedly more sober, hypothesis presumes that a baby died in 1523, an assumption that subsequent literature has tended to accept as fact. This essay presents documentary evidence to refute the widely held notion of a deceased newborn. Although they are not necessarily a record of family tragedy, nor a carefree backdrop for a lady's bath, the frescoes in the Camerino pointedly thematize issues of gender and, in so doing, imply Paola Gonzaga's presence.

The decorative scheme visualizes the myth of Diana and Actaeon in the context of a trellised bower, thereby inviting organizational and iconographic comparison to Correggio's Camera di San Paolo, a private space intended for an abbess (see Chapter 8). Parmigianino transformed this prototype to create a strikingly original solution that also suggests a female spectator, in this case, a lay noblewoman. The artist recast the ancient legend into an elegant and arcane story, including certain passages that bear no evident connection to a known textual source. Formal correspondences articulate and complicate a visual narrative about reversals of identity and fortune. This essay will consider Parmigianino's artistic invention in order to explore

more fully the poetic and playful, as well as the moralizing, dimensions of the fresco cycle, and their relation to Paola Gonzaga.

Located on the ground floor near the northwestern corner tower of the Rocca Sanvitale, the Camerino is a small rectangular space, its architecture establishing the framework for Parmigianino's decoration.[2] A relatively flat ceiling rests on sail vaults, which meet as pendentives at the corners of the room and create a series of alternating spandrels and lunettes, below which runs a wooden entablature bearing an inscription. Frescoes occupy this entire upper zone, variously interpenetrating the space depicted with that of the spectator. The ceiling (see Figure 9.1) is painted as a lush pergola that opens, enframed by roses, in a broad octagon to the fictive blue sky. At the centre of the ceiling exists an actual mirror, its frame inscribed with the words 'RESPICE FINEM.' In the lower regions corresponding to the spandrels, as if in front of the dense greenery and latticework, appear putti, some winged, who wield fruits, vegetables and drapery, in varied attitudes. The sail vaults are decorated to resemble gilded mosaic, each bearing a circular aperture to the painted sky above, ornamented with ribbons and strings of red beads, whereas the spandrels terminate in architectural corner finials and gesso reliefs of snake-haired female heads. A visual narrative involving Diana and Actaeon unfolds in the fourteen lunettes, set in an evocative landscape that extends illusionistically beyond the room.

The overall arrangement finds an important precedent in the small square room painted by Correggio around 1519 for Abbess Giovanna da Piacenza in the convent of San Paolo in Parma.[3] The umbrella vault of the so-called Camera di San Paolo is similarly shown as a verdant trellis (see Figure 8.1). Ribboned garlands of fruit and vegetation are intricately knotted about the patron's heraldic device at the centre of the room, and a fictive oculus pierces the base of each rib, revealing, as if behind the bower, a parade of cavorting putti with dogs. Monochromatic lunettes contain a series of classicizing relief-like images, beneath which is painted an entablature with faux-finials of rams' heads. Above the room's fireplace is shown the quiver-bearing goddess of the hunt, rising into the heavens upon her chariot (see Figure 8.5), a figure that Parmigianino freely copied in an early red-chalk drawing.[4] The young artist thus certainly knew the decoration, although the suggestion that he worked as an assistant in the Camera di San Paolo remains, without further documentation, merely a tantalizing hypothesis.[5]

The Camerino confirms Parmigianino's intimate knowledge of Correggio's organizational scheme, paying homage to the older master in a profoundly innovative adaptation. References abound, as do changes and substitutions. A mirror appears at the centre of the ceiling in lieu of a heraldic medallion, inviting the beholder's specular relation to the illusionism. The play between actual and implied space, between two and three dimensions, is intensified.

Gesso reliefs of snake-haired female heads replace the fictive rams' heads, and the lunettes become a continuous field for narrative. Opening his arbour to a broad expanse of sky, he choreographed gracious cousins of Correggio's plump, rambunctious putti in front of (rather than behind) the foliage. Twisting sinuously along the spandrels, they bear the unmistakable mark of Parmigianino's elegant style. In the Camera di San Paolo, these characters carry the severed head of a stag and hunting equipment, which, together with Diana's portrayal above the fireplace, may suggest the myth of Actaeon. Such an allusion is more explicit in the Camerino, where episodes from the legend of the ill-fated hunter appear in the lunettes. Parmigianino's departure from known literary sources, however, proves to be as imaginative as his response to Correggio's visual prototype.

Although mentioned by several ancient writers, the most complete redaction of the Actaeon myth is found in the third book of Ovid's *Metamorphoses*.[6] According to Ovid, Actaeon, after bidding his companions to stop hunting in the midday heat, wandered into a woodland cave in the valley of Gargaphie, where Diana and her attendants were bathing. The terrified nymphs attempted, in vain, to shelter the goddess from the intruder's gaze. Embarrassed and enraged, Diana gathered a handful of water and threw it in the young man's face, challenging him, if he could, to tell others that he had seen her undressed. Horns sprouted on his head; he was gradually transformed into a stag, but only later, observing his reflection, recognized his altered identity. His hounds, more than thirty of which are named by Ovid, caught sight of him as a stag; deprived of speech, and thus unable to make them recognize their master, the hunter became the hunted. Actaeon was torn asunder by his own dogs, while his unknowing companions called for him to share the news of their prey. Ovid emphasizes the hunter's innocence, yet notes the divided public opinion on his punishment: some thought the deity had been too cruel, while others praised her action in light of her strict chastity.[7]

In the Camerino, an inscription questions Diana about her revenge. It reads: 'AD DIANAM / DIC DEA SI MISERUM SORS HVC ACTEONA DUXIT A TE CVR CANIBUS / TRADITVR ESCA SVIS NON NISI MORTALES ALIQVO / PRO CRIMINE PENAS FERRE LICIT: TALIS NEC DECET IRA / DEAS' ('Tell me goddess, if Fate led hither the wretched Actaeon, why was he handed over as a mere morsel to his own dogs? It is not permitted except that mortals should pay the penalty for some crime, nor is such anger befitting to goddesses').[8] The literary source of this tersely elegant epigram is untraced, and recent attempts to identify its author have been unconvincing.[9] Penned in Renaissance rather than classical Latin, it may well have been expressly composed for the room, perhaps by a local poet or humanist.[10] The inscription encompasses the entirety of the room's entablature and underscores, quite literally, the cursive nature of the fresco cycle.

Parmigianino's visual tale comprises three main episodes, each occupying a wall, beginning on the northern side. The story flows effortlessly from one lunette to the next, its clockwise scansion established by the careful orchestration of a rich cast of humans and animals. Nearly twenty dogs direct attention throughout the cycle, especially facilitating visual transitions at the room's corners.[11] Compositional motifs echo and reverse each other. On the north wall (see Figure 9.2), for example, two men pursue a female hunter, one of whom pulls at her mantle, as she turns to look at him. The figural group formally corresponds to the scene directly across the room (see Figure 9.4), where a stag (Actaeon) regards a hunter blowing his horn, the call to the dogs that have begun to assail their master.[12] The fluent imagery invents, as much as illustrates, content. On the east wall (see Figure 9.3), two bathing nymphs calmly observe the nude Diana sprinkling water upon Actaeon, whose head is already zoomorphic. This episode, together with the canine attack on the south wall, accords generally with Ovid's redaction. Yet the pursuit scene on the north wall, so integral to Parmigianino's overall design and narrative structure, has no evident connection to a textual source. Through an intricate network of contrapuntal formal relationships, the artist has retold a classical myth about gendered vision and mutability, about reversals of identity and fortune.

Relatively few graphic preliminaries survive for Parmigianino's decorative programme, frustrating efforts to understand its creative evolution and intended message.[13] A preparatory study for Diana's confrontation with Actaeon differs considerably from the final solution; in particular, it depicts a fully human Actaeon in contemporary garb rather than, as painted, with a stag's head and classicizing costume.[14] Although clearly designated male in the drawing, the actor's gender in the fresco is uncertain. 'His' outfit is curiously similar to that worn by the female hunter on the adjacent north wall.[15] Actaeon looks back towards the scene of the latter's pursuit, underscoring the link between the two walls, and the gaze of Actaeon's stag head is mirrored by that of the female hunter's dog. A clever coincidence of word and image elaborates the gender ambiguity. Directly beneath the female hunter, on the entablature, appears the Latin accusative 'ACTEONA', a word with an ending that, in Italian, recalls feminine nouns.[16] Another visual pun is found on the east wall, where one of Diana's attendants rests her hand on two books (fons) by the side of the fountain (fons), perhaps a reference to Fontanellato (literally, the 'big fountain'),[17] as well as to the textual sources imaginatively re-presented in the room. Her companion points to herself at the same time, calling attention to Actaeon's conversion.[18] Such correspondences brilliantly visualize the reflexive operations of metamorphoses: human to animal, man to woman, other to self.

The west wall (see Figure 9.5), painted last in the sequence,[19] contains a central lunette of a woman holding two stalks of grain and a cup with

exaggerated voluted handles.[20] Dressed in flowing drapery that exposes her breasts, her eyes downcast, she turns her body in a three-quarter pose toward the north wall, where the narrative proper commences. A fictive golden niche isolates her from the overall cycle, but her strategic placement declares her importance. Just above the window, and on an axis with the room's original entrance,[21] she is directly across from Diana. The entablature inscription begins and ends to either side of the window below her, and the visual story similarly revolves around her. She has been variously called Hospitality, Abundance, Summer, Autumn, Pomona and Demeter (Ceres), personifications that take into account the wealth of vegetation depicted in the room.[22] Whatever her allegorical significance, she is commonly described as Galeazzo Sanvitale's wife, Paola Gonzaga, an identification that was first proposed in the nineteenth century.[23]

Born in 1504, Paola Gonzaga was the eldest daughter of Ludovico Gonzaga of Sabbioneta and Francesca dei Conti Fieschi.[24] Unlike her famed younger sister Giulia, a legendary beauty who later married Vespasiano Colonna, relatively little is known about Paola. Archival documents suggest her considerable wealth, partly amassed from a marriage that ended with her first husband's premature death. In 1516, at the age of twelve, she married Galeazzo Sanvitale, Count of Fontanellato, Belforte and Noceto, eight years her senior; the fruitful partnership lasted thirty-four years and resulted in nine children.[25] Parmigianino painted a portrait of Galeazzo Sanvitale[26] which bears the date 1524, a project contemporary with the Camerino decoration. A double-sided drawing (private collection, New York) offers a preliminary idea for the picture, in which the sitter turns to a woman, presumably his wife.[27] Her resemblance to the figure on the west wall seems to support the latter's connection with Paola Gonzaga. The possibility merits consideration, even if it cannot be verified, since a comparably pivotal character in the Camera di San Paolo is often linked with its patron Giovanna da Piacenza.[28] Nevertheless, the decorative scheme in the Camerino more broadly – if not so literally – fashions an image of Paola Gonzaga.

Although Galeazzo Sanvitale is traditionally considered to have been the patron of the Camerino, his wife may well have had an active share in the commission. Interpretations tend to associate the space with Paola Gonzaga. According to Augusta Ghidiglia Quintavalle, the room was Paola Gonzaga's *stufetta*, a hypothesis that takes its cue from the scene of Diana bathing on the east wall.[29] The author alluded to possible moral implications of the fresco cycle, yet emphasized its delightful vision of a mythological world.[30] Despite the lack of a plumbing system, she imagined a portable tub directly beneath the ceiling mirror, in which the lady of the castle admired her reflection, as she enjoyed the painted story. Maurizio Fagiolo Dell'Arco specified the bathroom to be a *balneum nuptiale*, a hermetic space for the *coniunctio* of female (Paola

Gonzaga) and male (Galeazzo Sanvitale) principles.[31] He did not adequately demonstrate, however, the patrons' interest in alchemical doctrine, nor the artist's, whose alleged preoccupation with alchemy dates to much later in his career.

Sydney Freedberg recognized certain liberties taken by Parmigianino with the Ovidian legend, such as the pursuit scene on the north wall, but concluded, rather generally, that the fresco cycle was a bucolic 'ode on the midsummer season, spun out on the ideal core of the Actaeon theme'.[32] In 1981 Germano Mulazzani also registered the artist's departures from the literary text and first observed, albeit in passing, the similar dress worn by the female hunter and by Actaeon on, respectively, the north and east walls. He understood the overall programme in terms of a duality between Diana (chastity, the hunt) and the figure on the west wall, whom he identified as Paola Gonzaga in the guise of Pomona (fertility, agriculture). Moreover, he pointed to the biographical implications of the joyous pictorial celebration of fecundity, noting that two putti (a little girl with earrings who holds a newborn) depicted on the central spandrel of the south wall are traditionally thought to be Paola Gonzaga's children.[33]

Six years after he wrote, Ute Davitt Asmus developed Mulazzani's comments to offer a very different, and enormously influential, hypothesis that linked the decoration instead to a candelit ritual space about maternal loss.[34] She described the figure on the west wall as Paola Gonzaga, holding the Eucharistic signs of bread and wine, and inferred from the darkened oculus above her that the room was originally unfenestrated.[35] The tripartite narrative cycle – the 'caccia d'amore', the fountain and the death – was seen as a passage toward transcendental experience. Davitt Asmus understood the sartorial parallel between the female hunter and Actaeon in terms of their symbolic identification, the lover transformed into the beloved, with Actaeon's conversion into a stag ultimately serving as an emblem of Christ's sacrifice.[36] The scholar related the imagery, especially the episode of Actaeon's demise, to the newborn child depicted in the spandrel just above (and pointing to) this scene, whose coral necklace and cherry branch are attributes associated with the Passion. She postulated that this infant represented Sanvitale and Gonzaga's dead baby, substantiating the claim with a hitherto unpublished document, dated 4 September 1523, concerning the baptism of an unnamed son of the couple.[37] Moreover, Davitt Asmus argued that the lack of early references to the Camerino was part of a deliberate suppression of the memory of Galeazzo Sanvitale by the Farnese in the sixteenth century.[38]

Davitt Asmus' theory has been so widely accepted that scholarly studies and tourist pamphlets alike have since regularly characterized the Camerino as a secret, originally unfenestrated, memorial to a dead baby. In 1990 Pietro Citati identified the figure on the west wall as Paola Gonzaga in the guise of

Demeter, an association that plausibly alludes to maternal suffering, since Demeter, goddess of fertility, lost her daughter, if only temporarily, to the Underworld. He speculated that the dark chamber was an *anaktoron* dedicated to the Eleusinian mysteries, a hypothesis for which no evidence exists.[39] Franco Maria Ricci and Gianni Guadalupi in 1994 considered the cycle to be an allegory of Paola Gonzaga's loss, in which Diana, goddess of maternity, unjustly punishes the innocent. They observed Actaeon's portrayal as a woman, pointing to the deliberate word-play of 'ACTEONA' on the inscription beneath the female hunter (Actaeon) on the north wall.[40] Roberto Tassi (also in 1994) suggested that the space was Paola Gonzaga's windowless *studiolo*, and followed Davitt Asmus and Citati in linking its decoration to personal grief;[41] Katherine McIver (in 1997) stressed Gonzaga's joint patronage with her husband, yet essentially reiterated Tassi's argument.[42] Not only has the putative death of a baby in 1523 been accepted as fact, but the cause of his death has also evidently been determined.[43]

Such propositions, though they provide a more sober alternative to interpreting the Camerino as a fanciful bathroom, rely on several key premises that should be reassessed, based on the evidence. For example, the recent restoration campaign in the Camerino indicates the original existence of a window, if smaller in dimension than the present aperture.[44] Parmigianino accommodated the actual light source by modulating the cast shadows in the fictive oculi. The blackened oculus above the figure on the west wall thus accords with the window's position directly below. It does not perforce associate her with symbolic darkness, nor substantiate that the chamber was once dark and candlelit. The widespread belief in the room's secret, even historically suppressed, character is also doubtful. Although the earliest-known published mention of the Camerino dates to the seventeenth century (by Fontana in 1696), a sixteenth-century manuscript belonging to the Sanvitale family lists the site as a touristic point of interest.[45]

Finally, the baptismal document published by Davitt Asmus confirms a son's birth, not death, and thus only tentatively supports her theory. Yet, as this essay contends, the document bears other key implications. Its neat notarial hand and decorative borders[46] bespeak an importance that is largely related to the eminent godfather named therein. On 4 September 1523, Cardinal Innocenzo Cybo[47] officially appointed two clerics in Parma to baptize the child by proxy and declared his spiritual kinship with Galeazzo Sanvitale and Paola Gonzaga.[48] The alliance typifies the early modern practice of selecting godparents for socio-political, as much as spiritual, reasons; Sanvitale's particular choice belies the recent contention that he was anti-papal to the point of unorthodoxy.[49] Perhaps the link between Cybo, whose mother was a Medici, and Sanvitale also facilitated, the following year, Parmigianino's access to the Medicean papal court; once in Rome, the artist

painted the cardinal's brother Lorenzo Cybo, a portrait similar in format to that of Galeazzo Sanvitale.[50]

The baby is predictably unnamed in the document, since children would officially receive their Christian names at the time of baptism. Newly discovered evidence permits me to identify the child in question and refute the theory of his premature death. Pompeo Litta's well-known genealogy registers that Sanvitale and Gonzaga had nine children, but does not include their birthdates.[51] The 1545 census of Parma lists the names and ages of all nine children, thereby allowing me to determine their respective years of birth.[52] In 1523, the couple had the first of their nine (recorded) children, Eucherio, who died in 1571 in France, where he served as Bishop of Viviers. His long and distinguished ecclesiastical career[53] may have had its auspicious beginnings in his parents' choice of a godfather. The census indicates that, already by 1545, Eucherio was a Monsignor living in Rome.

Although it is no dark memorial to a recently deceased newborn, the Camerino operates more broadly in poetic terms. Davitt Asmus equated the scene of pursuit on the north wall with a *'caccia d'amore'*, in which the lover is transformed into the beloved ('amor trasformat amantem in amatum'), and cited its literary tradition, although without mention of Petrarch.[54] Parmigianino's interest in Petrarch at the time is clear from the aforementioned preparatory drawing for the Sanvitale portrait, which includes pen trials with a phrase ('amor quando fioriva') that I have traced to a poem in the *Canzoniere*.[55] In 1996 Daniel Arasse suggestively linked the Camerino decoration with the poem (no. 23) 'Nel dolce tempo', in which Petrarch, transformed by his love for Laura, likens himself to Actaeon.[56] The poem reworks a series of Ovidian metamorphoses to thematize reversals in identity: the hunter turned into hunted, human into animal, self into other.[57] Parmigianino also manipulated his visual narrative into a complex system of shifting identities. As Arasse noted, the ceiling mirror serves to organize the entire fresco cycle's specular continuities ('spécularité giratoire'). Arasse linked Sanvitale with Actaeon, and Gonzaga with Diana, as well as Demeter, and concluded that the programme served as the husband's homage to his wife's beauty and fertility. Alessandro Nova and Michael Thimann have both identified the intended viewer as Sanvitale, rather than his wife, although each author offers a very different interpretation of the cycle's meaning. Nova read the cycle, perhaps too exclusively, in terms of male desire and voyeurism, whereas Thimann notes instead the philosophical and moralizing implications for the male viewer.[58]

I wish instead to consider more actively Gonzaga's role as viewer of the cycle and to link the interior more broadly to the material culture of childbirth in Renaissance Italy. Parmigianino's frescoes problematize a story about gendered vision and play with tensions between form and identity, notably

the ambiguity between the female hunter and Actaeon. The Camerino's original function is not known, but its position deep on the ground floor of the Rocca accords with that of summer apartments and women's quarters.[59] The bathing nymph's clever reference to books on the east wall suggests the possibility of a *studiolo*, perhaps intended for Gonzaga. The lack of a surviving contract frustrates a more precise understanding of the project, which may well have entailed her collaboration. Isabella d'Este, consort of Francesco Gonzaga, was profoundly involved in the commission to decorate her *studiolo*, using classicizing imagery to declare her erudition and moral virtue.[60] The Camerino decoration is based on that of the Camera di San Paolo, a private space intended for a woman, and, in turn, it inspired Girolamo Mazzola Bedoli's more prosaic design for a lady's chamber.[61] Given their documented connection to Abbess Giovanna da Piacenza's brother-in-law,[62] Sanvitale and Gonzaga may have known Correggio's room and requested Parmigianino to consider the prototype. The artist reworked Correggio's example to accommodate a lay female beholder, who, like Isabella d'Este, would have had different concerns to those of an abbess.

Beauty, chastity and procreation were major preoccupations for noblewomen, as for their husbands, who desired dynastic continuity. Awareness of the dangers associated with childbirth, such as high mortality rates, led to a variety of objects that provided young mothers with encouragement and talismanic protection.[63] Imagery on birth trays, for example, showing infant boys and lush vegetation, was typically used to stimulate the maternal imagination toward the creation of healthy, preferably male, children.[64] The almost exclusively male putti bearing fruit and vegetables in the Camerino accord with this visual tradition, as does the couple of fighting putti in the central spandrel on the north wall.[65] The more individualized pair on the south wall suggests portraiture, the younger of the two plausibly the newborn Eucherio.[66] His coral necklace is an object commonly worn by babies in early modern Italy for apotropaic purposes,[67] and the cherry branch is a possible allusion to fertility: a Renaissance birth tray, for instance, shows a winged putto with coral jewelry and two cherry-filled cornucopias.[68] The identity of the girl with earrings remains a mystery, since the first of Gonzaga's three (recorded) daughters was born in 1528.[69]

The myth of Actaeon appears on several Renaissance birth trays, a thematic choice only partly explained by Diana's traditional association with obstetrics. The story lent itself to moral judgements, as is made clear in the case of one such tray, whose reverse image includes a personification of Justice.[70] The female viewer was presumably to identify with Diana's chastity, an important attribute if the patrilineal purity of children was to be ensured. Yet the visual narrative in the Camerino complicates, if not inverts, such identification. The inscription questions Diana's revenge, thus emphasizing Actaeon's

innocence, and the visual story makes the latter's gender ambiguous. The parallel between Actaeon and the female hunter, as well as the word-play of 'ACTEONA', creates an interpretive game open to multiple readings. One of the goddess' attendants points to herself, while indicating Actaeon's metamorphosis, further underscoring the story's reflexive potential.

The elusive figure on the west wall, perhaps Paola Gonzaga in the guise of Demeter, begins and concludes a cycle that celebrates fecundity, yet recognizes the potential for sorrow. Her strategic placement across from Diana, as well as the inscription challenging the latter's retaliation, reinforces the message. So does the cautionary reminder inscribed along the ceiling mirror's frame, 'RESPICE FINEM' ['consider the end'].[71] The maxim derives from Solon's ancient wisdom not to consider oneself happy until the end, for only then can one's life be fully assessed.[72] Petrarch's writings, including his sonnets, allude to the adage, and his *De remediis utriusque fortunae* explicitly quotes the words to warn against fortune's whims.[73] This message had special relevance to Actaeon's grandfather Cadmus, who had a large family of great affection. 'But indeed, one must ever wait for the last day of a man's life', writes Ovid, 'and call no one happy until he is dead and buried.'[74] Actaeon's plight is the first of adversities to befall the house of Cadmus, among whom was numbered Narcissus, doomed to an inaccessible love that literally collapses the boundary between lover and beloved.

The reverse of the aforementioned drawing by Parmigianino for the Sanvitale portrait contains ideas for the Camerino finials, including a lovely female face that recalls the idealized likeness thought to be of Paola Gonzaga. The charming head would evolve into the snake-haired masks used as spandrel finials, part of a broader system of metamorphoses that declares art's petrifying capacity to alter nature. In the Camerino, Parmigianino transformed Correggio's example, and even the myth of Actaeon; the fresco cycle's specular reversals culminate in the ceiling mirror, a clever allusion perhaps to Ovid's third book, which includes the tale of Narcissus. The mirror's moralizing adage, as well as the entablature inscription's emphasis on justice, complements (but does not fully explain) the visual narrative.[75] The artist rendered a tragic story with exquisite grace, weaving together form and content, and choreographed putti in an arbour that portends bounty. He reworked the myth to address a noblewoman for whom beauty and fertility were presumably major concerns, and whose prosperity was to be cautiously enjoyed, as the bittersweet decorative scheme would have reminded her.

Seven years separate the time of Paola Gonzaga's marriage until her first (recorded) baby, leaving open the possibility that she may have lost a child before 1523. Nevertheless, the Camerino frescoes may have functioned in terms of sympathetic magic, as did birth trays and objects associated with

childbirth. She was no doubt aware of the attendant mortality associated with her maternal role; her sister Eleonora, married to Girolamo Martinego in Brescia, would die some years later while giving birth.[76] Paola Gonzaga bore eight children in close succession after Eucherio's arrival in 1523.[77] Among these was a daughter called Clizia,[78] the name of a nymph who turns into a sunflower in the *Metamorphoses*, suggesting that Gonzaga knew the Ovidian text well enough to appreciate Parmigianino's creative departures.

ACKNOWLEDGEMENTS

I am indebted to the Soprintendenza dei Beni Artistici e Storici di Parma e Piacenza, as well as to the Opificio delle Pietre Dure di Firenze, for access to the monument and its restoration. Research for this essay was made possible by the generous financial support of Villa I Tatti–The Harvard University Center for Italian Renaissance Studies, the National Endowment for the Humanities and the Fulbright Commission. I thank Nancy Palmeri and Giancarla Periti for editorial suggestions.

NOTES

1. For a summary of the project, see Vaccaro (2003): 143–5, with previous bibliography.

2. The room measures 3.5 by 4.36 metres. On the architectural history of the Rocca Sanvitale, see Grassi (1932) and Di Giovanni Madruzza (1981).

3. On the Camera di San Paolo, see Barocelli (1988), with colour reproductions and reprints of three major related studies, and the essay by Periti in the present volume.

4. Metropolitan Museum of Art, New York, inv. 10.45.4; Popham (1971): no. 295*recto*: illustrated with related catalogue entry in Bambach *et al.* (2000): 80. Bambach suggests that Parmigianino's drawing may have been an independent iconographic exercise for the Camerino.

5. Affò (1794b), reprinted in Barocelli (1988): 59–60, and Tassi (1994): 122.

6. Ovid, *Metamorphoses*, 3.138–255. A profusion of editions, including commentaries and translations, attests to the popularity and authority of Ovid's *Metamorphoses* in early modern Italy, for which see Guthmüller (1981). Nearly half of the 34 editions published by 1500 include Raphael Regius' Latin commentary, which moralizes Actaeon's predicament to warn against profligacy. The *Ovid moralizatus* instead compares Actaeon to Christ. On the Actaeon myth and its interpretation, see Barkan (1980). Textual sources have been used persuasively to explain Renaissance pictures after Ovidian themes (e.g., Ginzburg (1980)). Yet the Camerino eludes precise connection to a known literary redaction. On artists' deliberate departures from Ovid, including Parmigianino, see DeLong (1995).

7. 'Rumor in ambiguo est; aliis violentior aequo visa dea est, alii laudant dignamque severa virginitate vocant: pars invenit utraque causas [3.253–55].' Further on the association between chastity and Diana's action against Actaeon, see below.

8. I thank Nicholas Horsefall for the translation and expertise. The line breaks correspond to the inscription's placement along the walls, whereas the actual line breaks occur after *duxit*, *suis* and *penas*. The inscription appears to be integral, although the entablature is slightly cut to the north of the window, probably due to the window's subsequent enlargement.

9. McIver ((1997): 103, 106) asserts that Paola Gonzaga invited literary figures to Fontanellato, including Benedetto Albineo di Bianchi, who wrote a commentary on the Actaeon myth, as well as possibly the entablature inscription. To support the claim, McIver cites only Ricci, here listed as Dall'Acqua (1994): 14–16, in which Dall'Acqua mentions Albineo and other authors in the Sanvitale court at Sala, not Fontanellato. Compare Chiusa (2001) with a virtual transcription of

Dall'Acqua's text, without citing him as a source, nor adding further useful information. Although the two familial branches were presumably in contact, very little is known about the literary milieu of Fontanellato. I have not been able to confirm that Albineo wrote a commentary on Actaeon: according to Affò (1789–1833), 4: 254–5, not a single work by the elusive poet survives, nor is recorded.

10. A possible candidate is Giambattista Plauzio, who dedicated his commentary on Persius' *Satires*, published in 1516, to Galeazzo Sanvitale's father, Giacomo Antonio. According to Affò (1789–1833), 3: 232–4), the poet, a native of Fontanellato, was still alive in 1533.

11. Regarding a print source for the dogs, see Brown (1981).

12. The horn-blower's mouth, like Diana's eye on the east wall, shows evidence of gouging, as indicated to me by restorer Maria Rosa Lanfranchi (oral communication, 1999). The defacement seems intentional, perhaps by a beholder sympathetic to Actaeon's dilemma. On the magical power and deliberate destruction of images, see Freedberg (1989).

13. On the related drawings, see Popham (1963) and Vaccaro (2000): 68–71. Popham speculated that Parmigianino may originally have planned to include other scenes from the *Metamorphoses*, notably the Abduction of Europa.

14. Pierpont Morgan Library, New York, I, 49 (Popham (1971): no. 313*verso*); illustrated with related catalogue entry in Bambach *et al.* (2000): 88–9. The *recto* contains ideas for the putti in the spandrels. I cannot explain Freedberg's comment ((1950): 164) that, in the Morgan drawing, Actaeon was posed for by a draped female figure.

15. As first noted by Mulazzani (1981): 161. The only difference in costume is Actaeon's bow and arrow.

16. As noted by Ricci and Guadalupi in Dall'Acqua (1994): 135–6.

17. As noted by Davitt Asmus ((1987): 18–21), and Tassi ((1994): 135–6).

18. The woman's head formally echoes, in reverse, the placement of Actaeon's stag head, further linking the two actors. Her face resembles that of the female hunter on the north wall.

19. Corresponding to the last of the forty *giornate* during which Parmigianino executed the entire cycle. See related technical diagrams by Francesca and Anna De Vita in Fornari Schianchi (1999): 137–8.

20. The cup is not an ancient type, as kindly confirmed by Brian Rose (written communication, 2000). Its fanciful voluted handles typify Parmigianino's aesthetic tendencies; the basket beneath the pair of putti on the north wall has similarly exaggerated handles.

21. According to restorer Maria Rosa Lanfranchi (oral communication, 1999), the profile of the original entrance appears to be beneath the figure of Diana on the east wall.

22. The identification as Hospitality (e.g., Sanvitale (1857) derives from a twofold misconception that Sanvitale gave refuge to Parmigianino during his difficulties with the Steccata confraternity, and that the artist painted the Camerino late in his career as a gesture of gratitude. The first published mention of the room (Fontana (1696)) identifies the figure as a muse who directs attention to the entablature inscription. Ratti (1781) as Ceres; Affò (1784) as Summer or Autumn; Copertini (1932) as Ceres, Hospitality, or maybe Peace; Freedberg (1950) as Summer; for other interpretations, see below.

23. See Sanvitale (1857): 36, who also first mentions two children (one with a coral necklace, the other in earrings) depicted on the south wall as 'supponibile che fossero le effigie vere di due piccoli figliuoli del Signore della Rocca di Fontanellato'. Further on this below.

24. On Paola Gonzaga, see Vecchi (1996), with previous bibliography, and (with caution) McIver (1997).

25. See Vecchi (1996): 295, for a transcription of the dowry agreement (22 January 1516) between Paola Gonzaga's father and Galeazzo Sanvitale. The original is in the Archivio di Stato, Parma, Fondo Sanvitale, Patrimonio familiare, *busta* 10, which contains other documents related to the marriage, for example, Sanvitale's donation of property to his wife (e.g., 1 May 1548, rog. P. M. Bonvicini), which she, in turn, bequeathed to their six sons on 28 March 1551. Galeazzo died in 1550. Regarding their children, see below.

26. Museo e Gallerie Nazionali di Capodimonte, Naples, inv. Q111. Illustrated with related catalogue entry in Fornari Schianchi and Spinosa (1995): 180–81, and Vaccaro (2003): 194–6.

27. Private collection, New York (Popham (1971): no. 748*verso*); illustrated with related discussion in Bambach *et al.* (2000): 90, and Vaccaro (2000): 71. The *recto* contains ideas for the Camerino

finials, suggesting the artist's contemporaneous involvement with the project. Ghidiglia Quintavalle's hypothesis ((1967): 9–10) that the double portrait was originally planned for the central lunette on the west wall is not altogether persuasive.

28. Giovanna da Piacenza is often identified, heraldically and temperamentally, with the goddess Diana depicted in the Camera di San Paolo. The characterization of the abbess' belligerent, and even pagan, disposition is misguided, as recent studies (e.g., Winkelmes (1997)) recognize. Correggio's decorative scheme implies her chastity, erudition and religious charge, as does the adjacent room that Alessandro Araldi painted for the abbess some years earlier, for which see Zanichelli (1979). Parmigianino's drawing (see above, note 4) registers his interest in Correggio's figure of Diana.

29. See Ghidiglia Quintavalle (1967) and (1968): 74–168.

30. Ghidiglia Quintavalle ((1968): 74), links the moralized message to Galeazzo Sanvitale ('agire con oculata prudenza senza lasciarsi trascinare dall'ira, monito importante per un condottiere dell'epoca').

31. Fagiolo Dell'Arco (1970): 35–41, based, in part, on Popham's and Ghidiglia Quintavalle's respective suggestions that a scene of Europa and a double portrait may originally have been planned for the Camerino. Fagiolo Dell'Arco identifies Gonzaga with Diana (moon) and Sanvitale with Jupiter (sun). Neither Sanvitale, nor Jupiter's abduction of Europa, was depicted in the Camerino, however.

32. Freedberg (1950): 51–3. Freedberg's formal analysis of the Camerino and its harmonious design is astute.

33. Mulazzani (1981): 158–65.

34. Davitt Asmus (1987). I am indebted to Megan Weiler for her generous help with the German translation.

35. Ibid., esp. 38, n. 14, with mention of Parmigianino's design, possibly for a candelabrum (Popham (1971): no. 547), that once belonged to the Sanvitale. The design can be dated stylistically to the artist's second Parma period, however, much later than his work in the Camerino.

36. Ibid., esp. pp. 26–34. The decorative system, with its contrast of lifelike figures and animals with the petrified snake-haired female heads, is seen in terms of Christian triumph over the ancient world. The scholar alludes as well to the Jewish Laubhuttenfest, a festival traditionally held in an ephemeral garden-room.

37. See ibid., 22–3, and 46–7, n. 60, for a transcription of the document. The original is in Archivio di Stato di Parma, Fondo Sanvitale, *busta* 875.

38. Ibid., 52–53, n. 91. See Davitt Asmus (1983) on Galeazzo Sanvitale's portrait, and the hypothesis that the Farnese suppressed his memory due to his pro-French political ties and unorthodox religious views. Yet the Farnese probably acquired the portrait, along with the so-called Palazzetto Eucherio Sanvitale, directly from Galeazzo's son Eucherio, a steadfast Farnese ally. Further on Eucherio Sanvitale below.

39. Citati (1990): 4–5.

40. See Ricci and Guadalupi in Dall'Acqua (1994): 15–16, identifying the figure on the west wall as Diana/Hecate, and characterizing the room as 'un luogo della memoria e della meditazione, destinato al ricordo del bimbo morto ... rischiarato solo dalla luce artificiale delle candele, era un luogo privatissimo, una cripta del dolore riservata alla famiglia, che per un secolo la tenne nascosta ... '.

41. Tassi (1994): esp. pp. 127–38.

42. McIver (1997); Davitt Asmus's argument is also rehearsed, in Chiusa (2001): 42–53.

43. See McIver (1997): 106, claiming that the baby died of influenza, apparently a mistranslation of McIver's source (Tassi (1994): 127) that notes the influence of the child's death on the fresco cycle ('quella morte abbia avuto influenza sul significato della Camera e quindi possa averne modificato il progetto').

44. The figure on the west wall, and the fictive cornice beneath her, are painted on original intonaco. For the Camerino restoration, see Fornari Schianchi (1999) and Bandini *et al.* (2000). Thanks to Luisa Viola for providing me with a copy of the latter publication. I am grateful for related conversations with restorers Francesca and Anna DeVita, as well as Cristina Danti and Maria Rosa Lanfranchi.

45. Sanvitale (1857) quotes a sixteenth-century manuscript, at the time belonging to the Sanvitale family, which declares 'il camerino del Signor Luigi [son of Galeazzo Sanvitale and Paola Gonzaga, and count of Fontanellato after his father's death], tutto dipinto di mano di Francesco Mazzola, sopranominato il Parmigianino eccellente pittore', to be, together with the armoury, the main tourist attraction in the Rocca. I have not consulted the original manuscript.

46. Illustrated in Davitt Asmus (1987): 21 (figure 17).

47. On Innocenzo Cybo, see Petrucci (1981), with previous bibliography.

48. Archivio di Stato di Parma, Fondo Sanvitale, *busta* 875: 'Dominus Innocentius Cibo, miseratione divina sancte Marie in Donica [Dominica] diaconus cardinalis ... fecit, constituit, nominavit et solemniter ordinavit eius veros et legitimos procuratores, actores, factores et certos numptios speciales et quidquid melius et efficatius dici, nuncupari et esse potest, nobiles ac reverendos viros dominum Joannem Baptistam de Tonsis, parmensem, presentem et acceptantem, ac dominum Hieronimum etiam de Tonsis, parmensem, absentem sed tamquam presentem, specialiter nominatim et expresse, ad baptizandum et de sacro fonte levandum et ad baptismum sacrum tenendum filium illustrissimi comitis Galeacii de Sancto Vitali, conceptum et natum ex se et illustri domina Paula de Gonzaga, eius legiptima uxore, et acceptandum vice et nomine prelibati reverendissimi domini cardinalis constituentis, firmandum, ineundum, et contrahendum compartenitatem et spiritualem cognationem cum prefatis illustri comite Galeacio et domina Paula eius consorte ... '. I thank Fabrizio Tonelli for his transcription and expertise.

49. Davitt Asmus (1983); cf. Tassi (1994): 128.

50. Statens Museum for Kunst, Copenhagen, inv. Sp. 73; illustrated with related entry in Vaccaro (2003): 196–7. Lorenzo Cybo was Captain of the Papal Guard.

51. Litta (1820): table II. See Archivio di Stato di Parma, Ms.y8, table IIa for Ronchini's valuable additions to Litta's genealogical table, although also without birth dates for Sanvitale and Gonzaga's children.

52. Archivio di Stato di Parma, Archivio comunale, Estimi, Descrizione degli abitanti di Parma (1545), *busta* 1933. The respective names and ages of the entire Sanvitale household in the city, as well as at Fontanellato and abroad, are listed under the district of Santo Spirito (6 November 1545). At the time, the youngest children (Pierino, 13; Luigi, 10; and Roberto, 9) were living with their parents, presumably in the so-called Palazzetto Eucherio Sanvitale (near Santo Spirito). All three daughters (Philotea, 17; Clizia, 13; Pericaria, 11) were already in the Benedictine convent of S. Quintino. Federico (21) and Giacomo (18) are listed as living in France, and Eucherio (22), as a Monsignor in Rome. The children's years of birth: Eucherio, 1523; Federico, 1524; Giacomo, 1527; Philotea, 1528; Pierino and Clizia, 1532; Pericaria, 1533; Luigi, 1535; and Roberto, 1536.

53. Lasagni (1999), 4: 302–303, with previous bibliography. On Eucherio's career in France, see especially Antinori (1986).

54. Davitt Asmus (1987): 5–15.

55. Vaccaro (2000): 71. On Parmigianino and *Petrarchismo*, see Cropper (1976) and Vaccaro (2001).

56. See Arasse (1996).

57. See Barkan (1980): 335–42, on Petrarch's poetic strategy and the Actaeon myth.

58. See Nova (2000). Nova's comparison between Correggio's Camera di San Paolo and Parmigianino's Camerino explores the problem of female spectatorship only with regard to the former cycle. The Camerino, according to Nova (97, note 35), was part of Gonzaga's private apartments, where she could walk about without clothes, enhancing the erotic nature of the decoration for her husband. Compare Thimann (2002), who points (p. 97) to the presence of Galeazzo Sanvitale's coat-of-arms (on the corner architectural finials) in the room as evidence that he, and not his wife, was the patron and intended spectator. I think these architectural finials are decorative, rather than heraldic, in nature: the Sanvitale coat-of-arms consisted of a single red diagonal across a white field, whereas the finials show two criss-crossed gold bands. I thank Marianna Williamson for her help with translation of both German texts.

59. On the distribution of rooms in Italian Renaissance interiors, see Thornton (1991): 284–319. A larger room, the so-called *Sala delle Donne Equilibriste*, next to the Camerino and perhaps originally part of the same apartment, contains (damaged) early-sixteenth-century decoration *a grottesche*, attributed to Cesare Cesariano. Pairs of nude women, and men, recline along swags suspended between columns: among the women, most of whom hold bows and arrows, is one kissing a swan (a reference to Leda?). A small adjacent room, also decorated *a grottesche*, bears

the date 1522. The rooms and their relation to the architectural fabric of the Rocca, although beyond the scope of the present study, merit further analysis.

60. See San Juan (1991) for an excellent discussion of the matter, as well as Ferino-Pagden et al. (1994). For the relationship between Isabella's patronage, and that of her husband, see Bourne (2001). Isabella d'Este was affiliated, by marriage, with the Gonzaga line of Mantua: her husband's father Federico was the brother of Paola Gonzaga's grandfather, Gianfrancesco.

61. For Bedoli's design, see the entry by Oberhuber in Fuhring (1989), 1: 178–9 (figure 149), for which see Fornari Schianchi (1991): 76–8. Pairs of well-dressed noblewomen are depicted beneath an arbour that is clearly derived from the Camerino; mythological content is minimal (i.e., Daphne-like caryatids).

62. Scipione Della Rosa, who possibly introduced Correggio to his sister-in-law, appears in the 1516 dowry agreement (above, note 25) between Galeazzo Sanvitale and Paola Gonzaga's father. Della Rosa was involved in the sale of a palace in Parma to Galeazzo Sanvitale by 1527 (once identified with the so-called Palazzetto Eucherio Sanvitale in the Giardino Ducale, but more likely a larger, no longer extant structure, for which see Adorni and Furlotti (2002): 364–5. Sanvitale had strong ties to San Quintino, which was, like San Paolo, a Benedictine convent in Parma. Since 1505, his aunt and sister jointly ruled as abbesses at San Quintino; by 1545, as confirmed by the census, he and his wife had sent their three daughters there to become nuns. See AsPr-Fondo Sanvitale, *busta* 17, for a document (23 April 1547) regarding the daughters' spiritual dowry.

63. See Musacchio (1999) for an insightful survey. I thank Jacki Musacchio for her helpful related comments (written communication, 2001). Parmigianino was presumably familiar with such objects; he painted, according to Vasari, a baby crib (untraced) for the Parmesan noblewoman Angela de' Rossi.

64. Ibid., esp. pp. 64–80 and 126–34.

65. The two putti on the north wall are fighting over an object, possibly a vessel: compare the motif of unruly children in, for example, Musacchio (1999): figs 120–23, with discussion of the iconographic tradition.

66. A portrait of the adult Eucherio Sanvitale, attributed to the circle of Sebastiano del Piombo, exists in the Galleria Nazionale, Parma (inv. 323); illustrated, with related catalogue entry in Giusto (1998): 62. The sitter bears some points of physiognomic similarity to the baby depicted in the Camerino, but a definitive identification is difficult, if not impossible.

67. Callisen (1937). The necklace of the baby in the Camerino consists of alternating red (coral-like) and white (pearl-like) beads.

68. Ferrarese painter (*c.* 1450), Boston, Museum of Fine Arts, n. 17.198; illustrated in Musacchio 1999: figure 129, with related discussion. See also De Carli (1997): 158–61.

69. The couple's niece Silvia, who had also lived in the castle, was born, according to Lasagni ((1999), 4: 326), around 1503 and already married by 1523. The possibility of an unrecorded child's posthumous likeness cannot be totally excluded.

70. Maestro della Madonna Lazzaroni (*c.* 1400), San Francisco, Museum of Fine Arts, Palace of the Legion of Honor, inv. 78.78 (Roscoe and Margaret Oakes Collection); illustrated, with related catalogue entry, in De Carli (1997): 80–81. For other examples of the Actaeon myth on birth trays, see ibid., 118–19 and 196–9. See also Watson (1979): 99–101.

71. The mirror appears to be original to the decorative scheme. Recent restoration has revealed a plain yellow disk, painted on the ceiling beneath the mirror, that was, according to restorer Maria Rosa Lanfranchi (oral communication, 1999), probably never intended to be seen. The metal attachments for the mirror, albeit later replacements, correspond to breaks in the original intonaco.

72. See Herodotus (*Histories*, Book I) for Solon's admonishment to Croesus that he mark well the end, since divine forces often give men a taste of happiness and then plunge them into ruin. According to Solon, only the person who unites and retains the greatest number of advantages until death, and then dies peacefully, is entitled to be called happy. Cf. the proverb (e.g., Aesop) 'quidquid agis, prudenter agas, et respice finem' ('whatever you do, do it wisely, and be mindful of the end').

73. Book I (*In magna genitus sum fortuna*), cap. 17: 'Finem respice, ut reliquis, sic fortunae suo multum licet in regno, quo fortunatius principium, eo finis est incertior.' Translated with commentary in Petrarch (1991), 1: 49–51.

74. Ovid, *Metamorphoses*, 3.135–7: 'sed scilicet ultima semper exspectanda dies hominis, dicique beatus ante obitum nemo supremaque funera debet.' See Fornari Schianchi (1998): 23–4.

75. Given the lack of a contract, and relative paucity of preparatory drawings, it is impossible to determine the extent to which the patron(s) may have dictated, or influenced, the programme. If the entablature inscription was expressly composed for the room, perhaps its author (a local poet or humanist?) also collaborated with the artist. The fresco cycle's overall design, with its intricate relations between form and meaning, may be largely the artist's invention. Projects for which more graphic preliminaries survive suggest Parmigianino's often considerable creative liberty: see Vaccaro (2000).

76. Eleonora Gonzaga is associated with a lady's chamber in the Palazzo Martinego, Brescia. Painted by Moretto (*c.* 1545), the room's decorative scheme shows fashionably dressed women, presumably familial portraits, in a landscape. Illustrated in Begni Redona (1988): 450–56, with related discussion. I thank Gabriele Neher for her bibliographical help.

77. See above, note 52.

78. In early modern Italy, girls might receive less traditional names than did boys. Yet the names of Sanvitale and Gonzaga's three daughters appear to be relatively uncommon. Pericaria and Philotea derive from Greek. Besides the Ovidian reference, Clizia is the name of the protagonist in Machiavelli's eponymous play. Thanks to Ronald Martinez for discussing the matter with me.

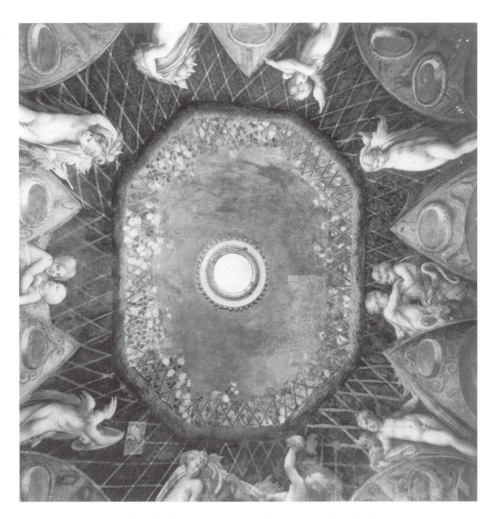

9.1 Francesco Mazzola, called Parmigianino, ceiling painting for the Camerino, *c.* 1523–24, fresco, Rocca of Fontanellato, Parma

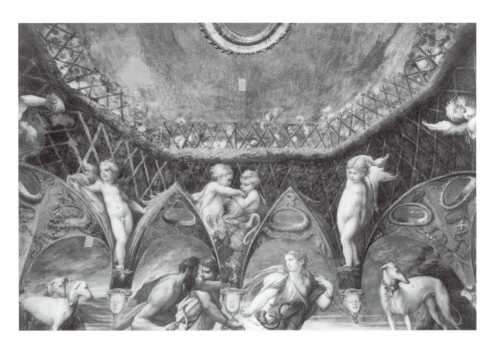

9.2 Francesco Mazzola, called Parmigianino, north wall of the Camerino, c. 1523–24, fresco, Rocca of Fontanellato, Parma

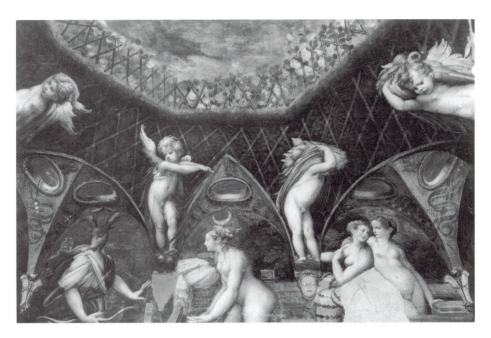

9.3 Francesco Mazzola, called Parmigianino, east wall of the Camerino, c. 1523–24, fresco, Rocca of Fontanellato, Parma

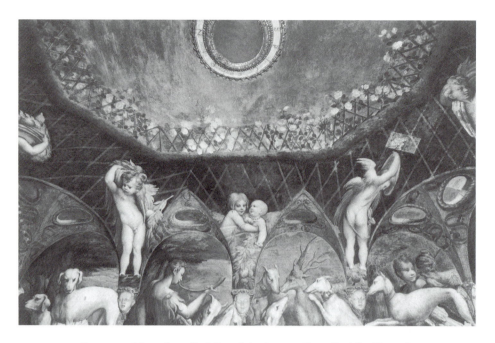

9.4 Francesco Mazzola, called Parmigianino, south wall of the Camerino, c. 1523–24, fresco, Rocca of Fontanellato, Parma

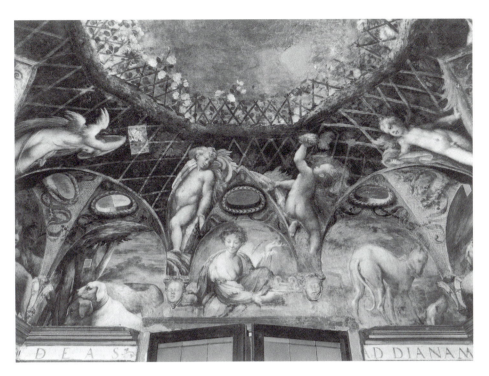

9.5 Francesco Mazzola, called Parmigianino, west wall of the Camerino, *c.* 1523–24, fresco, Rocca of Fontanellato, Parma

Bibliography

Primary sources: manuscript sources

BOLOGNA

Archivio di Stato: Fondo Demaniale, 9/7631.
Archivio di Stato: 'Rotuli dell'Università degli Artisti,' Cartella II.
Biblioteca Comunale dell'Archiginnasio: Fondo Gozzadini, MS Gozz. 203.
Biblioteca Comunale dell'Archiginnasio: MS [B.]983.
Biblioteca Comunale dell'Archiginnasio: MS [B.]16.
Biblioteca Universitaria: MS 2022, *Matricola della Compagnia del Buon Gesù.*

CESENA

Archivio di Stato: Not. Roberto Pasini, f. 332, 18 March 1518.
Biblioteca Comunale: MS 164/31, Carlantonio Andreini, *Memorie di Cesena* (nineteenth
　　century).

CREMONA

Biblioteca Civica: MS AA.4.46, Giuseppe Bresciani, *Origine et antichità della nobile
　　famiglia Zuccha di Cremona con gli huomini insigni d'essa sì nelle armi come lettere,*
　　1647.
Biblioteca Civica: *Domenici Burdigali inclyte urbis Cremone patricij cronicorum veterum
　　ab inicio mundi Mediolani precipue Cremone et Italie omnium provinciarum Europe
　　regine aggregatio suisque temporibus principum rerum gestarum et civitatum addicio
　　supplementum et chronicha seu istoria,* 1527, MSS Bib. Gov. 264.

FLORENCE

Biblioteca Riccardiana: MS 904, Basinio da Parma, *Diosymposis.*

MILAN

Biblioteca Ambrosiana: Archivio Falcò Pio di Savoia, v. N. 492, n.3, 24 April 1564.
Pinacoteca di Brera: *Inventario Napoleonico*, nos 255–7, 1811.
Pinacoteca di Brera: *Registro dei dipinti delle soppresse chiese e corporazioni religiose*, fol.
 4v, s.d. [after 1811].

OXFORD

Bodleian Library: *Hesperis*, MS Canon. Class. Lat. 81, Basinii Parmensis.

PARIS

Bibliothèque de l'Arsenal: *Hesperis*, MS 630, Basinii Parmensis.

PARMA

Archivio di Stato: Not. Gian Ludovico Sacca, f. 280, 28 November 1482.
Archivio di Stato: Not. Gaspare Bernuzzi, f. 611, 5 October 1518.
Archivio di Stato: Not. Galeazzo Piazza, f. 930, 26 January 1524.
Archivio di Stato: Not. Andrea Cerati, f. 744, 13 July 1528.
Archivio di Stato: Fondo Sanvitale, various *buste*.
Archivio di Stato: Archivio Comunale, Estimi, Descrizione degli abitanti di Parma
 (1545), *busta* 1933.
Archivio di Stato: MS Y8, 'Giunte all'albero de' Conti Sanvitale raccolte sopra documenti
 da A. R. [Amadio Ronchini].'
Soprintendenza per il Patrimonio Storico, Artistico e Demoetnoantropologico di Parma
 e Piacenza: MS 101–111, Enrico Scarabelli-Zunti, *Materiale per una guida artistica e
 storica di Parma*, 10 vols.
Soprintendenza per il Patrimonio Storico, Artistico e Demoetnoantropologico di Parma
 e Piacenza: MS. 162, Enrico Scarabelli-Zunti, *Blasonario Parmense*, 3 vols.

REGGIO EMILIA

Biblioteca A. Panizzi: MS 398, F. Michaelis Ferrarini Regiensis, *Antiquarium sive Divae
 Antiquitatis Sacrarium (Inscriptiones graecae et latinae undique collectae)*, 8 nn. + CCXII
 ff.

ROME (VATICAN CITY)

Biblioteca Apostolica Vaticana: Basinii Parmensi, *Hesperis*, MS Vat. lat. 6043.
Biblioteca Apostolica Vaticana: Petrarch, *Trionfi*, MS Barb. lat. 3943.

Printed literature

Adorni, Bruno, and Mariasita Furlotti, 'L'architettura a Parma nell'epoca del Parmigianino', in Lucia Fornari Schianchi ed., *Parmigianino ed il manierismo europes*. Proceedings of an International Symposium, Cinisello Balsamo, 2002: 360–69.

Affò, Ireneo, *Vita del graziosissimo pittore Francesco Mazzola detto il Parmigianio*, Parma, 1784.

—— (continued by Angelo Pezzana), *Memorie degli Scrittori e Letterati Parmigiani*, 6 vols, Parma, 1789–1833.

——, 'Notizie intorno la vita e le opere di Basinio Basini', in Lorenzo Drudi, ed., *Basinj Parmensis poetae opera praestantiora nunc primum edita et opportunis commentariis inlustrata*, 2 vols, Rimini, 1794, 2: 2–42 (= 1794a).

——, *Ragionamento sopra una Stanza dipinta dal celeberrimo Antonio Allegri da Correggio nel monistero di San Paolo in Parma*, Parma, 1794 (= 1794b).

Agosti, Giovanni, *Disegni del Rinascimento in Valpadana*, exh. cat., Florence, 2001.

Agostini, Grazia, and Luisa Ciammitti, eds, *Niccolò dell'Arca. Il Compianto di Santa Maria della Vita*, exh. cat., Bologna, 1985.

——, eds, *Niccolò dell'Arca*, Seminar of Studies, Bologna, 1989.

Alan of Lille, 'Anticlaudianus', in *Patrologiae cursus completus: series secunda*, ed. Jacques-Paul Migne, Paris, 1855, 210: 487–576.

Alberti, Leandro, *Descrittione di tutta Italia* (first publ. 1550), Venice, 1588.

Alberti, Leon Battista, *De re aedificatoria*, Florence, 1485.

——, *On the Art of Building in Ten Books*, trans. J. Rykwert and N. Lech, Cambridge, 1988.

Alce, Venturino, 'L'Immacolata nell'arte dalla fine del secolo XV al secolo XX', in *Virgo Immaculata*, Rome, 1957, 15: 107–35.

Alecci, Andrea, 'Busti, Bernardino', in *Dizionario Biografico degli Italiani*, Rome, 1972, 15: 593–5.

Alighieri, Dante, *La Divina Commedia*, ed. Giuseppe Vandelli, Milan, 1938.

Allen, Don Cameron, *Mysteriously Meant: the Rediscovery of Pagan Symbolism and Allegorical Interpretation in the Renaissance*, Baltimore and London, 1970.

Anderson, Jaynie, 'Il risveglio dell'interesse per le Muse nella Ferrara del Quattrocento', in Andrea Di Lorenzo and Alessandra Mottola Molfino, eds, *Le Muse e il Principe*, 2 vols, Modena, 1991, 2: 165–86.

Anon., 'Giovanna da Piacenza', in *Enciclopedia di Parma*, ed. Marzio Dall'Acqua, Milan, 1998: 532.

Anselmi, Georgius, *Epigrammaton Libri Septem. Sosthyrides Peplum Palladis Aeglogae Quattuor*, Venice, 1528.

Anselmus, Georgius, *In Cupidinem Captivum*, Parma, 1506.

Antinori, Carlo, 'Note sulla vita del Conte Eucherio Sanvitale Vescovo di Viviers', *Malacoda*, 8, 1986: 6–11.

Aporti, Ferrante, *Memorie di Storia Ecclesiastica Cremonese*, 2 vols, Cremona, 1837.

Appelt, C. Theodore, 'Studies in the Contents and Sources of Erasmus' Adagia', unpublished PhD thesis, University of Chicago, 1942.

Appuhn-Radtke, Sybille, 'Thesenschrift und Merkbild. Franziskanische Katechese in der *Disputatio über die Immaculata Conceptio* von Giovanni Antonio Sogliani', in *Italienische Forschungen. Kunst des Cinquecento in der Toskana*, Munich, 1992: 218–36.

Arasse, Daniel, 'Parmigianino au miroir d'Actéon', in *Andromède ou le héros à l'épreuve de la beauté*, eds Françoise Siguret and Alain Laframboise, Paris, 1996: 255–80.

Arcangeli, Letizia, 'Ragioni Politiche della Disciplina monastica. Il caso di Parma fra Quattrocento e Cinquecento', in *Donna, Disciplina, Creanza Cristiana dal XV al XVII secolo*, Rome: 1996: 165–88.

Arduini, Franca, *et al.*, eds, *Sigismondo Malatesta e il sus tempo: Mostra storica*, exh. cat., Vicenza, 1970.

Ariosto, Ludovico, *Orlando furioso*, trans. and intro. by Barbara Reynolds, 2 vols, London, 1987.

Aristotle, *Nicomachean Ethics*, trans. R. Rackham, Cambridge, MA and London, 1994.

Armentano, Lucia, Alfonso Garuti and Manuela Rossi, eds, *Il Palazzo dei Pio da Carpi*, Milan, 1999.

Augustine, St,'De natura et gratia', in *Patrologia Latina*, Paris, 1865, 44: 247–90.

——, 'Sermones ad populum', in *Patrologia Latina*, Paris, 1865, 39: 1493–2354.

——, *Confessions*, trans. Henry Chadwick, Oxford, 1991.

Azzeri, Fulvio, *Compendio dell'historie della città di Reggio*, Reggio, 1623.

Balavoline, Claude, 'Bouquets de fleurs et colliers de perles: sur les recueils de formes brèves au XVI siècle', in *Les Formes Brèves de la Prose et le Discours Discontinu (XVI–XVII siècles)*, ed. Jean Lafond, Paris, 1984: 51–72.

Balic, Carlo, 'The Mediaeval Controversy over the Immaculate Conception up to the Death of Scotus', in Edward O'Connor, ed., *The Dogma of the Immaculate Conception: History and Significance*, Notre Dame, 1958: 161–211.

Ballarin, Alessandro, *Dosso Dossi. La pittura a Ferrara negli anni del ducato di Alfonso I*, 2 vols, Cittadella [Padua], 1994–95.

Bambach, Carmen, *et al.*, *Correggio and Parmigianino: Master Draughtsmen of the Renaissance*, exh. cat., London, 2000.

Bandini, Fabrizio, Cristina Danti, Lucia Fornari Schianchi, Maria Rosa Lanfranchi, and Luisa Viola, 'Parmigianino a Fontanellato. Il restauro delle "Storie di Diana e Atteone"', *OPD Restauro: Rivista dell'Opificio delle Pietre Dure e Laboratori di Restauro di Firenze*, 12, 2000: 13–46.

Barbieri, Costanza, 'Il tema dell'Immacolata Concezione nel ciclo del Pordenone a Cortemaggiore', *Venezia Cinquecento*, 6, 1993: 53–98.

——, *Specchio di virtù. Il Consorzio della Vergine e gli affreschi di Lorenzo Lotto in San Michele al Pozzo Bianco*, Bergamo, 2000.

Barkan, Leonard, 'Diana and Acteon: The Myth as Synthesis', *English Literary Renaissance*, 10, 1980: 317–59.

Barocchi, Paola, 'Ricorsi italiani nei trattatisti d'arte francesi del Seicento', in *Il mito del Classicismo nel Seicento*, Messina and Florence, 1964: 125–47.

——, 'Storiografia e collezionismo dal Vasari al Lanzi', in *Storia dell'arte italiana. L'artista e il pubblico*, Turin, 1979, 2: 5–85.

——, 'L'antibiografia del secondo Vasari', in *Studi Vasariani*, Turin, 1984: 157–70.

Barocelli, Francesco, ed., *Il Correggio e la Camera di San Paolo*, Milan, 1988.

Barotti, Gianandrea, *Memorie Istoriche di letterati Ferraresi*, 3 vols, Ferrara, 1792–1811.

Baruffaldi, Girolamo, *Vite de' pittori e scultori ferraresi*, 3 vols, Ferrara, 1844.

Basini, Teresa, 'Achillini, Giovanni Filoteo', in *Dizionario Biografico degli Italiani*, Rome, 1960, 1: 148–9.

[Basinio di Parma], *Basinj Parmensis poetae opera praestantiora nunc primum edita et opportunis commentariis inlustrata*, ed. Lorenzo Drudi, 2 vols, Rimini, 1794.

Battaglia Ricci, Lucia, 'Immaginario trionfale: Petrarca e la tradizione figurativa,' in *I Triumphi di Francesco Petrarca*, ed. Claudia Berra, Bologna, 1999: 255–95.

Battaglini, Francesco Gaetano, 'Della vita e de' fatti di Sigismondo Pandolfo Malatesta Signor di Rimini,' in [Basinio da Parma], *Basinj Parmensis poetae opera praestantiora*

nunc primum edita et opportunis commentariis illustrata, ed. Lorenzo Drudi, 2 vols, Rimini, 1794.

Begni Redona, Pier Virgilio, *Alessandro Bonvicino. Il Moretto da Brescia*. Brescia, 1988.

Belli Barsai, Isa, 'Elisabetta. Iconografia', in *Bibliotheca sanctorum*, Rome, 1964, 4: 1089–93.

Belloni, Antonio, *Il poema epico e mitologico*, Milan, n.d. [1912].

Bembo, Pietro, *Le lettere*, ed. E. Travi, Bologna, 1987.

Benati, Daniele, catalogue entry in Andrea Di Lorenzo and Alessandra Mottola Molfino, eds, *Le Muse e il Principe*, Modena, 1991, 1: 426–30.

——, in *Haec sunt Statuta. Le corporazioni medievali nelle miniature bolognesi*, ed. Massimo Medica, exh. cat., Modena, 1999.

Bentivoglio-Ravasio, Raffaella, 'Un'aggiunta ad Amico Aspertini miniatore', *Paragone*, LI, 29, 2000: 14–25.

Berenson, Bernard, *The Drawings of the Florentine Painters*, amplified edition, 3 vols, Chicago, 1938.

Bernardo, S. Aldo, *Petrarch, Scipio and the 'Africa': The Birth of Humanism's Dream*, Baltimore, 1962.

——, 'Triumphal Poetry: Dante, Petrarch, and Boccaccio', in *Petrarch's Triumphs: Allegory and Spectacle*, eds Konrad Eisenbichler and Amilcare Iannucci, Toronto, 1990: 33–45.

Berra, Claudia, ed., *I Triumphi di Francesco Petrarca*, Bologna, 1999.

Bertling Biaggini, Claudia, *Il Pordenone: Pictor Modernus: zum Umgang mit Bildrhetorik und Perspektive im Werk des Giovanni Antonio de Sacchis*, Hildesheim, 1999.

Bessi, Rossella, 'Aggiornamento bibliografico', in *Il Quattrocento*, ed. Vittorio Rossi, Padua, 1992.

Bialostocki, Jan, '*Opus Quinque Dierum*: Dürer's *Christ among the Doctors* and its Sources', *Journal of the Warburg and Courtauld Institutes*, 22, 1959: 17–34.

Bianconi, Girolamo, *Guida del forestiere per la città di Bologna e suoi sobborghi*, Bologna, 1820.

Billerbeck, Margarethe, 'Die Unterweltsbeschreibung in den "Punica" des Silius Italicus', *Hermes*, 111.3, 1983: 326–38.

Boase, Thomas Sheer Ross, 'The Frescoes of Cremona Cathedral', *Papers of the British School at Rome*, 24, n.s. 40, 1956: 206–215.

——, *Giorgio Vasari: The Man and the Book*, Princeton, 1979.

Boccaccio, Giovanni, *Amorosa Visione*, ed. Vittore Branca, Florence, 1944.

——, *Genealogiae Deorum Gentilium Libri*, ed. Vincenzo Romano, Bari, 1951.

——, *Tutte le opere di Giovanni Boccaccio*, ed. Vittore Branca, Milan, 1974.

——, *Amorosa visione: Bilingual Edition*, trans. Robert Hollander, Timothy Hampton and Margherita Frankel, intr. Vittore Branca, Hanover and London, 1986.

Boiardo, Matteo Maria, *Orlando innamorato*, 2 vols, ed. Riccardo Bruscagli, Turin, 1995.

——, *Orlando Innamorato*, trans. and intr. Charles Stanley Ross, Berkeley and Los Angeles, 1989.

Bois, Yves-Alain, 'Panofsky Early and Late', *Art in America*, 73.7, 1985: 9–15.

Boitani, Piero, *Chaucer and the Imaginary World of Fame*, Cambridge, 1984.

Bologna, Ferdinando, *La coscienza storica dell'arte d'Italia*, Turin, 1982.

Bonde, Sheila and Clark Maines, 'A Room of One's Own: Elite Spaces in Monasteries of the Reform Movement and an Abbot's Parlor at the Augustian Saint-Jean-des-Vignes (Soissons), France', in *Religion and Belief in Medieval Europe*, eds Guy De Boe and Frans Verhaeghe, 4 vols, Zellik, 1997, 4: 43–53.

Bonetti, Carlo, *Memorie: la Fabbrica della Cattedrale, Laica o Ecclesiastica?*, Cremona, 1936.

——, *Cremona durante le guerre di predominio straniero. 1499–1526 (note e appunti)*, Collana storica cremonese, Cremona, 1939.

——, *Gli Ebrei a Cremona, 1278–1630*, (first pub. 1917) Bologna, 1982.

Bora, Giulio, 'Nota su Pordenone e i Cremonesi (e alcuni nuovi disegni)', in *Il Pordenone*, Atti del convengo Internazionale di studio, ed. Caterina Furlan, Pordenone, 1985.

Bouman, Cornelius, 'The Immaculate Conception in the Liturgy', in Edward O'Connor, ed., *The Dogma of the Immaculate Conception: History and Significance*, Notre Dame, 1958: 113–59.

Bourne, Molly, 'Renaissance Husbands and Wives as Patrons of Art: The Camerini of Isabella d'Este and Francesco II Gonzaga', in *Beyond Isabella: Secular Women Patrons of Art in Renaissance Italy*, eds Sheryl Reiss and David Wilkins, Kirksville, 2001: 93–123.

Branca, Vittore, 'Commento', in Giovanni Boccaccio, *Amorosa Visione*, ed. Vittore Branca, Florence, 1944.

Braudy, Leo, *The Frenzy of Renown Fame and its History*, Oxford, 1986.

Breventani, Luigi, *Supplemento alle cose notabili di Bologna e alla Miscellanea storico-patria di Giuseppe Guidicini*, Bologna, 1908.

Briganti, Giuliano, ed., *La pittura in Italia. Il Cinquecento*, Milan, 1987.

Brizzi, Gian Paolo, 'Modi e forme della presenza studentesca a Bologna in età moderna', in *L'Università a Bologna – Maestri, studenti e luoghi dal XVI al XIX secolo*, eds Gian Paolo Brizzi, Lino Marini and Paolo Pombeni, Milan, 1988: 59–74.

Brogsitter, Karl Otto, *Das hohe Geistergespräch: Studien zur Geschichte der humanistischen Vorstellungen von einer Zeitlosen Gemeinschaft der grossen Geister*, Bonn, 1958.

Brown, David Alan, 'A Print Source for Parmigianino at Fontanellato', in *Per A. E. Popham*, Parma, 1981: 43–54.

——, *Andrea Solario*, Milan, 1987.

Brownlee, Kevin, 'Dante and the Classical Poets', in *The Cambridge Companion to Dante*, ed. Jacoff Rachel, Cambridge, 1993: 100–119.

Brugnoli, Maria Vittoria, 'Le sculture e gli scultori delle porte minori di San Petronio', in *Jacopo della Quercia e la facciata di San Petronio a Bologna. Contributi allo studio della decorazione e notizie sul restauro*, Bologna, 1981.

Burger, Fritz, *Geschichte des florentinischen Grabmals von den ältesten Zeiten bis Michelangelo*, Strasbourg, 1904.

Burtius, Nicolaus, 'Carmen ex quo amoenitas situsque Bononiae nec non doctorum singularium atque illustrium virorum monumenta reserantur', in *Musarum nympharumque ac summorum deorum epytomata*, Bologna, 1498.

Calcagnini, Celio, *Opera Aliqua*, Basel, 1544.

Callisen, S. Adolph, 'The Evil Eye in Italian Art', *Art Bulletin*, 19, 1937: 450–62.

Calvesi, Maurizio, 'Gli Inconsulti ed i Virtuosi', *Art & Dossier*, 1990: 23–6.

——, 'Giove Statore nella Tempesta e nella Camera di San Paolo', *Storia dell'Arte*, 86, 1996: 5–12.

Calzini, Carlo, 'Giovanni del Sega', *Rassegna Bibliografica dell'Arte Italiana*, 8, 1905: 11–16.

——, 'L'Apollo e le muse dello studiolo del duca di Urbino', *L'Arte*, 15, 1908: 225–9.

Cammarota, Gian Piero, *Le origini della Pinacoteca Nazionale di Bologna. Una raccolta di fonti*, vol. 1: 1797–1815, Bologna, [n.d.].

Campana, Augusto, 'Il nuovo codice Vaticano della *Hesperis* di Basinio', *Studi Romagnoli*, 2, 1951–52: 104–108 (= 1951–52a).

——, 'Tavola delle illustrazioni dei codici miniati della *Hesperis* di Basinio,' *Studi Romagnoli*, 2, 1951–1952: 109–111 (=1951–52b).

——, 'Atti, Isotta degli', in *Dizionario biografico degli Italiani*, Rome, 1962, 4: 547–53.

——, 'Basinio da Parma', in *Dizionario biografico degli Italiani*, Rome, 1965, 7: 89–98.

Campbell, Stephen, *Cosmè Tura of Ferrara: Style, Politics and the Renaissance City, 1450–1495*, New Haven and London, 1997.

Carandente, Giovanni, *I trionfi nel primo Rinascimento*, Rome, 1963.

Caroli, Flavio, *L'anima e il volto. Ritratti e fisiognomica da Leonardo a Bacon*, exh. cat., Milan, 1998.

Casanova Uccella, Maria Letizia, *Palazzo Venezia. Paolo II e la fabbrica di San Marco*, Rome, 1980.

Casciu, Stefano, 'Francesco Signorelli. *Allegoria dell'Immacolata Concezione e profeti*', in *Il Museo Diocesano di Cortona*, ed. Anna Maria Maetzke, Florence, 1992: 127–8.

Castelli, Patrizia, 'Ghiberti e gli Umanisti: Coluccio Salutati', in *Lorenzo Ghiberti: Materia e ragionamenti*, eds Luciano Bellosi *et al.*, Florence, 1978: 520–23.

——, *I geroglifici e il mito dell'Egitto nel Rinascimento*, Florence, 1979.

Catullus, *The Poems and Fragments*, trans. Robinson Ellis, London, 1871.

Cavazzoni, Francesco, *Scritti d'arte*, ed. Marinella Pigozzi, Bologna, 1999.

Céard, Jean, and Jean-Claude Margolin, eds, *Rebus de la Renaissance. Des Images qui parlent*, 2 vols, Paris, 1986.

Ceccarelli, Carlo, 'The Accademia Atestina of Modena: from Idea and Inception to the Advent of Napoleon', in *Academies of Art between Renaissance and Romanticism*, eds A. W. A. Boschloo, E. J. Hendrikse, L. C. Smit, G. J. van der Sman, The Hague, 1989: 95–104.

Ceruti Burgio, Anna, *Studi sul Quattrocento Parmense*, Pisa, 1988.

Chamorat, Jean Jacques, *Grammaire et Rhétorique chez Erasme*, 2 vols, Paris, 1981.

Champigny, Robert, 'Semantic Modes and Literary Genres', in *Theories of Literary Genre*, ed. Joseph P. Strelka, London, 1978: 94–111.

Chapman, Hugo, 'Parmigianino in Bologna, Parma and Casalmaggiore', in Carmen Bambach *et al.*, *Correggio and Parmigianino: Master Draughtsmen of the Renaissance*, exh. cat., London, 2000: 146–53.

Charney, Sara, 'Artistic Representations of Petrarch's *Triumphus Famae*', in *Petrarch's Triumphs: Allegory and Spectacle*, eds Konrad Eisenbichler and Amilcare A. Iannucci, Toronto, 1990: 223–33.

Chaucer, Geoffrey, *The Works of Geoffrey Chaucer*, ed. F. Robinson, London and Oxford, 1974.

Cheles, Luciano, *Lo studiolo di Urbino. Iconografia di un microcosmo principesco*, Modena, 1986.

Chiodini, Fabio, 'Momenti e aspetti del collezionismo bolognese nella *Graticola*', in Pietro Lamo, *Graticola di Bologna*, ed. Marinella Pigozzi, Bologna, 1996: 125–46.

——, 'Scena pubblica e dimensione privata a Bologna fra XVI e XVII secolo', in Marinella Pigozzi, ed., *Bologna al tempo di Cavazzoni. Approfondimenti*, Bologna, 1999: 111–63.

Chiusa, Maria Cristina, *Parmigianino*, Milan, 2001.

Ciccuto, Marcello, 'Con la storia o contro: le cronache universali illustrate nel Quattrocento', in *Percorsi tra parole e immagini (1400–1600)*, eds Angela Guidotti and Massimiliano Rossi, Lucca, 2000: 37–50.

Cieri Via, Claudia, 'Ipotesi di un percorso funzionale e simbolico nel palazzo ducale di Urbino attraverso le immagini', in *Federico di Montefeltro. Lo stato, le arti, la*

cultura, ed. Giorgio Cerboni Baiardi, Giorgio Chittolini and Pietro Floriani, Rome, 1986: 47–64.

——, 'I Tarocchi cosidetti del Mantegna: origini, significato e fortuna di un ciclo di immagini', in *I Tarocchi. Le carte di gioco Gioco e magia alla corte degli Estensi*, exh. cat., ed. Giordano Berti and Andrea Vitali, Bologna, 1987: 49–77.

——, 'Il Tempio Malatestiano: Simbolismo funerario e cultura classica alla corte del Signore di Rimini', *Asmodée / Asmodeo*, 2, 1990: 21–45 (= 1990a).

——, 'Le Muse: storia di un'immagine. Le compagne di Apollo', *Arte e Dossier*, 46, 1990: 22–7 (= 1990b).

Cinotti, Mia, *L'opera completa di Bosch*, Milan, 1974.

Citati, Pietro, 'Il dolore di Demetra', *Paragone*, 41, 1990: 3–9.

Clark, J. Raymond, *Catabasis: Virgil and the Wisdom-Tradition*, Amsterdam, 1979.

Clark, Nicholas, *Melozzo da Forlì: Pictor Papalis*, Faenza, 1989.

Claudian, *De Raptu Proserpinae*, trans. Maurice Platnauer, 2 vols, Cambridge, MA and London, 1963.

Cohen, E. Charles, 'Pordenone's Cremona Passion Scenes and German Art', *Arte Lombarda*, 42–3, 1975: 74–96.

——, *The Art of Giovanni Antonio da Pordenone; Between Dialect and Language*, 2 vols, Cambridge, 1996.

Colie, L. Rosalie, 'Small Forms: Multo in Parvo', in *The Resources of Kind: Genre-Theory in the Renaissance*, ed. Barbara K. Lewalski, Los Angeles and London, 1973: 32–75.

Colombi Ferretti, Anna, *Dipinti d'altare in età di Controriforma in Romagna, 1560–1650: opere restaurate dalle diocesi di Faenza, Forlì, Cesena e Rimini*, Bologna, [1982].

——, Anna, *Girolamo Genga e l'altare di S. Agostino a Cesena*, Bologna, 1985.

[Colonna, Francesco], *Hypnerotomachia Poliphili*, Venice, 1499.

——, *Hypnerotomachia Poliphili*, eds Giovanni Pozzi and Lucia Ciapponi, 2 vols, Padua, 1980.

——, *Hypnerotomachia Poliphili*, eds Marco Ariani and Mino Gabriele, 2 vols, Milan, 1998.

Colosio, Innocenzo, 'Cavalca (Dominique), dominicain italien (†1342)', in *Dictionnaire de Spiritualité ascétique et mystique …*, Paris, 1953, 2: 374.

Colpe, Carsten, Ernst Dassmann, Josef Engemann, Peter Habermehl and Karl Hoheisel, 'Jenseits (Jenseitsvorstellungen)', in *Reallexikon für Antike und Christentum*, ed. Ernst Dassmann, Stuttgart, 1994–95, 17: 246–407.

Colpe, Carsten, and Habermehl, Peter, 'Jenseitsreise', in *Reallexikon für Antike und Christentum*, Stuttgart, 1995, 17: 490–543.

Copertini, Giovanni, *Il Parmigianino*, 2 vols, Parma, 1932.

Coppini, Donatella, 'Basinio e Sigismondo: Committenza collaborativa e snaturamento epico dell'elegia', in *Città e Corte nell' Italia di Piero della Francesca*, ed. Claudia Cieri Via, Venice, 1996: 449–67.

Cordellier, Dominique, 'Gli dei musici di Baldassare Peruzzi e l'organo d'alabastro di Federico Gonzaga', *Quaderni di Palazzo Te*, 9, 2001: 23–37.

Cortese, Ennio, 'Artisti e artigiani al Collegio di Spagna nel Cinquecento', in *El Cardenal Albornoz y el Colegio de España (V). Studia Albornotiana* 26, 1979: 79–181.

Couilleau, Guerric, 'Jean Climaque (saint), vers 575–vers 650', in *Dictionnaire de Spiritualité ascétique et mystique …*, Paris, 1974, 8: 370–89.

Courcelle, Jeanne and Pierre, *Iconographie de Saint Augustin*, vols 1–2, Paris, 1965–1969.

Cropper, Elizabeth, 'On Beautiful Women, Parmigianino, *Petrarchismo*, and the Vernacular Style', *The Art Bulletin*, 58, 1976: 374–94.

Crowe, A. Joseph, and Giovanni Battista, Cavalcaselle, *A History of Painting in Northern Italy*, 2 vols, London, 1871.

Cumont, Franz, *Lux perpetua*, Paris, 1949.

Cuppini, Giampiero, and Giancarlo eds, Roversi, *Palazzi senatorii a Bologna. Architettura come immagine del potere*, Bologna, 1974.

Curran, A. Brian, 'Ancient Egypt and Egyptian Antiquities in Italian Renaissance Art and Culture', unpublished PhD thesis, Princeton University, 1997.

——, *'De Sacrarum Litterarum Aegyptiorum Interpretatione*: Reticence and Hubris in Hieroglyphic Studies of the Renaissance: Pierio Valeriano and Annius of Viterbo', *Memoirs of the American Academy in Rome*, 43–4, 1998–99: 139–82.

Curtius, Ernst Robert, *Europäische Literatur und lateinisches Mittelalter*, 5th edn, Bern and Munich, 1965.

Curtius, Ernst, R., *Letteratura Europea e Medioevo Latino*, trans. Anna Luzzato and Mercurio Candela, Florence, 1997.

Dal Prà, Laura, *'Publica disputatio peracta est.* Esiti iconografici della controversia sull'Immacolata Concezione a Firenze', *Medioevo e Rinascimento*, 2, 1988: 267–80.

Dall'Acqua, Marzio, ed., *Il Monastero di San Paolo*, Milan, 1990.

——, Gianni, Guadalupi and Franco Maria Ricci, *Fontanellato*, Milan, 1994.

Dania, Luigi, and Demetrio Funari, *S. Agostino. Il Santo nella pittura dal XIV al XVIII secolo*, Milan, 1988.

Daremberg, Charles and Edmond Saglio, 'Artemis', in *Dictionnaire des Antiquités Grecques et Romaines*, Paris, 1892, 3: 130–57.

Davitt Asmus, Ute, 'Fontanellato I. Sabatizzare il mondo, Parmigianino's Bildnis des Conte Galeazzo Sanvitale', *Mitteilungen des Kunsthistorischen Institutes in Florenz*, 27, 1983: 2–40.

——, 'Fontanellato II. La trasformazione dell'amante nell'amato, Parmigianinos Fresken in der Rocca Sanvitale', *Mitteilungen des Kunsthistorischen Institutes in Florenz*, 31, 1987: 2–58.

De Alva y Astorga, Pedro, ed., *Armamentarium Seraphicum et Regestum Universale tuendo titulo Immaculatae Conceptionis* (first publ. 1649), 2 vols, Brussels, 1965.

De Carli, Cecilia, *I deschi da parto e la pittura del primo Rinascimento toscano*, Turin, 1997.

De Luca, Elena, 'Rhetoric, Silence and Secular Culture in the *"Symbolicae Quaestiones"* by Achille Bocchi, Bologna 1555', unpublished PhD thesis, University of East Anglia, Norwich, 1999.

De Maria, Sandro, 'Artisti, *"Antiquari"*, e collezionisti di antichità a Bologna fra XV e XVI secolo', in *Bologna e l'Umanesimo 1490–1510*, exh. cat., eds Marzia Faietti and Konrad Oberhuber, Bologna, 1988: 17–42.

De Vecchi, Pier Luigi, 'Iconografia e devozione dell'Immacolata in Lombardia', in *Zenale e Leonardo. Tradizione e rinnovamento della pittura lombarda*, Milan, 1982: 254–8.

——, 'Pala di Sant'Agostino', in *Raffaello e Brera*, Milan, 1984: 41–3.

Defendi, Nansen, 'La *Revocatio* nella polemica antiluterana in Italia', *Archivio storico lombardo*, 80, 1953: 69–132.

Del Re, Nicolò, and Isa Belli Barsai, 'Chiara da Montefalco', in *Bibliotheca Sanctorum*, Rome, 1963, 3: 1217–24.

Delaruelle, Etienne, Edmond-René Labande and Paul Ourliac, *La Chiesa al tempo del grande scisma e della crisi conciliare (1378–1449). Storia della Chiesa dalle origini ai nostri giorni*, ed. Giuseppe Alberigo, Turin, 1971, 14. 3: 1170–83.

Dell'Acqua, Gian Alberto, and Franco Mazzini, *Affreschi lombardi del Quattrocento*, Milan, 1965.

DeLong, Jan J., 'Ovidian Fantasies: Pictorial Variations on the Story of Mars, Venus, and Vulcan', in *Die Rezeption der Metamorphosen des Ovid in der Neuzeit: der Antike Mythos in Text und Bild*, eds Herman Wolter and Hans J. Horn, Berlin, 1995: 161–71.

Delucca, Oreste, 'Il canzoniere di Sigismondo Pandolfo Malatesta', *Romagna arte e storia*, 58, 2000: 87–90.

Dempsey, Charles, 'Malvasia and the Problem of the Early Raphael and Bologna', in James Beck, ed., *Raphael before Rome: Studies in the History of Art*, 1986: 57–70.

——, 'Renaissance Hieroglyphic Studies and Gentile Bellini's *Saint Mark Preaching in Alexandria*', in Ingrid Merlal and Allen G. Debus, eds, *Hermeticism and the Renaissance: Intellectual History and the Occult in Early Modern Europe*, Washington and London, 1988: 342–65.

——, '*Sua cuique mihi mea*: the Mottoes in the Camerino of Giovanna da Piacenza in the Convent of San Paolo', *Burlington Magazine*, 132, 1990: 490–93.

Di Giampaolo, Mario, *Parmigianino, catalogo completo*, Florence, 1991.

Di Giovanni Madruzza, Marilisa, 'L'architettura', in Roberto Greci, Marilisa di Giovanni Madruzza and Germano Mulazzani, eds, *Corti del Rinascimento nella provincia di Parma*, Turin, 1981: 118–36.

Di Lorenzo, Andrea, and Alessandra Mottola Molfino, *et al.*, eds, *Le Muse e il Principe: arte di corte nel Rinascimento padano*, exh. cat., 2 vols, Modena, 1991.

Dionisotti, Carlo, *Aldo Manuzio editore. Dediche, prefazioni, note ai testi*, intr. Carlo Dionisotti, trans. Giovanni Orlandi, Milan, 1975.

Direzione del R. Archivio di Stato in Bologna. Catalogo delle miniature e dei disegni posseduti dall'Archivio, ed. Francesco Malaguzzi-Valeri, Bologna, 1898.

Donati, Angela, ed., *Il potere, le arti, la guerra: lo splendore dei Malatesta*, Milan, 2001.

Donato, Maria Monica, 'Gli eroi romani tra storia ed exemplum: I primi cicli umanistici di Uomini Famosi', in *Memoria dell'antico nell'arte italiana*, ed. Salvatore Settis, 3 vols, Turin, 1985, 2: 97–152.

Dörrie, Heinrich, *Der heroische Brief: Bestandsaufnahme, Geschichte, Kritik einer humanistisch-barocken Literaturgattung*, Berlin, 1968.

Drudi, Lorenzo, ed., *see* [Basinio da Parma] (1794), *above*.

Drysdall, Denis, 'Filippo Fasanini and his Explanation of Sacred Writing', *Journal of Medieval and Renaissance Studies*, 13.1, 1983: 127–51.

Eden, Kathie, *Friends Hold All Things in Common: Tradition, Intellectual Property, and the Adages of Erasmus*, New Haven and London, 2001.

Eisenbichler, Konrad, and Amilcare Iannucci, eds, *Petrarch's Triumphs: Allegory and Spectacle*, Toronto, 1990.

Eisler, Colin, *The Genius of Jacopo Bellini: The Complete Paintings and Drawings*, New York, 1988.

Emiliani, Andrea, 'La prospettiva storica di Giovan Pietro Bellori', in *L'idea del Bello, Viaggio per Roma nel Seicento con Giovan Pietro Bellori*, ed. Evelina Borea and Carlo Gasparri, 2 vols, Rome, 2000, 1: 87–92.

Erasmus, Desiderius, *Adagiorum Chiliades*, Venice, 1508.

——, *The 'Adages' of Erasmus: A Study with Translations*, ed. Margaret Mann Phillips, Cambridge, 1964.

——, *Collected Works of Erasmus: Adages*, trans. Margaret Mann Phillips, annot. R. A. B. Mynors, vols 31–4 (= 4 vols), Toronto and London, 1991.

Ettlinger, Helen S., 'The Image of a Renaissance Prince: Sigismondo Malatesta and the Arts of Power', unpublished PhD thesis, University of California, 1988.

——, 'Sigismondo Malatesta of Rimini', *Schifanoia*, 10, 1990: 23–4 (= 1990a).

——, 'The Sepulchre on the Facade: A Re-Evaluation of Sigismondo Malatesta's Rebuilding of San Francesco in Rimini', *Journal of the Warburg and Courtauld Institutes*, 53, 1990: 133–43 (= 1990b).

——, 'Visibilis et Invisibilis: The Mistress in Italian Renaissance Court Society', *Renaissance Quarterly*, 47.4, 1994: 770–91.

Fagiolo Dell'Arco, Maurizio, *Il Parmigianino. Un saggio sull'ermetismo nel Cinquecento*, Rome, 1970.

Faietti, Marzia, catalogue entry in Andrea Di Lorenzo and Alessandra Mottola Molfino, eds, *Le Muse e il Principe*, Modena, 1991, 1: 431–7.

——, 'Amico Aspertini e Dosso Dossi, pittori "antidiligenti"', in *L'arte nella storia. Contributi di critica e storia dell'arte per Gianni Carlo Sciolla*, eds Valerio Terraroli, Franca Varallo and Laura De Fanti, Milan, 2000: 171–83.

——, 'Amico *invenit*. Marcantonio *sculpsit*? Il *Compianto su Cristo morto* di Berlino', in *Scritti in onore di Sylvie Béguin*, eds Mario di Giampaolo, Elisabetta Saccomani and Mina Gregori, Naples, 2001: 167–78.

——, and Dominique Cordellier, *Un siècle de dessin à Bologna, 1480–1580. De la Renaissance à la réforme tridentine*, exh. cat., Paris, 2001.

——, and Massimo Medica, eds, *La Basilica incompiuta. Progetti antichi per la facciata di San Petronio*, exh. cat., Ferrara, 2001.

——, and Konrad Oberhuber, *Bologna e l'Umanesimo 1490–1510*, exh. cat., Bologna, 1988.

——, and Daniela Scaglietti Kelescian, *Amico Aspertini*, Modena, 1995.

Fanti, Mario, 'Nuovi documenti e osservazioni sul *Compianto* di Niccolò dell'Arca e la sua antica collocazione in Santa Maria della Vita', in *Niccolò dell'Arca*, eds Grazia Agostini and Luisa Ciammiti, Bologna, 1989: 59–83.

——, *Confraternite e città a Bologna nel Medioevo e nell'età moderna*, Rome, 2001.

Fasti Farnesiani. Un restauro al Museo Archeologico di Napoli, Naples, 1988.

Feigenbaum, Gail, in Andrea Emliani, *Ludovico Carracci*, exh. cat., Bologna, 1993.

——, 'Per una storia istituzionale dell'arte bolognese, 1399–1650: nuovi documenti sulla corporazione dei pittori, i suoi membri, le sue cariche e sull'Accademia dei Carracci', in *Il restauro del Nettuno, la statua di Gregorio XIII e la sistemazione di Piazza Maggiore nel Cinquecento – Contributi anche documentari alla conoscenza della prassi e dell'organizzazione delle arti a Bologna prima dei Carracci*, Bologna, 1999: 353–77.

Fenlon, Iain, 'Gender and Generation: Patterns of Music Patronage among the Este', in Marianne Pade, Lene Waage Petersen and Daniela Quarta eds, *La corte di Ferrara e il suo mecenatismo 1441–1598*, Proceedings of an International Symposium, Modena, 1990: 213–32.

Fenzi, Enrico, 'Dall' "Africa" al "Secretum": Nuove ipotesi sul "Sogno di Scipione" e sulla composizione del poema', in *Il Petrarca ad Arquà*, ed. Giuseppe Billanovich and Giuseppe Frasso, Padua, 1975: 61–115.

Fera, Vincenzo, 'Annotazioni inedite del Petrarca al testo dell' "Africa", *Italia Medioevale e Umanistica*, 23, 1980: 1–25.

——, *Antichi editori e lettori dell'Africa*, Messina, 1984.

——, *La revisione petrarchesca dell'Africa*, Messina, 1984.

——, 'Editori e postillatori dell' "Africa" fra Tre e Quattrocento', *Studi petrarcheschi*, 4, 1987: 33–45.

Ferino-Pagden, Sylvia, Christian Beaufort-Spontin and Clifford Brown, eds, *Isabella d'Este: Fürstin und Mäzenatin der Renaissance*, exh. cat., Vienna, 1994.

Ferrari, Maria Luisa, *Il Romanino*, Milan, 1961.

Ferri, Ferruccio, 'Il poeta Basinio e la leggenda di S. Patrizio', *Aurea Parma*, 2.1–2, 1913: 101–105.

——, *La giovinezza di un Poeta: Basinii Parmensis Carmina*, Rimini, 1914.

Ferri Piccaluga, Gabriella, 'Sofia', *Achademia Leonardo da Vinci*, 7, 1994: 13–40.

Ficino, Marsilio, 'De Vita, De Novem Musis Studiosorum ducibus', in *Opera*, Basel, 1576.

Finsler, Georg, 'Sigismondo Malatesta und sein Homer', in *Festgabe für Gerold Meyer von Knonau*, Zurich, 1913: 285–303.

Fiocco, Giuseppe, *Giovanni Antonio Pordenone*, 2 vols, Pordenone, 1969.

Fioravanti, Baraldi, Anna Maria, 'Girolamo da Cotignola', in *Pittura bolognese del '500*, ed. Vera Fortunati Pietrantonio, Bologna, 1986, 1: 95–116.

Floriani, Pietro, *I gentiluomini letterati: studi sul dibattito culturale nel primo Cinquecento*, Naples, 1981.

Fontana, Carlo Giuseppe, *Pallade segretaria, o sia prima spedizione di lettere missive*, Parma, 1696.

Fontana, Walter, 'Disputa sull'Immacolata Concezione', in *Lorenzo Lotto nelle Marche. Il suo tempo, il suo influsso*, ed. Paolo Dal Poggetto and Pietro Zampetti, exh. cat., Florence, 1981: 165–8.

——, 'Disputa sull'Immacolata Concezione', in *Urbino e le Marche prima e dopo Raffaello*, ed. Maria Grazia Ciardi Duprè and Paolo Dal Poggetto, exh. cat., Florence, 1983: 363–5.

Fonti francescane, 1, Bologna, 1977.

Fornari Schianchi, Lucia, 'Palazzetto Eucherio Sanvitale. Qualche considerazione sulle decorazioni', in *La Reggia di là da l'acqua. Il giardino e il palazzo dei duchi di Parma*, ed. Giovanni Godi, Milan, 1991: 76–8.

——, ed., *Galleria Nazionale di Parma. Catalogo delle opere del Cinquecento e iconografia farnesiana*, Milan, 1998.

——, 'La Saletta del Parmigianino: problemi attuali di conservazione', in *Ripristino architettonico. Restauro o restaurazione?*, eds Lucia Masetti Bitelli and Marta Cuoghi Costantini, Fiesole, 1999: 127–43.

——, and Nicola Spinosa, eds, *I Farnese. Arte e collezionismo*, exh. cat., Milan, 1995.

Fortunati, Vera, 'Le metamorfosi della pala d'altare nel dibattito religioso del Cinquecento: il cantiere di San Giacomo', in *La pittura in Emilia e in Romagna. Il Cinquecento. Un'avventura artistica tra natura e idea*, Bologna, 1994: 218–43 (= 1994a).

——, 'Vita artistica e dibattito religioso a Bologna all'aprirsi del Cinquecento: la "Pietà" di Amico Aspertini in San Petronio', in *Sei secoli in San Petronio*, eds Mario Fanti and Deanna Lenzi, Proceedings of an International Symposium, Bologna, 1994: 307–309 (= 1994b).

Fortunati Pietrantonio, Vera, 'Cronaca di un "viaggio" attraverso la pittura bolognese nella Bologna pontificia del Cinquecento', in *Pittura bolognese del Cinquecento*, ed. Vera Fortunati Pietrantonio, 2 vols, Bologna, 1986, 1: XVII–XXXIX.

Fossaluzza, Giorgio, et al., *Pittura murale in Italia: Il Quattrocento*, ed. Mina Gregori, Bergamo, 1996.

Fowler, Alastair, *Kinds of Literature: An introduction to the Theory of Genres and Modes*, Cambridge, 1982.

Frangi, Francesco, 'Altobello Melone', in *Pittura a Cremona dal Romanico al Settecento*, ed. Mina Gregori, Cinisello Balsamo, 1990: 260.

Franzoni, Claudio, 'Rimembranze d'infinite cose. Le collezioni rinascimentali d'antichità', in *Memoria dell'antico nell'arte italiana*, 3 vols, ed. Salvatore Settis, Turin, 1984, 1: 316–38.

——, 'Le raccolte del' "Theatro" di Ombrone e il viaggio in Oriente del pittore: le "Epistole" di Giovanni Filoteo Achillini', *Rivista di letteratura italiana*, 8.2, 1990: 287–335.

——, ed., *'Il Portico dei Marmi'. Le prime collezioni a Reggio Emilia e la nascita del Museo Civico*, exh. cat., Reggio Emilia, 1999.

——, and Alessandra Sarchi, 'Entre Peinture, archéologie et muséographie: l'*Antiquarium* de Michele Fabrizio Ferrarini', *Revue de l'Art*, 125.3, 1999: 20–31.

Freedberg, David, *The Power of Images: Studies in the History and Theory of Response*, Chicago and London, 1989.

Freedberg, Sydney, *Parmigianino: His Works in Painting*, Cambridge, MA, 1950.

Frey-Sallmann, Alma, *Aus dem Nachleben antiker Göttergestalten: Die antiken Gottheiten in der Bildbeschreibung des Mittelalters und der italienischen Frührenaissance*, Leipzig, 1931.

Frommel, Christoph Luitpold, 'Baldassare Peruzzi als Maler und Zeichner', *Römisches Jahrbuch für Kunstgeschichte*, 11 (suppl.), 1967–68.

Frommel, Sabine, *Sebastiano Serlio pittore*, Milan, 1998.

Fuhring, Peter, ed., *Design into Art: Drawings for Architecture and Ornament, The Lodewijk Houthakker Collection*, 2 vols, The Hague, 1989.

Furlan, Caterina, *Il Pordenone*, Milan, 1988.

Galinsky, G. Karl, *The Heracles Theme: the Adaptations of the Hero in Literature from Homer to the Twentieth Century*, Totowa, NJ, 1972.

Galizzi Kroegel, Alessandra, 'Flying Babies in Emilian Painting: Iconographies of the Immaculate Conception circa 1500', unpublished PhD thesis, The Johns Hopkins University, 1992.

——, 'Franciscan Wordplay in Renaissance Annunciations', *The Canadian Journal of Rhetorical Studies*, 4, 1994: 63–78.

——, 'Una Sant'Anna problematica: l'invenzione immacolista per la pala del Pordenone a Cortemaggiore', in Marco Rossi and Alessandro Rovetta, eds, *Studi di Storia dell'arte in onore di Maria Luisa Gatti Perer*, Milan, 1999: 223–32.

Ganschinietz, P., 'Katabasis', in *Paulys Realencyclopädie der klassischen Altertumswissenschaft*, Stuttgart, 1919, X. 20: 2359–449.

Garattoni, Domenico, *Il Tempio Malatestiano: leggenda e realtà*, Bologna, 1951.

Garuti, Alfonso, *Il palazzo dei Pio di Savoia nel castello di Carpi: appunti per la storia edilizia e artistica dell'edificio*, Modena, 1983.

——, 'Ritrovamenti e restauri in castello', in Hans Semper, F. O. Schulze and W. Barth, *Carpi: Una sede principesa del Rinascimento*, ed. Luisa Giordano, trans. A. d'Amelio and A. E. Werdehausen, Pisa, 1999: 379–415.

Gelinne, Michel, 'Les champs Elysées et les Iles des Bienhereux chez Homère, Hesiode et Pindare: Essai de mise au point', *Les ètudes classiques*, 56, 1988: 225–40.

Gentile, Guido, 'Testi di devozione e iconografia del Compianto', in *Niccolò dell'Arca*, eds Grazia Agostini and Luisa Ciammiti, 1989: 167–211.

Gentili, Domenico, 'Nicola da Tolentino. Iconografia', in *Bibliotheca Sanctorum*, Rome, 1967, 9: 966–98.

Geronimus, Dennis, 'The Birth Date, Early Life and Career of Piero di Cosimo', *Art Bulletin*, 82, 2000: 164–70.

Ghidiglia Quintavalle, Augusta, ed., *Arte in Emilia*, exh. cat., Parma, 1962.

——, 'Il *Boudoir* di Paola Gonzaga Signora di Fontanellato', *Paragone*, 18, 1967: 3–17.

——, *Gli affreschi giovanili del Parmigianino*, Milan, 1968.

Giamatti, Bartlett, *The Earthly Paradise and the Renaissance Epic*, Princeton, NJ, 1966.

Giehlow, Karl, 'Die Hieroglyphenkunde des Humanismus in der Allegorie der

Renaissance, besonders der Ehrenpforte Kaisers Maximilian I', *Jahrbuch der Kunsthistorisches Sammlungen des Allerhoechstern Kaiserhauses*, 32, 1915: 1–232.

Gilbert, Creighton, 'The Fresco by Giotto in Milan', *Arte Lombarda*, 47–8, 1977: 56–65.

Gilchrist, Roberta, *Gender and Material Culture: The Archeology of Religious Women*, London and New York, 1994.

Gilmore, Myron, 'Erasmus and Alberto Pio Prince of Carpi', in *Action and Conviction in Early Modern Europe: Essays in honor of E. Harris Harbison*, ed. Theodore Rabb and Jerrold E. Siegel, Princeton, 1969: 299–318.

Ginzburg, Carlo, *Il nicodemismo: simulazione e dissimulazione nell'Europa del '500*, Turin, 1970.

——, 'Tiziano, Ovidio e i codici della figurazione erotica nel '500', in *Tiziano e Venezia*, Proceedings of an International Symposium, Vicenza, 1980: 125–35.

Ginzburg, Silvia, 'Domenichino e Giovan Battista Agucchi', in *Domenichino*, exh. cat., Milan, 1996: 121–37.

[Giraldi, Lilius Gregorius] Gyraldus, Lilius Gregorius, *Libelli Duo, in quorum altero Aenigmata pleraque Antiquorum, in altero Pythagorae Symbola*, Basle, 1551.

Giraldi, Lilius Gregorius, *Opera Omnia*, 2 vols, Leyden, 1580.

——, *De Deis Gentium varia et multiplex Historia* (first publ. 1548), New York, 1976.

Giubbini, Guido, 'Saggio bio-bibliografico', in Francesco Scannelli, *Il Microcosmo della Pittura*, Milan, 1966.

Giusto, Mariangela, in Lucia Fornari Schianchi, ed., *Galleria Nazionale di Parma. Catalogo delle opere del Cinquecento e iconografia farnesiana*, Milan, 1998.

Goebel, Gerhard, *Poeta Faber: Erdichtete Architektur in der italienischen, spanischen und französischen Literatur der Renaissance und des Barock*, Heidelberg, 1971.

Goffen, Rona, *Piety and Patronage in Renaissance Venice*, New Haven and London, 1986.

Gombrich, Ernst, *Topos and Topicality in Renaissance Art*, London, 1975.

Gössmann, Maria Elisabeth, *Die Verkündigung an Maria im dogmatischen Verständnis des Mittelalters*, Munich, 1957.

Gould, Cecil, *National Gallery Catalogues: The Sixteenth-Century Italian Schools*, London, 1975.

Gramaccini, Norberto, *Alfonso Lombardi*, Frankfurt and Bern, 1980.

Grassi, Enrico, *Fontanellato. La famiglia e la Rocca Sanvitale*, Noceto, 1932.

Greenblatt, Stephen, 'Fiction and Friction', in *Reconstructing Individualism: Autonomy, Individuality, and the Self in Western Thought*, ed. Thomas C. Heller, Morton Sosna and David E. Wellbery, Stanford, 1986: 30–52.

Greene, Thomas, 'Erasmus's *Festina Lente*: Vulnerabilities of the Humanist Text', in *Mimesis, From Mirror to Method, Augustine to Descartes*, eds John Lyons and Stephen Nichols, Hanover and London, 1982: 132–48.

Gregori, Mina, 'Alessandro Pampurino', in *I Campi e la cultura artistica cremonese del Cinquecento*, exh. cat., Milan, 1985: 43–50.

Gregory the Great, Pope, 'Liber Responsalis sive Anthiphonarius', in *Patrologia Latina*, Paris, 1849, 78: 798.

Grigioni, Carlo, 'Per la tavola di Girolamo Genga nella Chiesa di S. Agostino in Cesena', *Rassegna bibliografica dell'arte italiana*, 12, 1909: 56–61.

——, 'La dimora di Girolamo Genga in Romagna e la cappella Lombardini nella chiesa di S. Francesco a Forlì', *La Romagna*, 1927: 174–83.

Grigioni, Giovanni, *Marco Palmezzano pittore forlivese*, Faenza, 1956.

Guazzoni, Valerio, 'La Cattedrale nella vita religiosa e civile di Cremona', in *Cremona. La Cattedrale*, eds Franco Voltini, Valerio Guazzoni, Cinisello Balsamo, 1989.

Guidicini, Giuseppe, *Cose notabili della città di Bologna ossia storia cronologica de'suoi stabili sacri, pubblici e privati*, 5 vols, Bologna, 1868–73.

——, *Miscellanea storico-patria bolognese tratta dai manoscritti di Giuseppe Guidicini data alle stampe dal figlio Ferdinando*, Bologna, 1872.

Gundert, Hermann, 'Zur Eschatologie in Pindars zweiter olympischer Ode', in ERMHNEIA: *Festschrift zum 60. Geburstag Otto Regenbogen dargebracht von Schuelern und Freunden*, Heidelberg, 1952: 46–65.

Guthmüller, Bodo, *Ovidio Metamorphoseos Vulgare: Formen und Funktionen der volkssprachlichen Wiedergabe klassischer Dichtung in der italienischen Renaissance*, Boppard am Rhein, 1981.

Hagen, Oskar, 'Die Camera di San Paolo zu Parma Betrachtungen über das Verhältnis von Malerei und Architektur', in *Festschrift Heinrich Wöfflin*, Munich, 1924: 110–120.

Haig Gaisser, Julia, *Catullus and his Renaissance Readers*, Oxford, 1993.

Hansen, Dorothee, 'Antike Helden als "causae": Ein gemaltes Programm im Palazzo Pubblico in Siena', in *Malerei und Stadtkultur in der Dantezeit*, eds Hans Belting and Dieter Blume, Munich, 1989: 133–48.

Higgins, Andrew, 'Notes on the Church of Saint Francis, or Tempio Malatestiano, at Rimini: More Especially as Regards the Sculptured Decorations', *Archeologia, Or Miscellaneous Tracts Relating to Antiquity*, 53, 1892: 187–92.

Hill, George Francis, *Corpus of Italian Medals of the Renaissance before Cellini*, 2 vols, London, 1930.

——, and Graham Pollard, *Renaissance Medals from the Samuel H. Kress Collection at the National Gallery of Art*, London, 1967.

Himmelmann, Nikolaus, 'Antike Götter im Mittelalter', in *Trierer Winckelmanns-programme*, ed. Günter Grimm, Mainz am Rhein, 1986, 7: 1–22.

Hollander, Robert, *Boccaccio's Two Venuses*, New York, 1977.

Holly, Michael Ann, *Panofsky and the Foundations of Art History*, Ithaca, 1984.

Hope, Charles, 'The Early History of the Tempio Malatestiano', *Journal of the Warburg and Courtauld Institutes*, 55, 1992: 51–154.

Horapollo, *Hieroglyphics*, ed. George Boas, New York, 1950.

Horsfall, Nicholas, 'Aeneid', in *A Companion to the Study of Virgil*, ed. Nicholas Horsfall, Leiden, 1995: 101–216.

Humfrey, Peter, 'Cima da Conegliano and Alberto Pio', *Paragone*, 29, f. 341, 1978: 86–100.

——, 'Il Compianto di Cristo morto di Cima da Conegliano', in *Quadri Rinomatissimi. Il collezionismo dei Pio di Savoia*, ed. Jadranka Bentini, Modena, 1994: 53–60.

Hutton, James, *The Greek Anthology in Italy to the year 1800*, Ithaca and New York, 1935.

I Rotuli dei Lettori Legisti e Artisti dal 1384 al 1799 pubblicati dal Dott. Umberto Dallari, 2 vols, Bologna, 1888–1889.

Il Tempio di San Giacomo Maggiore in Bologna, Bologna, 1967.

Iodice, Manuela, 'Regesto', in Marzia Faietti and Daniela Scaglietti Kelescian, *Amico Aspertini*, Modena, 1995: 343–8.

Iversen, Erik, *The Myth of Egypt and its Hieroglyphs in European Tradition*, Copenhagen, 1961.

Jackson Knight, W. F., *Elysion: On Ancient Greek and Roman Beliefs Concerning a Life After Death*, London, 1970.

Joost-Gaugier, L. Christiane, 'A Rediscovered Series of *Uomini Famosi* from Quattrocento Venice', *Art Bulletin*, 58, 1976: 184–95.

Jouassard, Georges, 'The Fathers of the Church and the Immaculate Conception', in Edward O'Connor, ed., *The Dogma of the Immaculate Conception: History and Significance*, Notre Dame, 1958: 51–85.

Journet, Charles, 'Scripture and the Immaculate Conception: A Problem in the Evolution of the Dogma', in Edward O'Connor, ed., *The Dogma of the Immaculate Conception: History and Significance*, Notre Dame, 1958: 1–50.

Kallendorf, Craig, 'Cristoforo Landino's *Aeneid* and the Humanist Critical Tradition', *Renaissance Quarterly*, 36, 1983: 519–46.

——, *In Praise of Aeneas: Virgil and Epideictic Rhetoric in the Early Renaissance*, Hanover and London, 1989.

Kanter, Laurence, 'Francesco Signorelli', *Arte cristiana*, 72, 1994: 199–212.

Kauffman, Hans, 'Fama', in *Reallexikon zur deutschen Kungstgeschichte*, ed. Karl-August Wirth, Munich, 1973, 6: 1426–45.

Klinger, Lynda S., 'The Portrait Collection of Paolo Giovio', 2 vols, unpublished PhD thesis, Princeton University, 1991.

Kokole, Stanko, "Agostino di Duccio in the Tempio Malatestiano 1449–1457: Challenges of Poetic Invention and Fantasies of Personal Style', 2 vols, unpublished PhD thesis, The Johns Hopkins University, 1997.

——, 'Appian's "Punica" 8. 66 and the "Triumph of Scipio" on the Tomb of the Ancestors in the Tempio Malatestiano', in *Opere e giorni: Studi su mille anni di arte europea dedicati a Max Seidel*, eds Klaus Bergdolt and Giorgio Bonsanti, Venice, 2001: 315–20.

Kroll, Josef, 'Elysium', in *Arbeitsgemeinschaft für Forschung des Landes Nordrhein-Westfalen. Geisteswissenschaften*, Cologne and Opladen, 1953, 2: 7–35.

Kropfinger-von Kügelgen, Helga, 'Amico Aspertinis Malerisches Werk. Ein Beitrag zur Bologneser Malerei der ersten Häfte des Cinquecento', unpublished dissertation, University of Bonn, 1973.

Kühlenthal, Michael, 'Studien zum Stil und zur Stilentwicklung Agostino di Duccios', *Wiener Jahrbuch für Kunstgeschichte*, 24, 1971: 59–100.

Kuhn, Victoria, 'Erasmus: Prudence and Faith', in *Rhetoric, Prudence, and Skepticism in the Renaissance*, Ithaca and New York, 1985.

Kyriakides, Strates, *Narrative Structure and Poetics in the Aeneid: the Frame of Book 6*, Bari [1998].

Lamo, Pietro, *Graticola di Bologna*, ed. Marinella Pigozzi, Bologna 1996.

Lanzi, Luigi, *Storia pittorica d'Italia*, 3 vols, Bassano, 1795–96.

Lasagni, Roberto, ed., 'Sanvitale, Eucherio', in *Dizionario biografico dei Parmigiani*, 4 vols., Parma, 1999, 4: 302–303.

Laurentin, René, 'The role of the Papal Magisterium in the Development of the Dogma of the Immaculate Conception', in Edward O'Connor, ed., *The Dogma of the Immaculate Conception: History and Significance*, Notre Dame, 1958: 217–324.

Le Bachelet, Xavier-Marie, and Martin Jugie, 'Immaculée Conception', in *Dictionnaire de Théologie Catholique*, Paris, 1927, 7: 845–1218.

Lefebvre, Henri, *The Production of Space*, trans. Donald Nicholson-Smith, Oxford and Cambridge, 1984.

Lehmann, Phyllis Williams, 'Cyriacus of Ancona's Visit to Samothrace', in Phyllis Williams Lehmann, and Karl Lehmann, *Samothracian Reflections: Aspects of the Revival of the Antique*, Princeton, NJ, 1973: 3–56.

Lehmann-Hartleben, Karl, 'Cyriacus of Ancona, Aristotle and Teiresias in Samothrace', *Hesperia*, 12, 1943: 15–25.

Levenson, Jay A., 'Masters of the Tarocchi', in *Early Italian Engravings from the National*

Gallery of Art, eds Jay Levenson, Konrad Oberhuber and Jacquelyn Sheehan, Washington, 1973: 81–157.

Levi D'Ancona, Mirella, *The Iconography of the Immaculate Conception in the Middle Ages and Early Renaissance*, New York, 1957.

——, *The Garden of the Renaissance: Botanic Symbolism in Italian Painting*, Florence, 1977.

Liebenwein, Wolfang, 'Lo studiolo come luogo del principe', in Andrea Di Lorenzo and Alessandra Mottola Molfino, eds, *Le Muse e il Principe*, 2 vols, Modena, 1991, 2: 135–44.

——, *Studiolo*, ed. Claudia Cieri Via, trans. A. Califano (first publ. 1977), Modena, 1992.

Lightbown, Ronald W., *Mantegna: With a Complete Catalogue of the Paintings, Drawings and Prints*, Oxford, 1986.

Lippincott, Kristen, 'The neo-Latin historical Epics of the North Italian Courts: an Examination of "Courtly Culture" in the Fifteenth Century', *Renaissance Studies*, 3.4, 1989: 418–20.

Litta, Pompeo, *Famiglie celebri d'Italia*, Milan, 1820.

Lollini, Fabrizio, in *Biblioteca comunale dell'Archiginnasio. Bologna*, ed. Piero Bellettini, Fiesole, 2001: 194–5 (= 2001a).

——, 'Giovanni da Fano miniatore rinascimentale riminese: Basinio da Parma, *Hesperis* 1462–1464 circa', in *Il Potere, le Arti, la Guerra: lo Splendore dei Malatesta*, ed. Angela Donati, Milan, 2001: 312 (= 2001b).

Longhi, Roberto, *Il Correggio nella Camera di San Paolo a Parma*, Genova, 1956 (= 1956a).

——, *Officina ferrarese* (first publ. 1934), Florence, 1956 (= 1956b).

——, 'Momenti della pittura bolognese [1934]', in *Da Cimabue a Morandi: saggi di storia della pittura italiana*, ed. Gianfranco Contini, Milan, 1974.

Lucan, *The Civil War, Books I–IX*, trans. James D. Duff, Cambridge, MA and London, 1943.

Lucco, Mauro, 'La pittura a Bologna e in Romagna nel secondo Quattrocento', in *La pittura in Italia. Il Quattrocento*, 2 vols, Milan, 1987, 1: 247–67.

Malehrbe, J. Abraham, 'Herakles', in *Reallexikon für Antike und Christentum*, eds Ernst Dussmann *et al.*, Stuttgart, 1988, 14: 559–83.

Malke, Lutz S., 'Contributi alle figurazioni dei Trionfi e del Canzoniere del Petrarca', *Commentari*, 28.4, 1977: 236–61.

Malvasia, Carlo Cesare, *Le pitture di Bologna ... rendono il passeggiere disingannato ed instrutto*, Bologna, 1686.

——, *Felsina Pittrice – Vite de' pittori bolognesi* (first publ. 1678), 2 vols, Bologna, 1841.

——, *Le Pitture di Bologna 1686*, ed. Andrea Emiliani, Bologna, 1969.

Mancini, Giulio, *Considerazioni sulla pittura*, 2 vols, Rome, 1956.

Mann Phillips, Margaret, 'Ways with Adages', in *Essays on the Work of Erasmus*, ed. Richard DeMolen, New Haven and London, 1978: 51–60.

——, 'Comment s'est-on servi des Adages?', in *Actes du Colloque International Erasme*, eds Jacques Chamorat, André Godin, Jean-Claude Margolin, Geneva, 1990: 326–36.

Manzini, Gabriella, 'Antonio Morandi, il "Terribilia", nell'architettura bolognese del'500', *Il Carrobbio*, 9, 1983: 243–55.

Marani, Pietro, *Leonardo. Una carriera di pittore*, Milan, 1999.

Marrow, John, '*Circumdederunt me canes multi*: Christ's Tormenters in Northern European Art of the Late Middle Ages and Early Renaissance', *Art Bulletin*, 59, 1977: 167–81.

Marzocchi, Lea, ed., *Scritti originali del Conte Carlo Cesare Malvasia spettanti alla sua Felsina Pittrice*, Bologna, s.d. [1983].

Masini, Antonio, *Bologna perlustrata terza impressione notabilmente accresciuta* (first publ. 1650), Bologna, 1666.

——, *Bologna perlustrata*, Bologna, 1650.

Massèra, Aldo Francesco, 'I poeti isottei I–III: Appendice', *Giornale storico della letteratura italiana*, 92, 1928: 1–55.

——, *Roberto Valturio: 'Omnium scientiarum doctor et monarcha' (1405–1475)*, ed. Remigio Pian, Faenza, 1958.

Mazzatinti, Giuseppe, 'La biblioteca di San Francesco (Tempio Malatestiano) in Rimini', in *Scritti vari di filologia dedicati a Ernesto Monaci per l'anno XXV del suo insegnamento*, Rome, 1901: 347–52.

McGushin, Patrick, *The Transmission of the Punica of Silius Italicus*, Amsterdam, 1985.

McIver, Katherine A., 'Love, Death and Mourning: Paola Gonzaga's Camerino at Fontanellato', *Artibus et historiae*, 36, 1997: 101–108.

"Medica, Massimo"', 'In margine all'attività bolognese di Taddeo Crivelli: il caso del Maestro del Libro dei Notai', *Arte a Bologna bollettino dei musei civici d'arte antica*, 3, 1993: 121–8.

Medioli Masotti, Paola, 'Letteratura e società a Parma nel Quattrocento', in *Parma e l'Umanesimo italiano*, ed. Paola Medioli Masotti, Padua, 1986.

Mengs, Antonio Raphael, *Pensieri sulla pittura*, Palermo, 1996.

Miccoli, Giovanni, *Francesco d'Assisi. Realtà e memoria di un'esperienza cristiana*, Turin, 1991.

Michiel, Marcantonio, *Anonimo Morelliano. Notizie di opere del Disegno*, ed. Theodor von Frimmel, Bologna, 1884.

Mitchell, Charles, 'Archeology and Romance in Renaissance Italy', in *Italian Renaissance Studies*, ed. E. F. Jacob, London, 1960: 476–84.

Mommsen, Theodor E., 'Petrarch and the Decoration of the Sala Virorum Illustrium in Padua', *Art Bulletin*, 34, 1952: 95–116.

Monticelli, Marina, 'Annunciazione', in *Imago Virginis. Dipinti di iconografia mariana nella diocesi Cesena-Sarsina dal XIV al XVIII secolo*, ed. Marina Cellini, exh. cat., Cesena, 1988: 51–3.

Morabito, Giuseppe, 'Angelo da Gerusalemme o da Licata, santo, martire', in *Bibliotheca Sanctorum*, Rome, 1961, 1: 1240–43.

Morandotti, Alessandro, 'Disputa sull'Immacolata Concezione', in *Catalogo. Pinacoteca di Brera. Scuole dell'Italia centrale e meridionale*, Milan, 1992: 126–31.

——, 'Gerolamo Genga negli anni della Pala di Sant'Agostino a Cesena', *Studi di Storia dell'Arte*, 4, 1993: 275–90.

Morselli, Alfonso, *Ludovico Ariosto tra Ippolito d'Este e Alberto Pio*, Modena, 1937.

Morselli, Alfredo, 'Notizie e documenti sulla vita di Alberto Pio: lettere inedite', *Memorie storiche e documenti sull'antico principato di Carpi*, 9, 1932: 82.

Morselli, Raffaella, *Repertorio per lo studio del collezionismo bolognese del Seicento*, Bologna, 1997.

——, *Collezioni e quadrerie nella Bologna del Seicento. Inventari 1640–1707 Documents for the History of Collecting: Italian Inventories*, vol. 3, Los Angeles, 1998.

Moss, Ann, *Printed Commonplace-Books and the Structuring of Renaissance Thought*, Oxford, 1996.

Mulazzani, Germano, 'La pittura. L'età del Parmigianino', in Roberto Greci, Marilisa di Giovanni Madruzza and Germano Mulazzani, eds, *Corti del Rinascimento nella provincia di Parma*, Turin, 1981: 158–75.

Murphy, Stephen, 'Petrarca's "Africa" and the Poet's Dream of Glory', *Italian Culture*, 9, 1991: 75–83.

Musacchio, Jacqueline Marie, *The Art and Ritual of Childbirth in Renaissance Italy*, New Haven and London, 1999.

Nardi, Bruno, 'Achillini, Alessandro', in *Dizionario Biografico degli Italiani*, Rome, 1960, 1: 144–5.

——, *Studi su Pietro Pomponazzi*, Florence, 1965.

Nardi, Luigi, *Descrizione antiquario-architettonica con rami dell'arco di Augusto, Ponte di Tiberio e Tempio Malatestiano di Rimino* (first publ. 1813), Rimini, 1979.

Negro, Emilio, and Nicosetta Roio, *Francesco Francia e la sua scuola*, Modena, 1998.

——, *Lorenzo Costa 1460–1535*, Modena, 2001.

Nicolini, Simonetta, 'Alcune note su codici riminesi e malatestiani', *Studi Romagnoli*, 39, 1988: 17–39.

——, 'Giovanni di Bartolo Bettini da Fano, miniatore rinascimentale riminese: Basinio da Parma, *Hesperis* 1462–1464 circa', in *Il Potere, le Arti, la Guerra: lo Splendore dei Malatesta*, ed. Angela Donati, Milan, 2001: 314.

Norden, Eduard, *P. Vergilius Maro: Aeneis Buch VI*, 3d edn, Leipzig and Berlin, 1934.

Nova, Alessandro, 'I tramezzi in Lombardia fra XV e XVI secolo: scene della Passione e devozione francescana', in *Il Francescanesimo in Lombardia: storia e arte*, Milan, 1983: 196–215.

——, 'Folengo and Romanino: The *Questione della Lingua* and its Eccentric Trends', *Art Bulletin*, 71.4, 1994: 664–79 (= 1994a).

——, *Girolamo Romanino*, Turin, 1994 (= 1994b).

——, 'Beobachten und Beobachtet werden: Die Metamorphose des Betrachters und des Betrachteten bei Correggio und Parmigianino', in *Imagination und Wirklichkeit. Zum Verhältnis von mentalen und realen Bildern in der Kunst der Fruehen Neuzeit*, ed. Klaus Krueger and Alessandro Nova, Mainz, 2000: 81–98.

Novati, Francesco, 'Una poesia politica del Cinquecento: *Il Pater Noster* dei Lombardi', *Giornale Filologico Romano*, 2, 1879: 1–32.

——, 'La vita e le opere di Domenico Bordigallo', *Archivio Veneto*, 19, 1880: 1–72.

O'Connor, Edward, ed., *The Dogma of the Immaculate Conception: History and Significance*, Notre Dame, 1958.

Oliva, Carlo, 'Nota sull'insegnamento di Pomponazzi', *Giornale critico della filosofia italiana*, 7, 1926: 179–90.

Onians, John, 'Serlio and the History of Architecture', in *Il luogo e il ruolo della città di Bologna tra Europa continentale e mediterranea*, ed. Giovanna Perini, Proceedings of the XXVIIth Conference in the History of Art, CIHA, Bologna, 1992: 181–93.

Ortner, Alexandra, *Petrarcas 'Trionfi' in Malerei, Dichtung und Festkultur: Untersuchungen zur Entstehung und Verbreitung eines florentinischen Bildmotivs auf cassoni und deschi da parto des 15. Jahrhunderts*, Weimar, 1998.

Ovid, *Metamorphoses*, trans. A. D. Melville, intro. by E. J. Kenney, Oxford and New York, 1986.

——, *Metamorphoses*, trans. Frank Justus Miller, 6 vols, Cambridge, MA and London, 1977–84.

Pächt, Otto, 'Giovanni da Fano's Illustrations for Basinio's Epos Hesperis', *Studi Romagnoli*, 2, 1951–1952: 91–103.

Pade, Marianne, 'Guarino and Caesar at the Court of the Este', in *La corte di Ferrara e il suo mecenatismo 1441–1598*, Proceedings of an International Symposium, eds Marianne Pade, Lene Waage Petersen and Daniela Quarta, Modena, 1990: 71–92.

Pagnotta, Laura, *Giuliano Bugiardini*, Turin, 1987.

Panazza, Gaetano, *Affreschi di Girolamo Romanino*, Milan, 1965.

Panofsky, Erwin, *The Iconography of Correggio's Camera di San Paolo*, London, 1961.

Pardo, Mary, 'Paolo Pino's Dialogo di Pittura: a Translation with Commentary', unpublished PhD thesis, University of Pittsburgh, 1984.

Pasini, Pier Giorgio, *I Malatesti e l'arte*, Milan, 1983.

——, *Il Tempio malatestiano: splendore cortese e classicismo umanistico*, Geneva, 2000.

Pattanaro, Alessandra, 'Il Garofalo e il Cesariano a Ferrara', *Prospettiva*, 73–4, 1994: 97–110.

Patzac, Bernhard, 'Genga, Girolamo', in Ulrich Thieme and Felix Becker, eds, *Allgemeines Lexikon der Bildenden Künstler*, Leipzig, 1920, 13: 387.

Pelicelli, Nestore, 'Bernardino Loschi', in Ulrich Thieme and Felix Becker, eds, *Allgemeines Lexikon der Bildnender Künstler*, Leipzig, 1929, 23: 401–402.

Pelta, Maureen, 'Form and Convent: Correggio and the Decoration of the Camera di San Paolo', Unpublished PhD thesis, Bryn Mawr College, 1989.

Perini, Giovanna, 'La storiografia artistica a Bologna e il collezionismo privato', *Annali della Scuola Normale Superiore di Pisa*, 11.1, 1981: 181–243.

——, 'Luigi Lanzi: questioni di stile, questioni di metodo', in *Gli Uffizi: quattro secoli di una Galleria – Fonti e documenti*, Florence, 1982: 215–65.

——, 'L'epistolario del Malvasia – Primi frammenti: le lettere all'Aprosio', *Studi secenteschi*, 25, 1984: 183–230.

——, review of Lea Marzocchi, ed., *Scritti originali del Conte Carlo Cesare Malvasia spettanti alla sua* Felsina Pittrice, Bologna: Alfa, s.d. [1983], in *Studi e problemi di critica testuale*, 28, 1984: 211–20 (=1984b).

——, 'Carlo Cesare Malvasia's Florentine Letters: Insight into Conflicting Trends in Seventeenth Century Italian Art Historiography', *Art Bulletin*, 70, 1988: 273–99.

——, 'Natura ed espressione nel linguaggio critico di Carlo Cesare Malvasia', in *Il luogo ed il ruolo della città di Bologna tra Europa continentale e mediterranea*, Proceedings of the xxvIIIth Conference in the History of Art (CIHA), Bologna, 1992: 511–28.

——, 'Paura di volare', in *Domenichino*, exh. cat., Milan, 1996: 57–119.

——, 'Carmi inediti su Raffaello e sull'arte della prima metà del Cinquecento a Roma e Ferrara ed il mondo dei *Coryciana* con un'appendice "A proposito di critica positiva e verità storiografica: la vera data di morte del Francia e la presenza di Raffaello a Bologna"', *Römisches Jahrbuch der Bibliotheca Hertziana*, 32, 1997–98: 367–407.

——, 'Giovannino da Capugnano: leggenda biografica e realtà storica', *Gente di Gaggio*, 18, 1998: 110–20.

——, 'Una sorta di introduzione, ovvero appunti sulla storiografia della scultura bolognese', in *Il restauro del Nettuno, la statua di Gregorio XIII e la sistemazione di Piazza Maggiore nel Cinquecento – Contributi anche documentari alla conoscenza della prassi e dell'organizzazione delle arti a Bologna prima dei Carracci*, Bologna, 1999: 7–86.

——, 'Una certa idea di Raffaello nel Seicento', in *L'idea del Bello. Viaggio per Roma nel Seicento con Giovan Pietro Bellori*, ed. Evelina Borea and Carlo Gasparri, 2 vols, Rome, 2000, 1:153–61 (=2000a).

——, 'The Notion of "School of Painting": its Italian Birth and its European Diffusion and Application, 1600–1800 ca.', paper read at the xxxth International Conference in the History of Art (CIHA), University of London, London, September 2000 (=2000b).

Pernis, Maria Grazia, and Laurie Schneider Adams, *Federico da Montefeltro and Sigismondo Malatesta: The Eagle and the Elephant*, New York, 1996.

[Petrarch] Petrarca, Francesco, *L'Africa: edizione critica*, ed. Nicola Festa, Florence, 1926.

——, *Petrarch's Africa*, trans. and annot. Thomas G. Bergin and Alice S. Wilson, New Haven, 1977.

——, *Petrarch's Remedies for Fortune Fair and Foul*, trans. and ed. Conrad H. Rawski, 5 vols, Bloomington and Indianapolis, 1991.

——, Francesco, *Opere: Canzoniere, Trionfi, Familiarium rerum libri*, ed. Mario Martelli, Florence, 1992.

——, *Songbook: Rerum Vulgarium Fragmenta*, trans. James Wyatt Cook, Italian text Gianfranco Contini, Binghamton, 1995.

Petrioli Tofani, Anna Maria, 'Girolamo Genga', in *Urbino e le Marche prima e dopo Raffaello*, ed. Maria Grazia Ciardi Duprè and Paolo Dal Poggetto, exh. cat., Florence, 1983: 355–8.

Petrocchi, Giorgio, 'Cultura e poesia del Trecento', in *Storia della letteratura italiana*, ed. Emilio Cecchi and Natalino Sapegno, *Il Trecento* (first publ. 1965), Milan, 1970, 2: 561–724.

Petrucci, Ferruccio, 'Cibo, Innocenzo', in *Dizionario biografico degli Italiani*, Rome, 1981, 2: 249–55.

Pfisterer, Ulrich, 'Künstlerische *potestas audendi* und *licentia* im Quattrocento. Benozzo Gozzoli, Andrea Mantegna, Bertoldo di Giovanni', *Römisches Jahrbuch der Bibliotheca Hertziana*, 31, 1996: 107–48.

Piana, Celestino, 'Gli inizi e lo sviluppo dello Scotismo a Bologna e nella regione Romagnolo-Flaminia (sec. xiv–xvi)', *Archivium Franciscanum Historicum*, 1947, 40: 1–32.

——, 'Un saggio dell'attività francescana nella difesa e propagazione del culto alla Concezione Immacolata', in *Virgo Immaculata*, Rome, 7.3, 1957: 1–41.

Pico della Mirandola, Giovanni, 'Commento alla canzone d'amore di Girolamo Benivieni', in *Heptalus De Ente et Uno e scritti vari*, ed. Eugenio Garin, Florence, 1942.

Pigozzi, Marinella, ed., *Bologna al tempo di Cavazzoni. Approfondimenti*, Bologna, 1999.

Pinelli, Antonio, and Orietta Rossi, *Genga architetto. Aspetti della cultura urbinate del primo Cinquecento*, Rome, 1971.

Pino, Paolo, 'Dialogo di Pittura', in *Trattati d'Arte del Cinquecento*, ed. Paola Barocchi, 3 vols, Bari, 1960.

Piromalli, Antonio, *Dal Quattrocento al Novecento: saggi critici*, Florence, 1965.

——, 'Un elemento cortigiano dell'ideologia culturale di Sigismondo Malatesta: l'isottismo', in *Mediterraneo medievale: scritti in onore di Francesco Giunta*, 3 vols, Soveria Mannelli, 1989, 3: 999–1013.

Pitture scolture ed architetture delle chiese, luoghi pubblici, palazzi, e case della città di Bologna, e suoi sobborghi …, Bologna, 1782.

Plautus, Actius Asinius, *Comoediae viginti nuper emendatae, et in eas Pilade Brixiani Lucubrationes: Thadei Ugoleti, et Grapaldi virorum illustrium Scholia, Anselmi Ephylliades*, Parma, 1510.

Pliny, *Natural History*, trans. H. Rackham, 9 vols, Cambridge, MA and London, 1995.

Poeschke, Joachim, *Die Skulptur der Renaissance in Italien*, vol. 1: *Donatello und seine Zeit*, Munich, 1990.

Pointner, Andy, *Die Werke des florentinischen Bildhauers Agostino d'Antonio di Duccio*, Strasbourg, 1909.

Popham, E. Arthur, 'Drawings by Parmigianino for the Rocca of Fontanellato', *Master Drawings*, 1, 1963: 3–10.

——, *Catalogue of the Drawings by Parmigianino*, 3 vols, New Haven and London, 1971.

Possidius, *Sancti Augustini vita scripta a Possidio Episcopo*, ed. and trans. Herbert T. Weiskotten, Princeton, NJ, 1919.

Pozzi, Giovanni, *Poesia per gioco*, Bologna, 1984.

——, *Sull'orlo del visibile parlare*, Milan, 1993.

Previtali, Giovanni, *La fortuna dei primitivi dal Vasari ai Neoclassici*, Turin, 1964.

Propertius, *Elegiae*, ed. and trans. G. P. Goold, Cambridge, MA and London, 1990.

Pseudo-Augustine, *Sermones ad fratres in heremo commorantes*, in *Patrologia Latina*, vol. 40, Paris, 1887: 1234–358.

Puerari, Alfredo, *Il Duomo di Cremona*, Cinisello Balsamo, 1971.

Raggi, Angelo Maria, 'Monica. Iconografia', in *Bibliotheca sanctorum*, Rome, 1967, 9: 558–61.

Rano, Balbino, 'Agostiniane, monache', in *Dizionario degli Istituti di Perfezione*, Rome, 1973, 1: 155–90 (=1973a).

——, 'Agostiniani', in *Dizionario degli Istituti di Perfezione*, Rome, 1973, 1: 278–349 (= 1973b).

Ratti, Carlo Giuseppe, *Notizie storiche sincere intorno la Vita e le Opere del celebre pittore Antonio Allegri da Correggio*, Finale, 1781.

Rearick, R. William, 'Pordenone "Romanista"', in *Il Pordenone*, Atti del convegno Internationale di studio, ed. Caterina Furlan, Pordenone, 1985: 127–34.

Reeve, D. Michael, 'Appendix Virgiliana', in *Texts and Transmission*, Oxford and New York, 1983: 437–40.

Ricci, Corrado, 'Per la storia della pittura forlivese. II. Giovanni del Sega', *L'Arte*, 17, 1911: 88–91.

——, *Il Tempio Malatestiano*, Milan and Rome, n.d. [1924].

——, 'Di un codice Malatestiano della "Esperide" di Basinio', *Accademie e Biblioteche d'Italia*, 1, 1927–28: 20–48.

——, *Correggio*, London and New York, 1930.

Ridolfi, Angelo Calisto, *Indice dei notai bolognesi dal XIII al XIX secolo*, ed. Graziella Grandi Venturi, intr. Mario Fanti and Diana Tura, Bologna, 1990.

Ridolfi, Carlo, *Le meraviglie dell'arte* (first publ. Venice, 1648), 2 vols, Rome, 1965.

Roio, Nicosetta, 'L'eredità del Francia', in *Francesco Francia e la sua scuola*, ed. Emilio Negro and Nicosetta Roio, Modena, 1998.

Romano, Giovanni, 'Verso la maniera moderna', in *Storia dell'arte italiana*, ed. Federico Zeri, 12 vols, Turin, 1981, 6.1: 5–72.

——, 'Il Cinquecento di Roberto Longhi Eccentrici, classicismo, maniera', in *Storie dell'arte – Toesca, Longhi, Wittkower, Previtali*, Rome, 1998: 23–62.

Rombaldi, Odoardo, 'Profilo biografico di Alberto III Pio Conte di Carpi', in *Alberto III Pio, Signore di Carpi (1475–1975)*, Proceedings of an International Symposium, Modena, 1977: 1–40.

Rossi, Francesco, *Accademia Carrara di Bergamo. Catalogo dei dipinti*, Bergamo, 1979.

Rotondi, Pasquale, *Il palazzo ducale di Urbino*, Urbino, 1950.

Rotondò, Antonio, 'Bocchi, Achille', in *Dizionario Biografico degli Italiani*, Rome, 1969, 11: 67–70.

Roversi, Giancarlo, ed., *Palazzi e case nobili del 500 a Bologna. La storia, le famiglie, le opere d'arte*, Bologna, 1986.

Rubin, Patricia, *Giorgio Vasari: Art and History*, New Haven and London, 1995.

Rubinstein, Nicolai, 'Political Ideas in Sienese Art: The Frescoes by Ambrogio Lorenzetti and Taddeo di Bartolo in the Palazzo Pubblico', *Journal of the Warburg and Courtauld Institutes*, 21, 1958: 179–207.

Ruhmer, Eberhard, *Malatesta-Tempel*, Biberach an der Riss, n.d. [1970].

Sacchi, Federico, *Notizie Pittoriche Cremonesi* (first publ. 1872), Cremona, 1985.

Saint-Jean, Raymond, 'Prudence', in *Dictionnaire de Spiritualité ascétique et mystique, doctrine et histoire*, ed. Marcel Viller, Paris, 1986, 12. 2: 2475–84.

Salmi, Mario, 'Intorno al Genga', *Rassegna marchigiana*, 6, 1927–8: 229–36.

[Salutati, Coluccio], *Epistolario di Coluccio Salutati*, ed. Francesco Novati, 4 vols, Rome, 1891–1911.

Sammarini, Achille, 'Lettere inedite dei Signori Pio da Carpi ai principi Gonzaga di Mantova 1366–1518', *Memorie storiche e documenti sulla città e l'antico principato di Carpi*, 1, 1877: 351.

San Juan, Rose Marie, 'The Court Lady's Dilemma: Isabella d'Este and Art Collecting in the Renaissance', *Oxford Art Journal*, 14, 1991: 67–78.

Sanvitale, Luigi, *Memorie intorno alla Rocca di Fontanellato ed alle pitture che vi fece Francesco Mazzola detto il Parmigianino*, Parma, 1857.

Sardi, Vincenzo, *La solenne definizione del Dogma dell'Immacolato Concepimento di Maria Santissima*, 2 vols, Rome, 1904.

Sassu, Giovanni, in Francesco Cavazzoni, *Scritti d'arte*, ed. Marinella Pigozzi, Bologna, 1999.

——, *Il Santuario di Santa Maria della Pioggia già chiesa di San Bartolomeo di Reno*, Bologna, 2001a.

——, in *Petronio e Bologna. Il volto di una storia. Arte, storia e culto del Santo Patrono*, ed. Beatrice Buscaroli and Roberto Sernicola, exh. cat., Bologna, 2001b.

Saxl, Fritz, 'The Classical Inscription in Renaissance Art and Politics Bartolomaeus Fontius: *Liber monumentorum Romanae urbis et aliorum locorum*', *Journal of the Warburg and Courtauld Institutes*, 4, 1940–41: 19–46.

——, and Hans Meier, *Verzeichnis astrologischer und mythologischer illustrierten Handschriften des lateinischen Mittelalters*, vol. III: *Handschriften in englischen Bibliotheken 1*, ed. Harry Bober, London, 1953.

Scaglietti, Daniela, 'La Cappella di Santa Cecilia', in *Il Tempio di San Giacomo Maggiore in Bologna*, Bologna, 1967.

Scaglietti Kelescian, Daniela, 'Nuovi dipinti di Amico Aspertini', in *Scritti di storia dell'arte in onore di Jürgen Winkelmann*, Naples, 1999: 321–33.

Scannelli, Francesco, *Il Microcosmo della Pittura* (first publ. Cesena, 1657), Milan, 1966.

Schaff, P. M., 'Isolani ou de Isolanis Isidore, dominicain de la congrégation de Lombardie (†1528)', in *Dictionnaire de Théologie Catholique*, Paris, 1924, 8: 112–15.

Schiller, Gertrud, *Ikonographie der christlichen Kunst*, 5 vols, Gütersloh, 1966–80.

Schlosser, Julius von, *Quellenbuch: Repertorio di fonti per la Storia dell'Arte del Medioevo occidentale (secoli IV–XV)*, 2d edn, ed. János Végh, Florence, 1992.

Schmidt, L. Peter, 'Culex', in *Der Neue Pauly: Encyklopaedie der Antike – Altertum*, eds Huber Kancik and Helmuth Schneider, Stuttgart and Weimar, 1977, 3: 3–228.

Schmidt Arcangeli, Caterina, 'Cima da Conegliano e Vincenzo Catena pittori veneti a Carpi', in *La Pittura Veneta negli Stati Estensi*, ed. Jadranka Bentini, Sergio Marinelli and Angelo Mazza, Verona, 1996: 95–116.

Schmitt, Annegrit, 'Herkules in einer unbekannten Zeichnung Pisanellos: Ein Beitrag zur Ikonographie der Frührenaissance', *Jahrbuch der Berliner Museen*, 1975, 17: 51–86.

Schröter, Elisabeth, *Die Ikonographie des Themas Parnass vor Raphael: Die Schrift- und Bildtradition von der Spätantike bis zum 15. Jahrhundert*, 2 vols in one, Hildesheim and New York, 1977.

Schwarzweller, Kurt, 'Giovanni Antonio Pordenone', unpublished Inaugural-Dissertation, Georg-August-Universität, Göttingen, 1935.

Sebastian, Wenceslaus, 'The Controversy over the Immaculate Conception from after Scotus to the End of the Eighteenth Century', in Edward O'Connor, ed., *The Dogma of the Immaculate Conception: History and Significance*, Notre Dame, 1958.

Semper, Hans, F. O. Schulze and W. Barth, *Carpi: Una sede principesca del Rinascimento*, ed. Luisa Giordano, trans. A. D'Amelio and A. E. Werdehausen, Pisa, 1999.

Sepulveda, Juan Ginès, *Opera cum edita tum inedita accurante regia historiae academia*, 4 vols, Madrid, 1780.

[Servins], *Servii grammatici qui Ferunt in Virgil carmina commentarii*, ed. Georg Thilo and Herman Hagen, 2 vols, Leipzig, 1884.

Setaioli, Aldo, 'Inferi', in *Enciclopedia Virgiliana*, Rome, 1985, 2: 953–63.

Settis, Salvatore, 'Citarea su un'impresa di bronconi', *Journal of the Warburg and Courtauld Institutes*, 34, 1971: 135–77.

Seznec, Jean, *The Survival of the Pagan Gods: The Mythological Tradition and its Place in Renaissance Humanism and Art* (first publ. in French, 1940), trans. Barbara F. Sessions, New York, 1953.

——, *La Sopravvivenza degli Antichi Dei* (first publ. in French, 1940), Turin, 1981.

Shapiro, Maurice, 'Summaries of Dissertations: Studies in the Iconology of the Sculptures in the Tempio Malatestiano', *Marsyas*, 7, 1957: 89.

——, 'Studies in the Iconology of the Sculpture in the Tempio Malatestiano', unpublished PhD thesis, New York University, 1958.

Shapley, Fern Rusk, *Paintings from the Samuel H. Kress Collection: Italian Schools XV–XVI Century*, 2 vols, New York, 1968.

Sheard Stedman, Wendy, *Antiquity in the Renaissance*, Northampton, MA, 1978.

Shearman, John, *Raphael in Early Modern Sources, 1483–1600*, 2 vols, New Haven and London, 2003.

Shorr, C. Dorothy, 'Some Notes on the Iconography of Petrarch's Triumph of Fame', *Art Bulletin*, 20, 1938: 100–107.

Silius Italicus, *Punica*, trans. J. D. Duff, 2 vols, Cambridge, MA and London, 1934.

Simi Varanelli, Emma, *La glorificazione della madre di Dio nei dipinti marchigiani dei secoli XIV e XV. Il contributo essenziale della pittura della Marca alla definizione della figura della Immacolata*, Macerata, 1986.

Simon, Erika, and Bauchhess, Gerhard, 'Artemis/Diana', in *Lexikon Iconographicum Mythologiae Classicae*, Zürich, 1981, 1: 900–911.

Snow-Smith, Joanne, 'Leonardo's *Virgin of the Rocks* (Musée du Louvre): A Franciscan Interpretation', *Studies in Iconography*, 11, 1987: 35–94.

Söll, George, *Storia dei dogmi mariani*, Rome, 1981.

Solmsen, Friederich, 'The World of the Dead in Book 6 of the Aeneid', *Classical Philology*, 67.1, 1972: 31–41.

Sommi-Picenardi, Guido, *La Famiglia Sommi; Memorie e Documenti di Storia Cremonese*, Cremona, 1893.

Sorbelli, Albano, *Inventari dei manoscritti delle biblioteche d'Italia*, vol. XXIII: Bologna, Florence, 1915.

——, *Inventari dei manoscritti delle biblioteche d'Italia*, vol. LXVI, Bologna, Florence, 1937.

Sourvinou-Inwood, Christiane, *'Reading' Greek Death: to the End of the Classical Period*, Oxford and New York, 1996.

Southorn, Janet, *Power and Display in the Seventeenth Century – The Arts and their Patrons in Modena and Ferrara*, Cambridge, 1988.

Squadroni, Alessandro, *Fasciculus laudum Regii Lapidi ab eodem in hac secunda editione auctus*, Reggio, 1620.

Statius, *Silvae, Thebaid i–iv*, trans. John Henry Mozley, Cambridge MA and London, 1955.

——, *Thebaid v–xii, Achilleid*, trans. John Henry Mozley, Cambridge MA and London, 1957.

Stefaniak, Regina, 'Correggio's *Camera di San Paolo*: An Archeology of the Gaze', *Art History*, 16.2, 1993: 203–38.

——, 'Amazing Grace: Parmigianino's *Vision of Saint Jerome*', *Zeitschrift für Kunstgeschichte*, 58, 1995: 105–15.

——, 'On Looking into the Abyss: Leonardo's *Virgin of the Rocks*', *Konsthistorisk tidskrift*, 66.1, 1997: 1–36.

Stiennon, Jacques, 'L'iconographie de saint Augustin d'après Benozzo Gozzoli et les Croisiers de Huy', *Bulletin de l'Institut Historique Belge de Rome*, 27, 1952: 235–48.

Strobl, Barbara, 'Der "Liber de amore Iovis in Isottam" des Porcelio de' Pandoni: Rezeption antiker Mythologie und Liebesdichtung zum Lob des Sigismondo Malatesta von Rimini', unpublished MA thesis, University of Vienna, 1990.

Superbi, Agostino, *Apparato de gli huomini illustri della città di Ferrara*, Ferrara, 1620.

Svalduz, Elena, 'Notizie e documenti su Alberto III Pio', in Hans Semper, F. O. Schulze and W. Barth, *Carpi: Una sede principesca del Rinascimento*, ed. Luisa Giordano, trans. A. D'Amelio and A. E. Werdehausen, Pisa, 1999: 471–81.

——, 'Alberto Pio e la città: ipotesi e novità di lettura', in *La città del Principe Semper e Carpi, attualità e continuità della ricerca*, Proceedings of an International Symposium, Pisa, 2001 (= 2001a).

——, *Da castello a città Carpi e Alberto Pio (1472–1530)*, Rome, 2001 (= 2001b).

Talignani, Alessandra, '*Quis Evadet*: Una traccia dell'*Hypnerotomachia Poliphili* a Parma nel sepolcro di Vincenzo Carissimi', *Artes*, 5, 1997: 111–37.

Tassi, Roberto, 'La Camera di Fontanellato. La giovinezza del Parmigianino', in *La corona di primule. Arte a Parma dal xii al xx secolo*, Parma, 1994.

Tazartes, Maurizia, 'Nouvelles perspectives sur la peinture lucquoise du Quattrocento', *Revue de l'Art*, 75, 1987: 29–36.

Tea, Eva, 'L'Immacolata Concezione nell'arte', in *L'Immacolata Concezione. Storia ed esposizione del dogma*, Milan, 1954: 145–62.

Terpstra, Nicholas, *Lay Confraternities and Civic Religion in Renaissance Bologna*, Cambridge, 1995.

——, 'Confraternities and Mendicant Orders: The Dynamics of Lay and Clerical Brotherhood in Renaissance Bologna', *Catholic Historical Review*, 82.1, 1996: 1–22.

Thimann, Michael, *Lügenhafte Bilder: Ovids favole und das Historienbild in der italienischen Renaissance*, Göttingen, 2002.

Thoenes, Christof, ed., *Sebastiano Serlio*, vith International Seminar in the History of Architecture, Milan, 1989.

Thornton, Agathe, *The Living Universe: Gods and Men in Virgil's Aeneid*, Leiden, 1976.

Thornton, Peter, *The Italian Renaissance Interior 1400–1600*, New York, 1991.

Tiraboschi, Girolamo, *Biblioteca Modenese*, 6 vols, Modena, 1781–86.

Tissoni Benvenuti, Antonia, 'Baiardi, Antonio', in *Letteratura Italiana, Il Quattrocento*, Bari, 1972, 2: 398–9, 422–3.

Tonini, Luigi, *Guida illustrata di Rimini*, Rimini, 1893.

Toscano, Giuseppe Maria, *Il pensiero cristiano nell'arte*, 3 vols, Bergamo, 1960.

Trapp, J. B., 'Portrait of Ovid in the Middle Age and the Renaissance', in *Die Rezeption*

der Metamorphosen des Ovid in der Neuzeit: Der Antike Mythos in Text und Bild, ed. Hermann Walter and Hans Jürgen Horn, Berlin, 1995: 252–77.

Traversa, Maria Paola, *Il 'Fidele' di Giovanni Filoteo Achillini. Poesia, sapienza e 'divina' conoscenza*, Modena, 1992.

Treu, Max, 'Die neue "orpische" Unterweltsbeschreibung und Vergil', *Hermes*, 82, 1954: 24–51.

Trium poetarum elegantissimorum Porcellii, Basinii et Trebani opuscula, nunc primum diligentia eruditissimi viri Christophori Preudhomme Barroducani in lucem edita, Paris, 1539.

Trombetti Budriesi, Anna Laura, 'Sui rapporti tra i Pio e gli Estensi: lo scambio Carpi-Sassuolo', in *Società politica e cultura ai tempi di Alberto III Pio*, Proceedings of an International Symposium, 2 vols, Padua, 1981, 2: 395–425.

Tumidei, Stefano, 'Un'aggiunta al "Maestro dei Baldraccani" e qualche appunto sulla pittura romagnola del tardo Quattrocento', *Prospettiva*, 49, 1987: 80–91.

——, 'Melozzo da Forlì: fortuna, vicende, incontri di un artista prospettico', in *Melozzo da Forlì: la sua città e il suo tempo*, ed. Marina Foschi and Luciana Prati, Milan, 1994: 19–81.

Turchini, Angelo, ed., *Isotta bella sola ai nostri giorni: Sonetti di Sigismondo Pandolfo Malatesti*, Rimini, 1983.

——, *Il Tempio Malatestiano, Sigismondo Malatesta e Leon Battista Alberti*, Cesena, 2000.

Tuttle, Richard J., in *Giulio Romano*, exh. cat., Milan, 1989.

Urbini, Silvia, 'Amico Aspertini poligrafo dell'illustrazione libraria', in *Nuovi Studi Rivista di Arte Antica e Moderna*, 4, 1996: 143–55.

——, 'Arte italiana e arte tedesca fra le pagine dei libri', in *I Quaderni della Fondazione Ugo Da Como*, 3.4/5, 2001: 39–68.

Vaccaro, Mary, 'Parmigianino and the Poetry of Drawing', in Sylvie Béguin, Mario Di Giampaolo and Mary Vaccaro, *Parmigianino: The Drawings*, Turin, 2000: 61–95.

——, 'Parmigianino and Andrea Baiardi: Figuring Petrarchan Beauty in Renaissance Parma', *Word & Image*, 17, 2001: 243–58.

——, *Parmigianino: The Paintings*, London and Turin, 2003.

Valeriano, Pierio, *Hieroglyphica*, Basle, 1556.

Valerius Flaccus, *Argonautica*, trans. J. H. Mozley, London and Cambridge, MA, 1934.

Valturius, Robertus, *Ad illustrem heroa Sigismundum Pandulphum Malatestam Ariminensium regem de re militari lib[ri] XII*, Paris, 1532.

Varese, Ranieri, *Lorenzo Costa*, Milan, 1967.

Vasari, Giorgio, *Le Vite de' più eccellenti Pittori Scultori ed Architettori*, ed. Gaetano Milanesi, 9 vols, Florence, 1906.

——, *Le Vite de' più eccellenti Pittori, Scultori e Architettori nelle redazioni del 1550 e 1568*, eds Paola Barocchi and Rosanna Bettarini, 6 vols, Florence, 1966–87.

Vasoli, Cesare, 'Alberto Pio e la cultura del suo tempo', in *Società politica e cultura ai tempi di Alberto III Pio*, Proceedings of an International Symposium, 2 vols, Padua, 1981, 1: 3–42.

Vattasso, Marco, *I codici petrarcheschi della Biblioteca Vaticana*, Rome, 1908.

Vecchi, Valeria. 'Tre Donne Sanvitale nel primo Cinquecento a Parma. Susanna, Laura, Paola, III', *Aurea Parma*, 80, 1996: 287–95.

Vedriani, Ludovico, *Raccolta de' pittori, scultori, et architetti modonesi più celebri*, Modena, 1662.

Venturelli, Roberto, '*Duorum populorum divisio*: la *Crocifissione* del Pordenone e il conflitto ebraico-cremonese del 1519–1521', in *La Cattedrale di Cremona. Affreschi e sculture*, ed. Alessandro Tomei, Casalmorano and Cinisello Balsamo, 2001: 163–73.

Venturi, Adolfo, *Storia dell'arte italiana. La pittura del Cinquecento*, 9, Milan, 1932.

Verdon, Timothy, 'Si tu non piangi quando questo vedi ...': penitenza e spiritualità laica nel Quattrocento', in *Niccolò dell'Arca*, eds Grazia Agostini and Luisa Ciammitti, Bologna, 1989: 151–66.

Vignes, Jean, 'La poésie gnomique', in *Poétiques de la Renaissance*, intr. Terence Cave, ed. Perrine Galand-Hallyn and Fernand Hallyn, Geneva, 2001: 364–73.

[Virgil], 'P[ublii] V[irgilii] Maronis aeneidos libri duodecim cum Servii grammatici et Donati atque Christophori Landini interpretationibus', in [Virgil], *Omnia opera*, Venice, 1508.

——, *Aeneid VII–XII, The Minor Poems*, trans. H. Rushton Fairclough, Cambridge, MA and London, 1935 (= 1935a).

——, *Eclogues, Georgics, Aeneid I–VI*, trans. H. Rushton Fairclough, Cambridge, MA and London, 1935 (= 1935b).

——, *P. Vergilii Maronis Aeneidos liber sextus*, with a commentary by R. G. Austin, Oxford, 1977.

——, *The Sixth Book of Virgil's Aeneid*, trans. and comm. Sir John Harington, ed. Simon Cauchi, Oxford, 1991.

Viroli, Giordano, *La Pinacoteca Civica di Forlì*, Forlì, 1980.

Vloberg, Maurice, 'The Iconography of the Immaculate Conception', in Edward O'Connor, ed., *The Dogma of the Immaculate Conception: History and Significance*, Notre Dame, 1958: 463–506.

Voigt, Georg, *Die Wiederbelebung des classischen Alterthums oder das erste Jahrhundert des Humanismus*, ed. Max Lehnerdt, 2 vols, Berlin, 1893.

Voltini, Franco, and Valerio Guazzoni, eds, *Cremona. La Cattedrale*, Cinisello Balsamo, 1989.

Voragine, Jacobus da, *Legenda aurea*, ed. Alessandro and Lucetta Vitale Brovarone, Turin, 1995.

Vuilleumier Laurens, Florence, *La Raison des Figures Symboliques à la Renaissance et à l'Âge Classique. Etudes sur les fondements philosophiques, théologiques et rhétoriques de l'image*, Geneva, 2000.

Waldman, Louis Alexander, 'Fact, Fiction, Hearsay: Notes on Vasari's Life of Piero di Cosimo', *Art Bulletin*, 82, 2000: 171–9.

Waser, Otto, 'Elysion', in *Paulus Realencyclopaedie der classischen Altertumswissenschft*, Stuttgart, 1905, v. 2: 2470–76.

Watson, Paul F., *The Garden of Love in Tuscan Art in the Early Renaissance*, Philadelphia and London, 1979.

Wesseling, Ari, 'Dutch Proverbs and Expressions in Erasmus' *Adages, Colloquies*, and *Letters*', *Renaissance Quarterly*, 55, 2002: 81–147.

Wind, Edgar, 'Ripeness is All', in *Pagan Mysteries in the Renaissance*, New York and London, 1968: 97–112.

——, *Misteri pagani nel Rinascimento* (trans. from the 1968 English edn), Milan, 1971.

Winkelmann, Jurgen, 'Giovanni Battista Ramenghi detto il Bagnacavallo Junior', in *Pittura bolognese del '500*, ed. Vera Fortunati Pietrantonio, vol. 2, Bologna, 1986: 429–47.

Winkelmes, Mary-Ann, 'Taking Part: Benedictine Nuns as Patrons of Art and Architecture', in *Picturing Women in Renaissance and Baroque Italy*, eds Geraldine A. Johnson and Sara Matthews Grieco, Cambridge and New York, 1997: 91–110.

Wittkower, Rudolf, 'Transformations of Minerva in Renaissance Imagery', *Journal of the Warburg and Courtauld Institutes*, 2, 1938–39: 194–205.

——, 'Hieroglyphics in the Early Renaissance', in *Allegory and the Migration of Symbols* (first publ. 1977), London, 1987: 114–28.

Wolf, Eugen, 'Die Allegorische Vergilerklaerung des Cristoforo Landino', *Neue Jahrbuecher das Klassische Altertum*, 43, 1919: 453–79.

Wyss, Robert L., 'Die neun Helden: Eine ikonographische Studie', *Zeitschrift für schweizeirische Archäologie und Kunstgeschichte*, 17.2, 1957: 98–102.

Yriarte, Charles, *Rimini. Un condottiere au xve siècle: Études sur les lettres et les Arts à la cour des Malatesta*, Paris, 1882.

Zabughin, Vladimiro, *Vergilio nel rinascimento italiano da Dante a Torquato Tasso*, I: *Il Trecento ed il Quattrocento*, Bologna, 1921.

Zacchi, Alessandro, 'Sala di Susanna', in *L'immaginario di un ecclesiastico. I dipinti murali di Palazzo Poggi*, eds Vera Fortunati and Vincenzo Musumeci, Bologna, 2000: 130–37.

Zanichelli, Giuseppa, *Iconologia della Camera di Alessandro Araldi nel Monastero di San Paolo in Parma*, Parma, 1979.

Zanti, Giovanni, *Nomi et cognomi delle contrade et strade di Bologna per ordine di alfabeto*, Bologna, 1583.

Zarri, Gabriella, 'Storia di una committenza', in *L'Estasi di Santa Cecilia di Raffaello da Urbino nella Pinacoteca Nazionale di Bologna*, exh. cat., Bologna, 1983: 21–37.

——, *Donne, Clausura e Matrimonio nella prima età moderna*, Bologna, 2000.

Zelzer, Michaela, 'Hesperis', in *Kindlers neues Literatur Lexikon*, ed. Walter Jens, Munich, 1988, 2: 292.

Zemon Davis, Natalie, 'Boundaries and the Sense of Self in Sixteenth-Century France', in *Reconstructing Individualism: Autonomy, Individuality, and the Self in Western Thought*, eds Thomas C. Heller, Morton Sosna and David E. Wellbery, Stanford, 1986: 53–63.

Zeri, Federico, 'Presentazione', in *Pittura bolognese del Cinquecento*, 2 vols, ed. Vera Fortunati Pietrantonio, Bologna, 1986, 1: VII–XVI.

Index

Picture references have been set in bold.